SERENGETI

SERENGETI

Natural Order on the African Plain

Mitsuaki Iwago

Chronicle Books • San Francisco

First published in the United States 1987 by
Chronicle Books, San Francisco

Printed in Japan by Toppan Printing Co., Tokyo, Japan.

First published in Japan by Shogakukan Inc.

Library of Congress Cataloging-in-Publication Data

Iwagō, Mitsuaki, 1950–
 Serengeti, natural order on the African plain.

 Translation of: Okite.
 1. Zoology–Tanzania–Serengeti National Park–
Pictorial works. 2. Serengeti National Park (Tanzania)–
Pictorial works. I. Title.
QL337.T3I9313 1987 591.9678'27 87-6393
ISBN 0-87701-441-8 (cloth)
ISBN 0-87701-432-9 (pbk.)

Edited by Charles Robbins

Distributed in Canada by
Raincoast Books
112 East 3rd Avenue
Vancouver, B.C.
V5T 1C8
10 9 8 7 6 5 4 3

Chronicle Books
One Hallidie Plaza
San Francisco, CA 94102

SERENGETI

Natural Order on the African Plain

Serengeti National Park stretches for endless miles across the wilds of East Africa. A world of calm beauty and quick violence, it is home to over two million animals and witness to daily dramas of life and death played against a background of sublime grandeur.

To capture that fascinating world in photos, I lived in the park for a year and a half, from August 1982 to March 1984. Before that time, I had traveled all over the globe to photograph wild animals in their natural habitats. Nevertheless, I had become frustrated because I felt there was a limit to how well I could understand the animals' lives when working in a hurried, detached manner. I finally asked myself if I could truly capture the essence of nature and animals without living among them.

Consequently, I decided to stay in one region and tackle the problems of working in a single locale. I chose the Serengeti National Park because I had visited the area several times and was intrigued by it.

Serengeti means "endless plain" in the language of the Masai people, a seminomadic tribe living in the region. The park is possibly the finest area in the world for its selection and number of large animals. A year and a half did not seem long enough for my task because to know the park well one would undoubtedly need to live there five or ten years. However, I did my best in the limited time available.

With my wife and four-year-old daughter, I rented a small house in a village called Seronera, located in the center of the park. Its population consists of six hundred Tanzanians who are rangers in the park or employees of the tourist lodges.

In this small village, no gas or electricity was available, and water had to be pumped from a spring fifty-five miles away. The water pipe was very old and often out of order.

Because of the water shortage, it was often difficult to wash or find drinking water. On days when the water flowed, my wife scrubbed our clothes on a washboard she had found, after many days of searching, in Tokyo. We were in constant need of meat and fresh vegetables.

Books, newspapers, and music were also in short supply. My wife frequently listened to tapes of classical music. Mozart is her favorite, and she believed the sound of the violin suited the plain. Although I am a fan of rock music, I had to agree.

We realized that we had a lot of the "dirt" that we call "civilization" from our city life in Japan. As the time passed, the "dirt" slowly disappeared, and we began to feel refreshed. By the time we decided to return to Japan, my wife expressed her appreciation and love for Serengeti, saying, "I could stay here by myself."

During those eighteen months, the faces of the wild animals began to look familiar to me. Of course, they did not exhibit signs of intimacy, but I felt something like friendship for them. Whenever I saw a family of cheetahs or lions, I could not help hoping that the cubs would grow up safely.

As I kept pushing the shutter release of my camera, I came eventually to a conclusion, a truth about nature. I began to call this truth "Okite." It is the Law that rules everything in Serengeti; in fact, it governs all life on earth. Human beings are no exception. This is my deep belief.

Nature can be both severe and gentle. Through the photographs in this book, I hope you will understand the significance nature and Okite have for me.

What image do you have of the wilds of eastern Africa or of the animals living there? It is difficult for people who have never visited that region to form a realistic picture of it. Some might think that joining a safari is the best way to experience Africa. Perhaps they

of the Frankfurt Zoological Society spent many years doing research on the Serengeti. He was instrumental in strengthening conservation efforts, especially through the success of his book, *Serengeti Shall Not Die,* published in 1959. On his advice, the conservation area was expanded to its present boundaries.

Designation of the boundaries was, of course, by the hand of man. As a result of this artificial situation, various problems have developed. Chief among them is the impact of human beings on the animals.

For instance, poaching has increased significantly. It is estimated that many of the 200,000 annual wildebeest deaths are caused by poachers, although the hunting of wildebeests is prohibited. Originally, many Africans hunted for their own meat and took very few of the wildebeests. Recently, poaching for profit has increased, and the wildebeests are being killed in larger numbers.

Even more serious is the terrible slaughter of rhinos and elephants by poachers who take only the tusks and horns. It is said that 65 percent of the African ivory is exported to Japan.

Also the human population is growing around the park and pressing at its boundaries. Many inhabitants raise cattle, and, consequently, wildebeests are in great danger of infection by rinderpest, a disease carried by cattle. It has been estimated that the herds will decrease by two-thirds if the wildebeests are not quickly innoculated.

Wild dogs offer a sharp reminder of the dangers of civilization to the animals of the Serengeti. Reportedly, fewer than a hundred wild dogs remain in the park. This sudden drop is the result of a distemper infection passed to the wild dogs by domesticated animals.

Examination of these problems has convinced me that humans can coexist with wild animals only with great difficulty. The artificial borders, the poaching, and the spread of infectious diseases all result from human violations of Okite, the law governing nature in the Serengeti. I am convinced that sooner or later we will suffer the consequences of this flagrant disregard of nature's laws.

There are no easy answers to these difficulties. Unless we make a consistent and intelligent effort to respect life in all its beautiful and varied forms and learn to recognize the reality of the laws governing all life, we will face a bleak future.

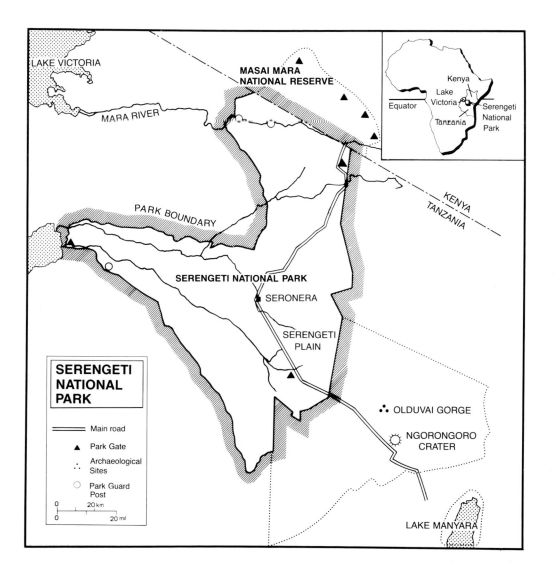

SERENGETI NATIONAL PARK

LAKE VICTORIA

MARA RIVER

MASAI MARA NATIONAL RESERVE

PARK BOUNDARY

KENYA
TANZANIA

SERENGETI NATIONAL PARK

■ SERONERA

SERENGETI PLAIN

OLDUVAI GORGE

NGORONGORO CRATER

LAKE MANYARA

Kenya
Lake Victoria
Equator
Tanzania
Serengeti National Park

**SERENGETI
NATIONAL
PARK**

Main road

▲ Park Gate

Archaeological
Sites

○ Park Guard
Post

0 20 km
0 20 ml

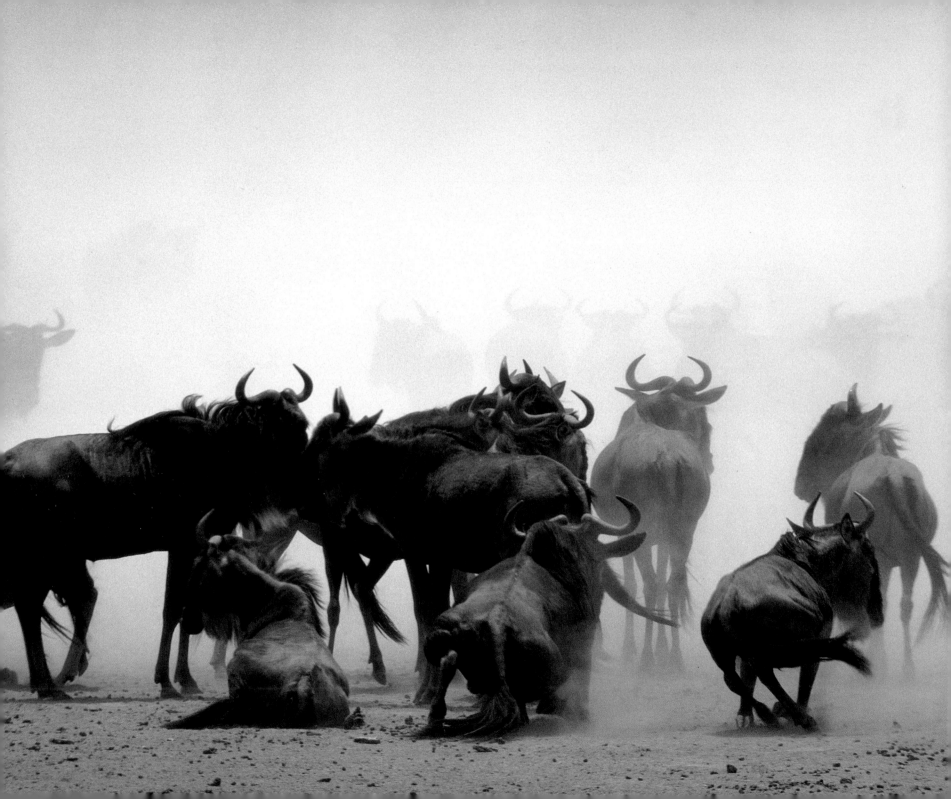

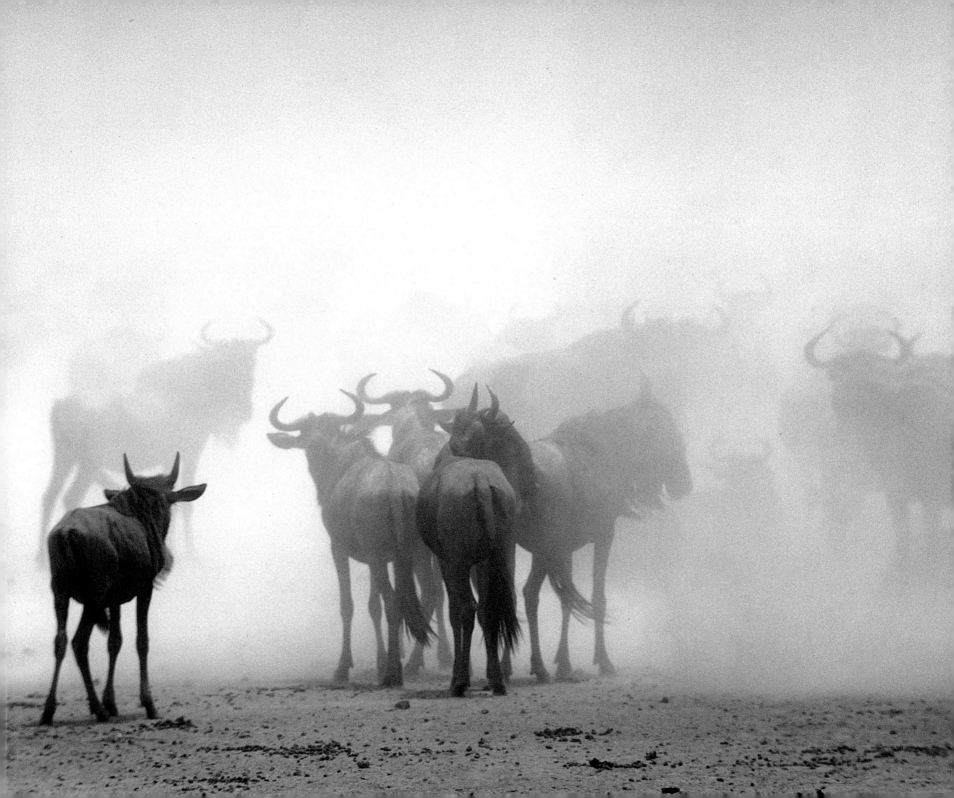

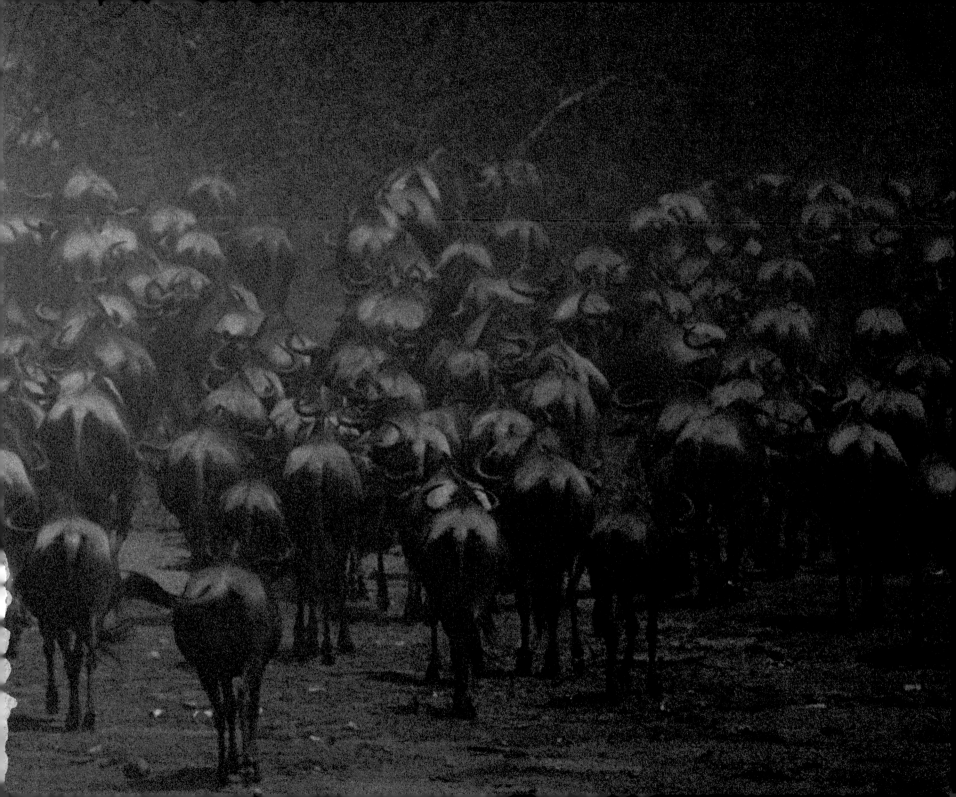

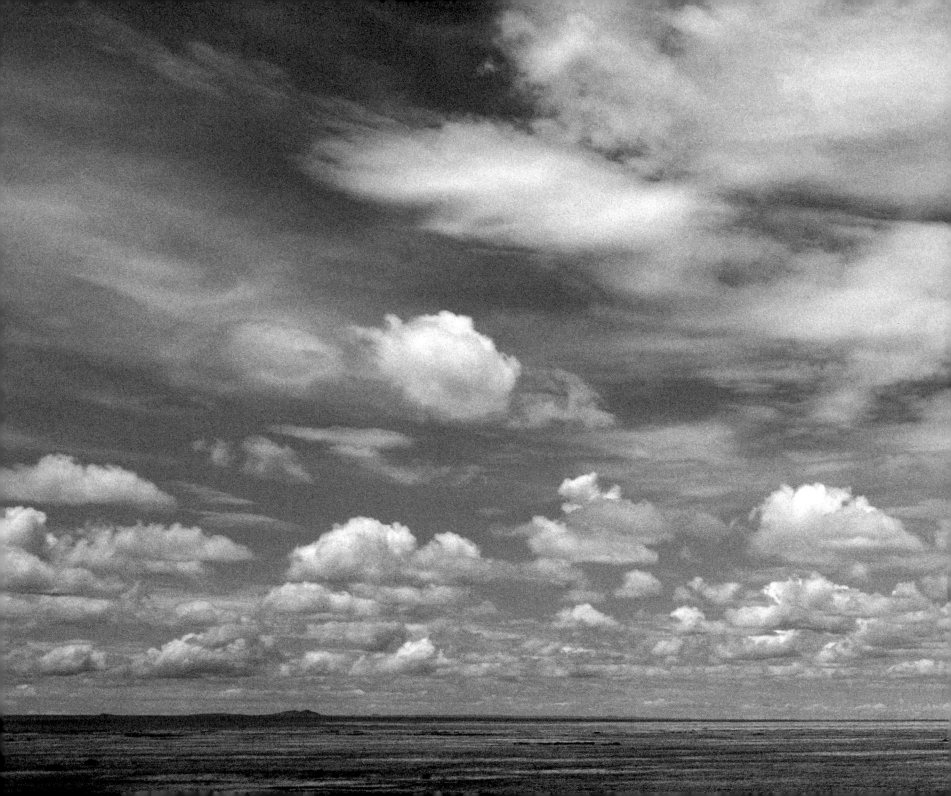

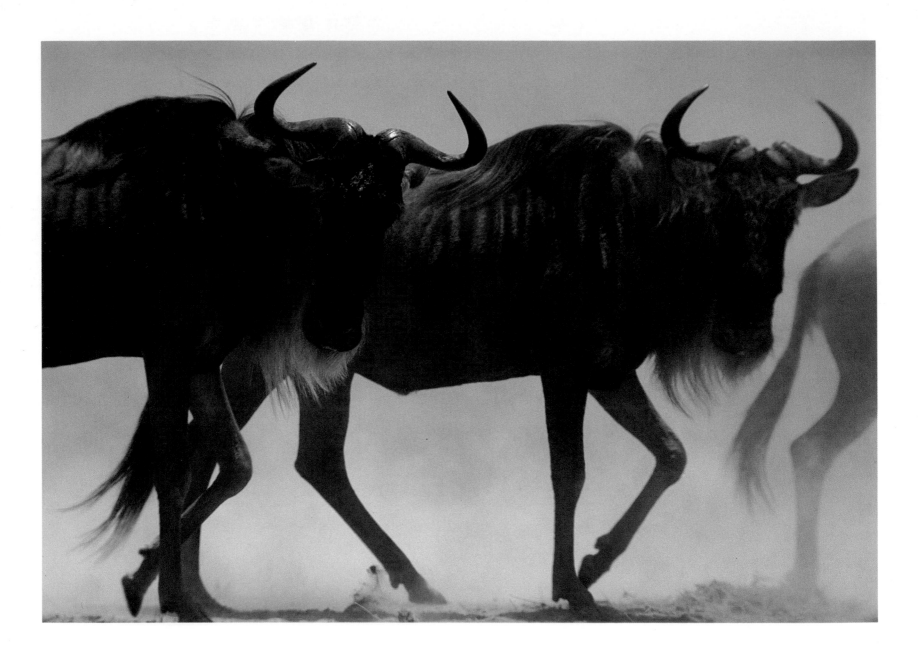

Previous pages: The wind blows constantly on the Serengeti Plain, creating billowing clouds and carrying the promise of rain.

Above: As the dry season ends, hungry wildebeests in the north of Serengeti National Park begin their migration.

Right: In the south, on the Serengeti Plain, the parched earth awaits rain.

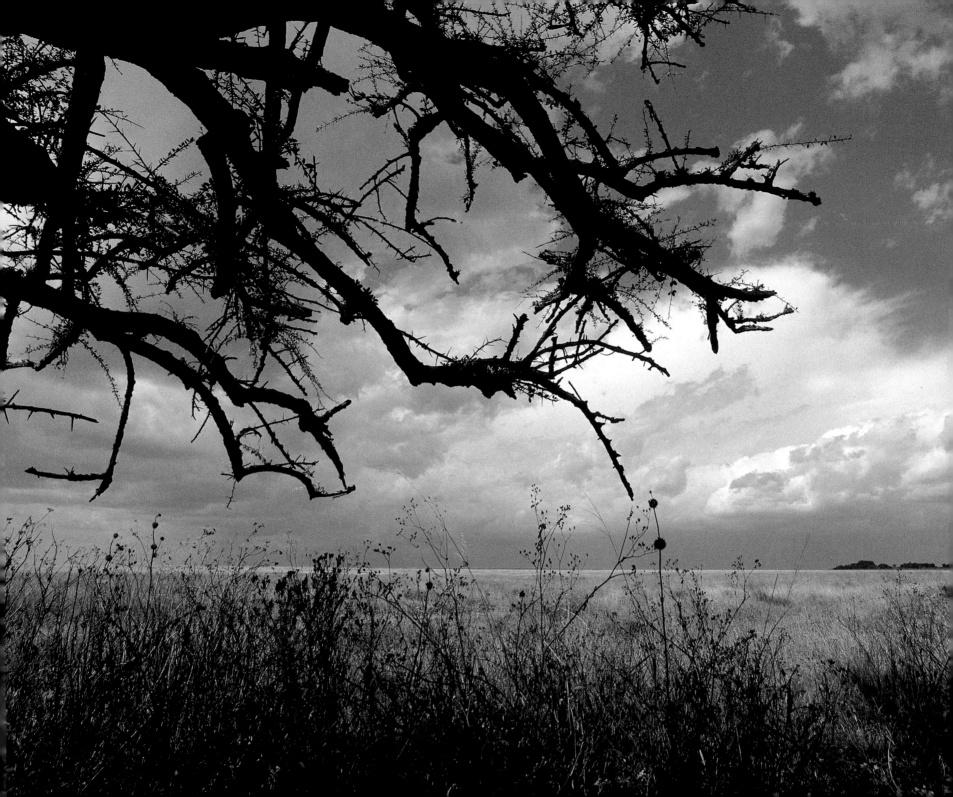

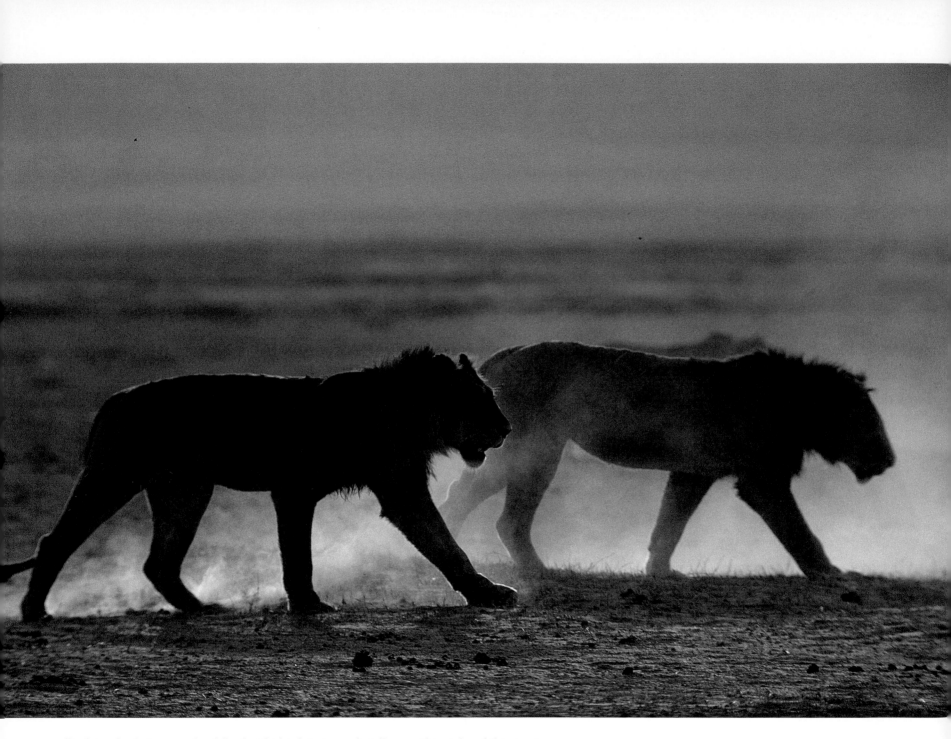

Predators begin to move also, following the herds to prey primarily upon the weak and the young.

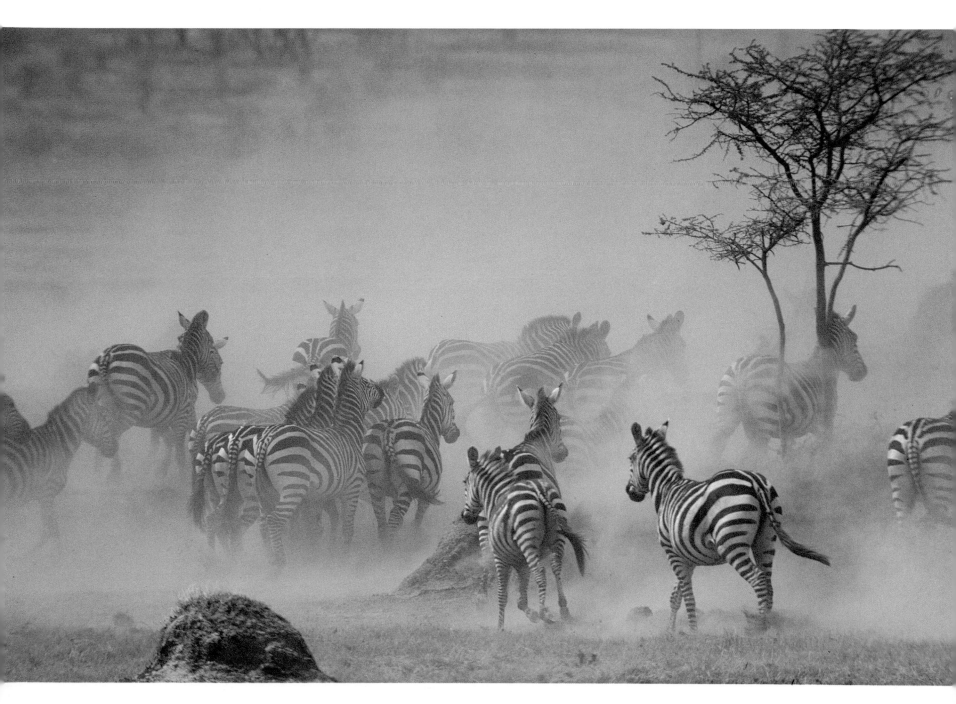

Running hoofs stir up the dry soil.

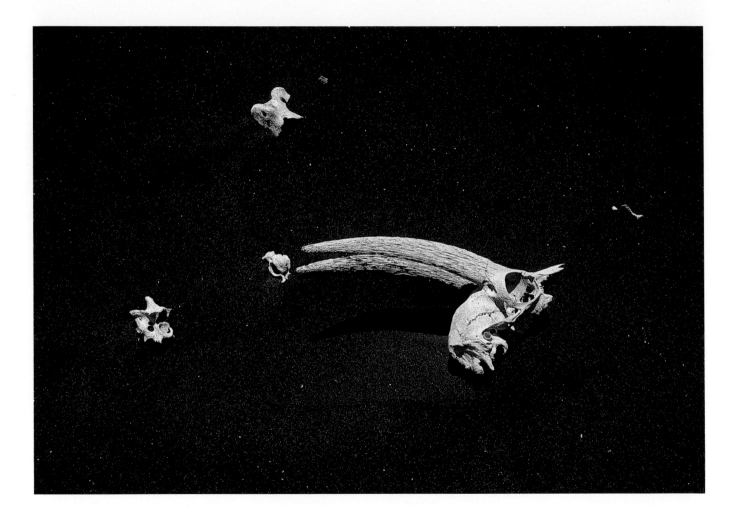

Above: Bones of the dead are scattered throughout the plain.

Right: Flight is the wildebeests' best protection against predators.

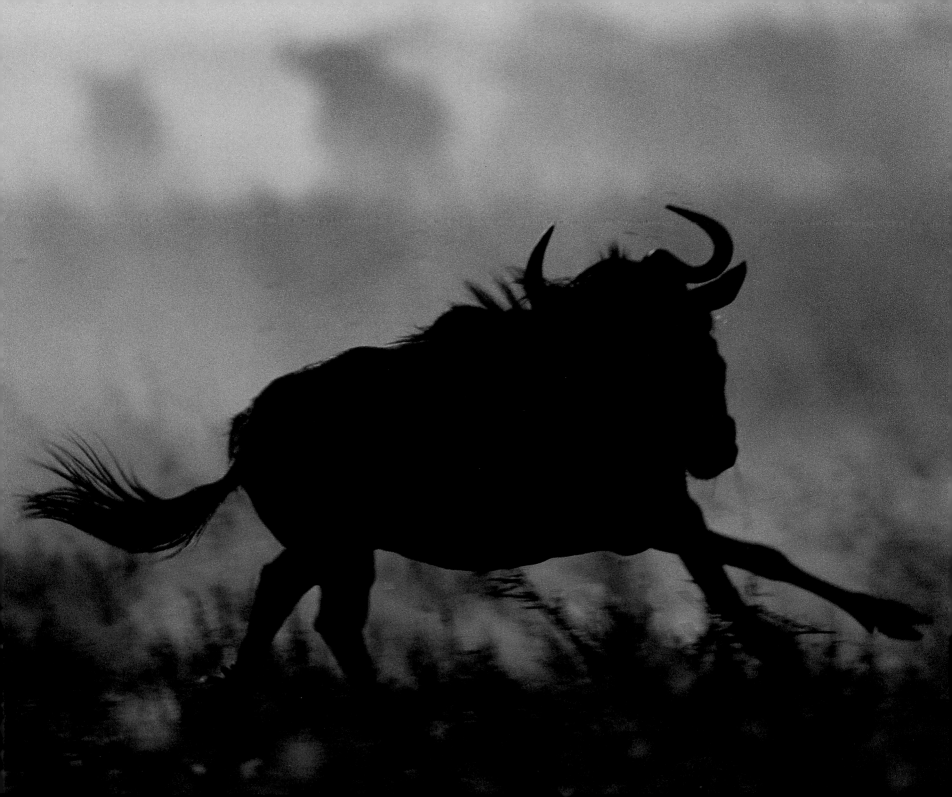

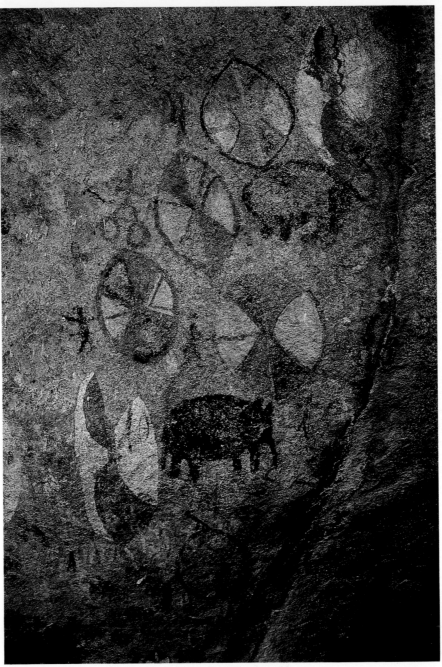

Above: This Masai wall painting is said to be 100 years old.

Right: A desolate lake bed in the gigantic Ngorongoro Crater will be a swamp during the rainy season.

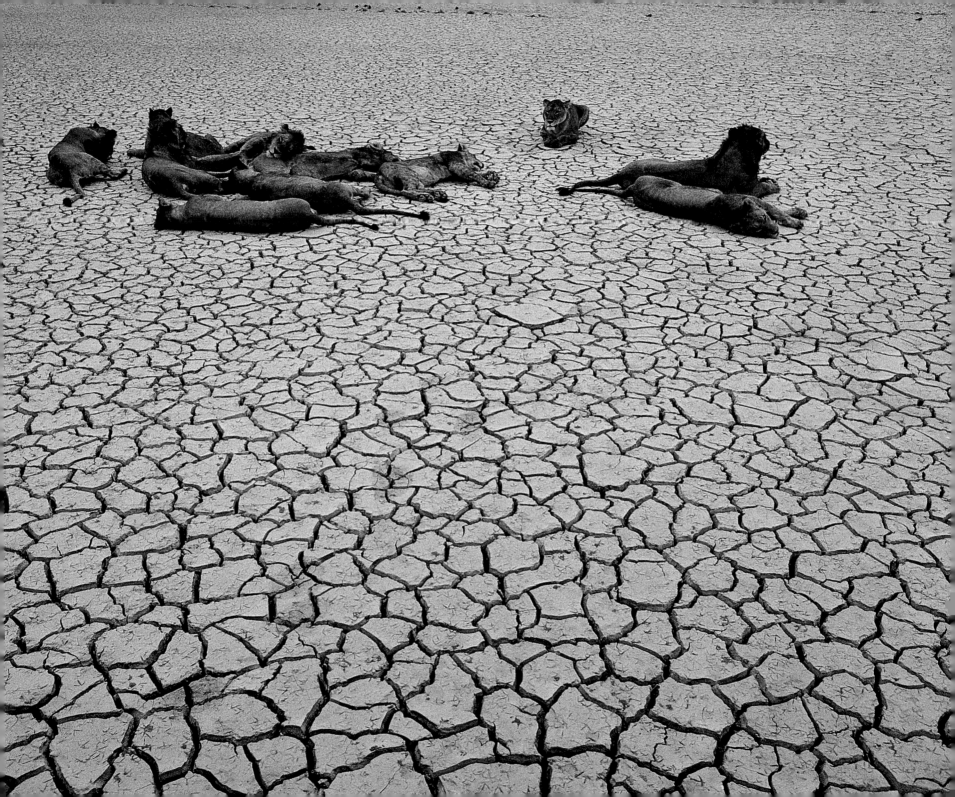

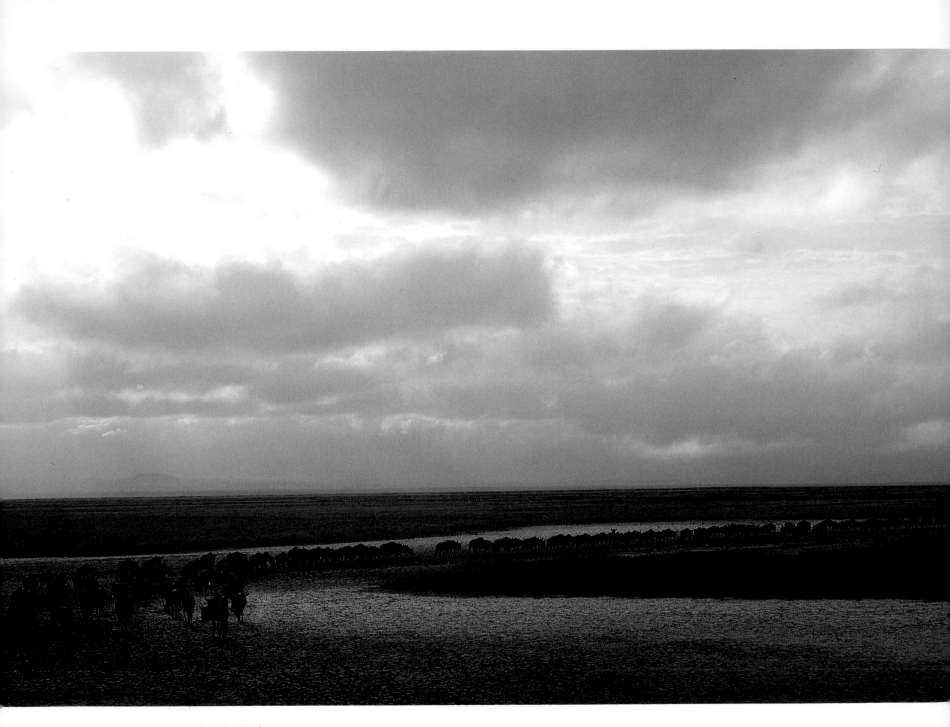

At the onset of rain, the migration begins.

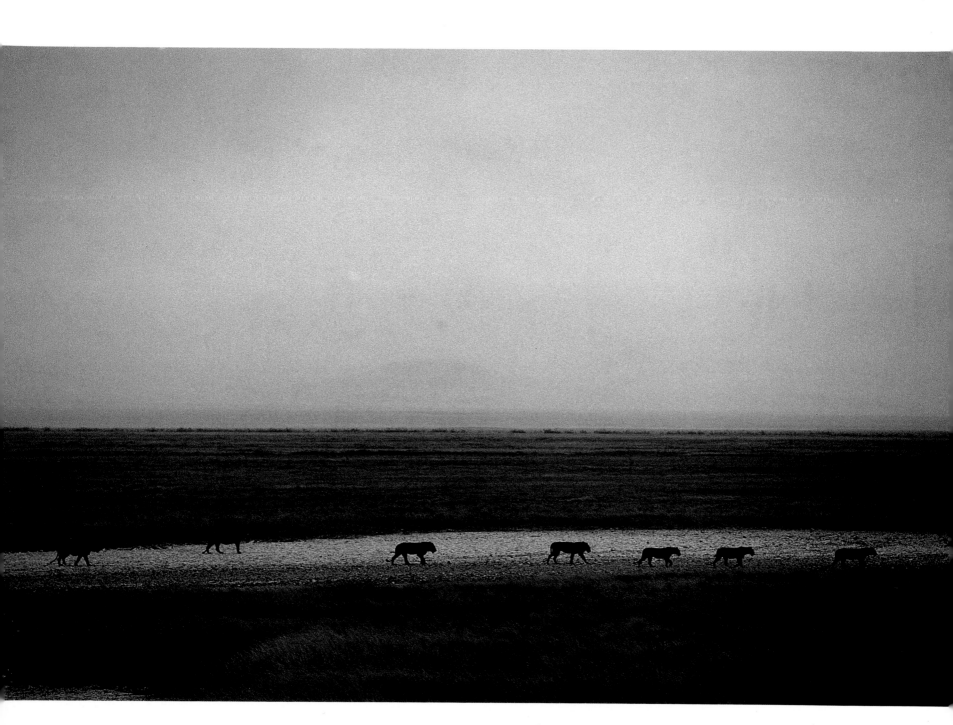

Among the big cats, lions exhibit the most cooperation during the hunt.

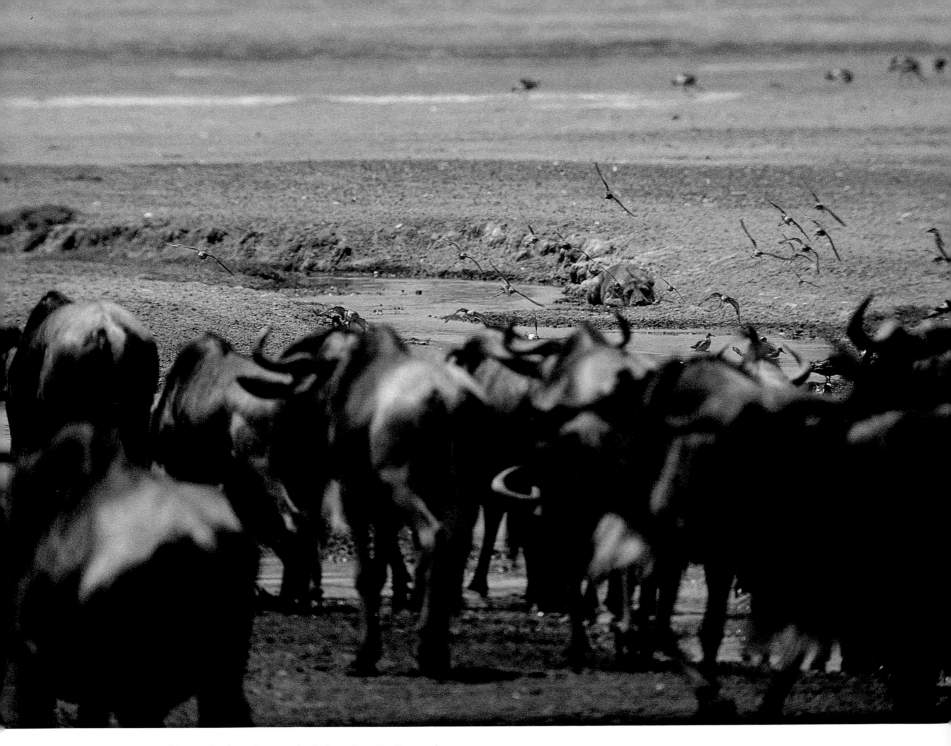

The need for water drives animals to the watering holes where the lions wait.

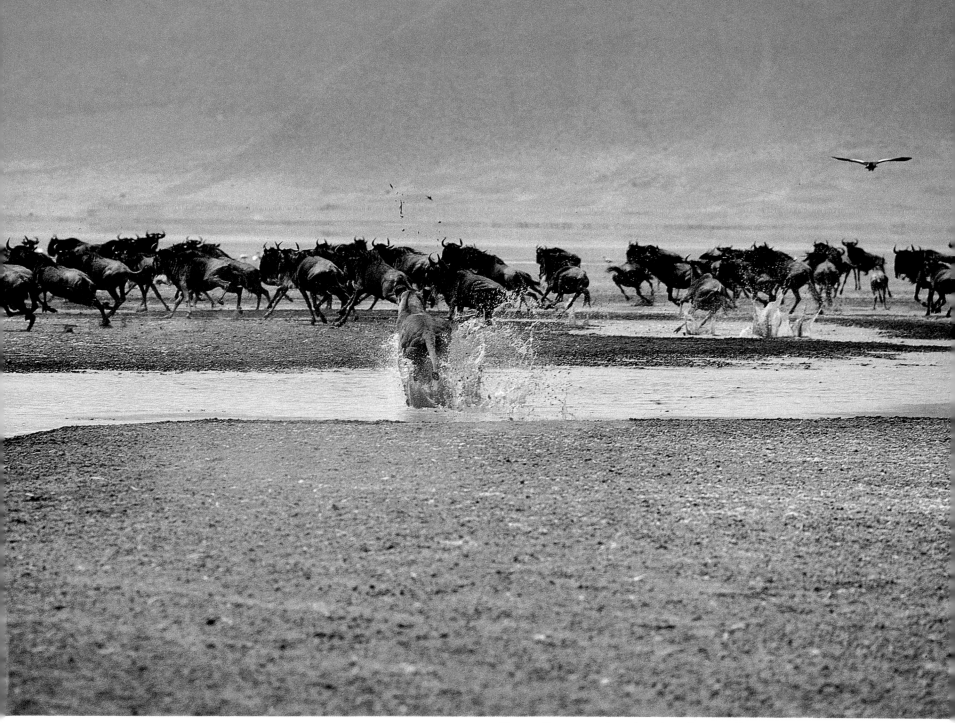

Because lions can sprint only a short distance, this cat has crouched motionless in a small hollow; then, when the wildebeests are in range, she explodes from concealment.

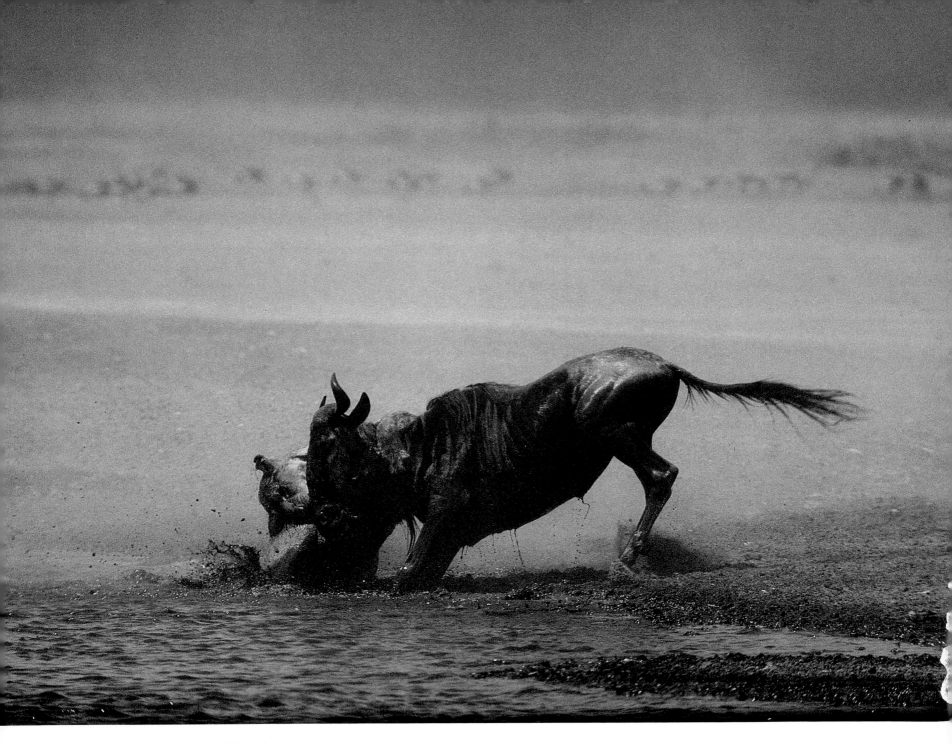

Powerful forelegs grasp the victim's neck.

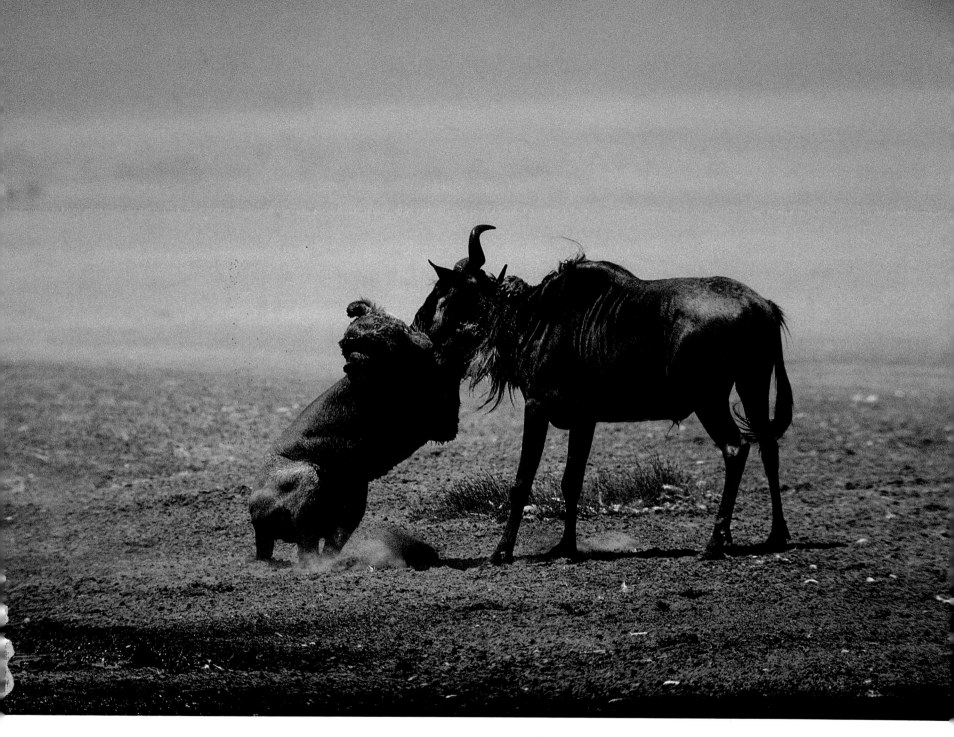

By bracing her back legs on the ground, the lioness seeks leverage to topple the wildebeest.

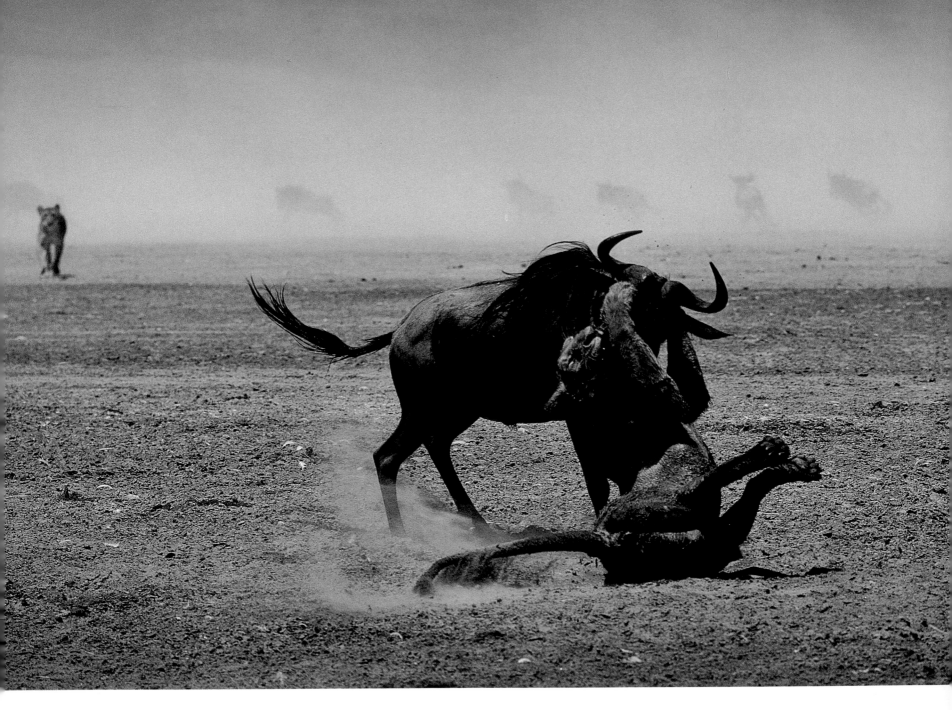

The wildebeest resists defiantly.

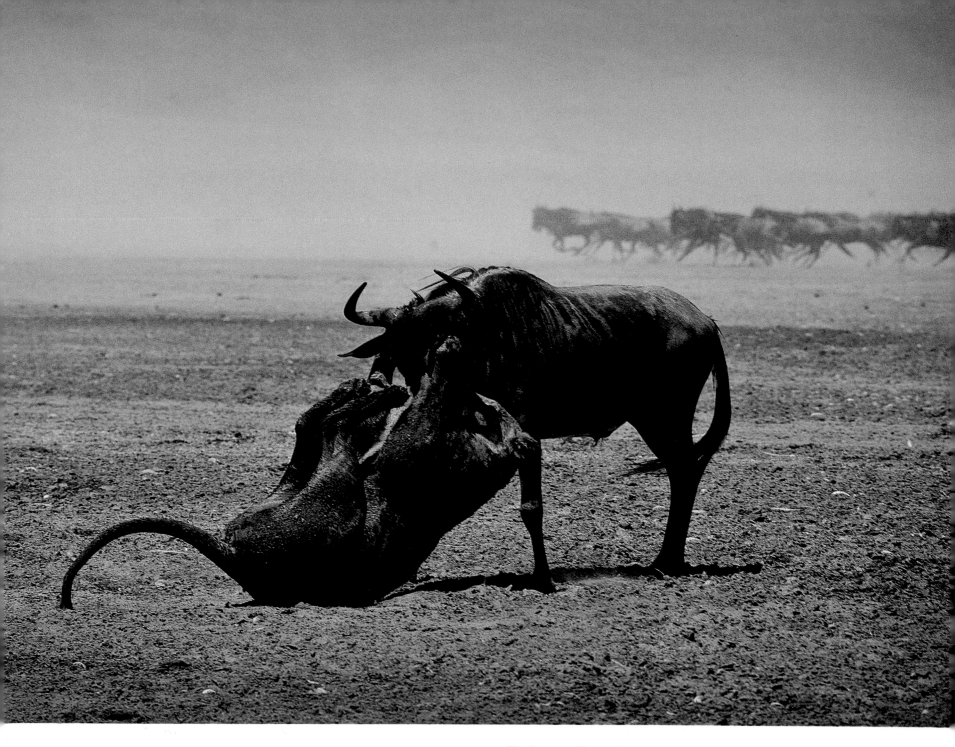

The lioness suffocates the animal by clamping her jaws over its nose and mouth.

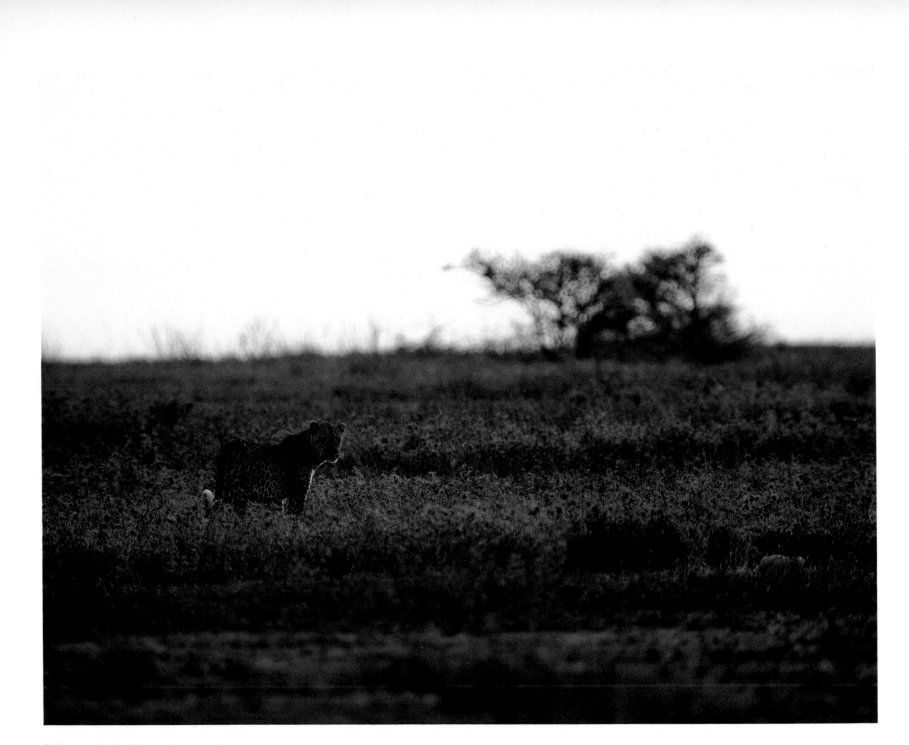

Solitary and aloof, leopards are rarely seen.

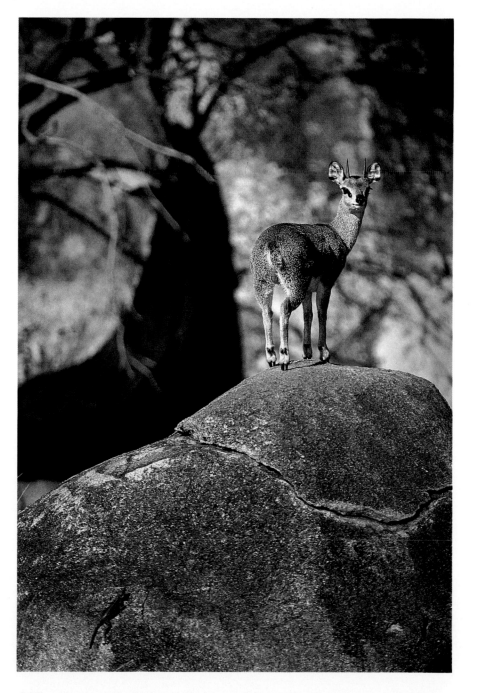

A klipspringer stands alertly on a kopje, one of the rock outcroppings that dot the plain.

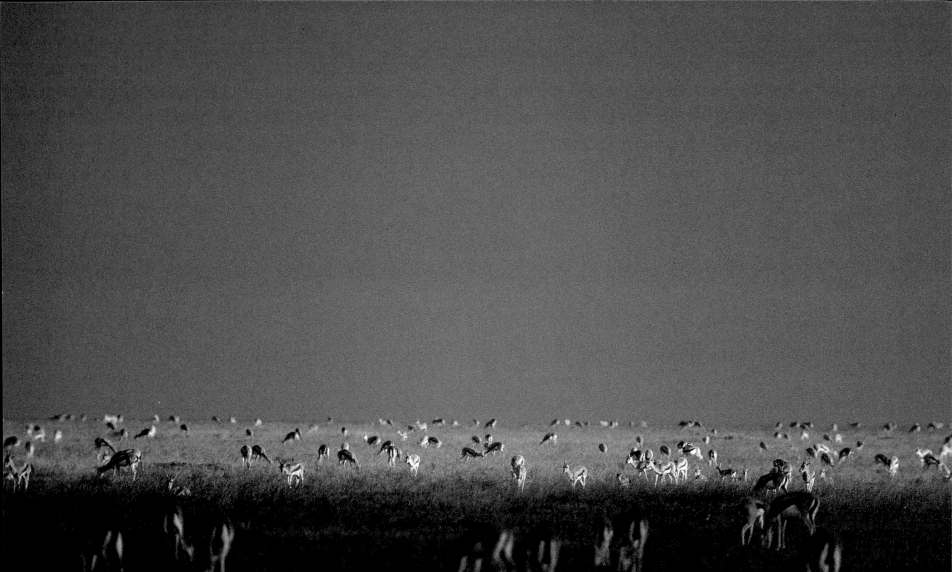

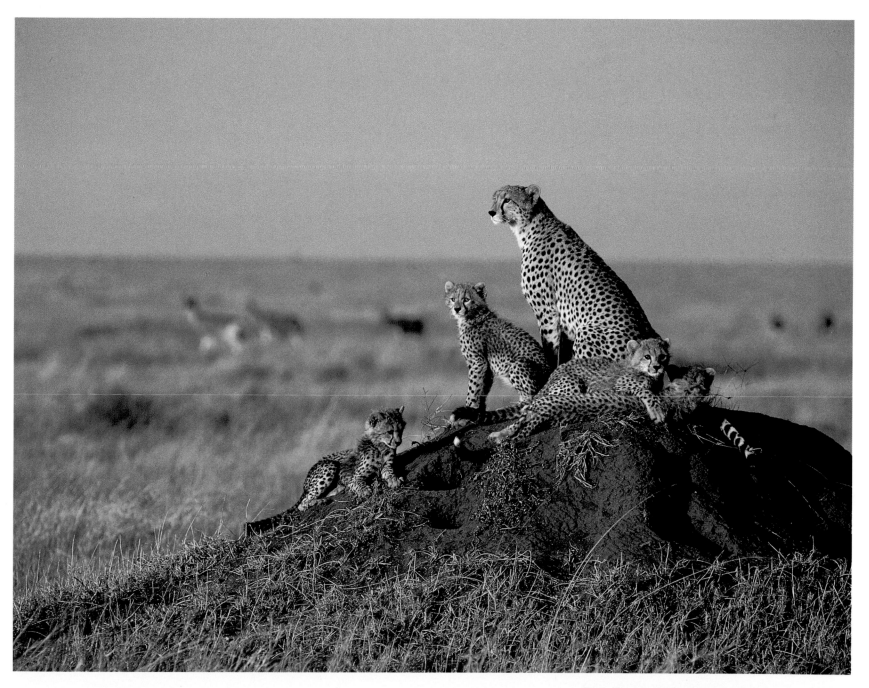

Left: Thomson's gazelles are prey to many predators.

Above: From a termite mound where they have climbed for a better view, a cheetah family follows the movement of Thomson's gazelles.

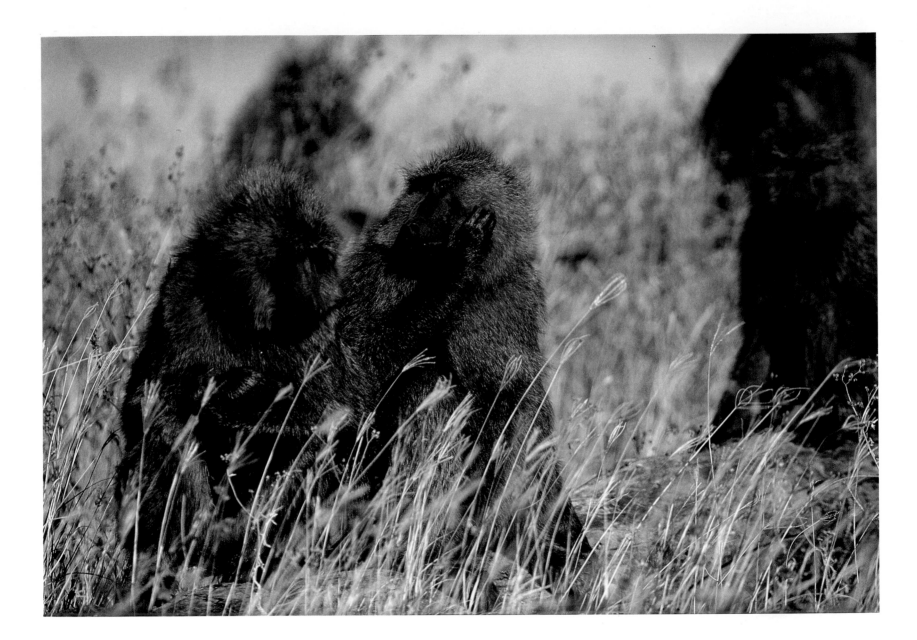

Originally tree dwellers, baboons have evolved a complex social organization
allowing them to survive on the open plains.

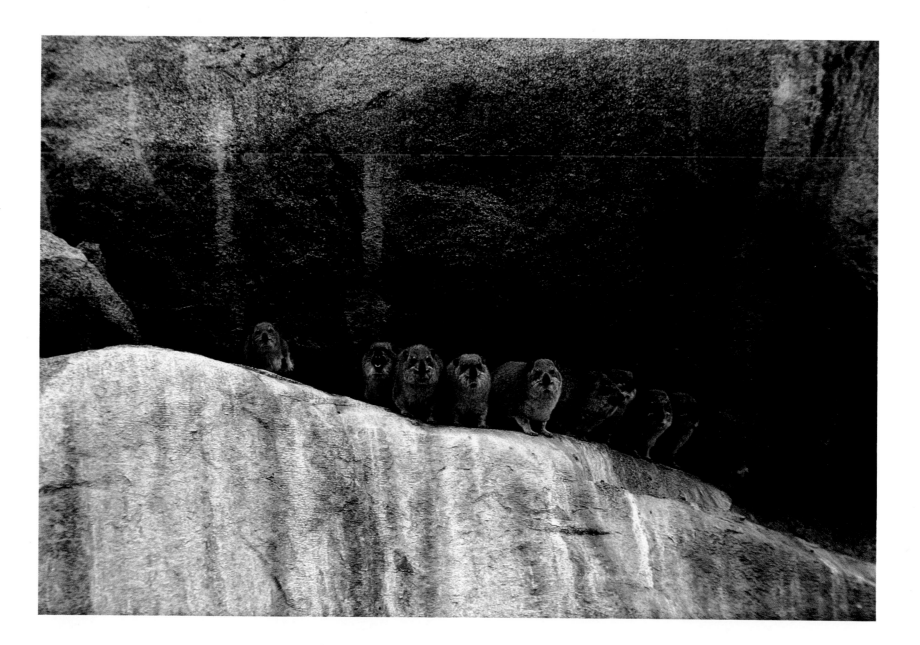

Hyraxes, small, furry creatures similar to rabbits
in appearance, are actually the closest living relatives to elephants.

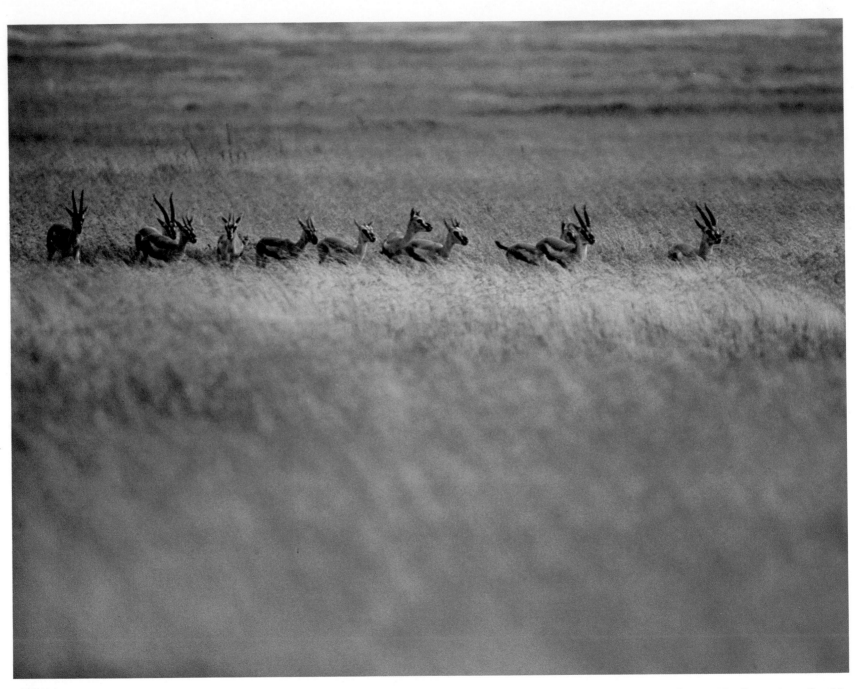

Above: Identified by the long black stripes on their sides, Thomson's gazelles feed constantly, ever alert for predators.

Right: Thomson's gazelles can run at speeds up to 35 miles per hour. Capable of nearly twice that speed, cheetahs are the gazelles' most dangerous enemy.

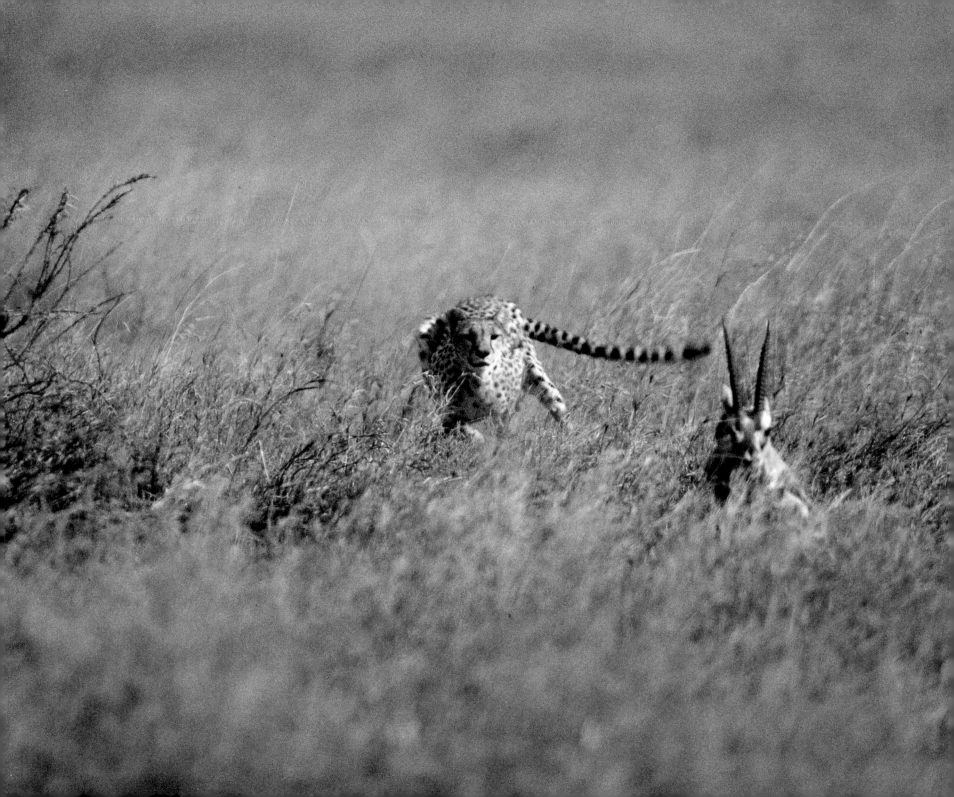

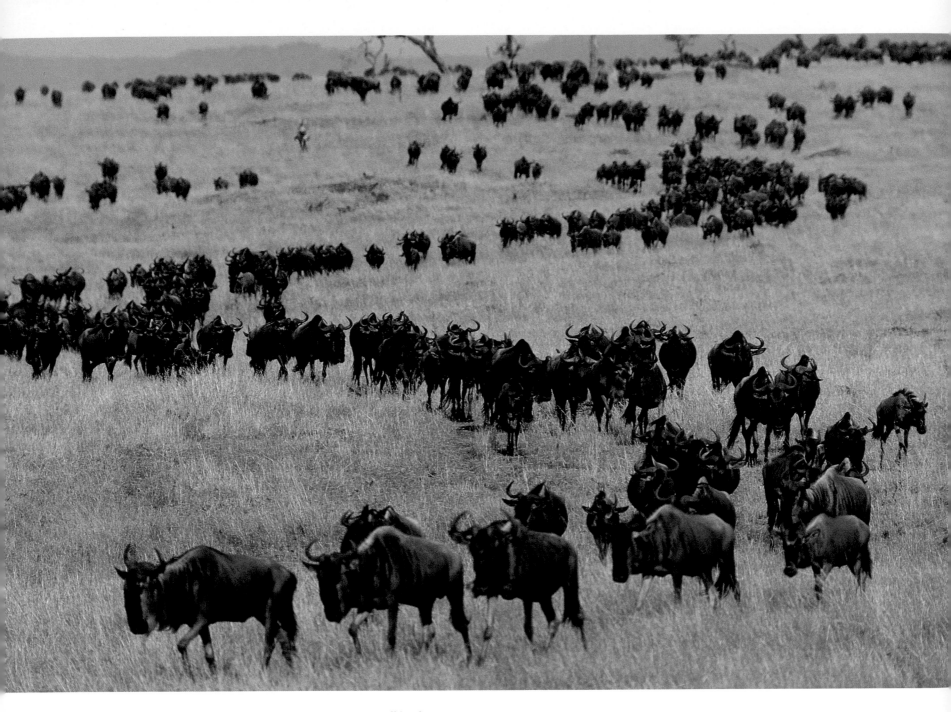

The migrating mass of wildebeests is composed of numerous small herds.

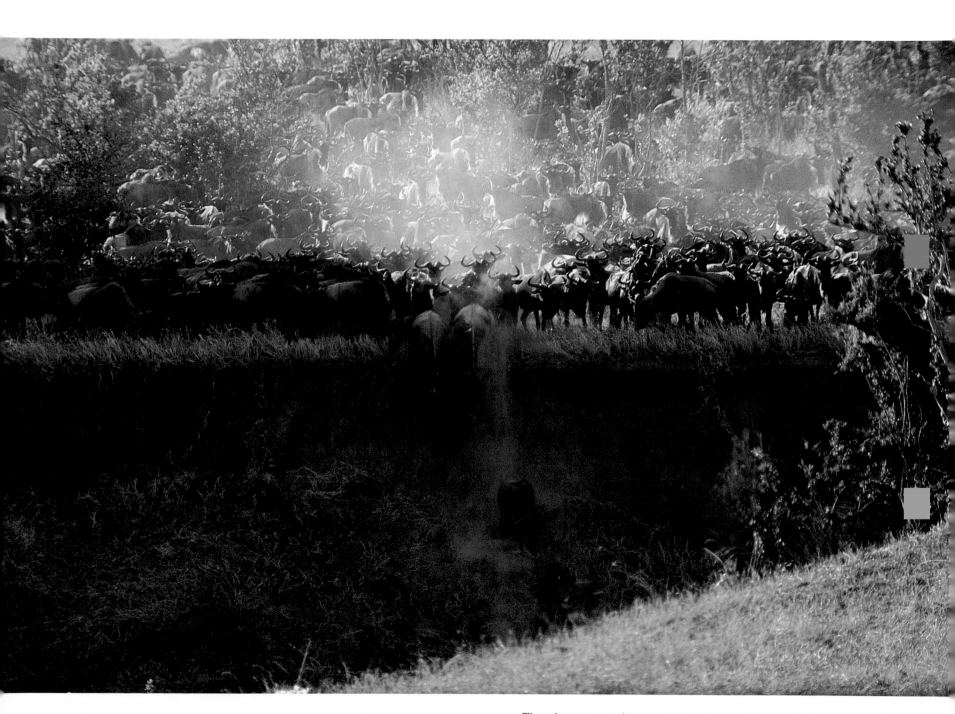

The migratory urge is so great that almost nothing can deflect the animals.

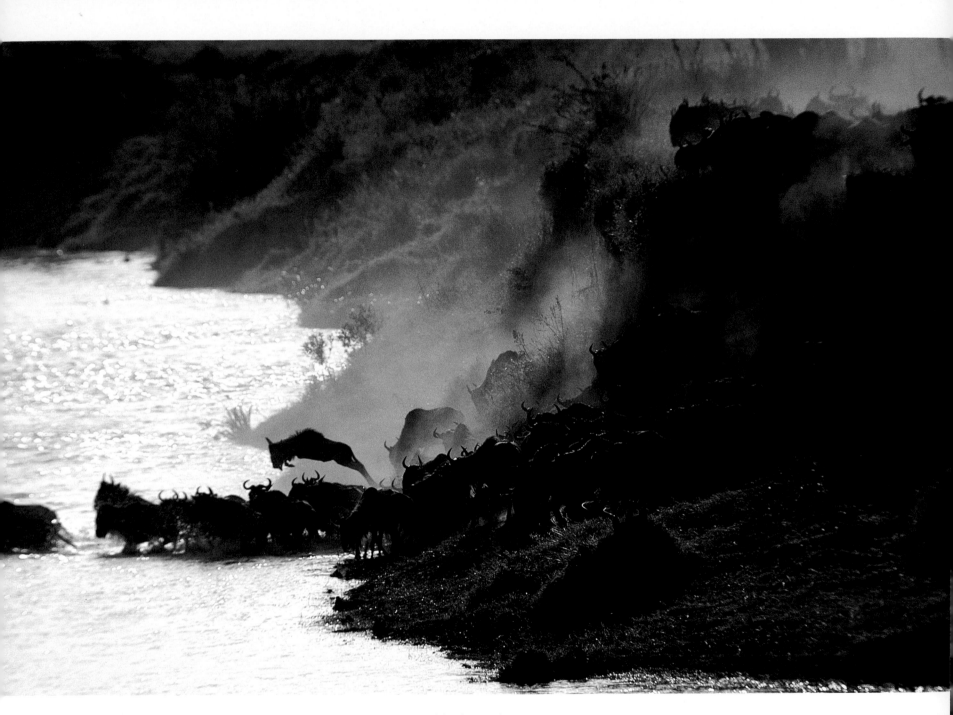

Upon reaching the broad Mara River, wildebeests plunge into the water and begin to swim.

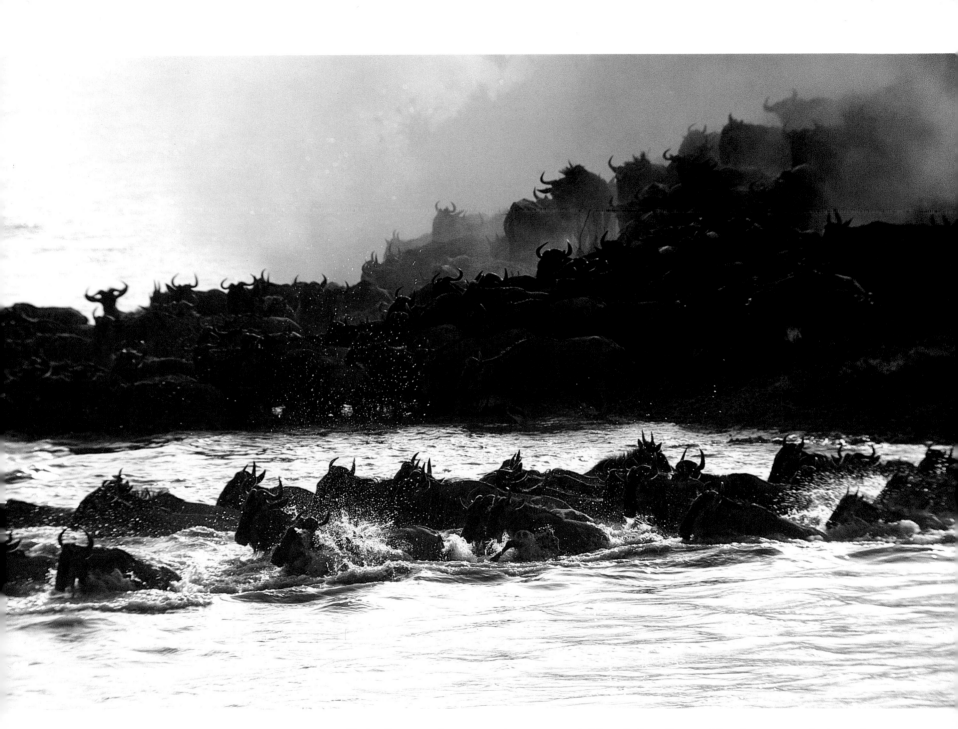

During these crossings, many calves are separated from their mothers, making them easy marks for predators.

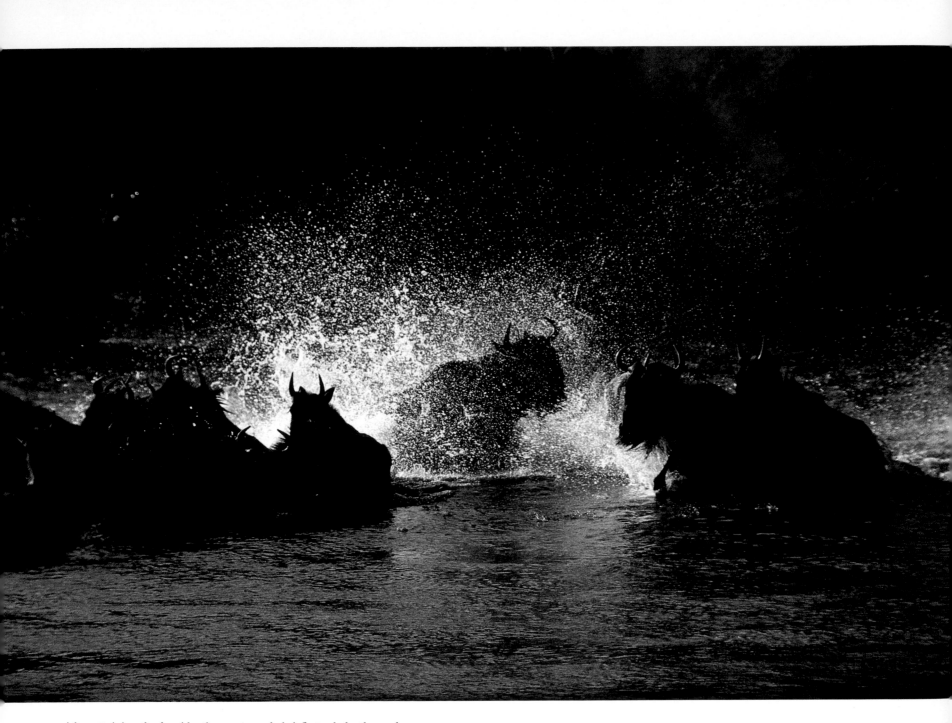

After attaining the far side, they pause only briefly to shake themselves.

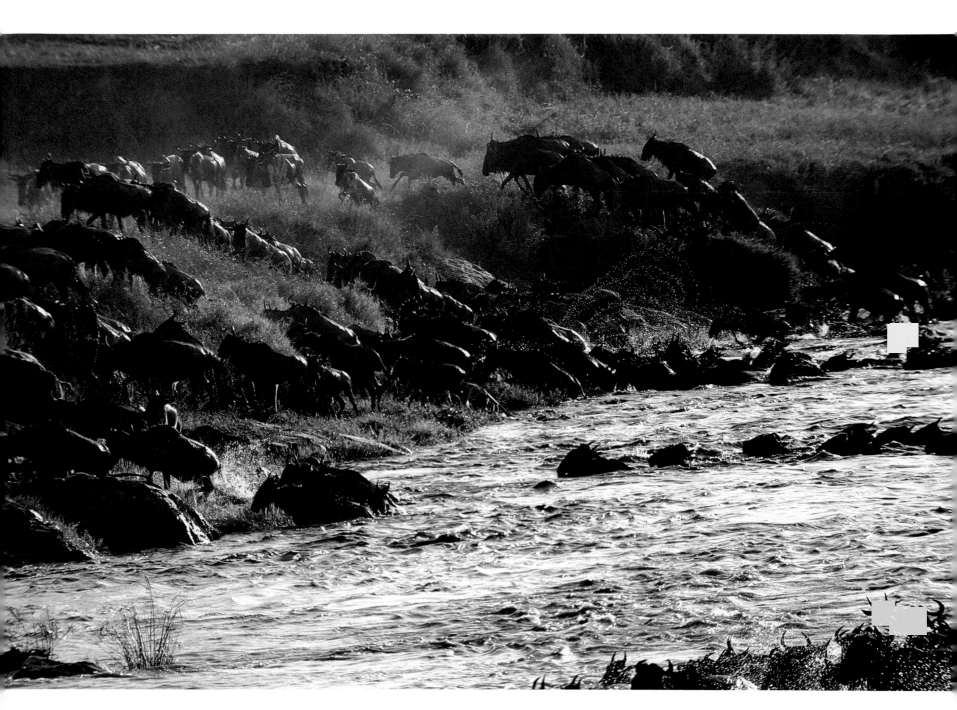

The animals rush out of the river to the dry land.

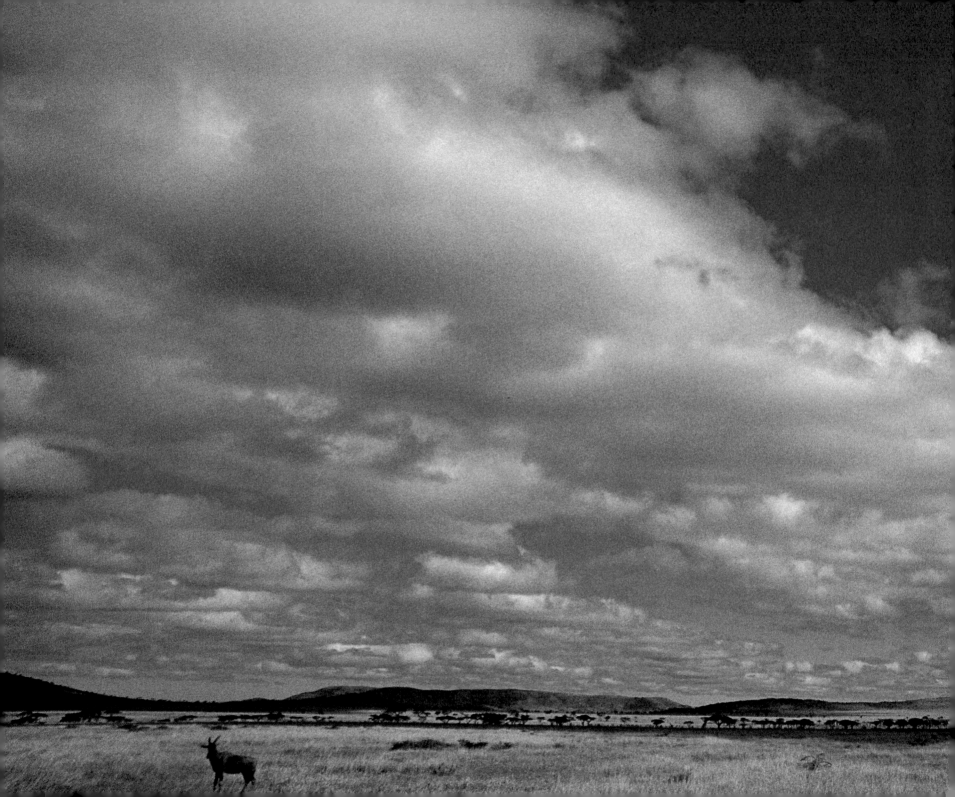

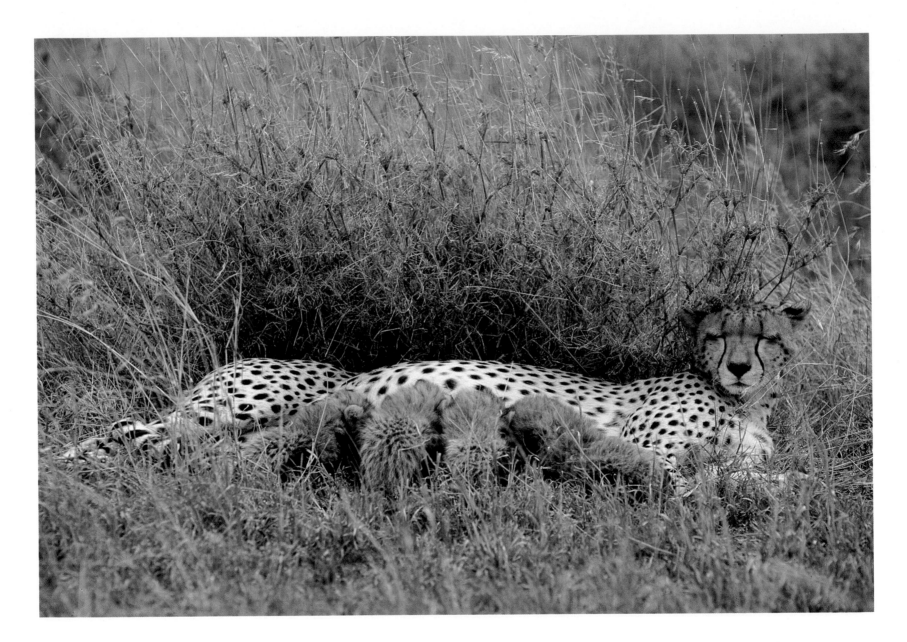

Previous pages: The plain is a vast landscape of danger and beauty.

Above: Predators on the Serengeti give birth before the rains begin.

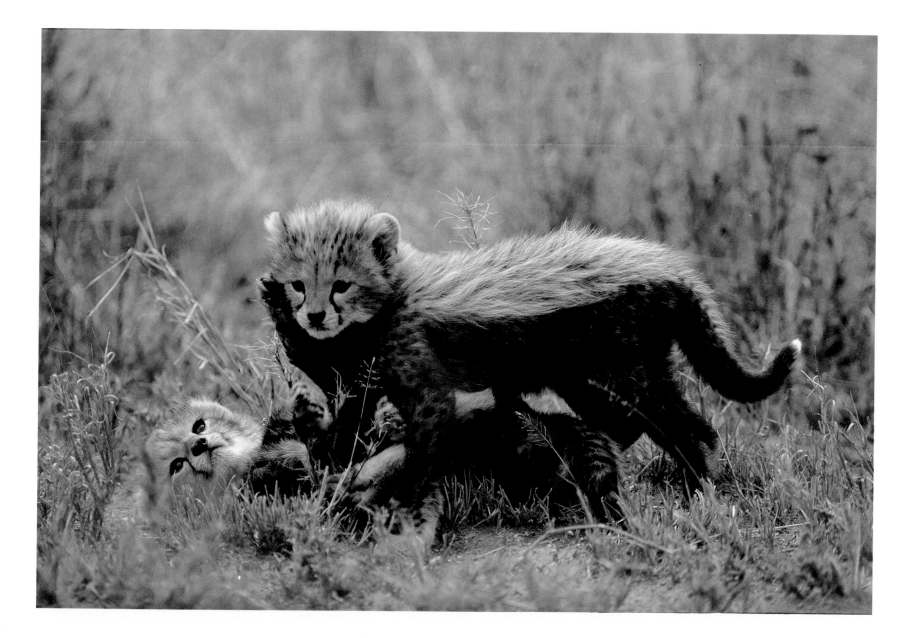

For the first few months, the cheetah cub's fur is fluffy from head to tail.

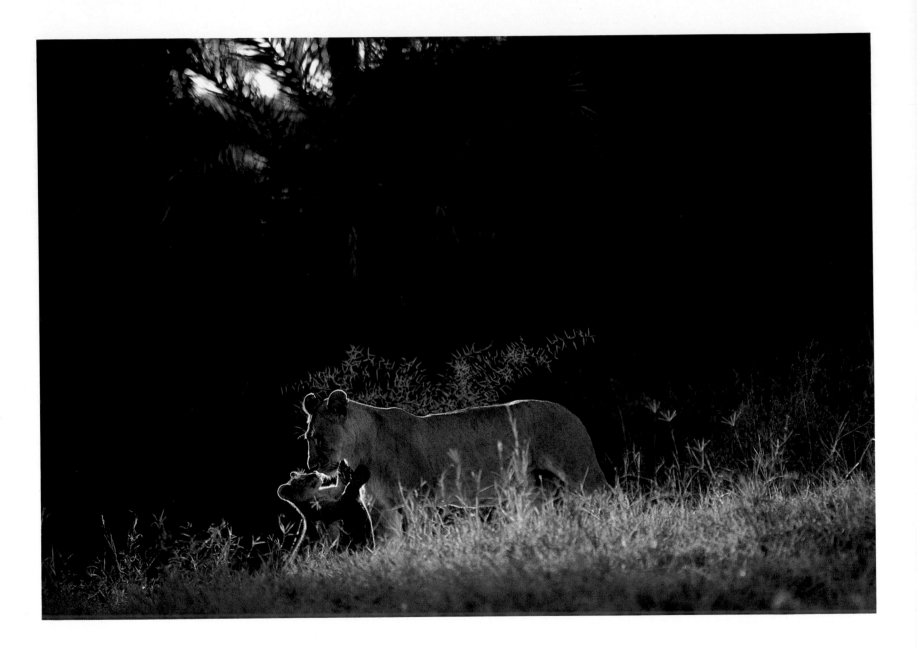

Above: The cub's early months are spent in playing and learning.

Right: Many different animals intermingle easily in this wilderness.

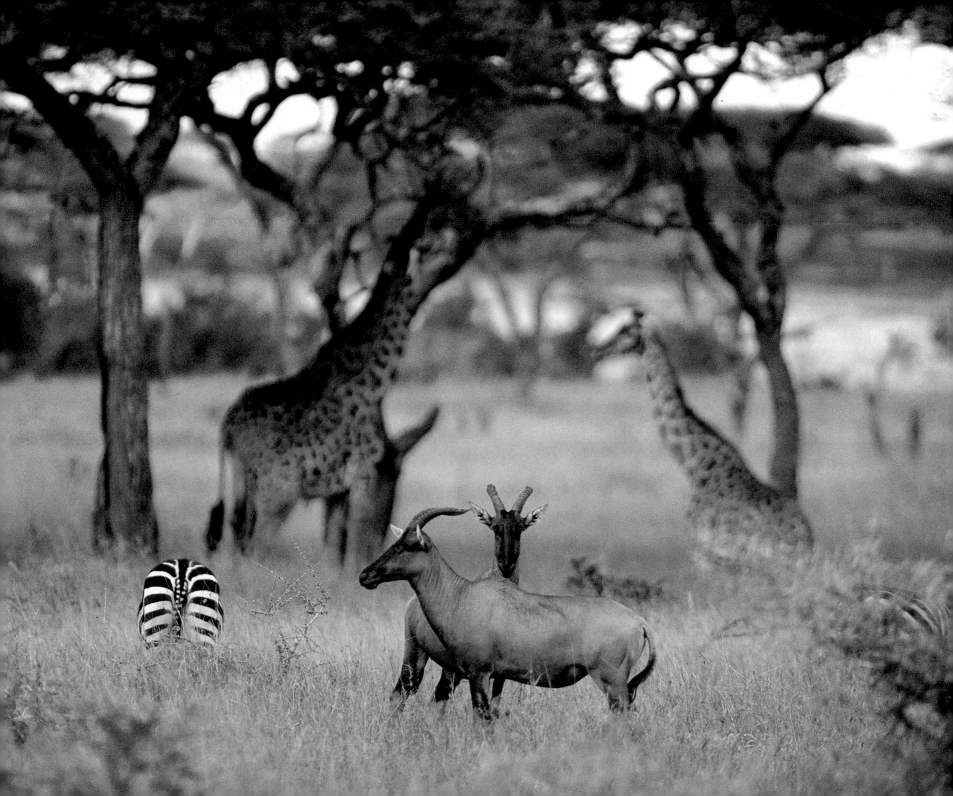

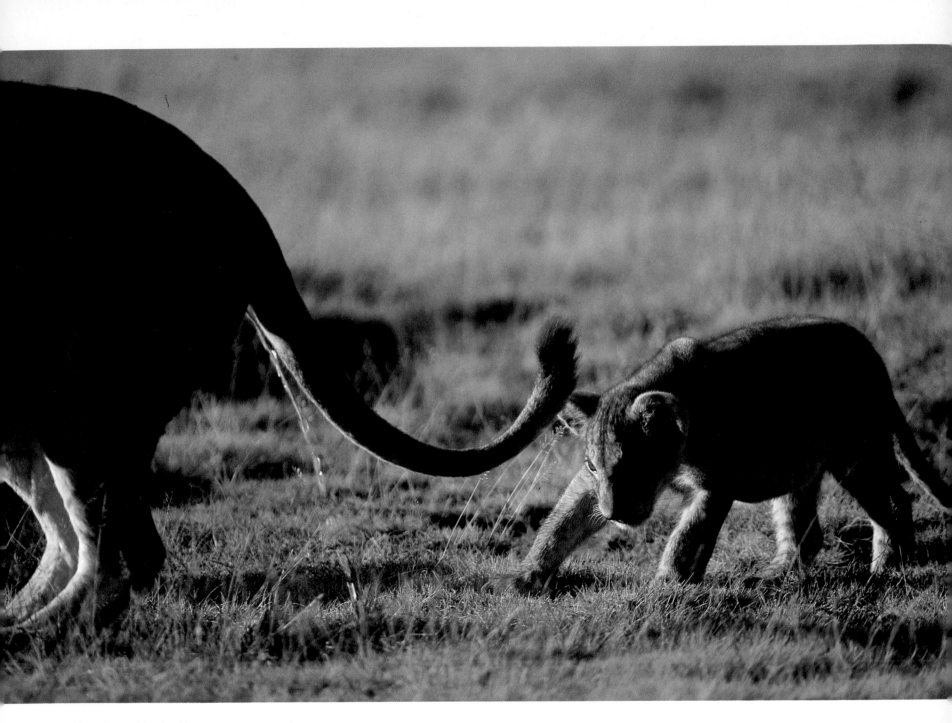

Above: Everything is of interest to a young cub.

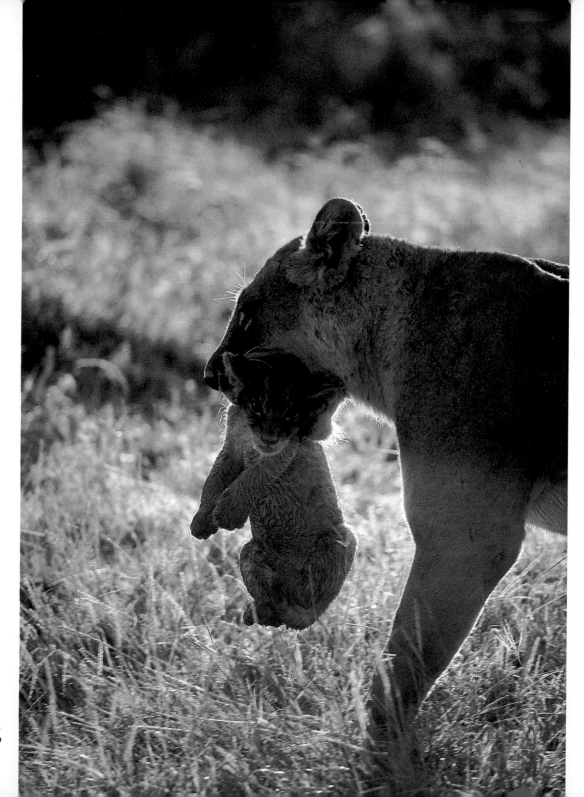

Right: Until the young are
one month old, mothers will
occasionally move the lair to
insure their safety.

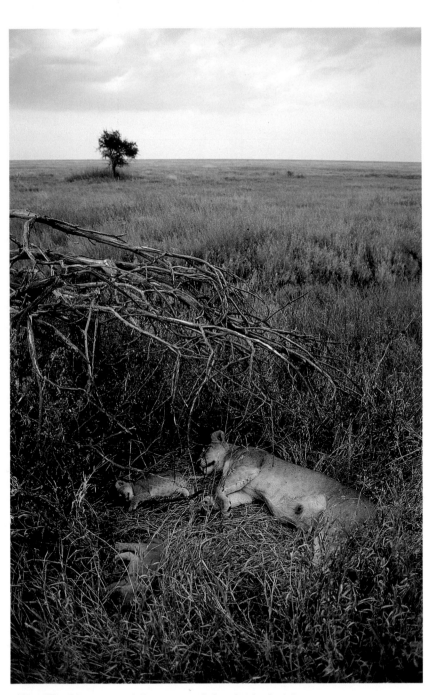

Above: The big cats use fallen trees and river banks for lairs.
Right: A Masai house, constructed of cow dung and straw, is enclosed by the cattle compound where the prized animals are carefully guarded.

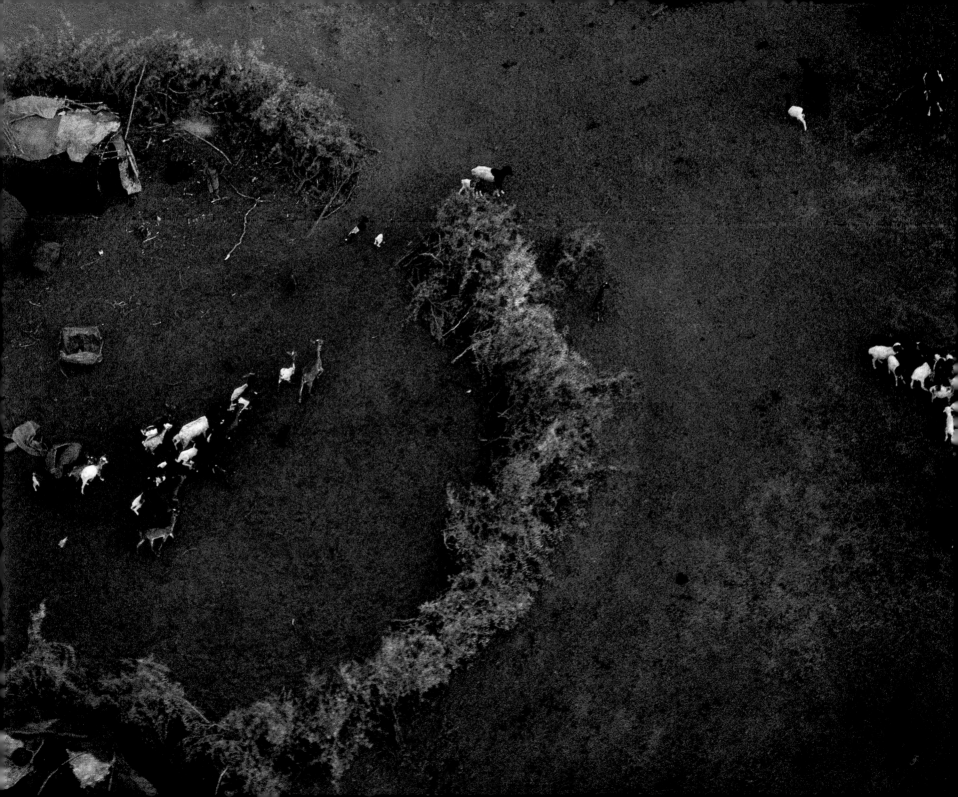

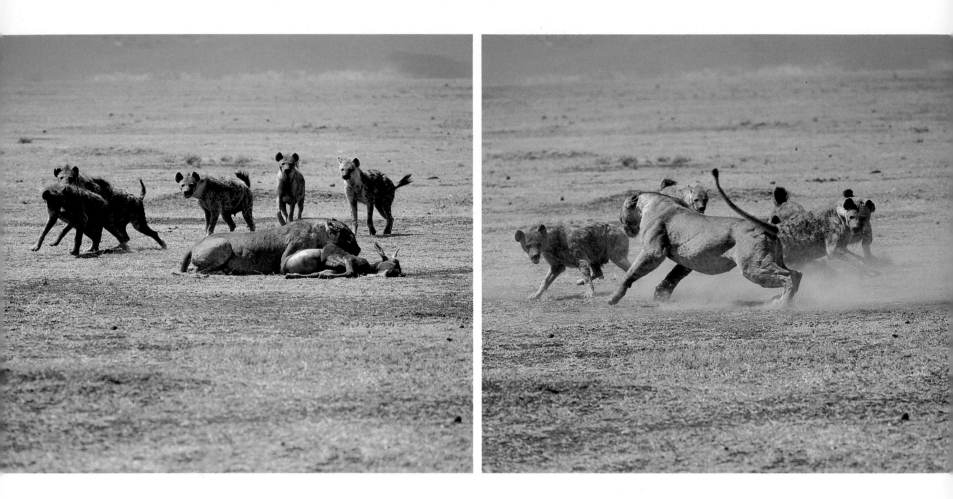

Although lions usually hunt at night, some, such as this lioness feasting on prey dragged down by a hyena pack, will scavenge during the day.

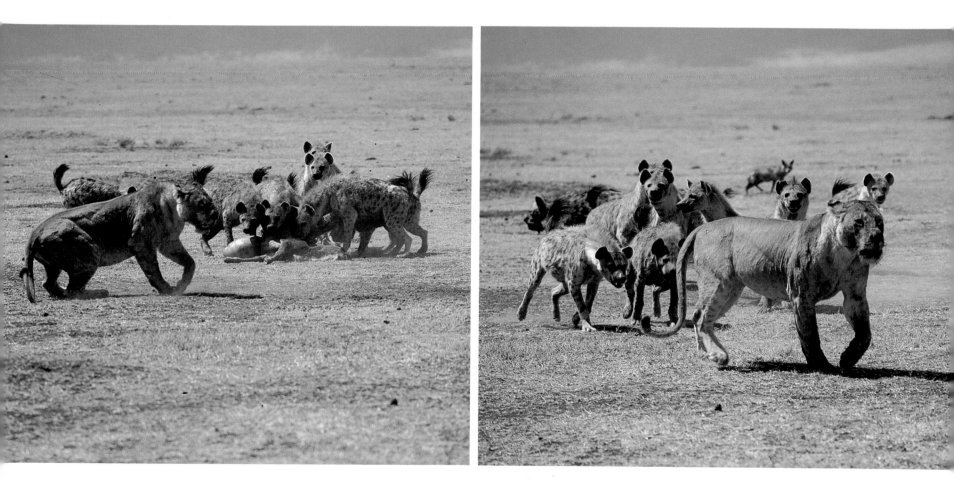

Efficiently organized, the hyenas combine to attack the lioness, forcing her to abandon her meal.

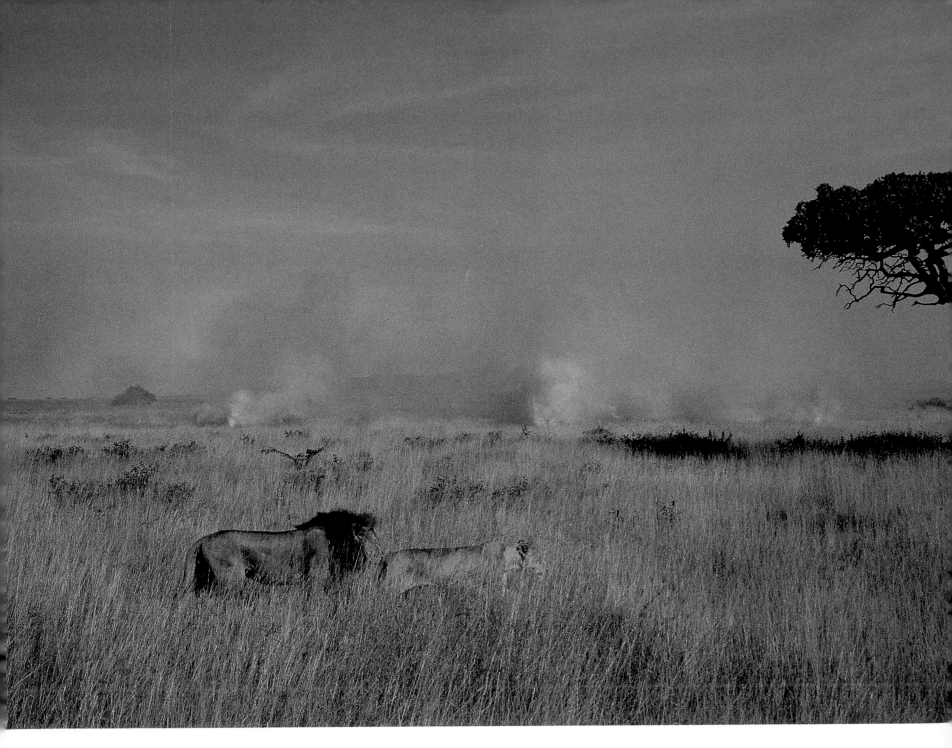

Park rangers often set fires to control vegetation.

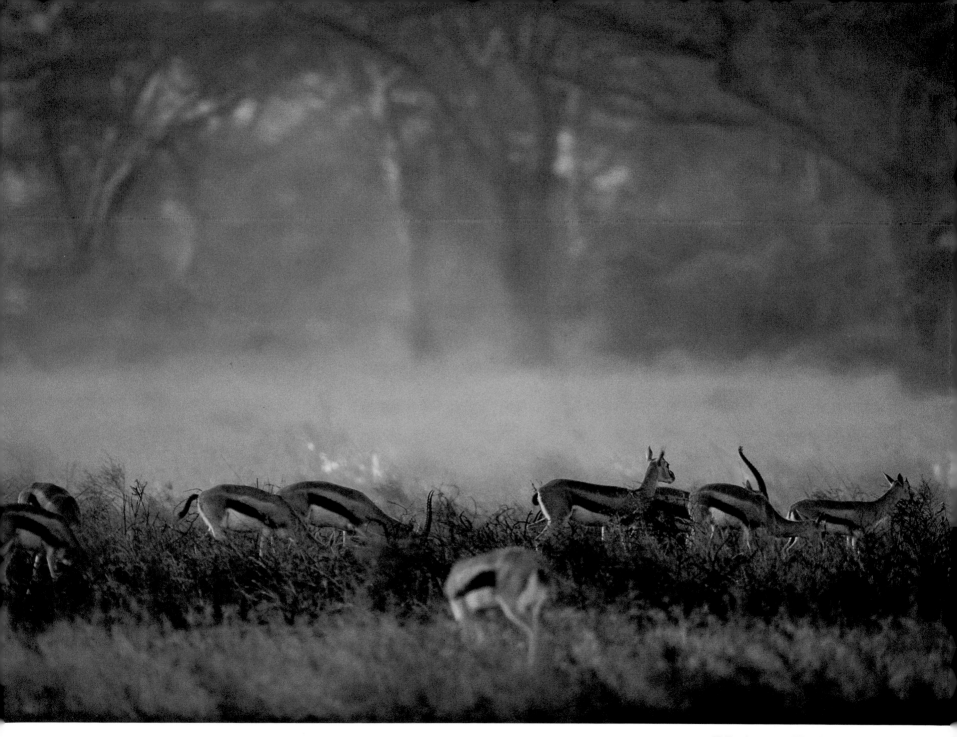

Above: Most animals and birds are not endangered by the fires.

Following pages: The fires are spread
by the strong winds that blow constantly during the day.

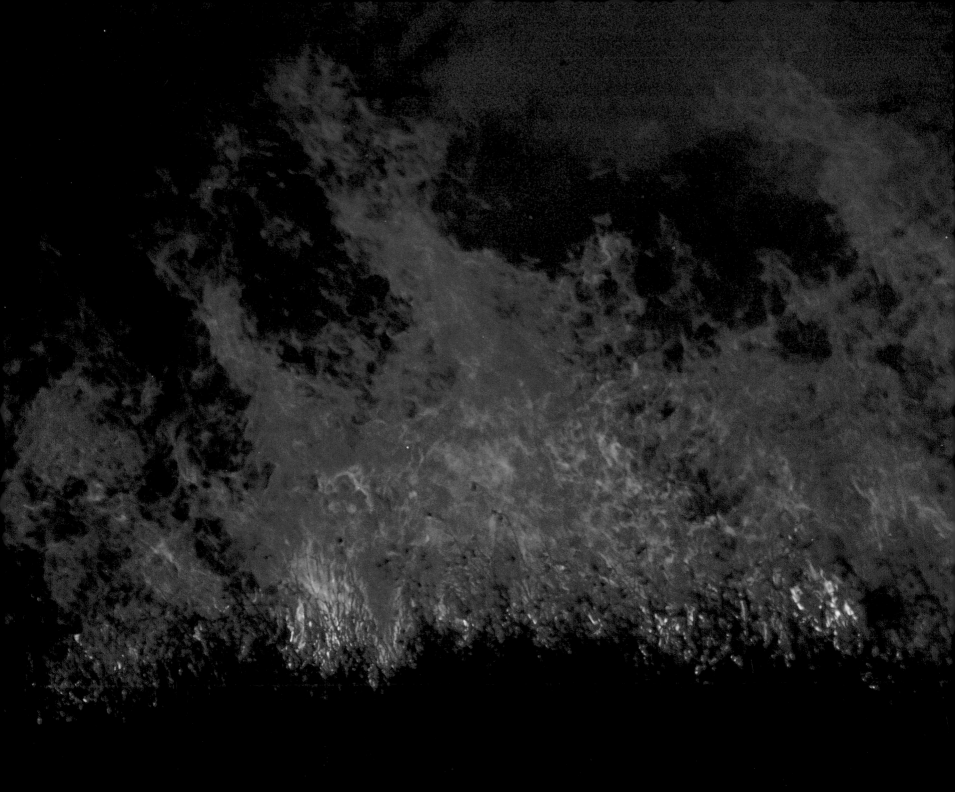

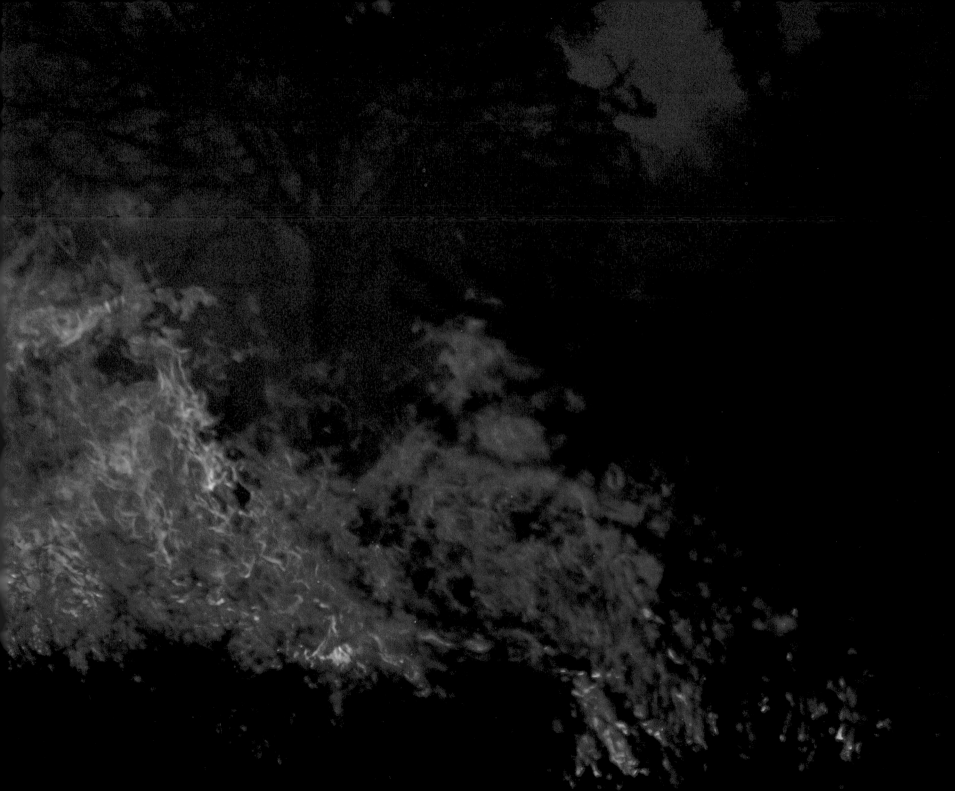

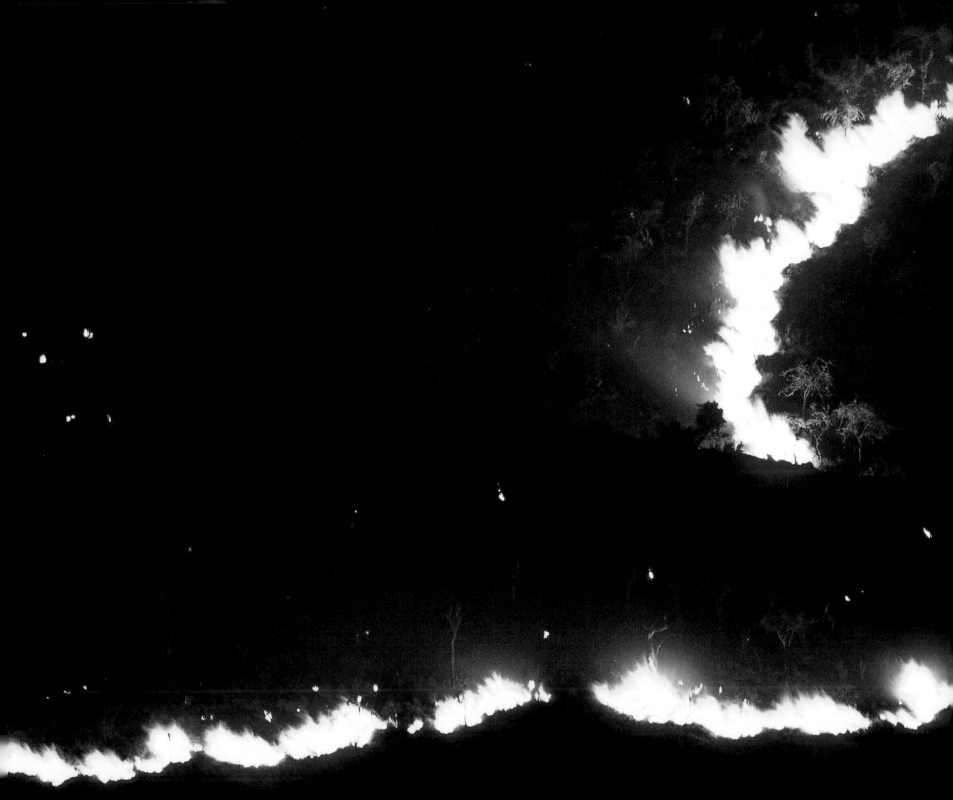

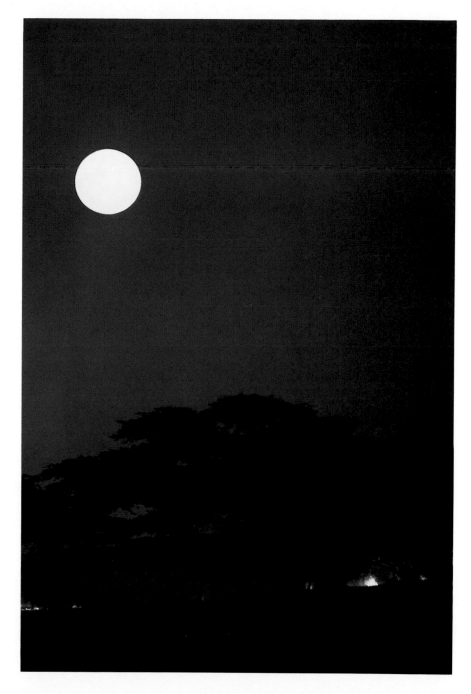

At night, when the wind dies down, the fires go out.

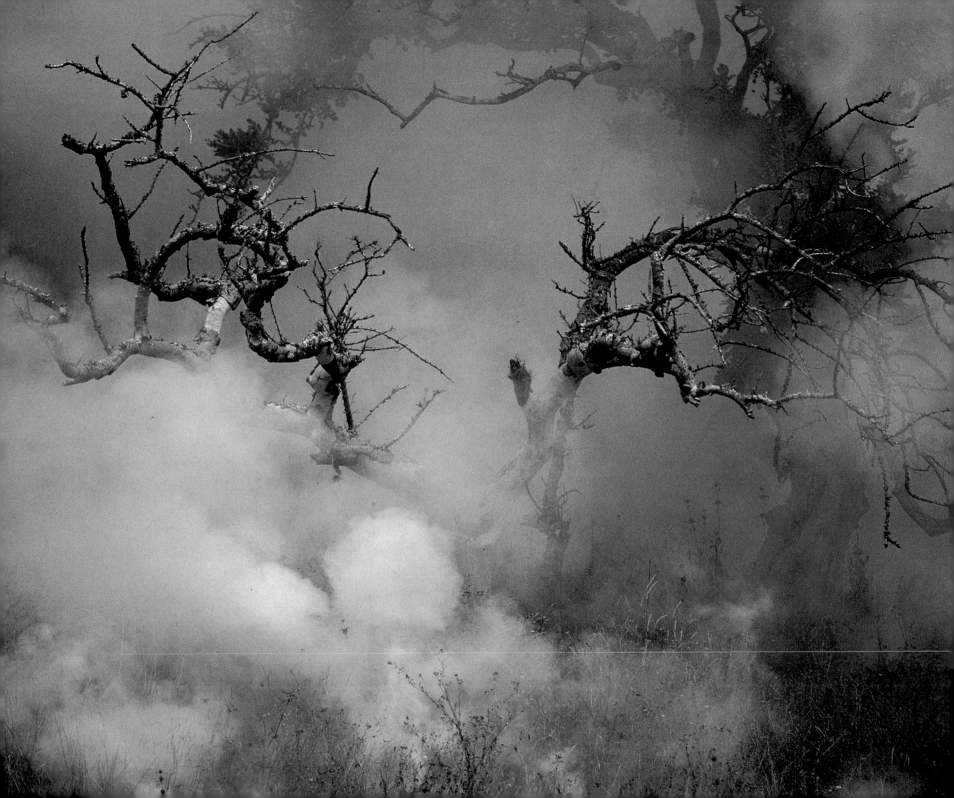

Left: The plants have sturdy root systems that remain undamaged by fire.

Above: Marabou storks watch for snakes and insects escaping the fire.

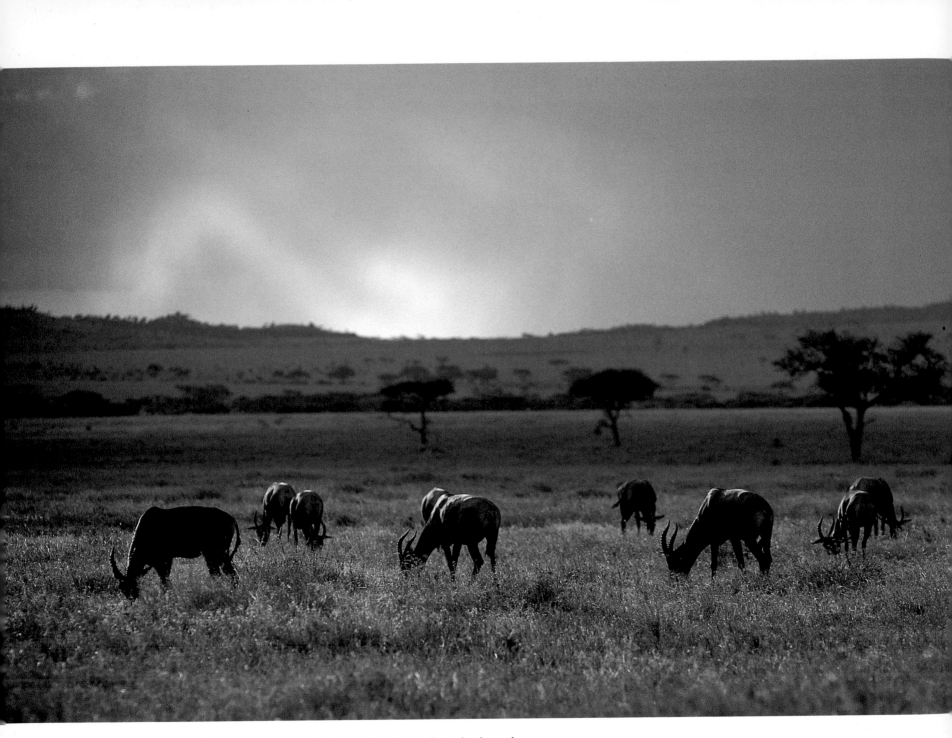

According to rangers, the blaze hastens the growth of plants that the grazing animals need.

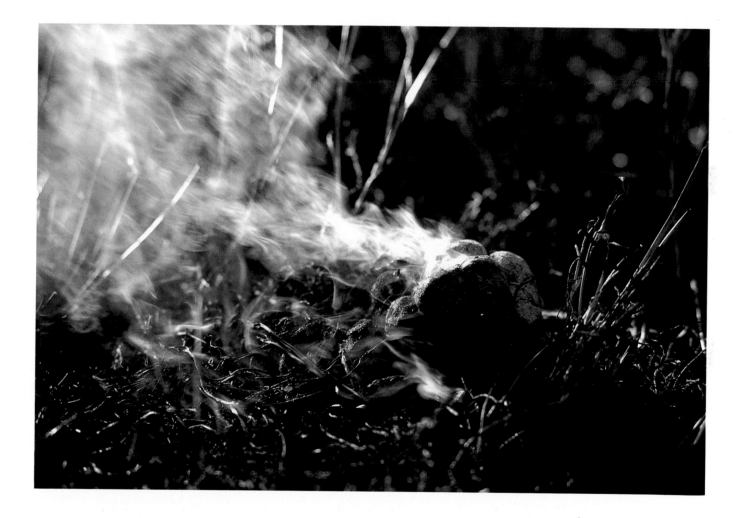

Animal dung smolders after a fire.

Following a fire, a
Thomson's gazelle forages
for small plants.

Above: Beyond the burned tree, moisture and green plants remain in the ground.

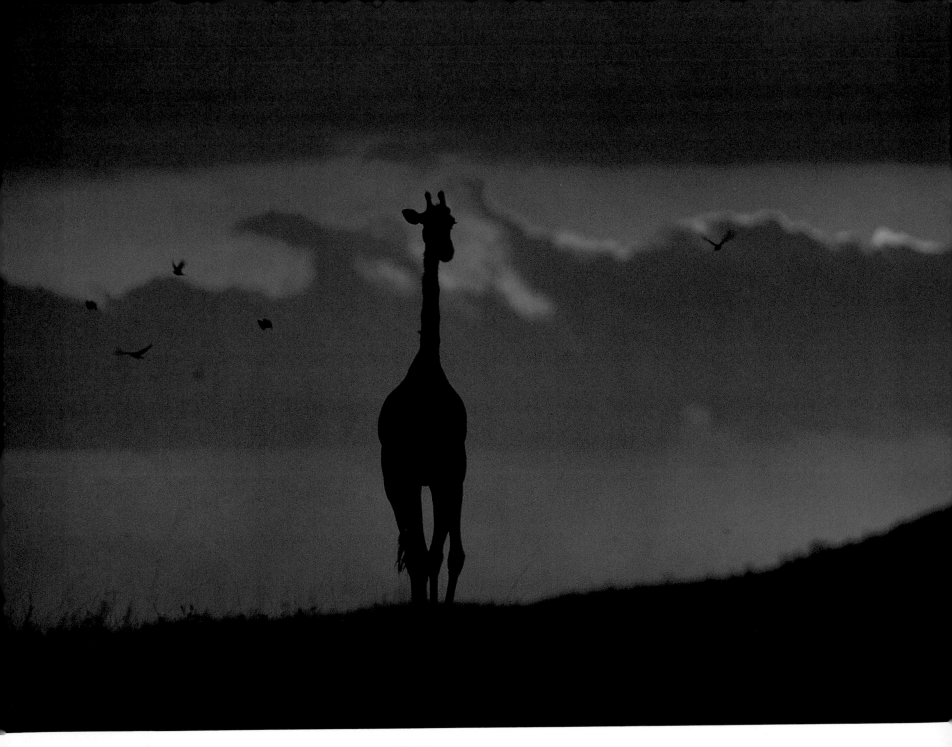

A giraffe is silhouetted against clouds formed from the hot smoke of the blaze.

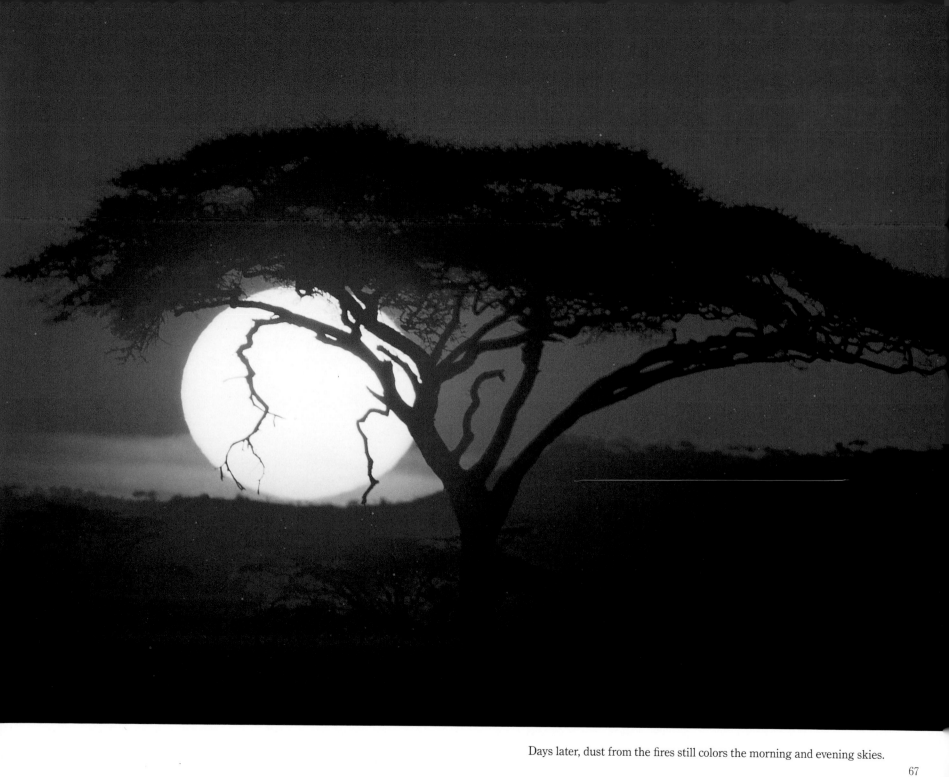

Days later, dust from the fires still colors the morning and evening skies.

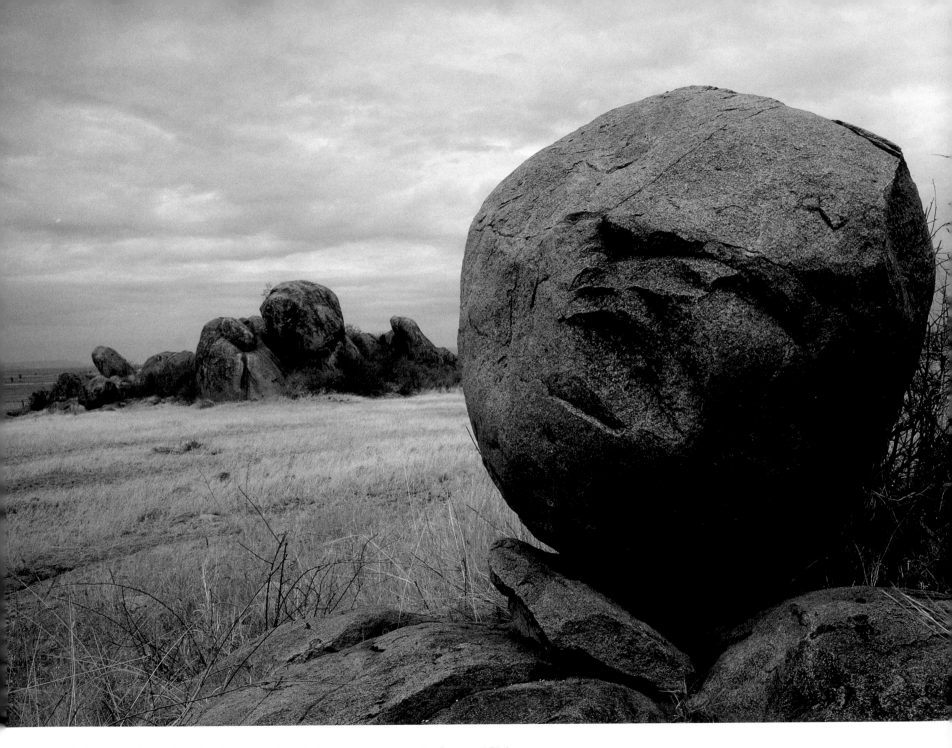

Each day clouds slowly gather from beyond the horizon until they cover the Serengeti Plain.

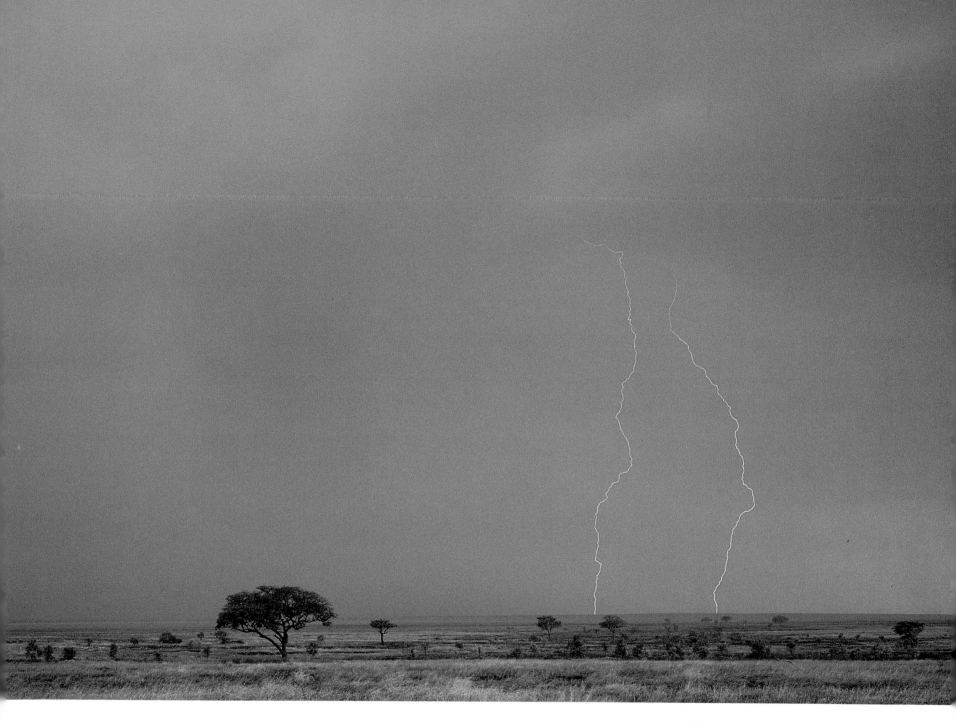

The heat generates daily thunderstorms.

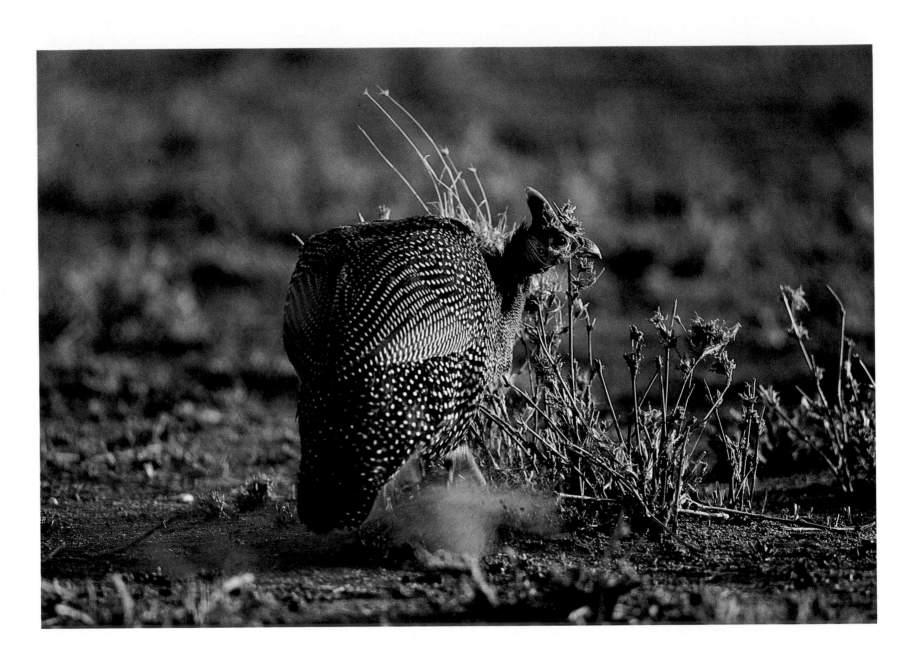

Above: In its search for food, a guineafowl batters the earth, raising clouds of dust visible even from far away.

Right: The approaching storm turns large portions of the sky black and pushes before it the sweet scent of rich, damp soil.

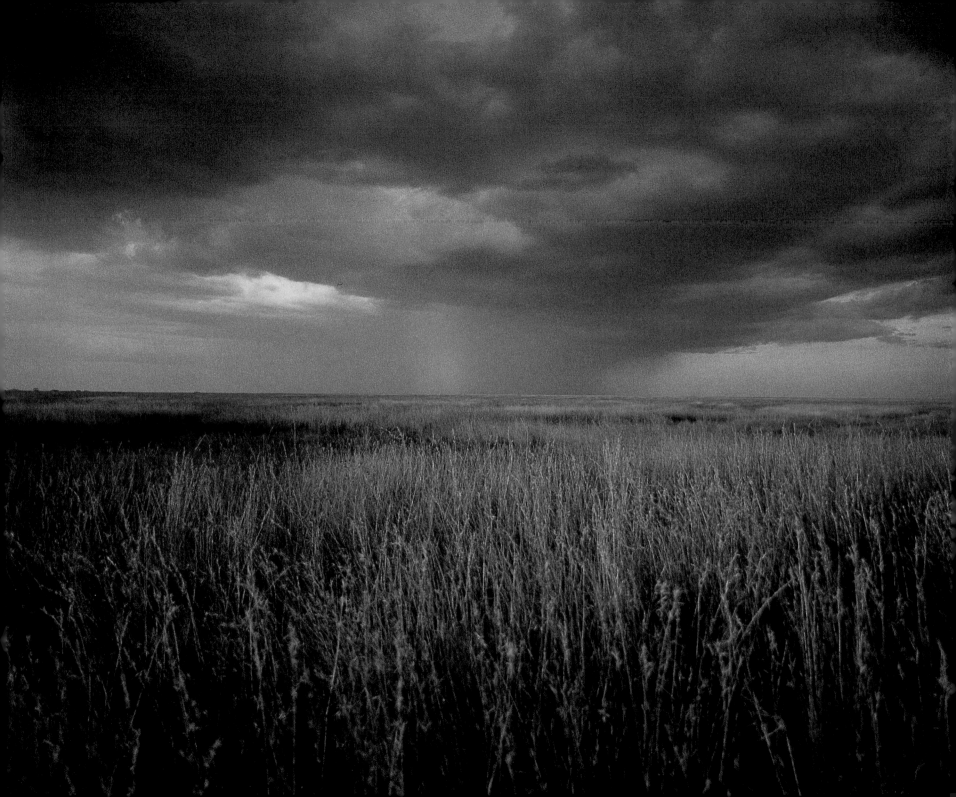

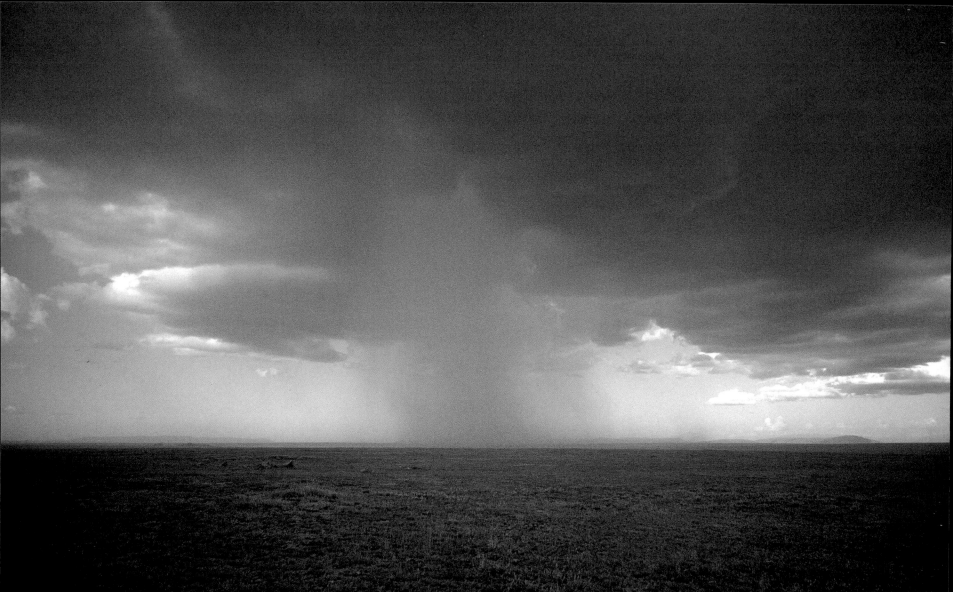

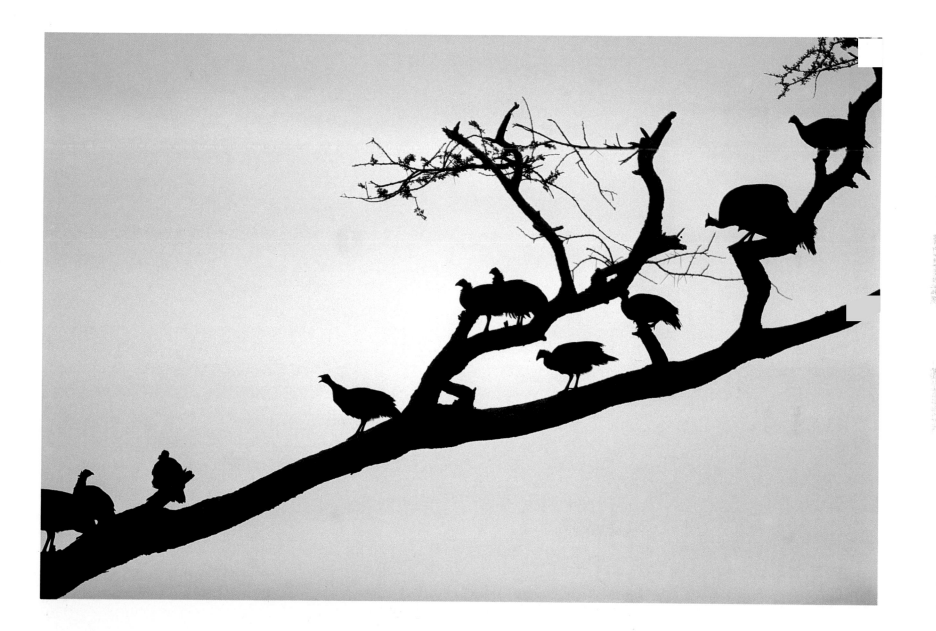

Left: The daily storms are short but intense, the huge drops of rain falling with surprising force.

Above: Although resting quietly in a tree, these guineafowl will cry shrilly to warn their neighbors of a predator's approach.

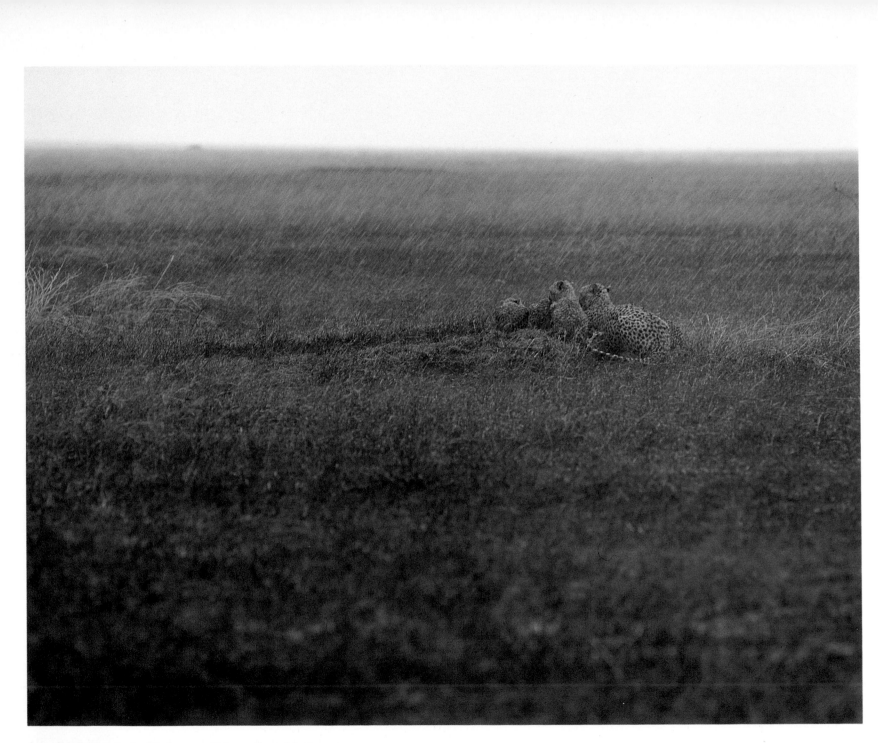

A family of cheetahs huddle for warmth beneath a cold rain.

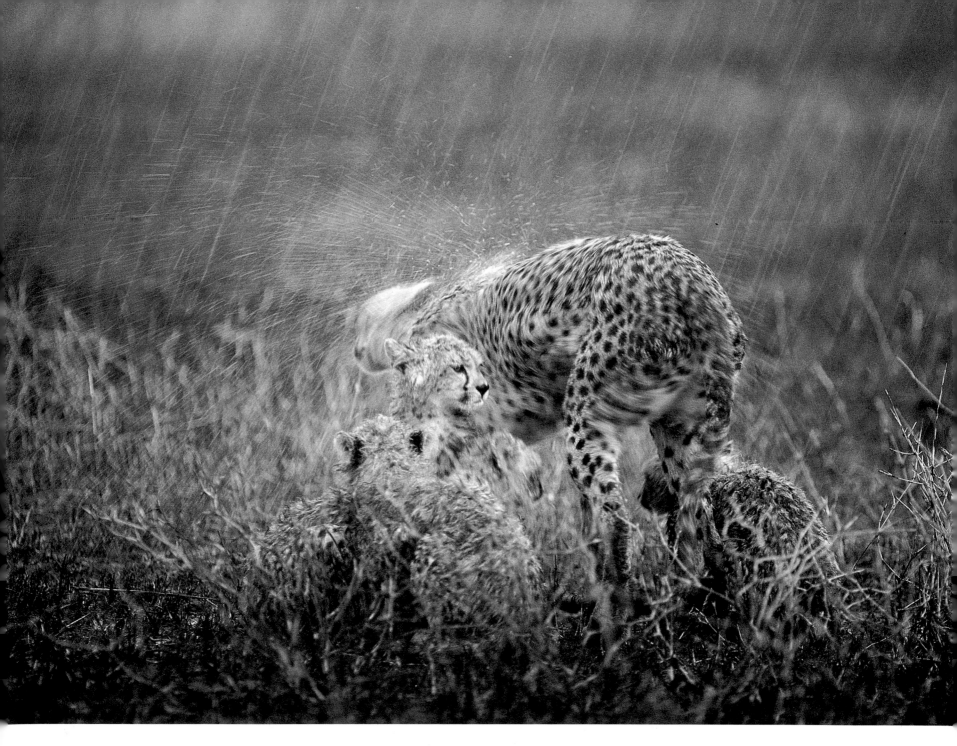

As the shower eases, the mother cheetah shakes herself.

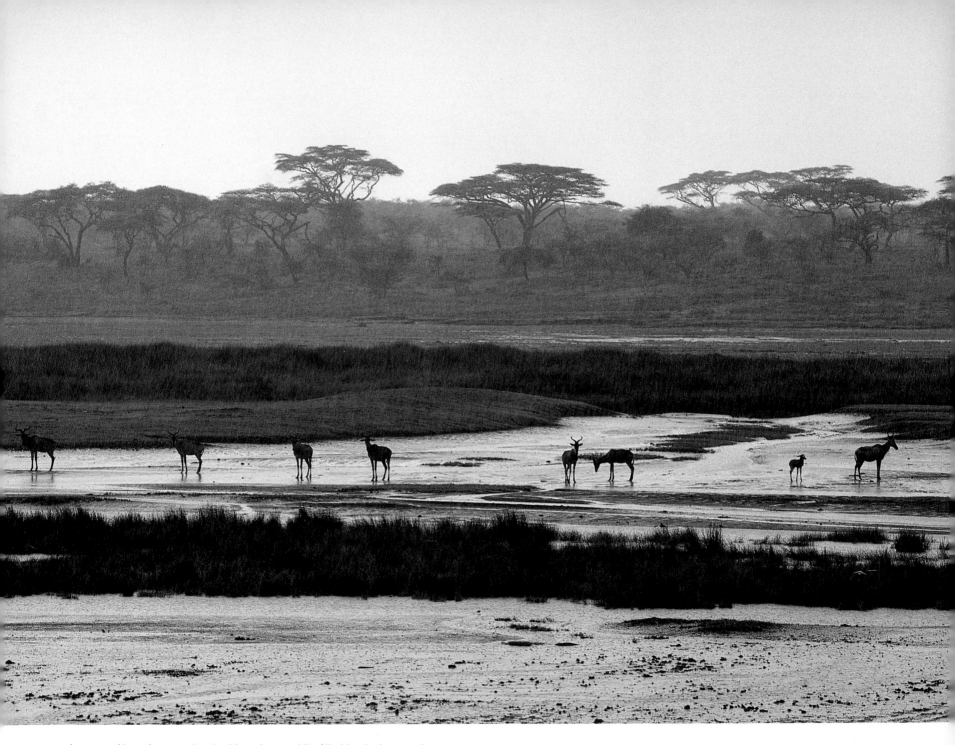

A group of hartebeest gather beside a river rapidly filled by the heavy rains.

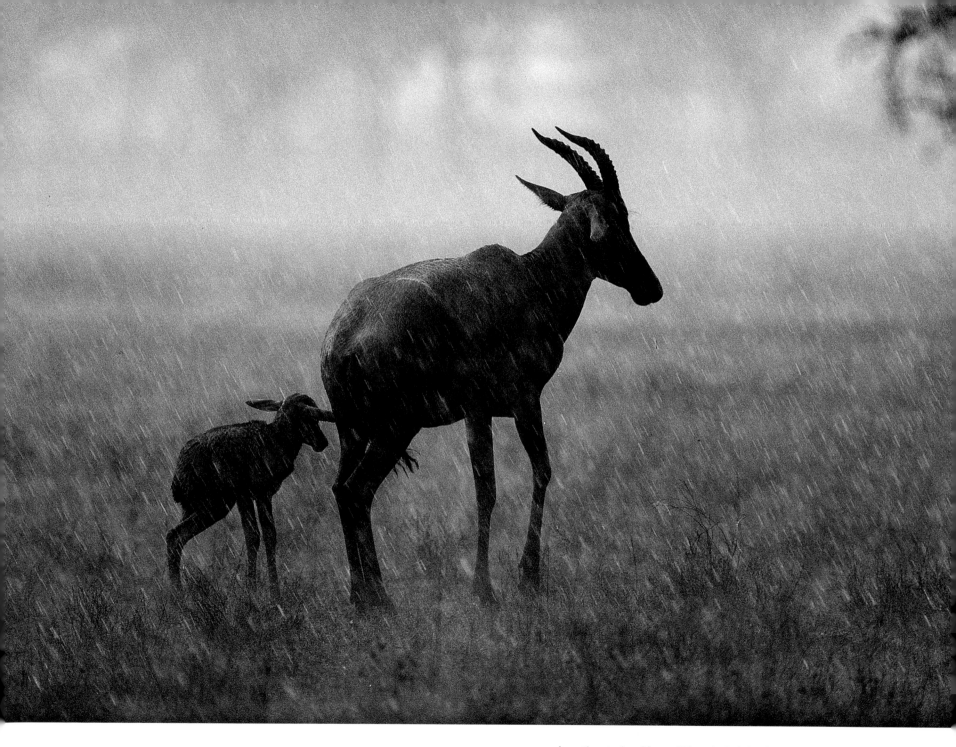

A mother topi and her calf hunch their backs against the downpour.

Above: As the rain continues, earth and sky are quickly saturated.
Right: During the storm, hunting is easier because the predator's movements
and sounds are masked by the noise of thunder and rain.

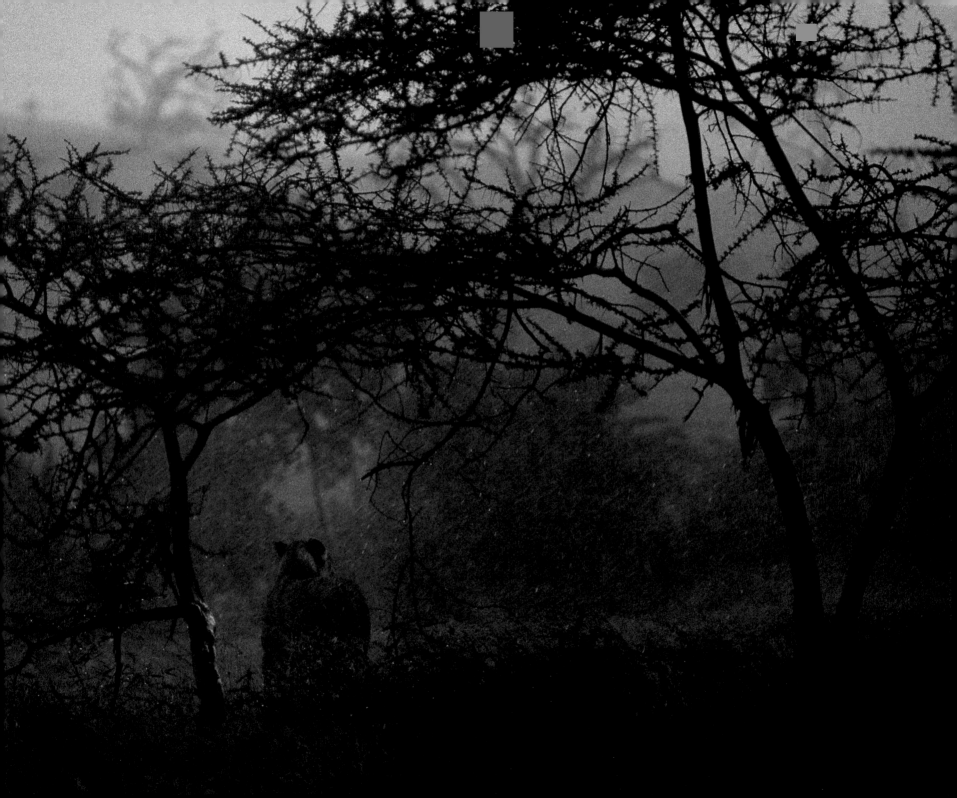

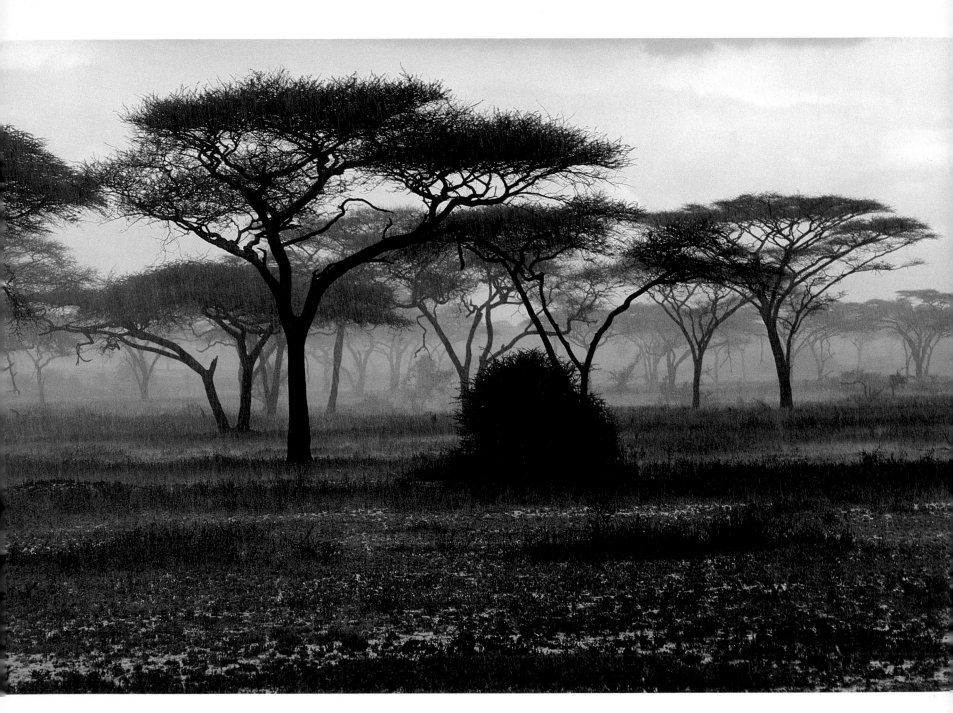

The very heavy rain usually stops after an hour.

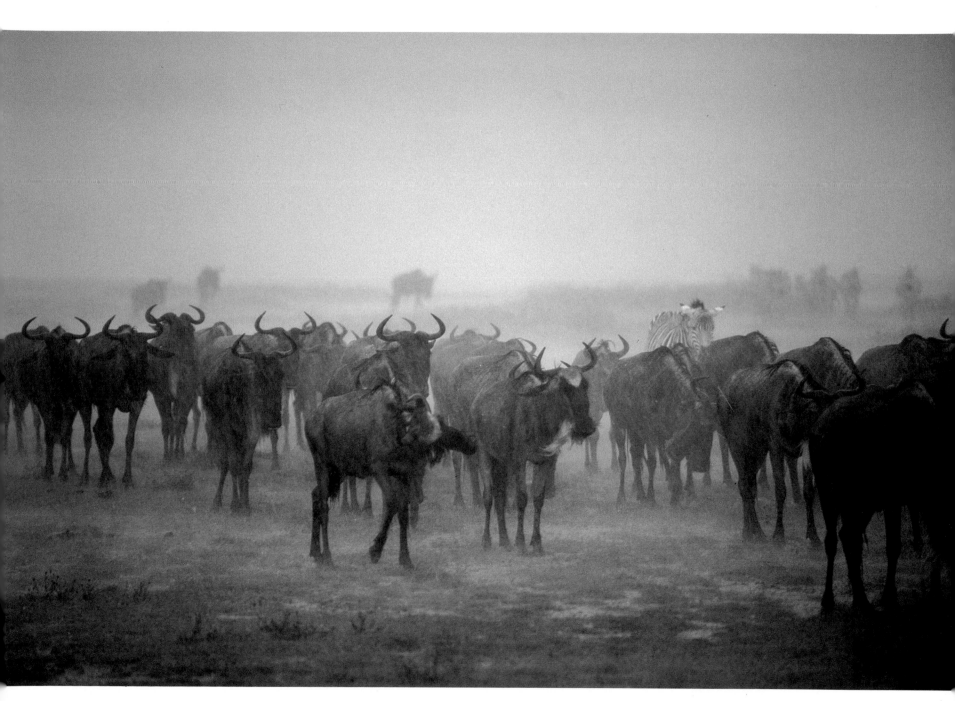

Herds of wildebeest begin to appear on the plain;
the zebras mix with them, apparently for added protection against predators.

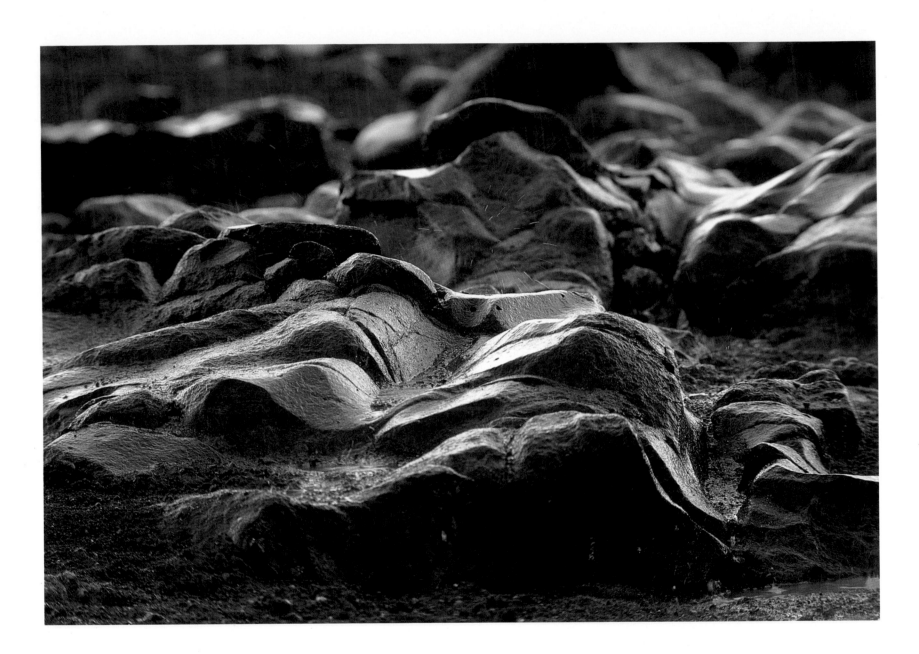

The earth eagerly soaks up the nourishing water.

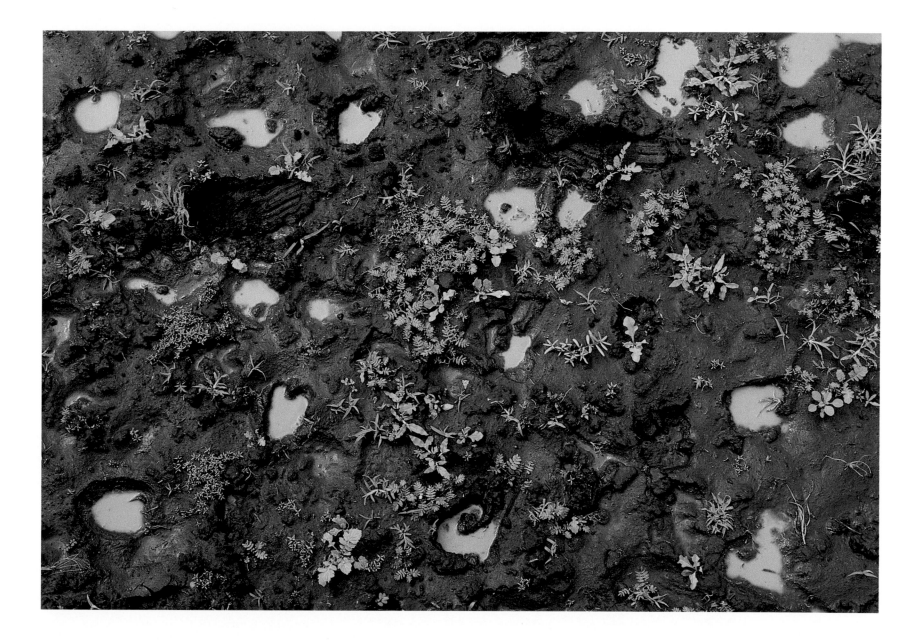

After the rain, the fertile earth blossoms.

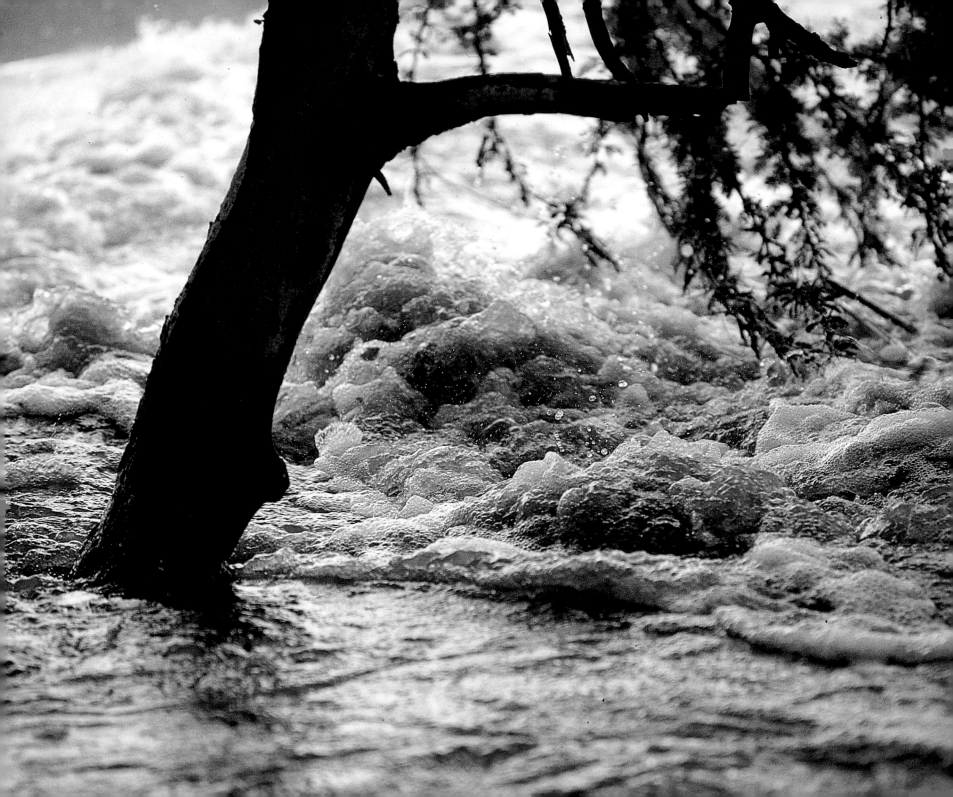

Left: Water boils over a river bank. *Above:* The storm leaves a gentle beauty on the land.

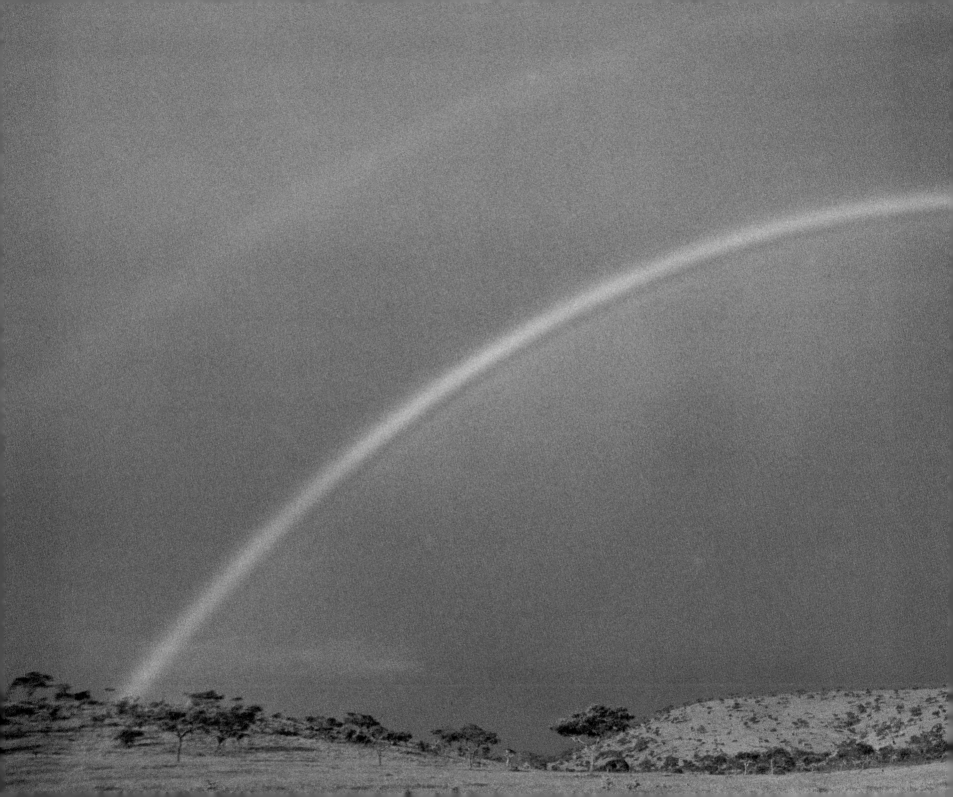

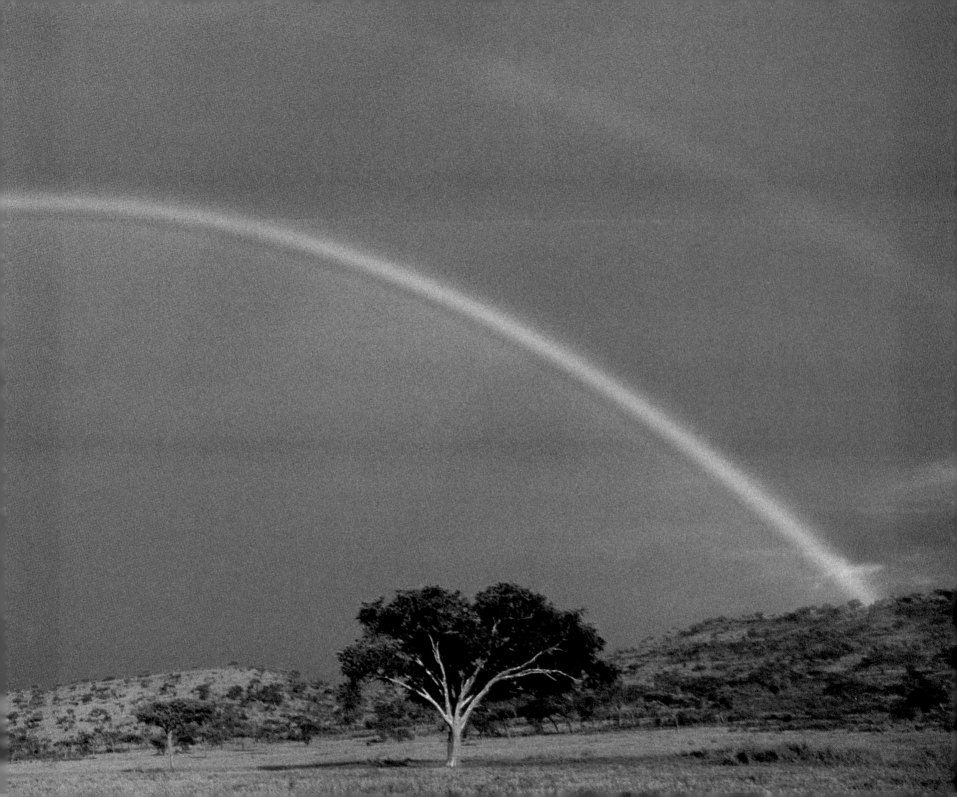

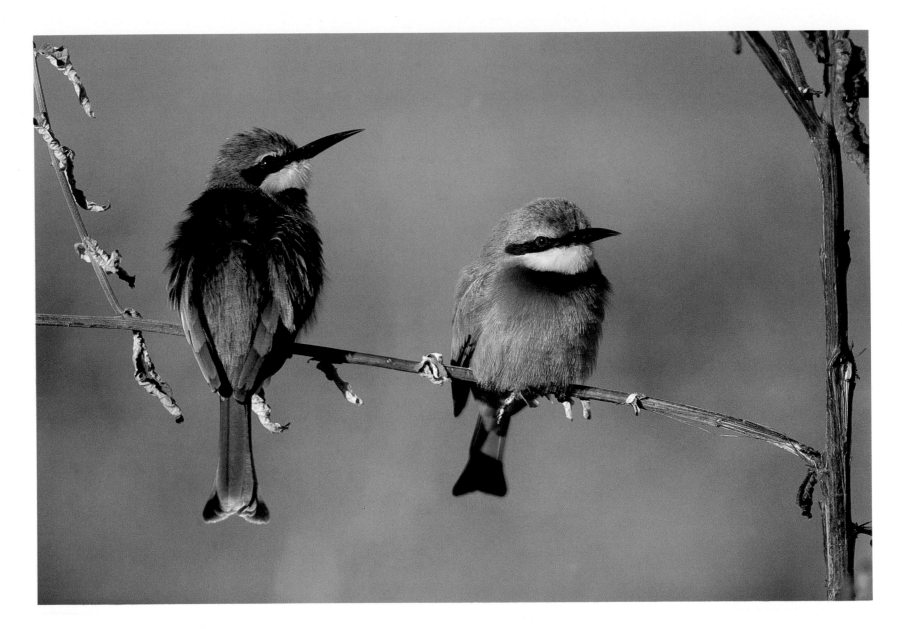

Previous pages: Strengthened and refreshed, nature renews itself.

Above: The colors of nature revive, and many birds, such as the little bee-eater, return.

Right: Shortly after the first rain, the plain bursts into bloom, a colorful welcome for the arriving herds.

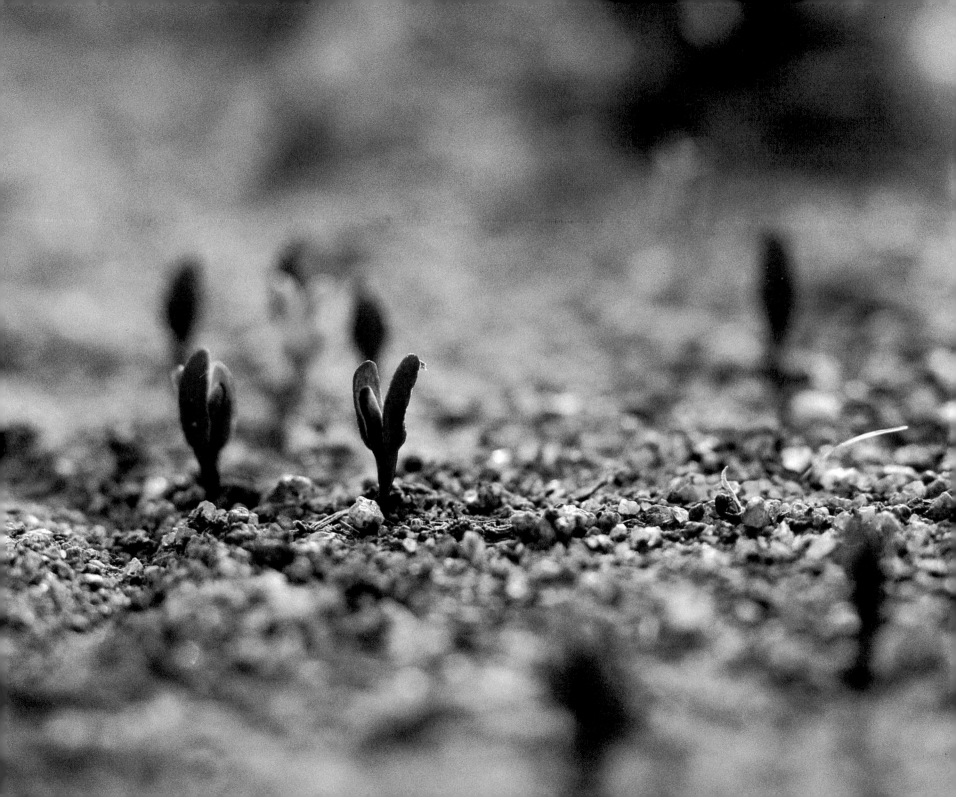

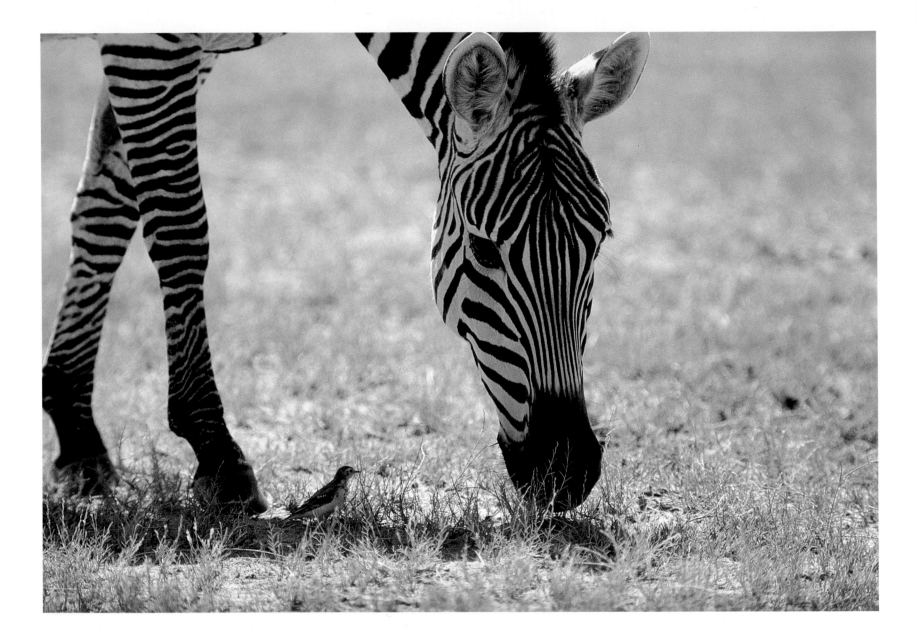

Above: The animals relish the new sprouts.

Right: New life is evident in every corner of the plain.

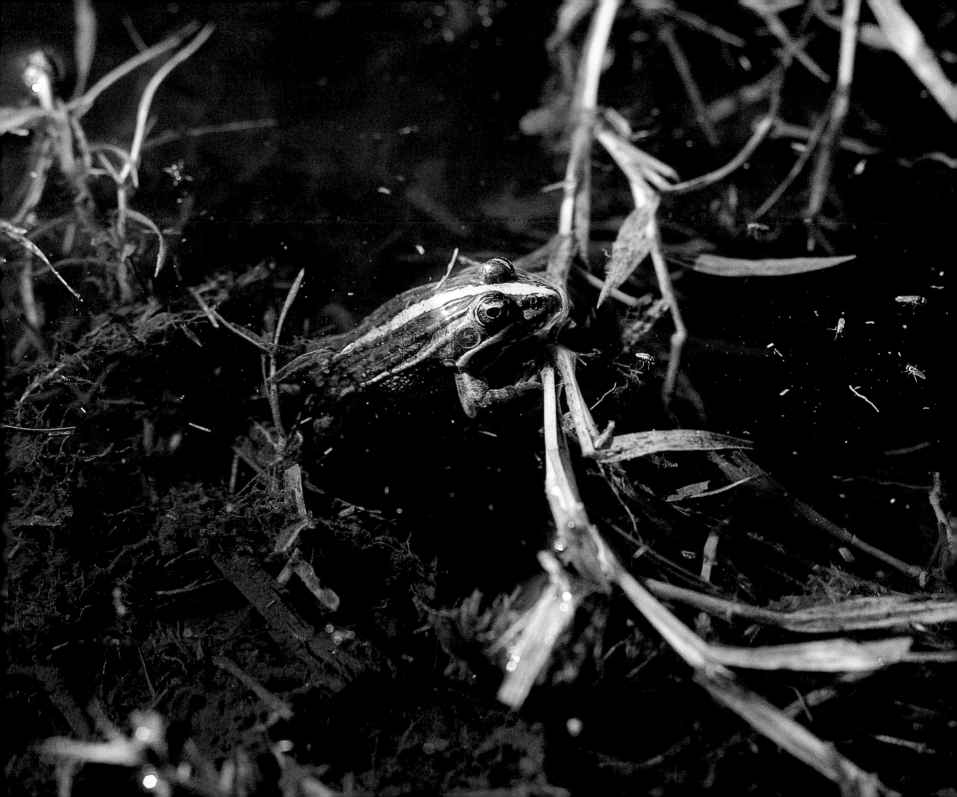

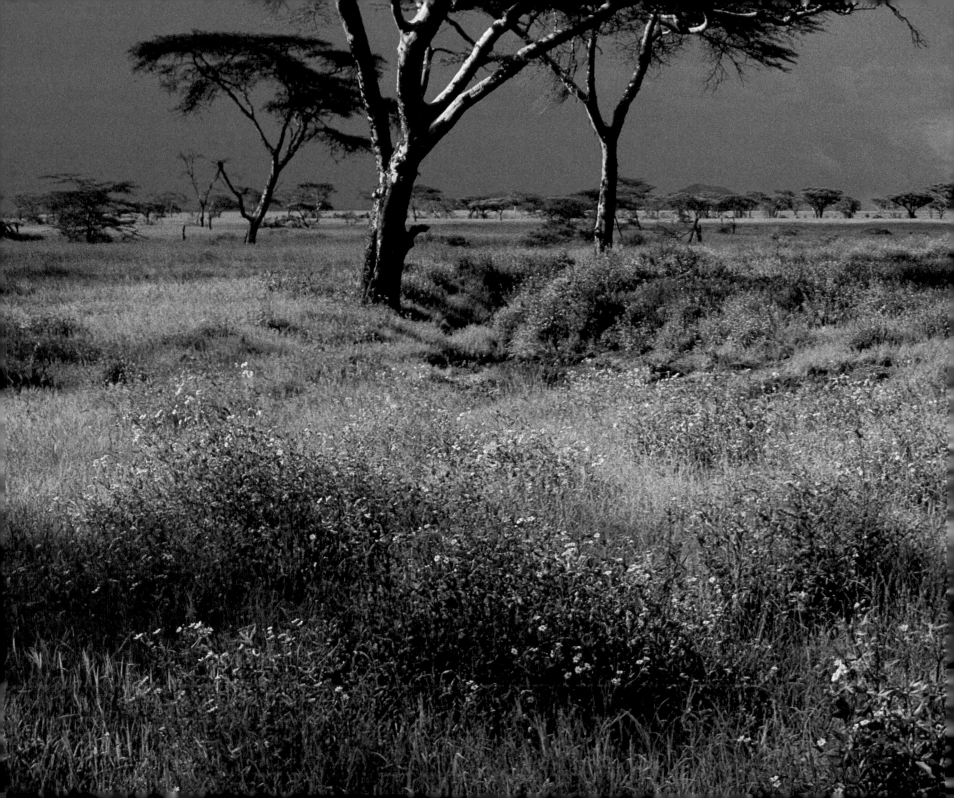

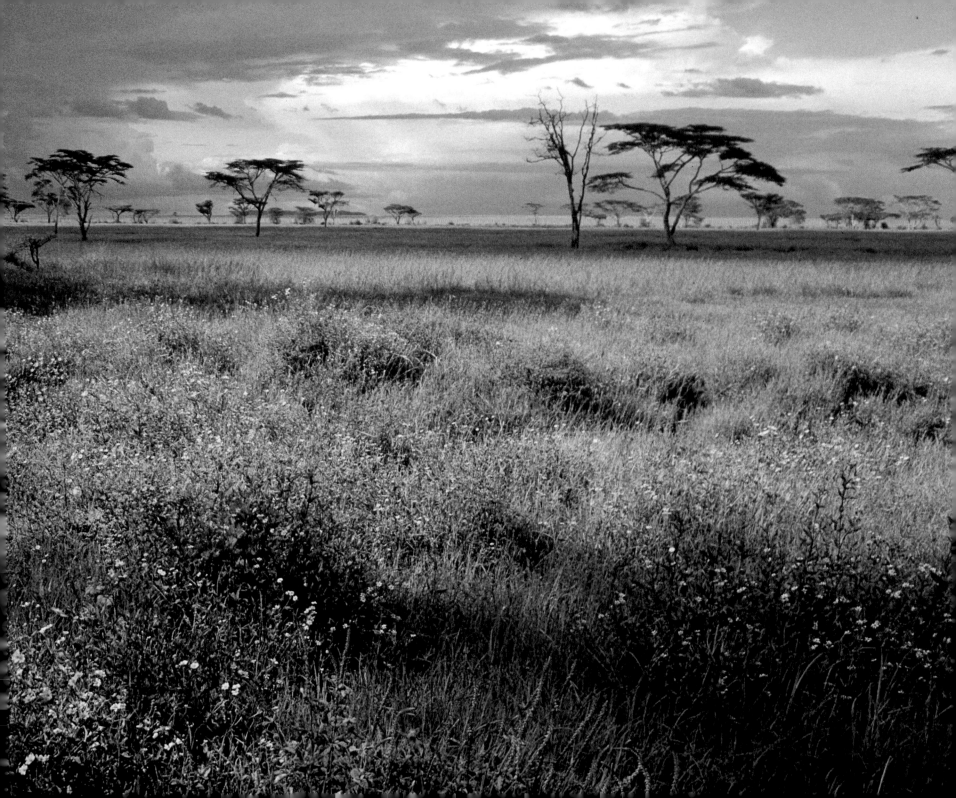

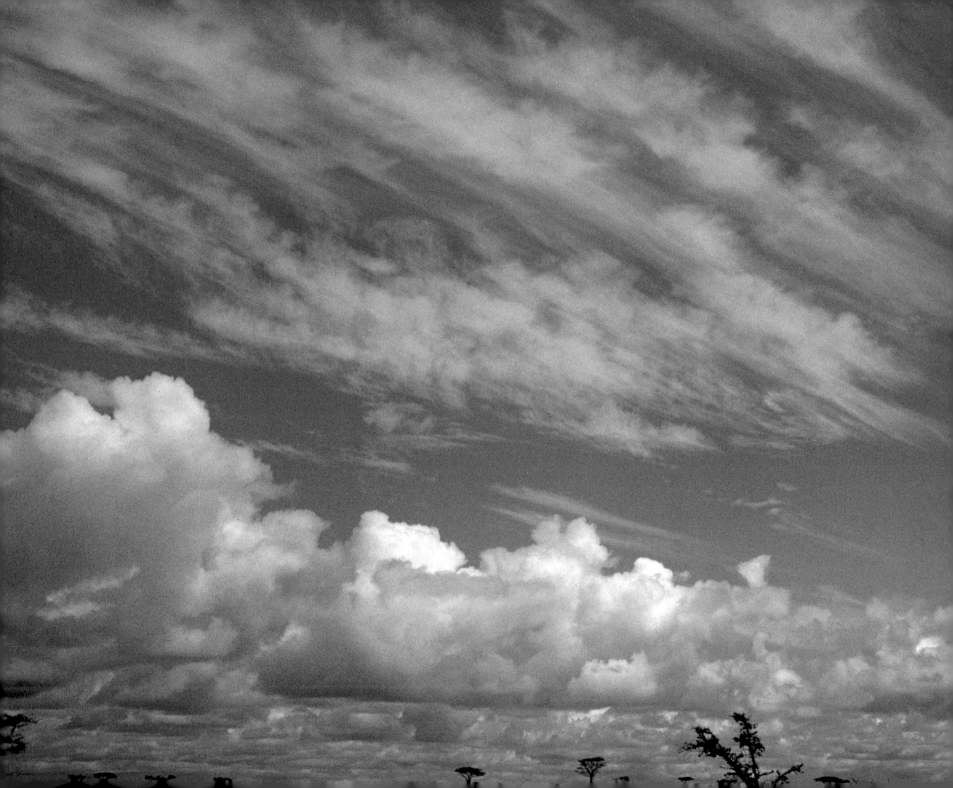

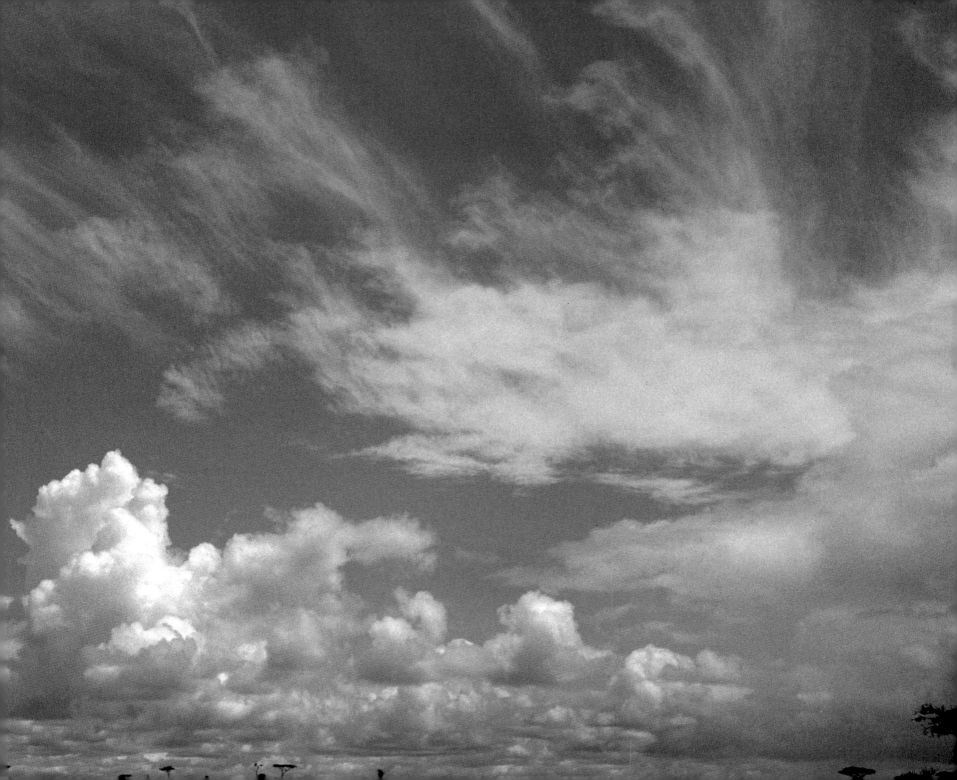

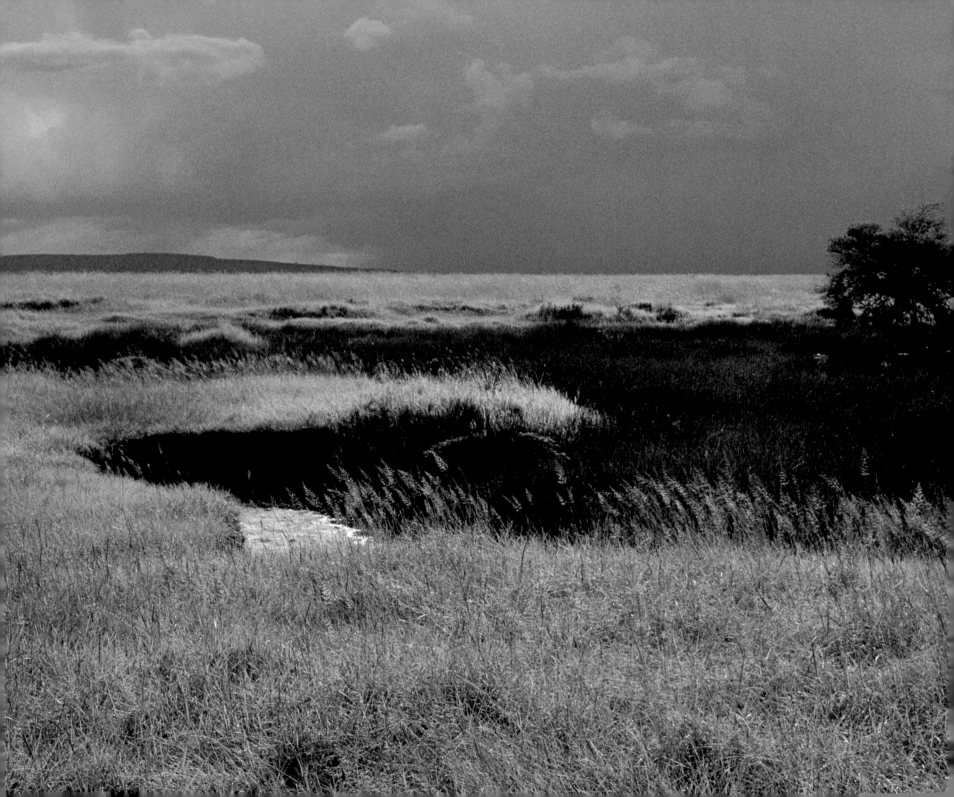

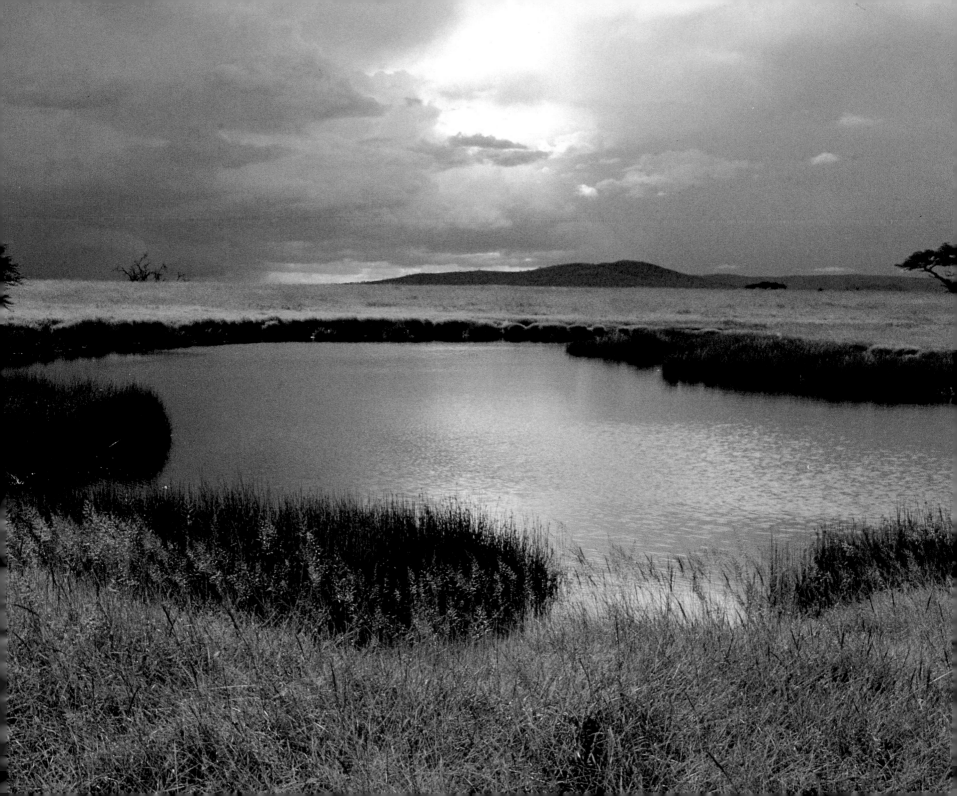

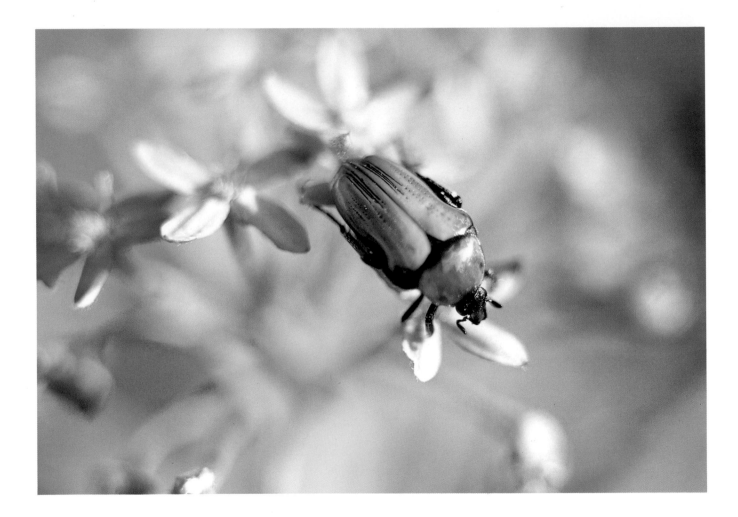

Previous pages: With its power to nourish, water has transformed life on the plain.

Above: Insects add to the color and feverish activity of the plain.

Right: In stark contrast to the dust of the dry season,
the green carpet of grass holds the promise of life for the Serengeti's inhabitants.

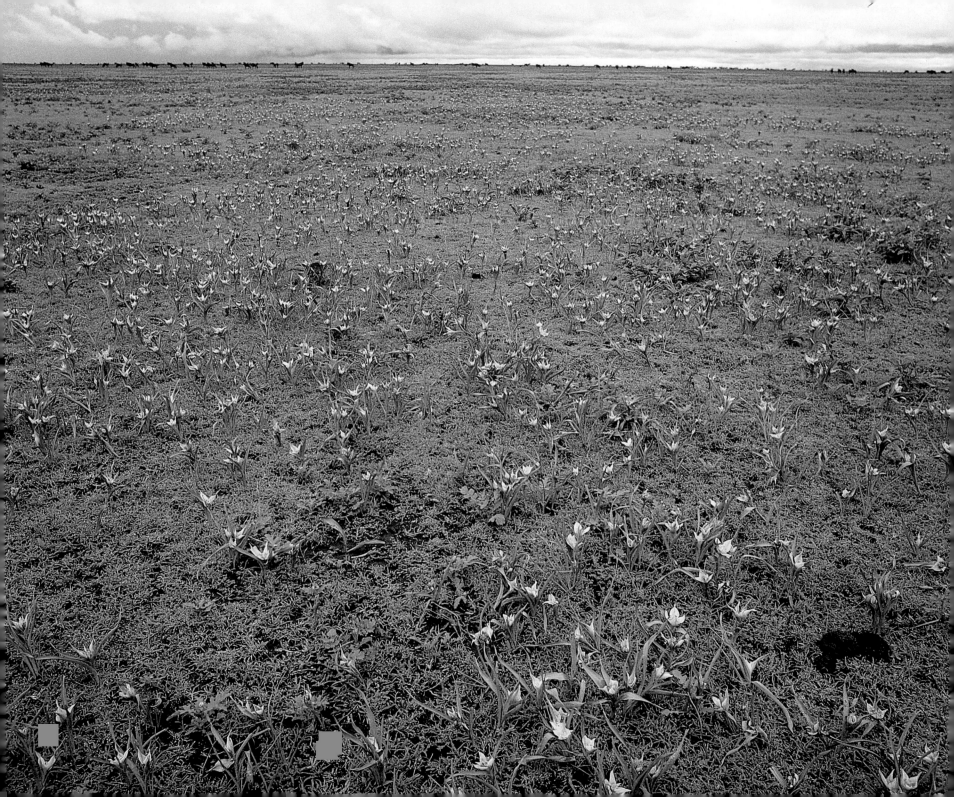

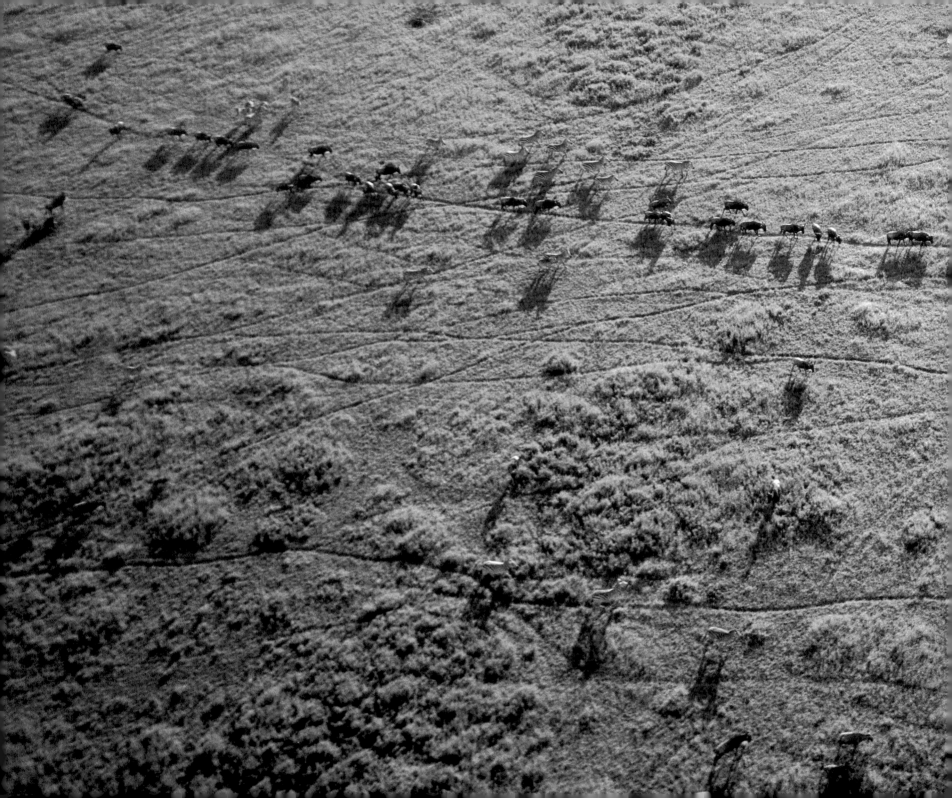

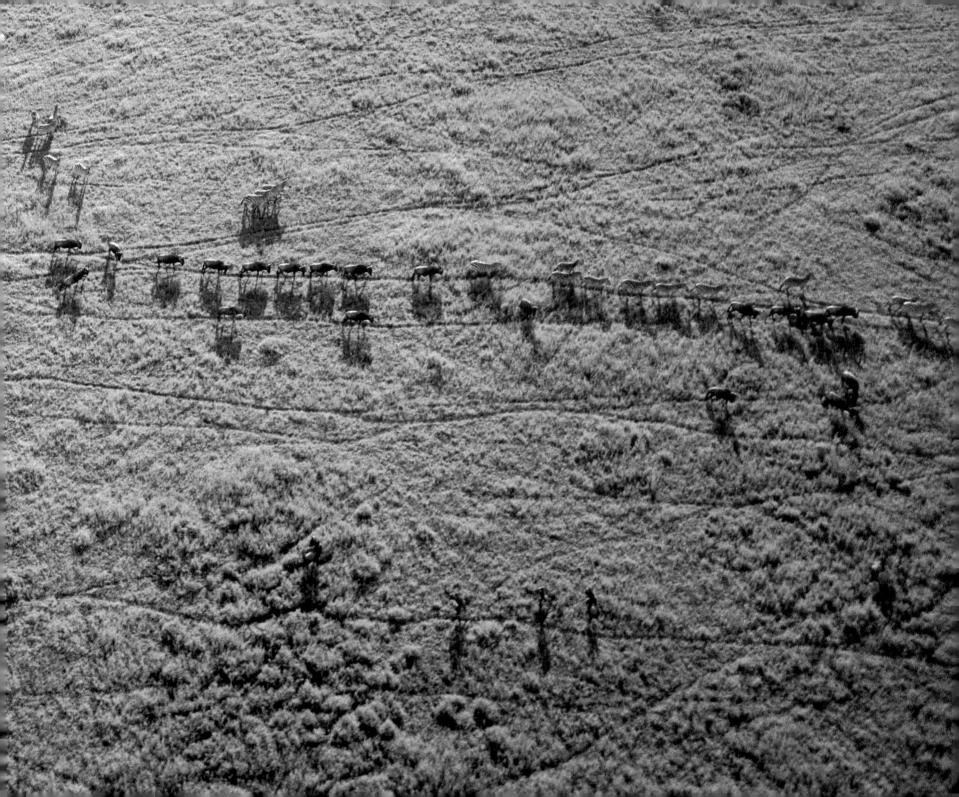

Previous pages: The migrating herds wear deep ruts in the landscape.

Above: In its turn, the earth is sustained by the animals.

Right: The transformation continues.

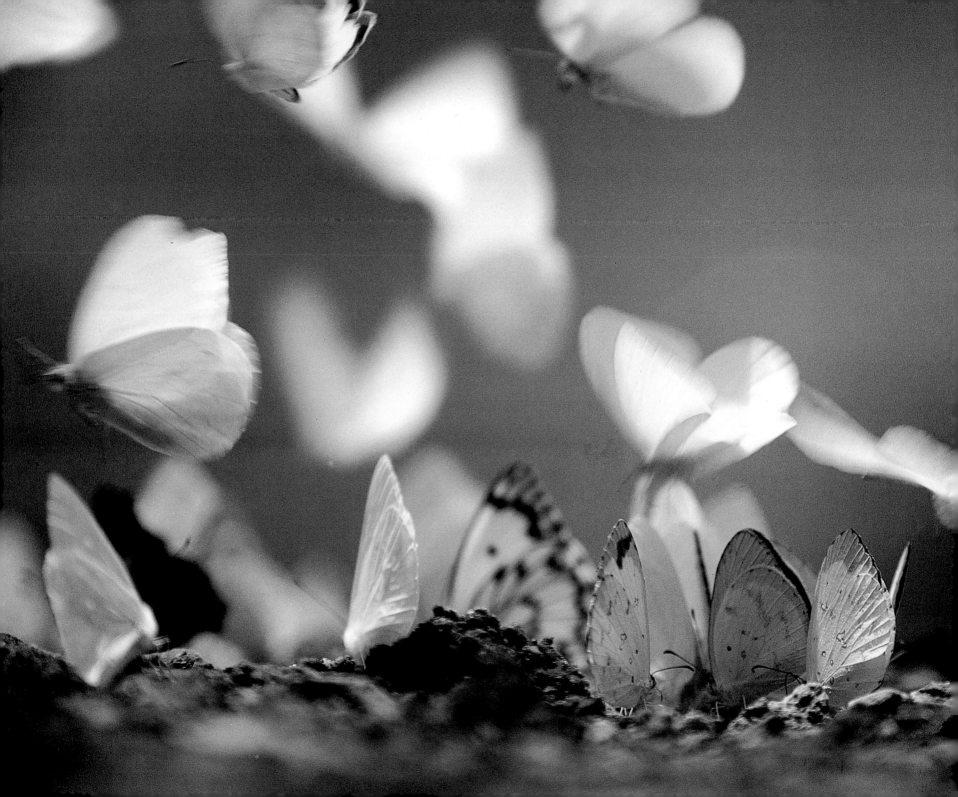

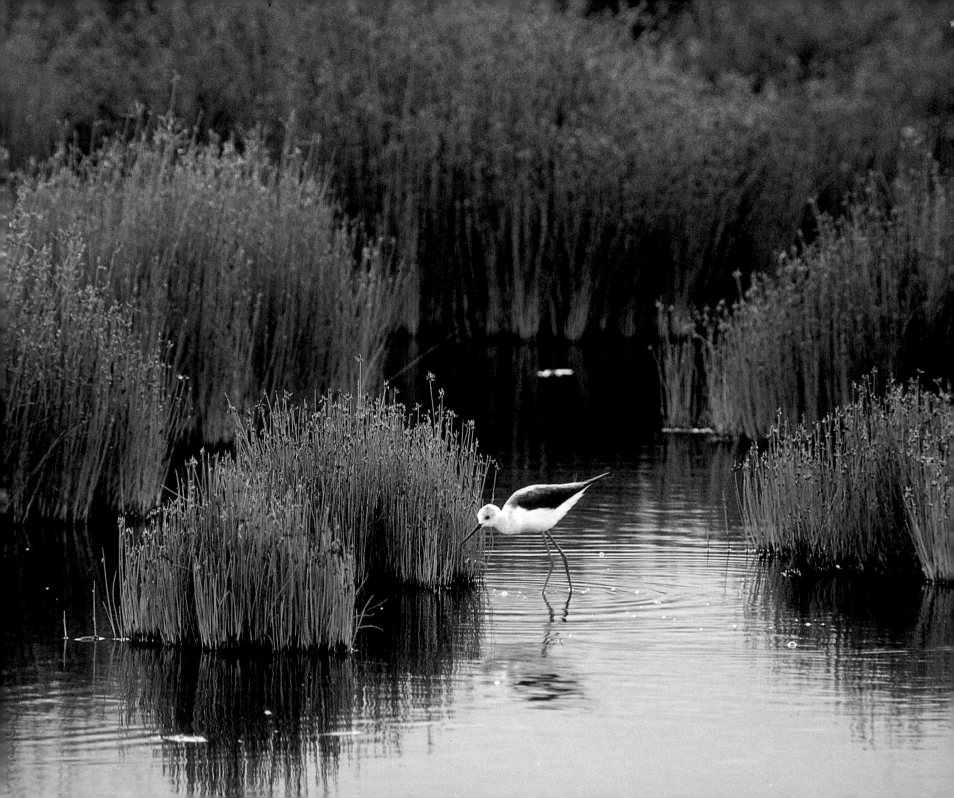

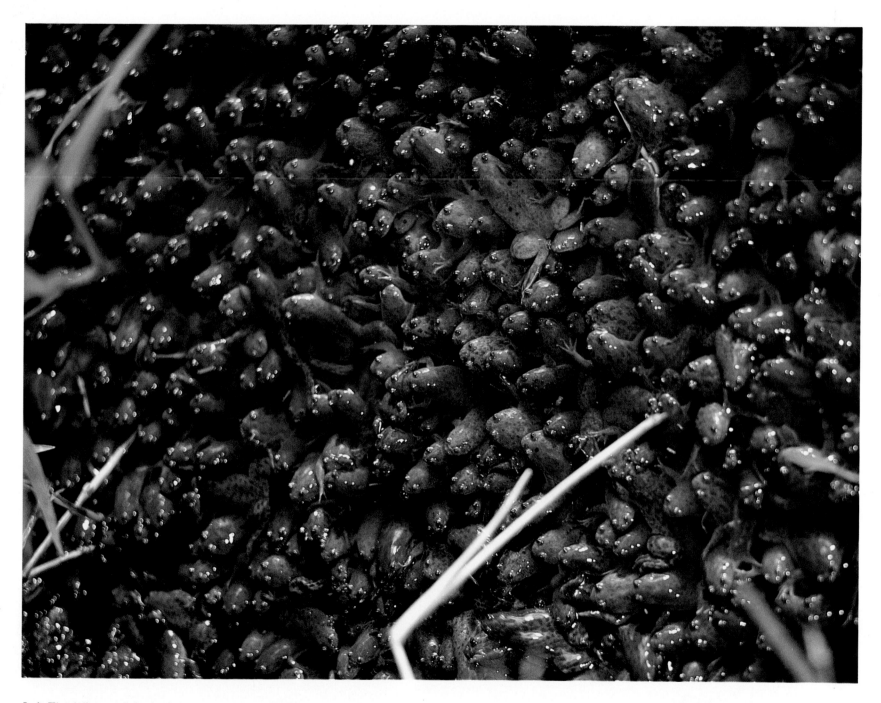

Left: The daily search for food now seems more peaceful.

Above: The plain is overflowing with life.

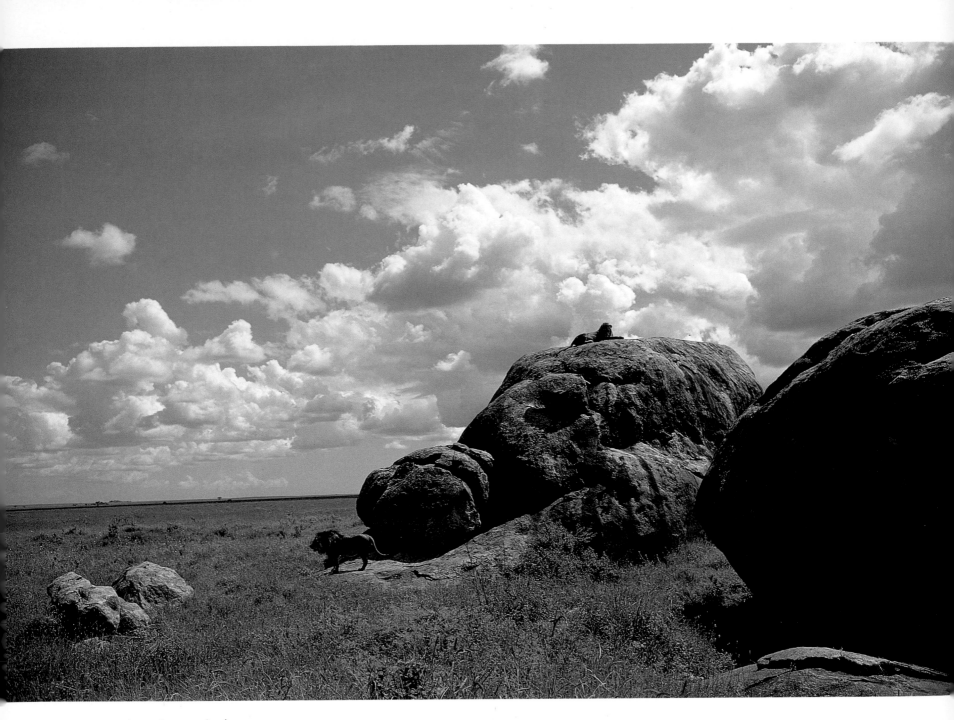

Lions sun themselves on a kopje.

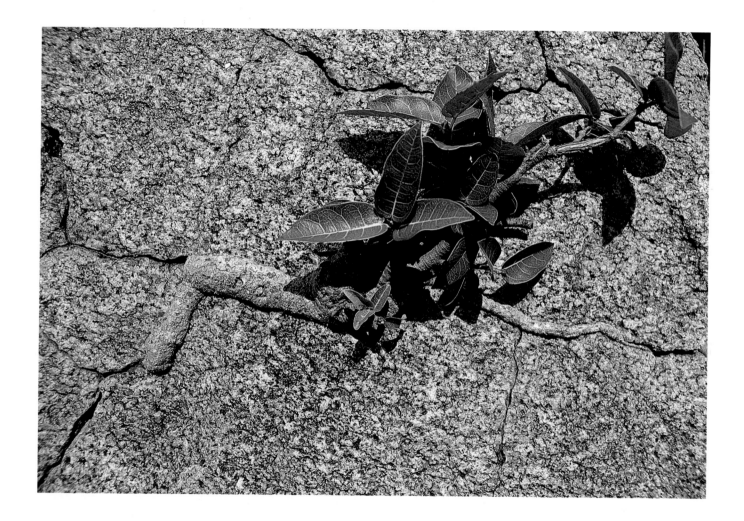

A fig branch grows out of a crack in the rock.

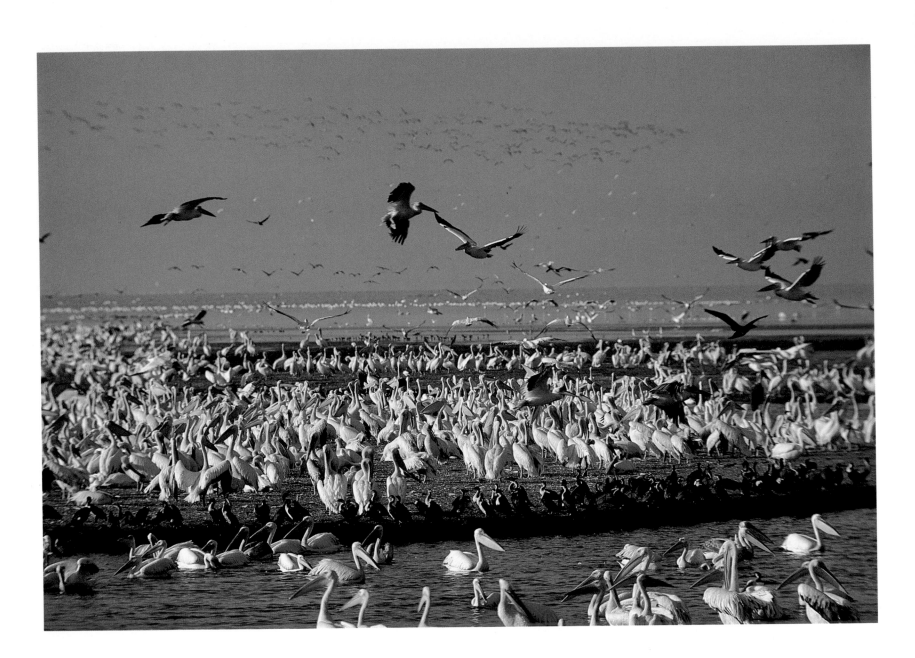

Pelicans nest on Lake Manyara.

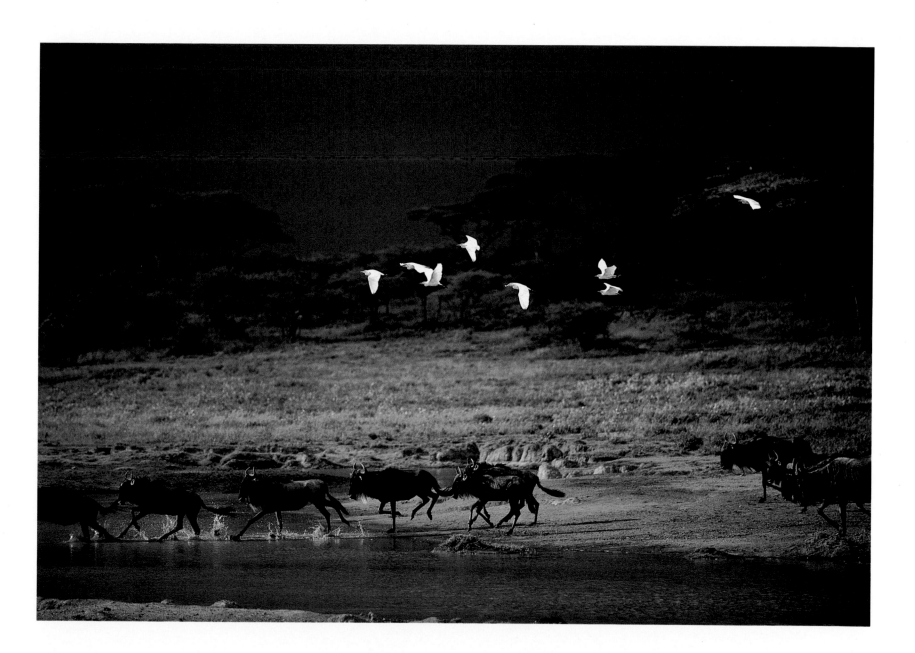

A rain cloud approaches from a few miles away.

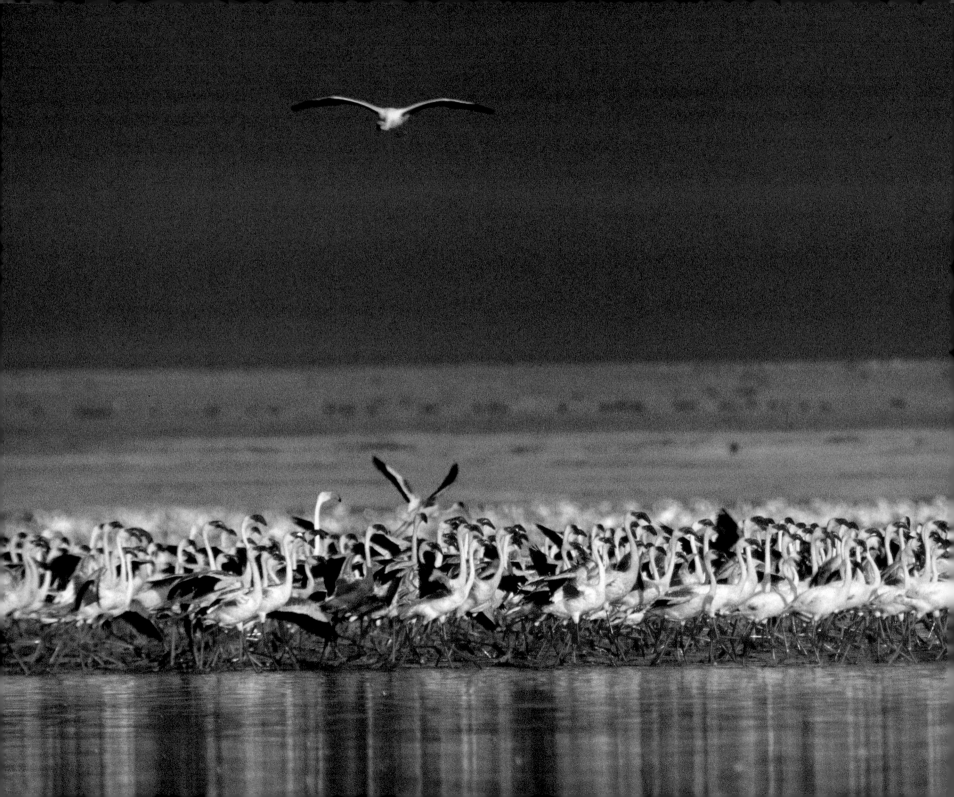

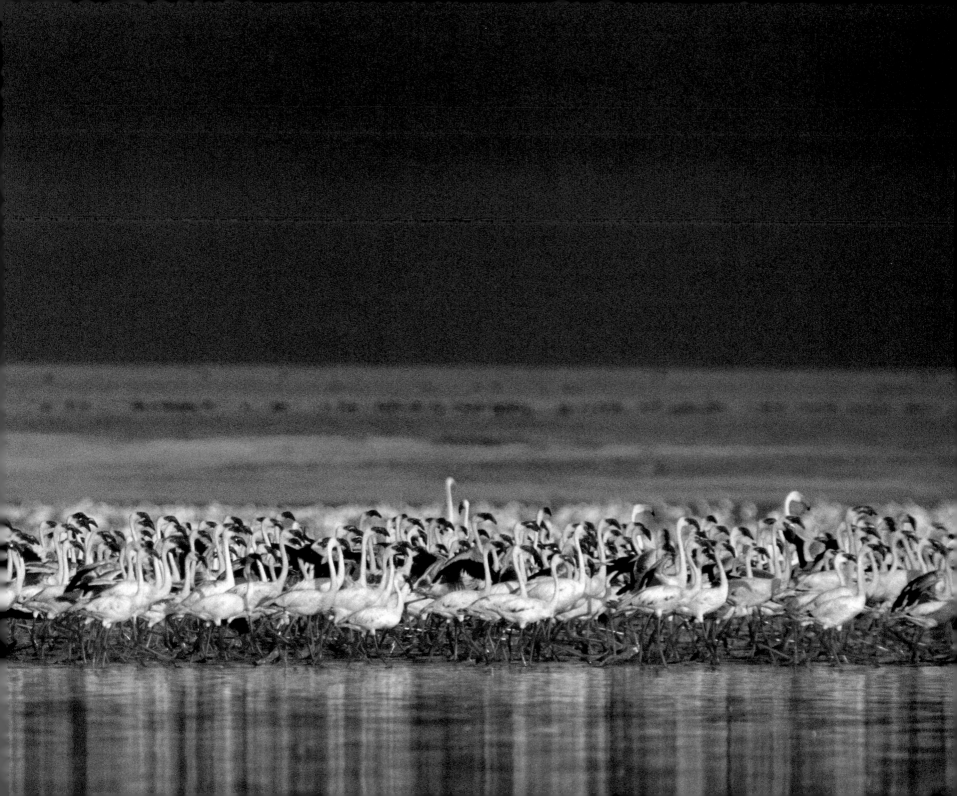

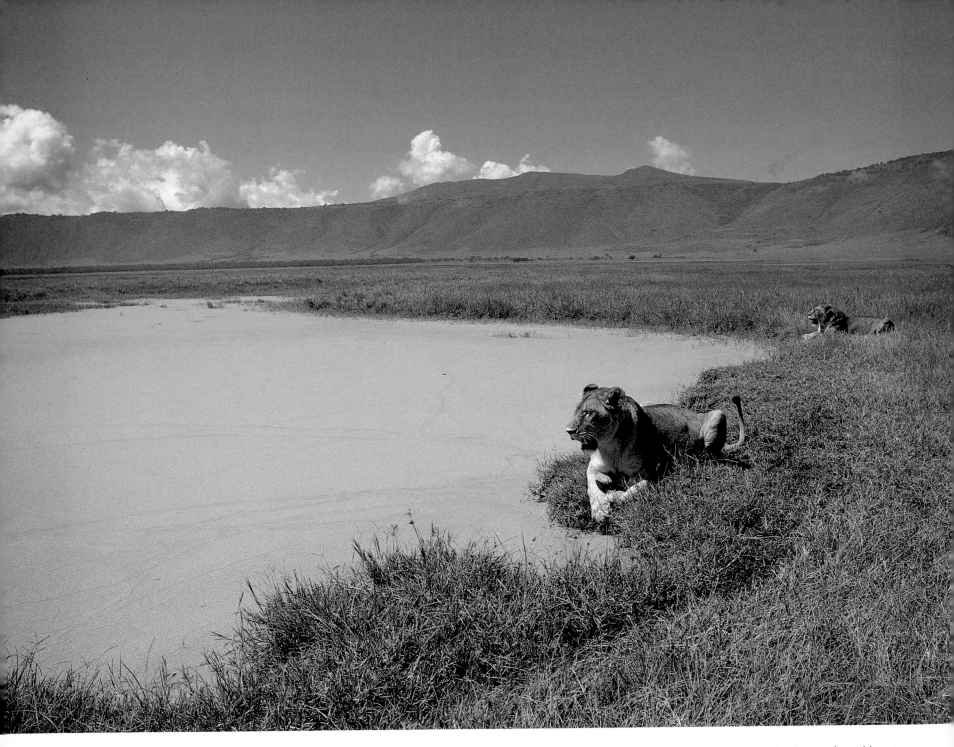

Previous pages: These flamingoes are often hunted by lions and hyenas.

Above: The presence of lions keeps grazing animals away from this water.

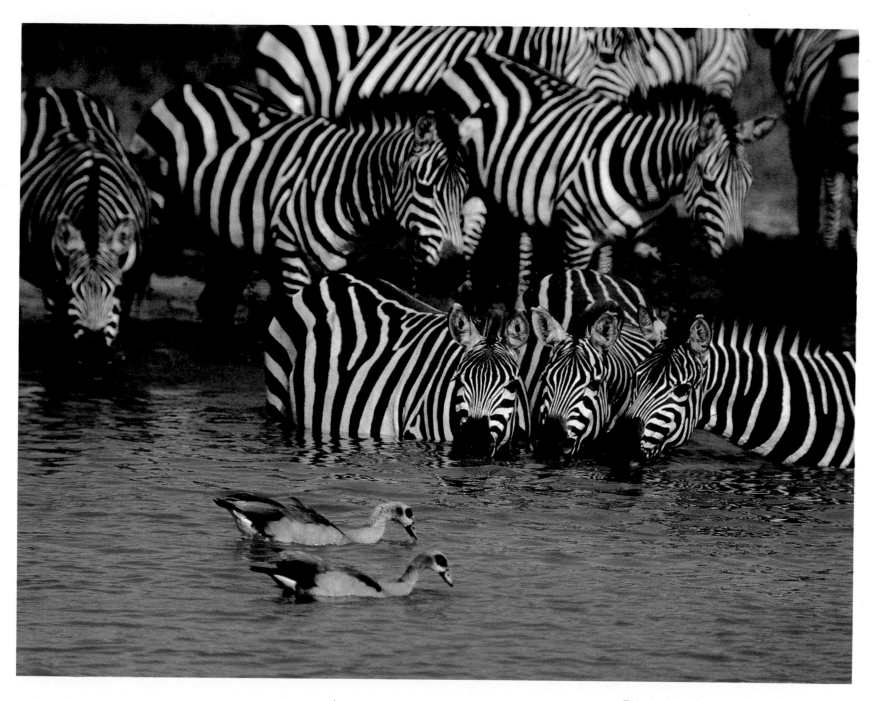

Zebras come to this watering hole twice a day.

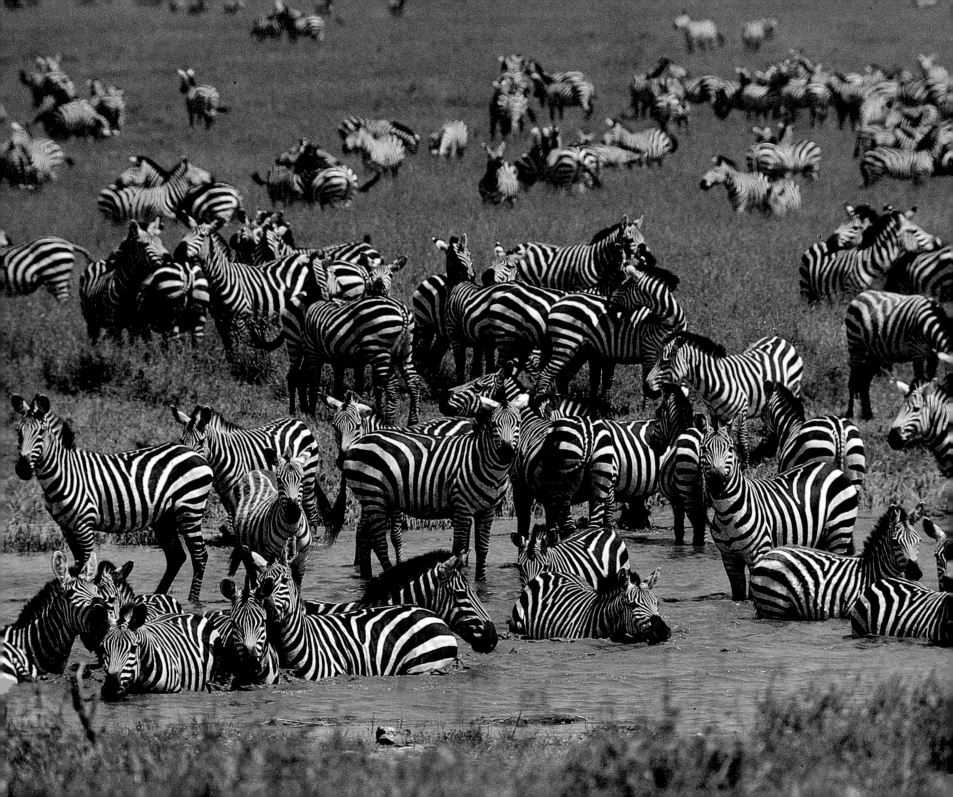

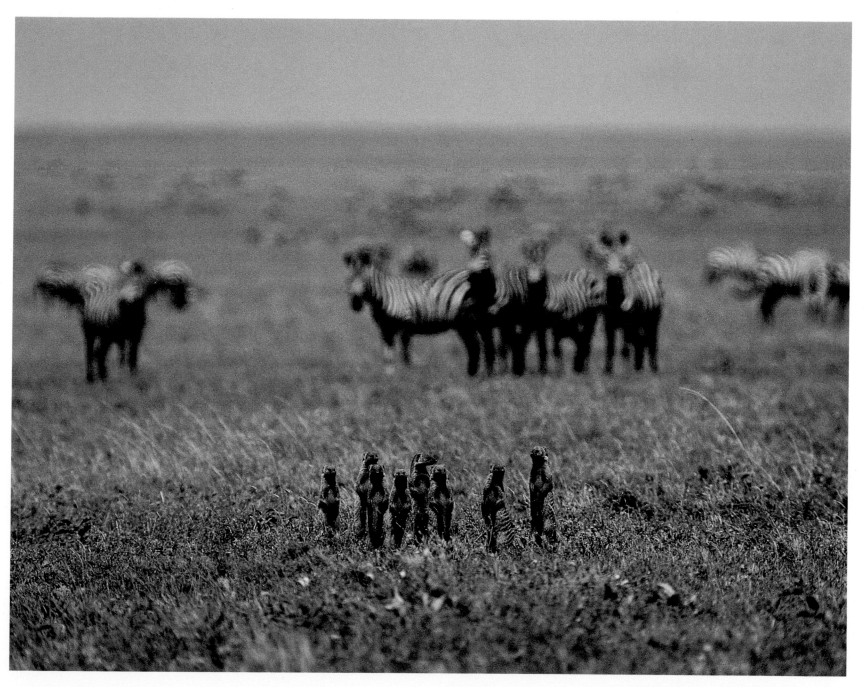

Left: The zebra's stripes are as individual as fingerprints.

Above: Mongooses, the clowns of the plain,
are intelligent foragers that feed on insects, lizards, and, if given the chance, snakes.

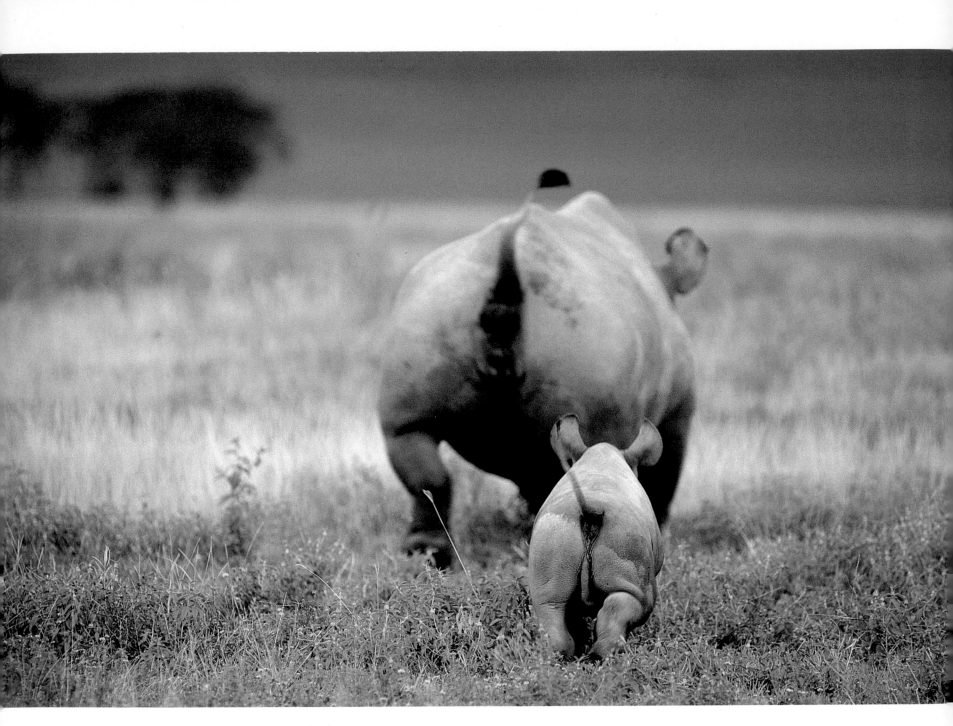

Poached for their horns, rhinoceros are near extinction.

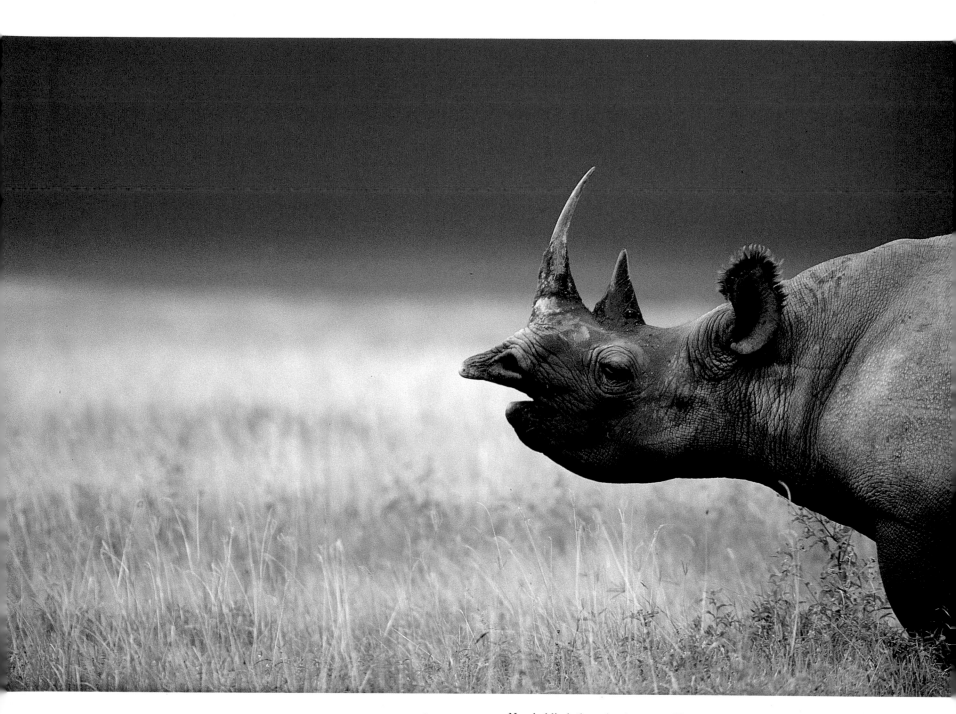

Nearly blind, the animals are readily approached, making them easy targets.

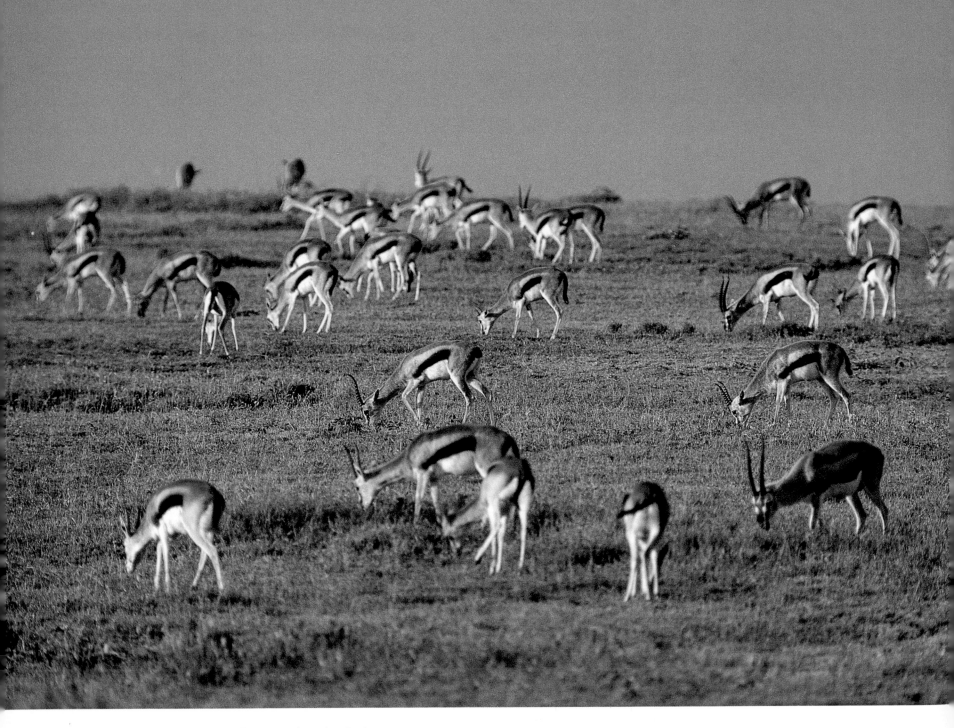

Thomson's gazelles twitch their tails constantly as they feed.

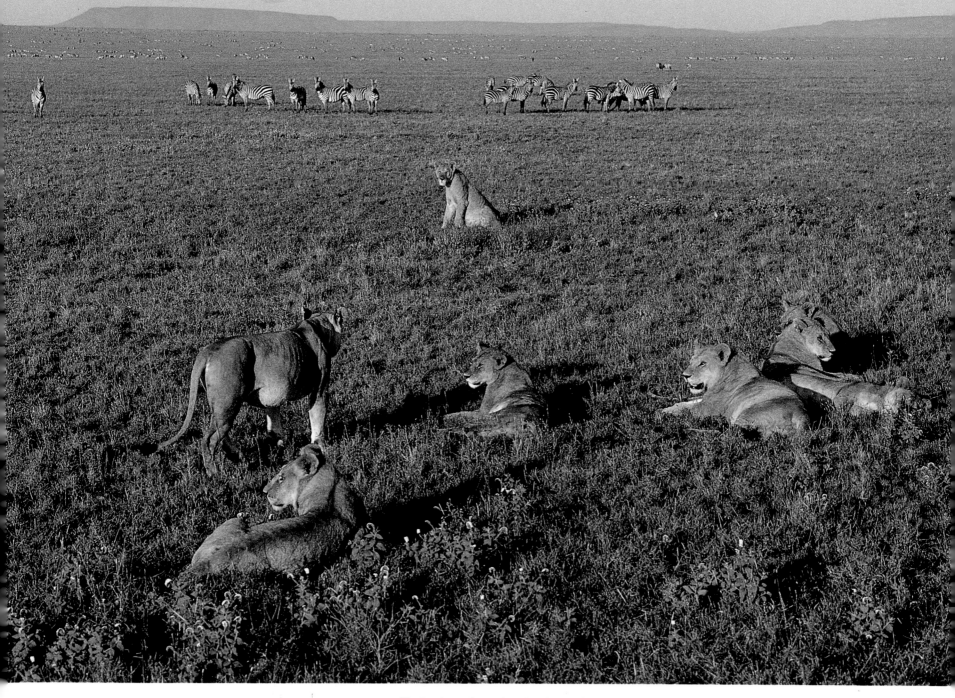

Having feasted on zebra the night before, these satiated lions have temporarily lost interest in prey.

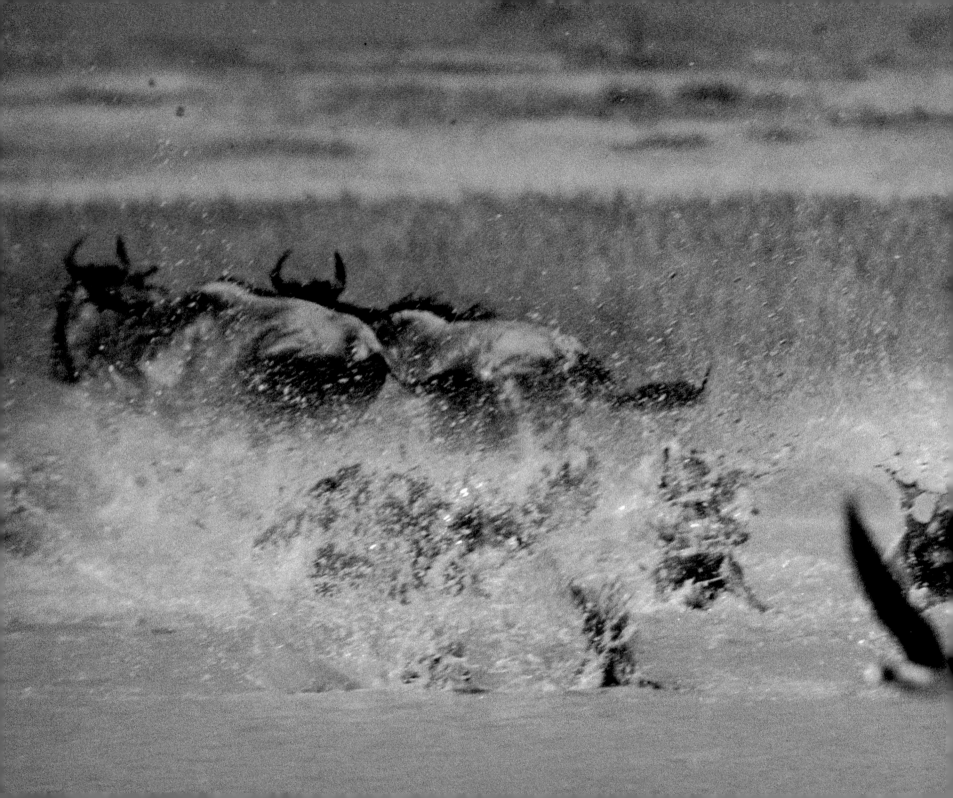

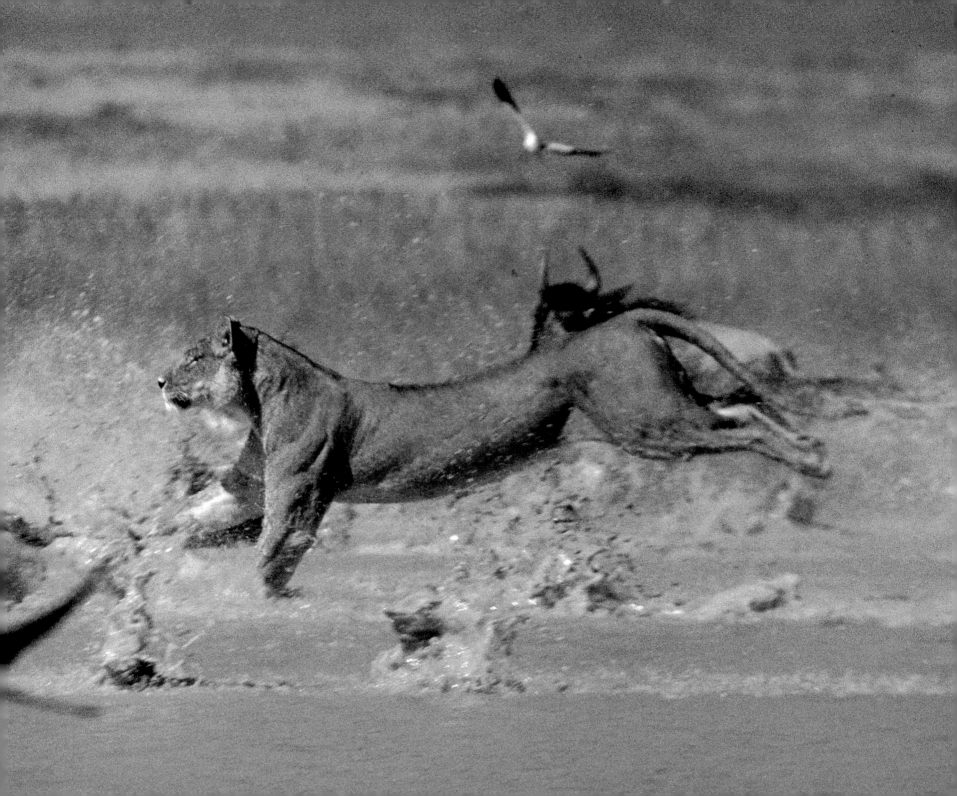

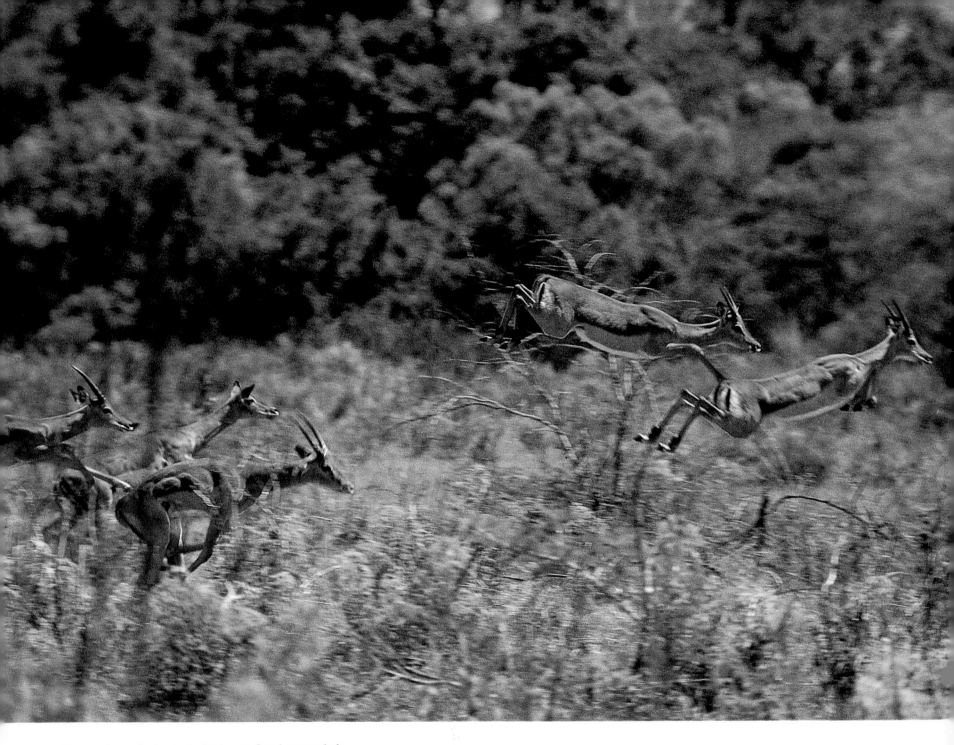

Previous pages: Ambushed wildebeests flee the water hole.

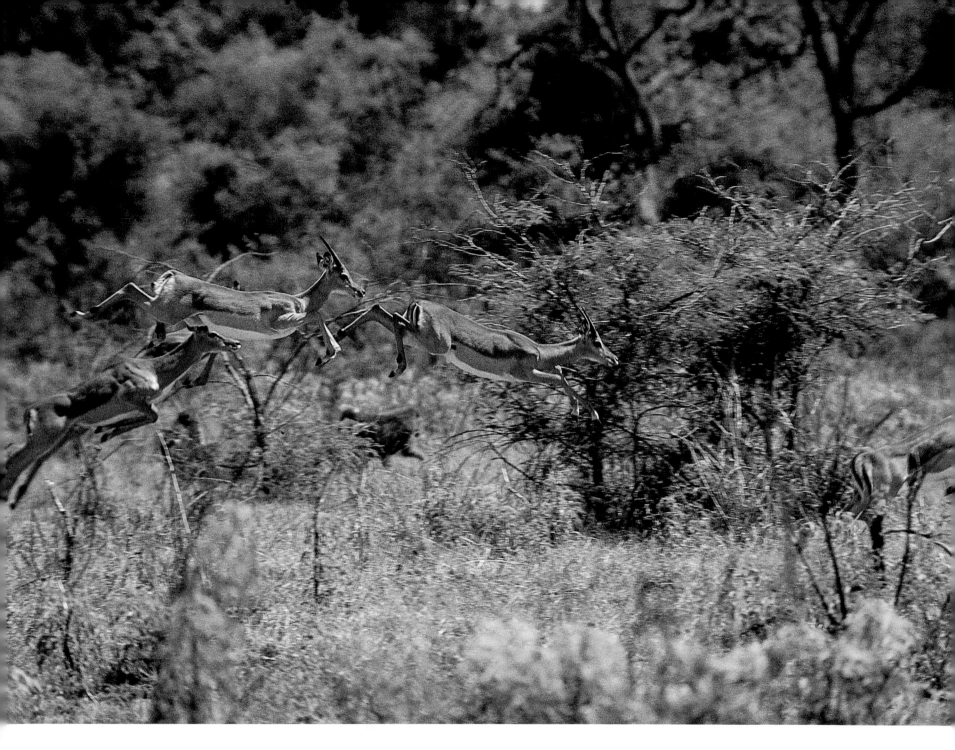

Above: To confuse pursuers, impalas run in zigzagging leaps.

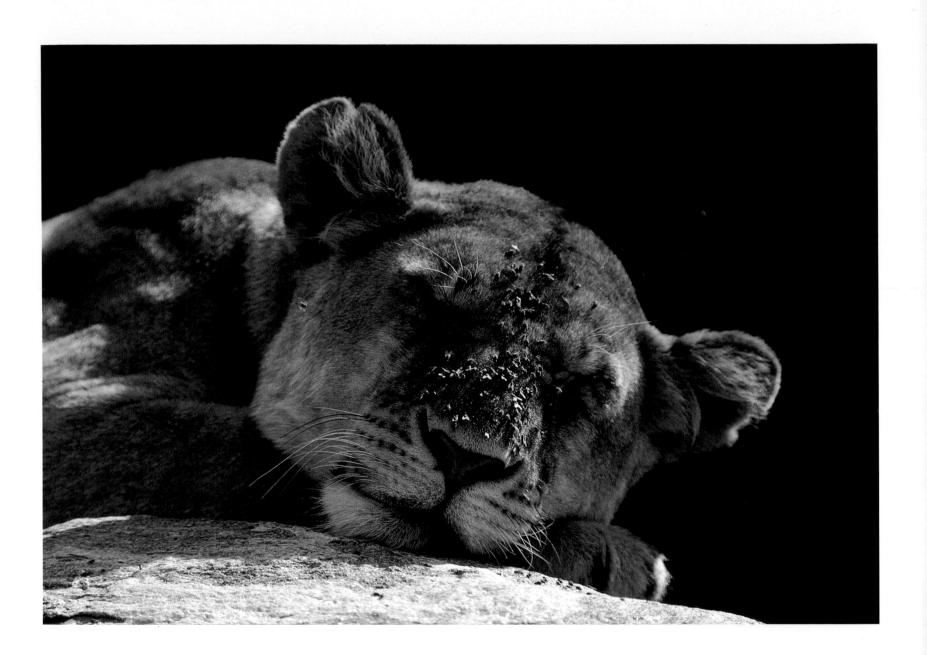

Above: As the number of animals increases, so do the flies.

Right: A small portion of the thousands of migrating animals.

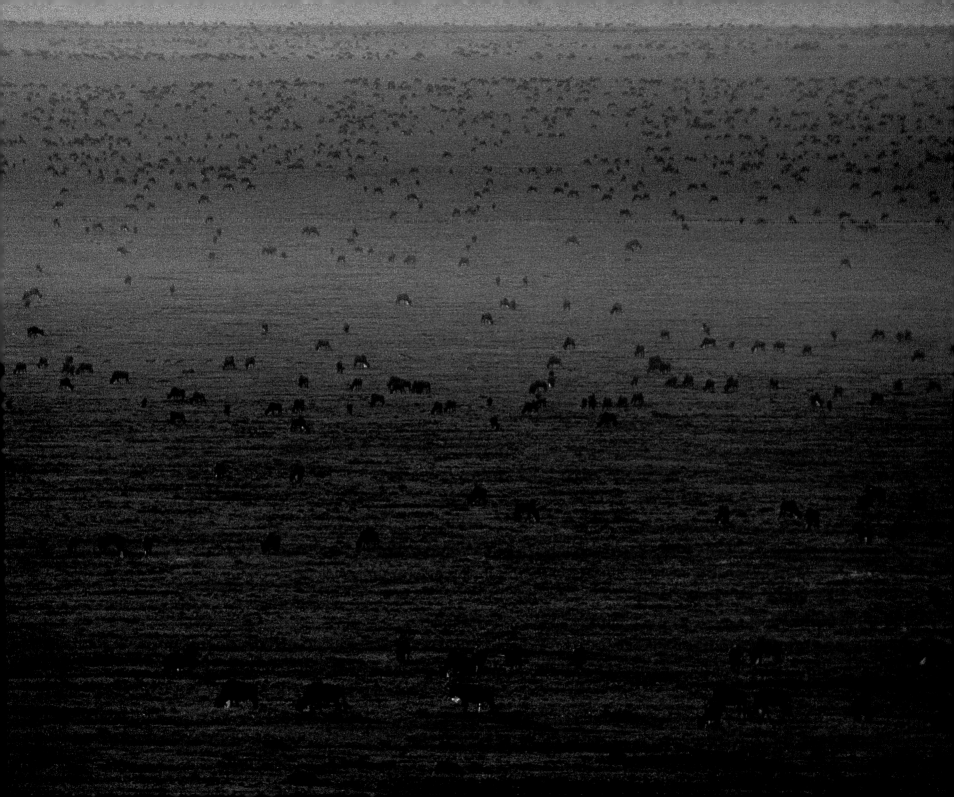

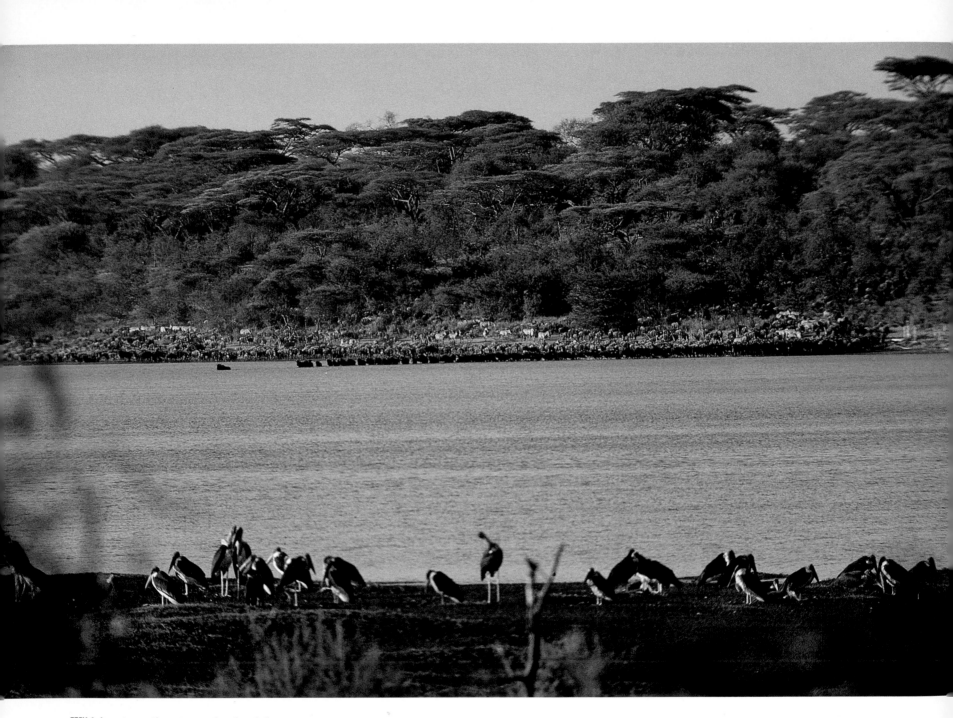

Wildebeests continue to wander the plain.

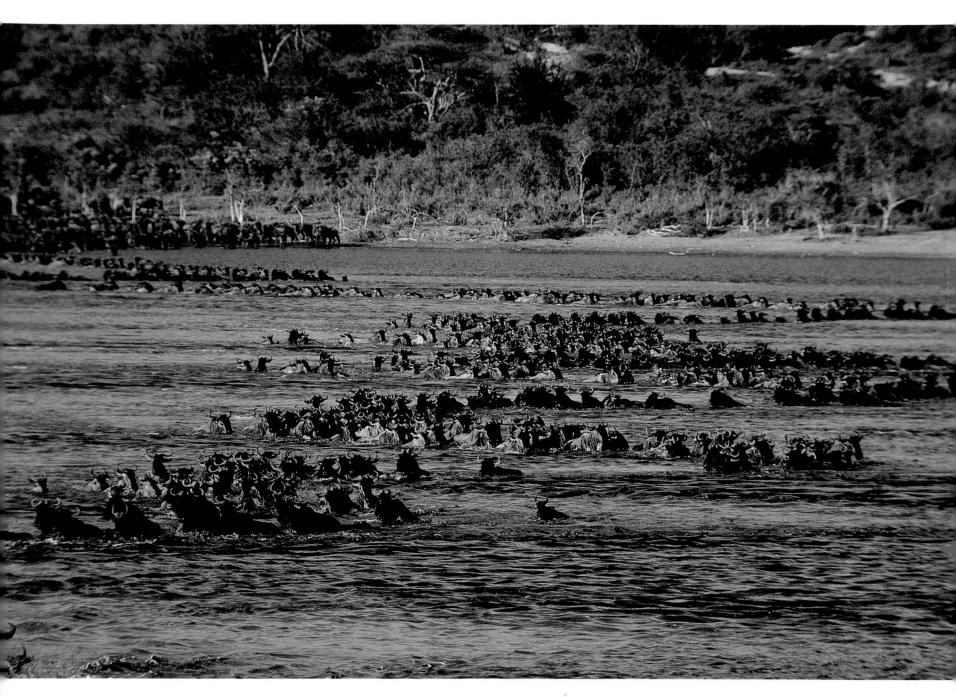

Even Lake Ndutu cannot stem the migration.

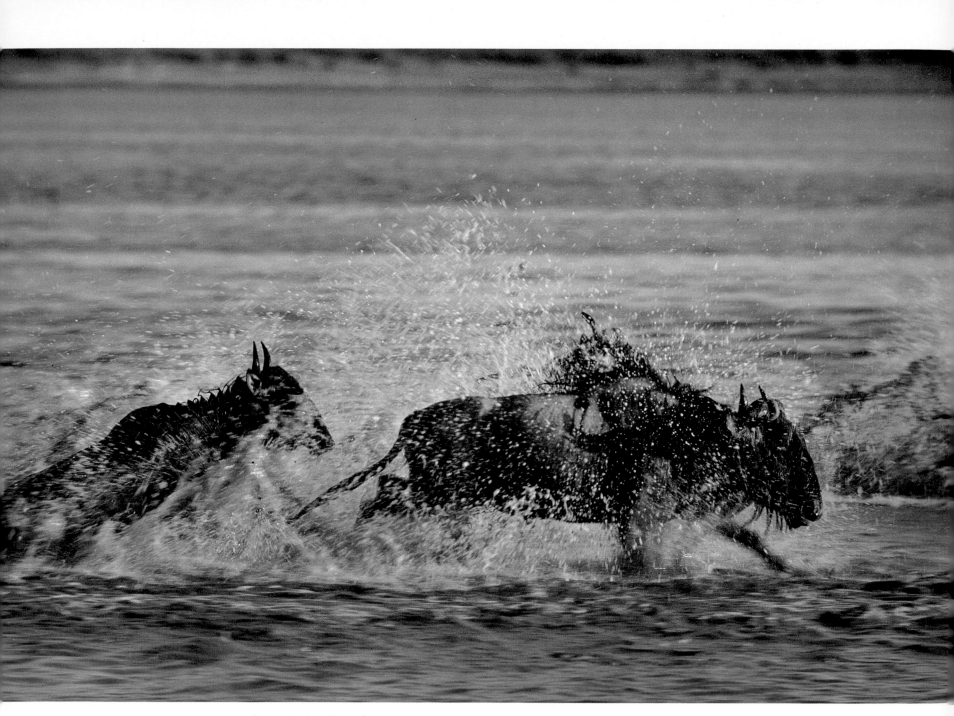

Fortunately for the impetuous wildebeests, the lake is not deep.

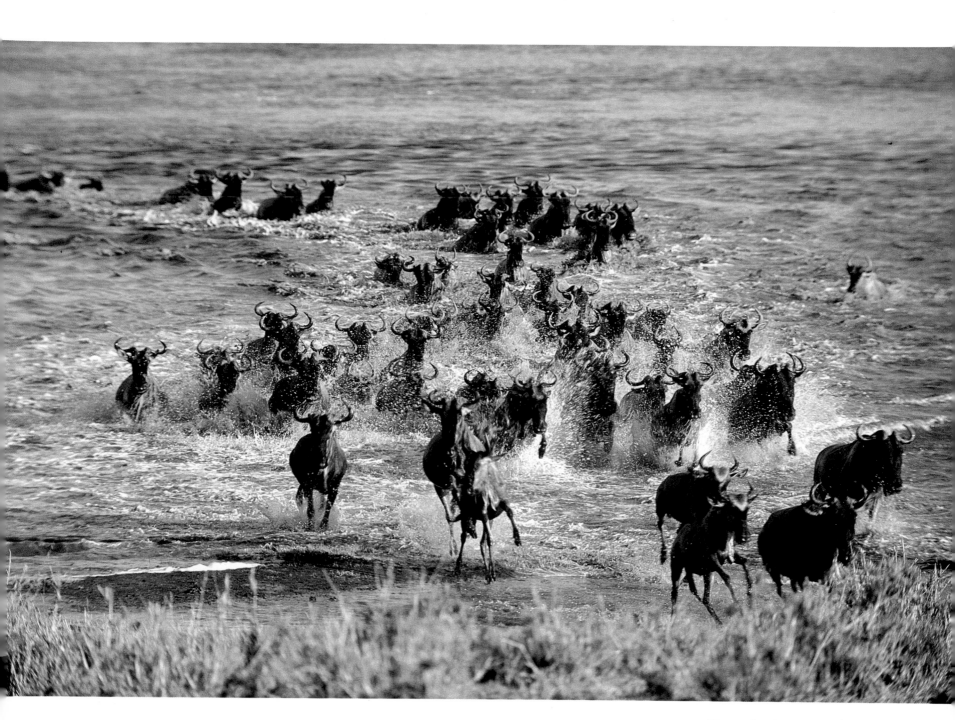

They rush to leave the water behind.

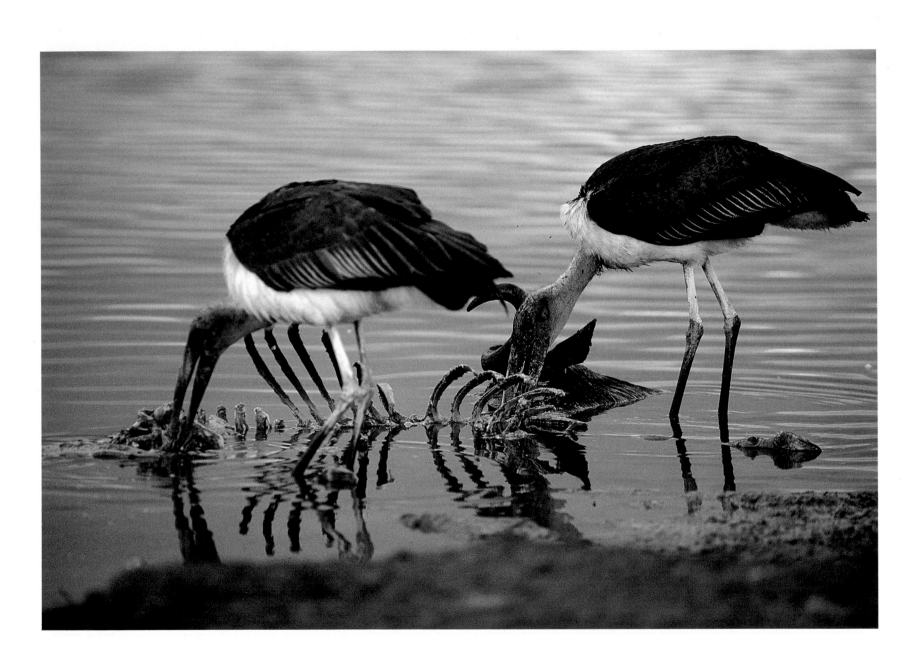

The endless cycle of feeding continues.

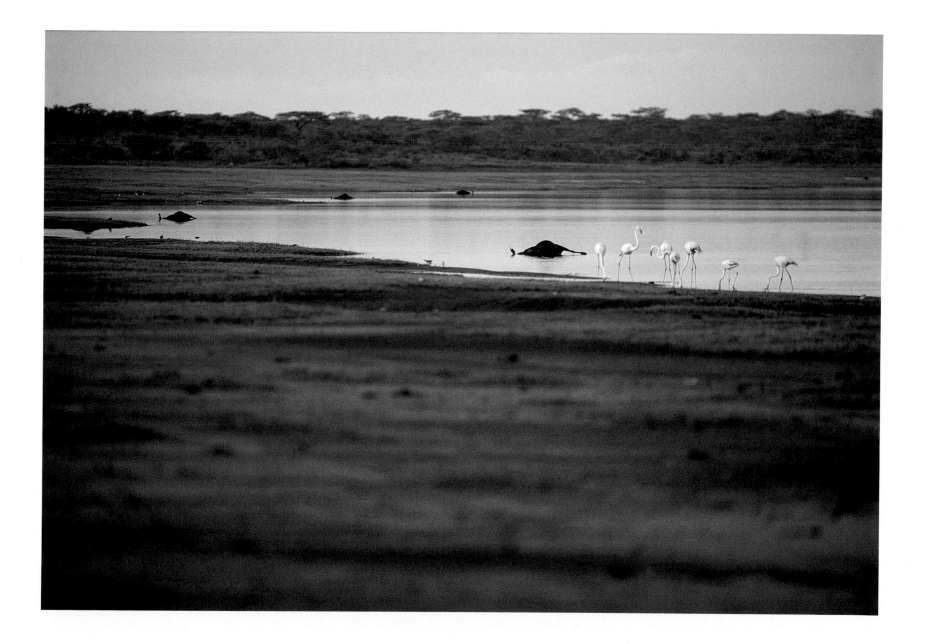

As always, some are drowned in the crossing.

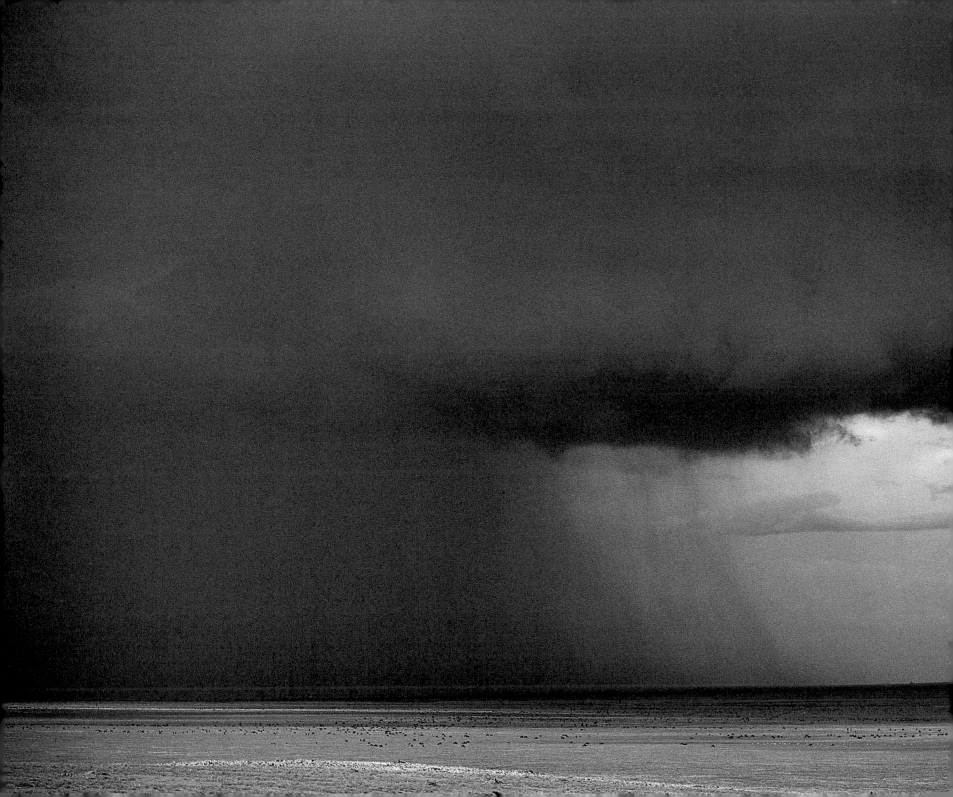

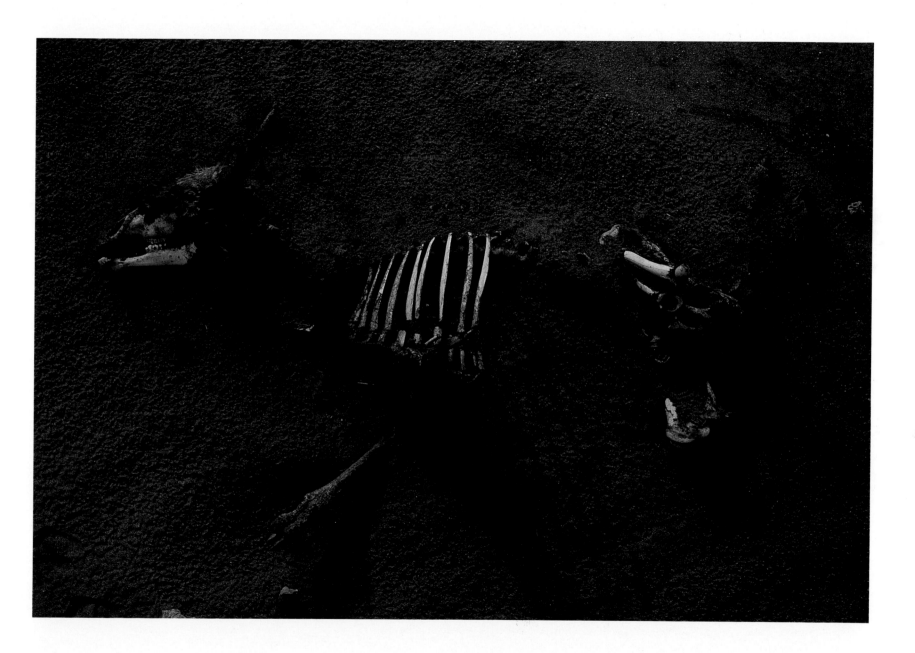

Left: A moving wall of rain descends on the plain.

Above: These remains of a wildebeest calf are a reminder
that the young and the infirm are the first to perish in the Serengeti's harsh world.

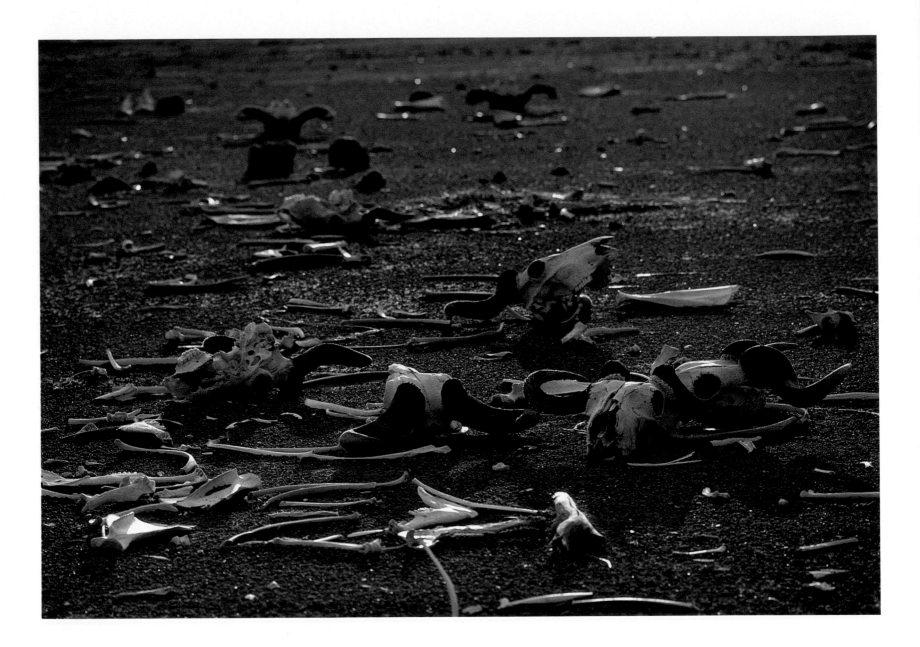

Above: Washed white by the rain, these wildebeest bones are just a few of the thousands scattered on the plain.

Right: The wildebeests grow fat and healthy on the new vegetation.

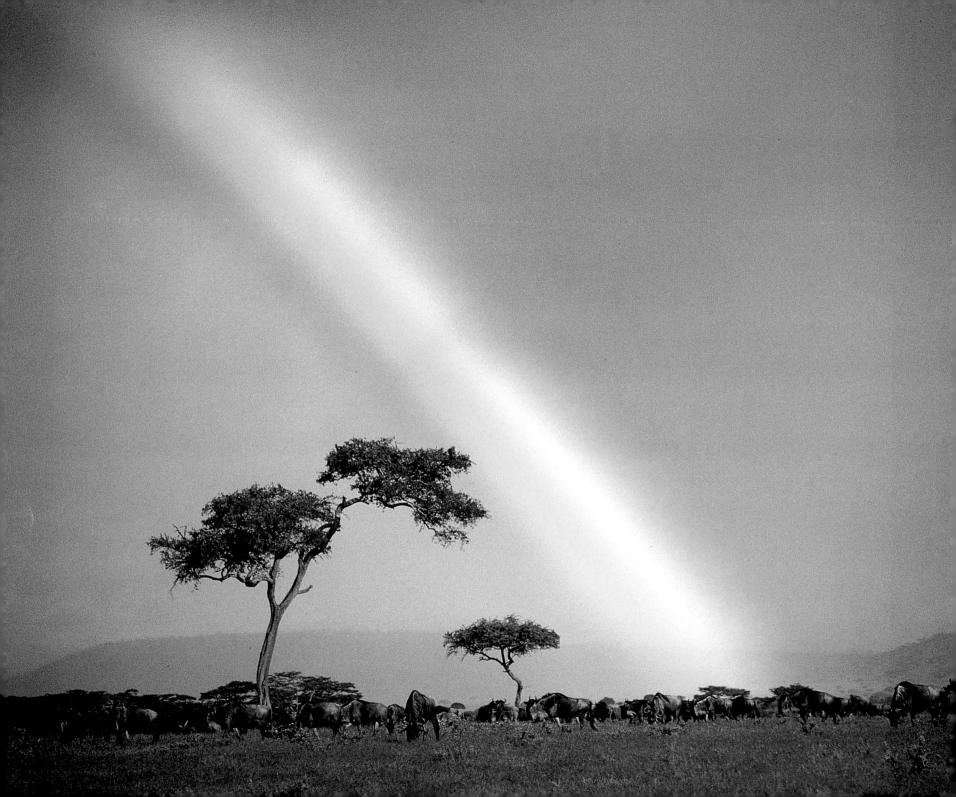

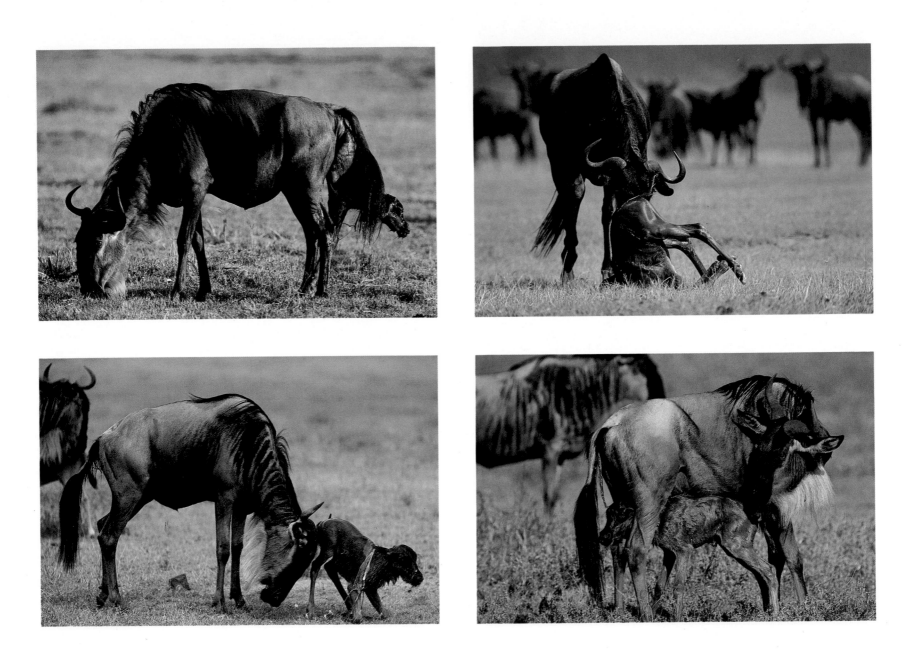

Above: Almost 200,000 wildebeest calves are born within a two-week period.

Right: The sudden increase in calves insures the survival of the species because there are far more youngsters than the predators can possibly eat.

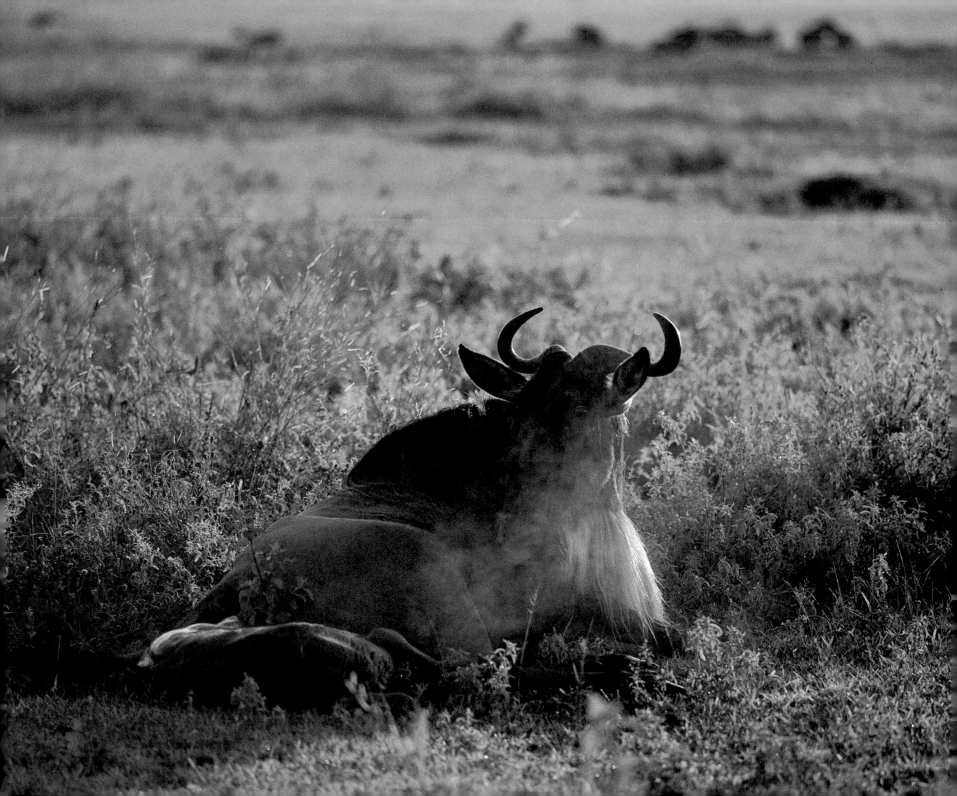

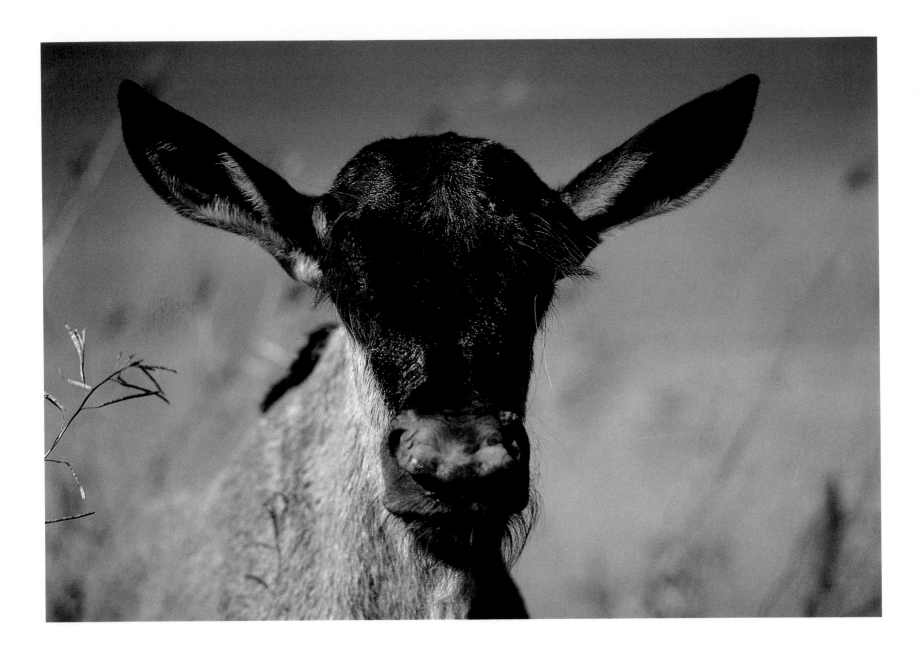

The number of births is so great that it seems the calves have sprung from the ground.

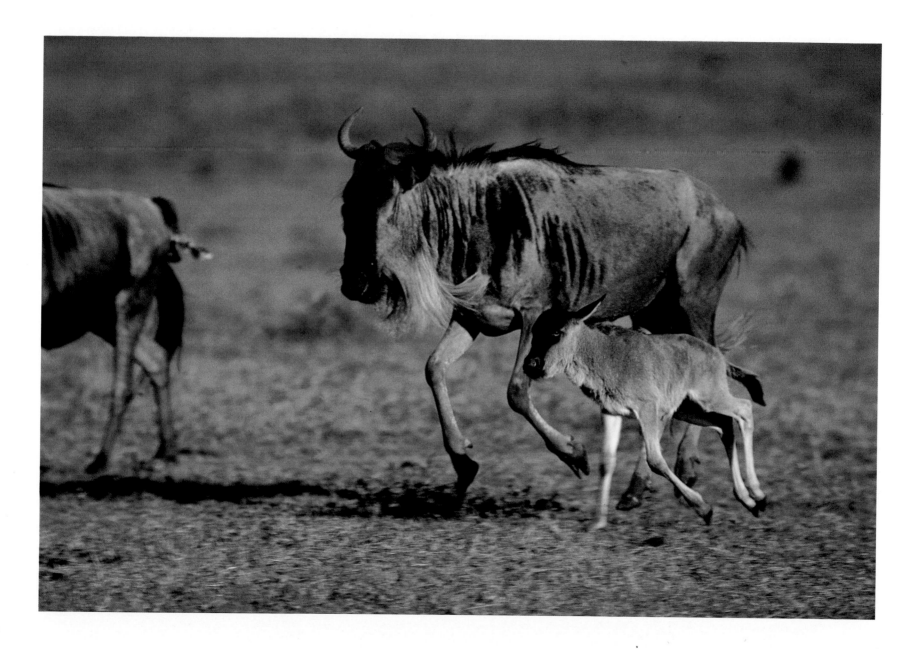

To survive, the calf must learn to run only minutes after birth.

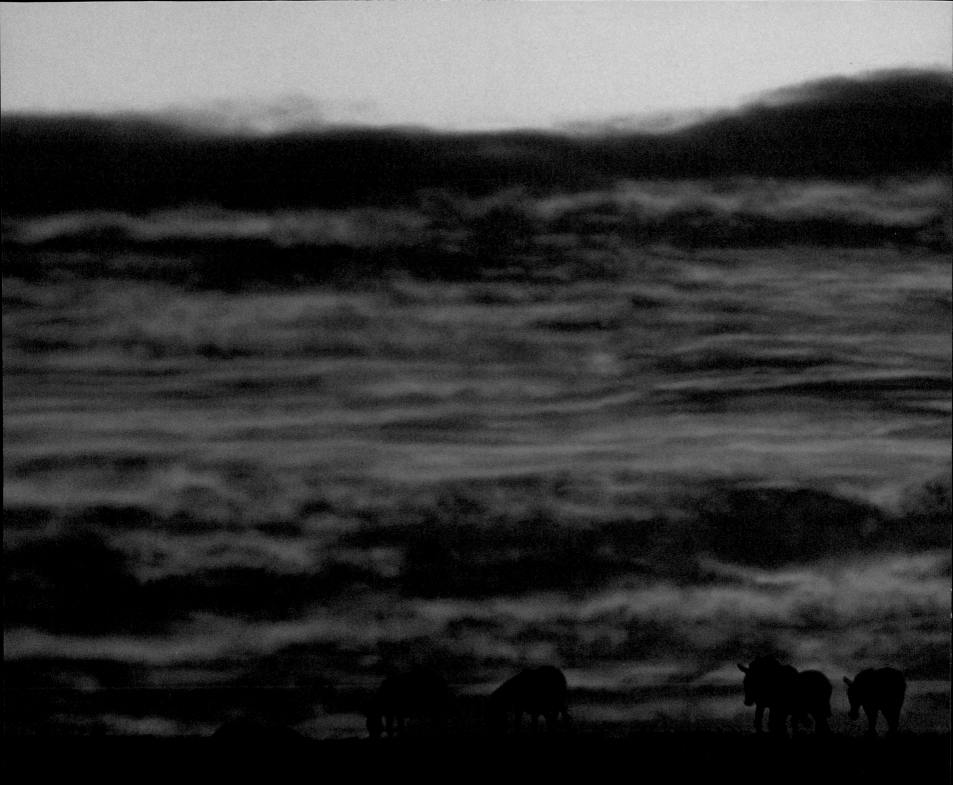

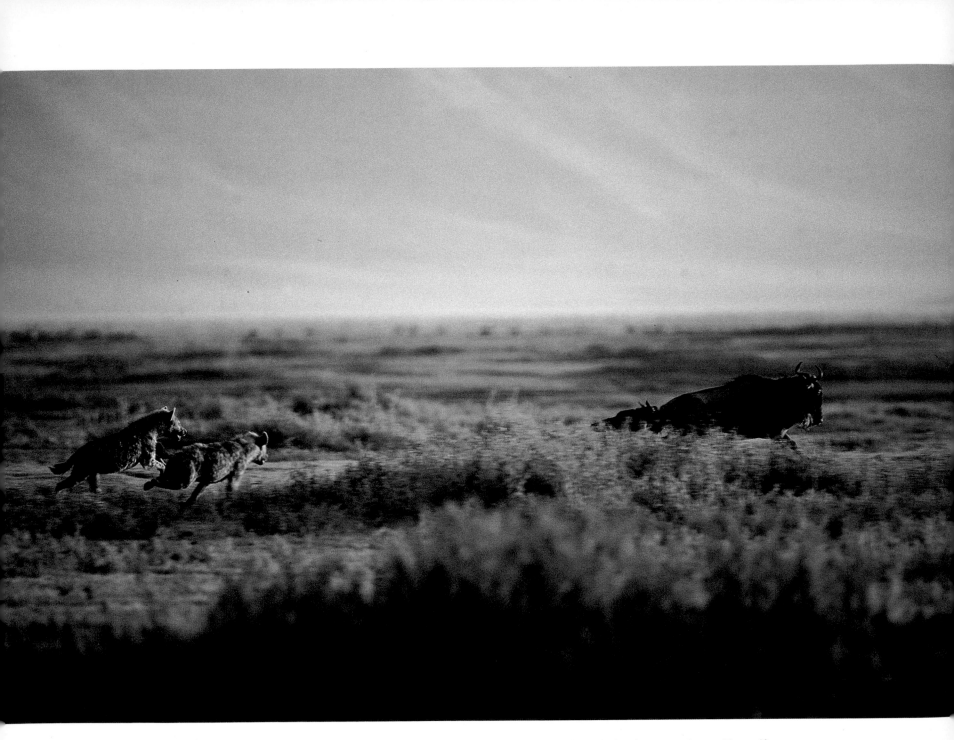

Previous pages: Twilight in the tropics is brief, the arrival of night swift.

Above: Hyenas hunt a mother and her calf.

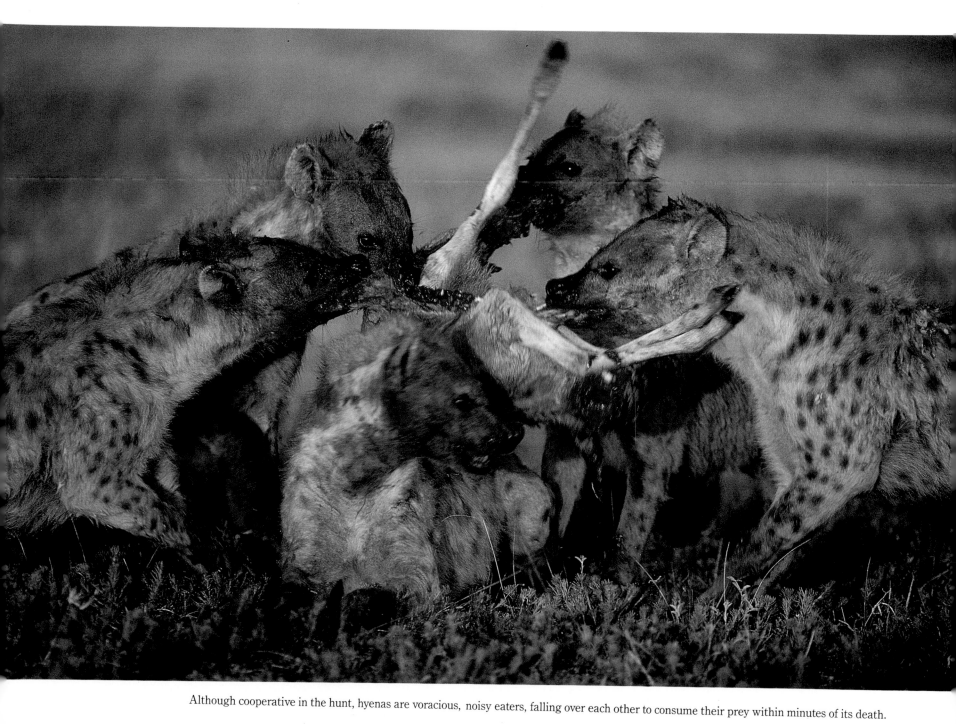

Although cooperative in the hunt, hyenas are voracious, noisy eaters, falling over each other to consume their prey within minutes of its death.

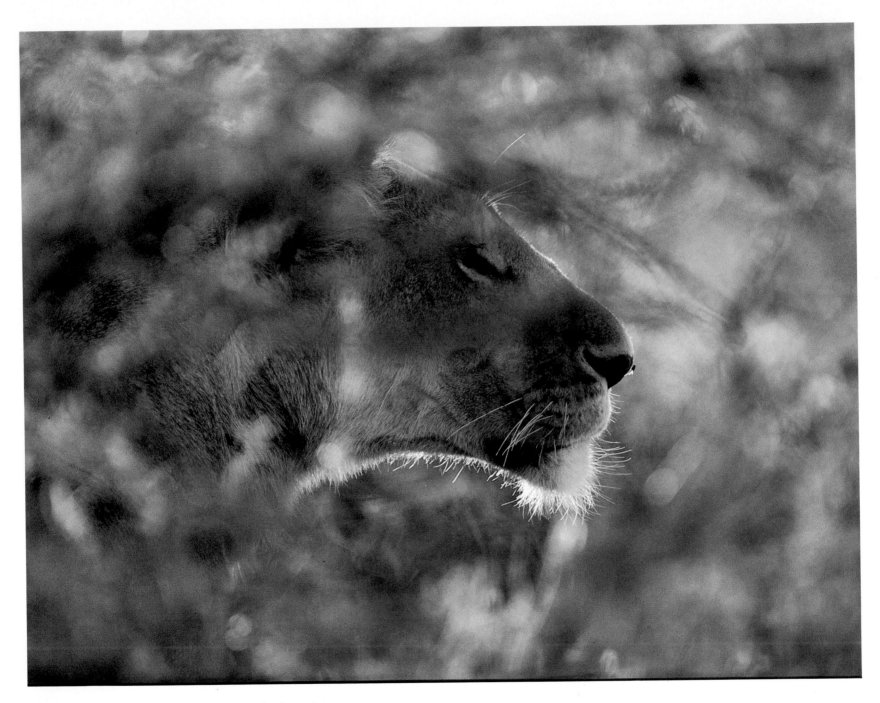

The lion's strong jaws are well suited to the needs of a predator.

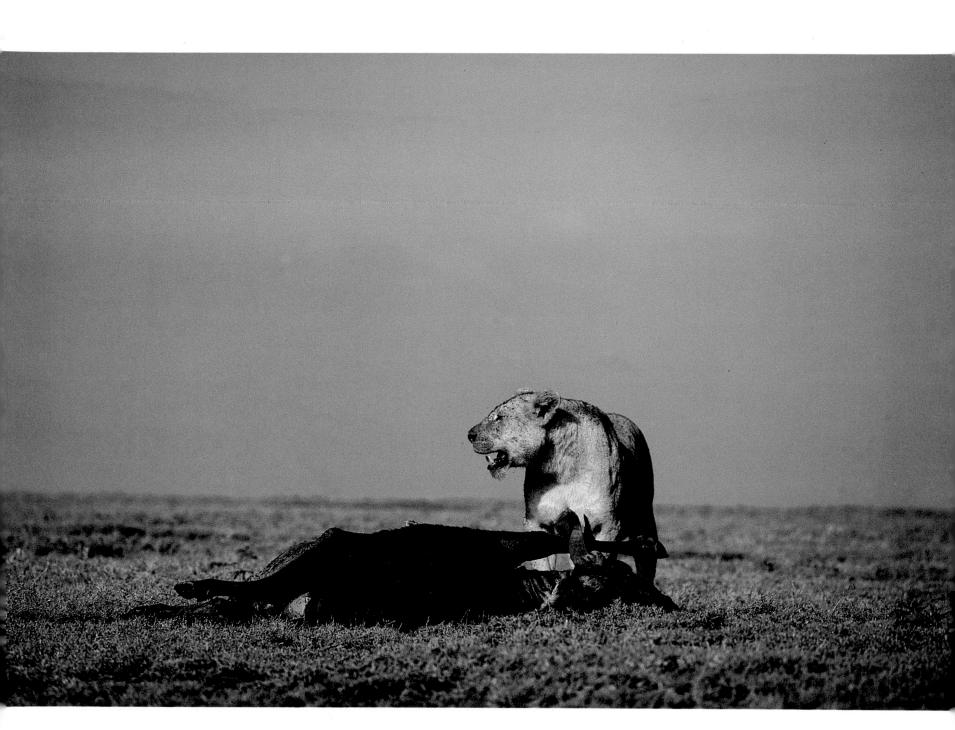

Prey is plentiful during the rainy season.

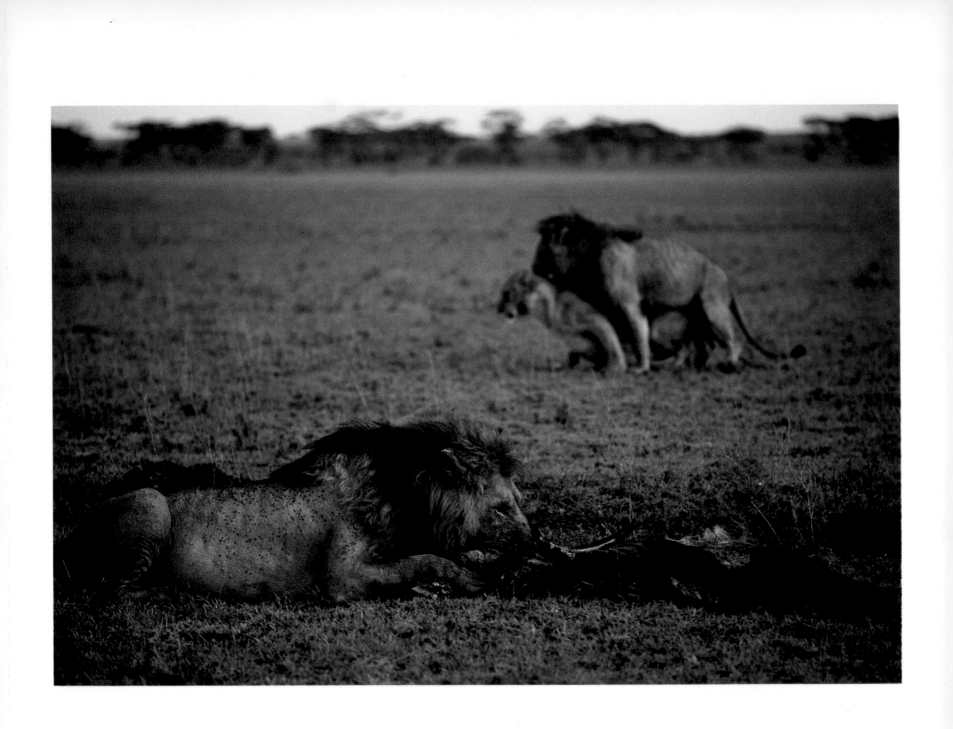

Above: Lions rarely eat for five to ten days when mating.

Right: Insects inhabit their own tiny, colorful world.

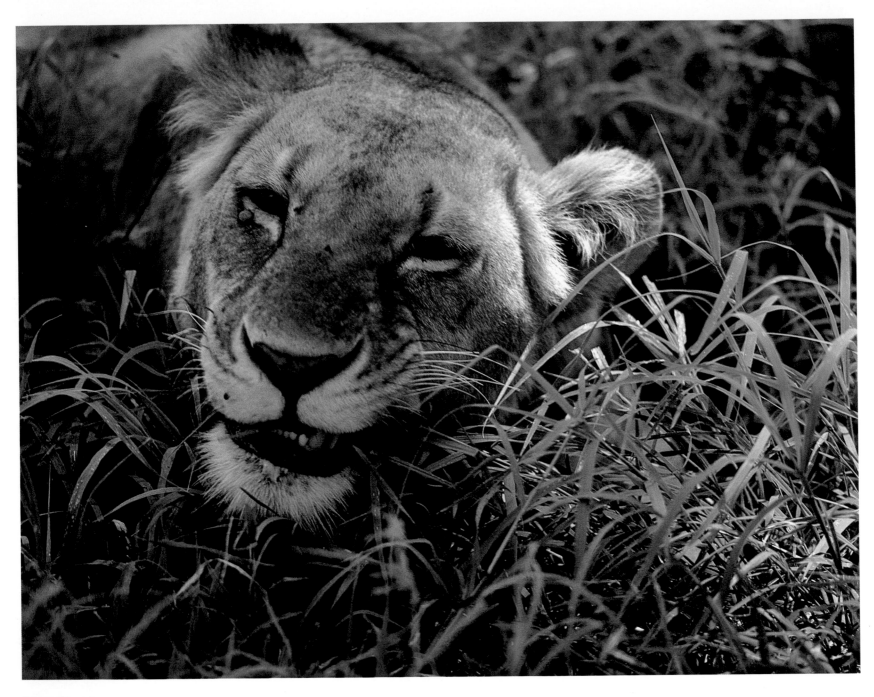

Lions also eat grass.

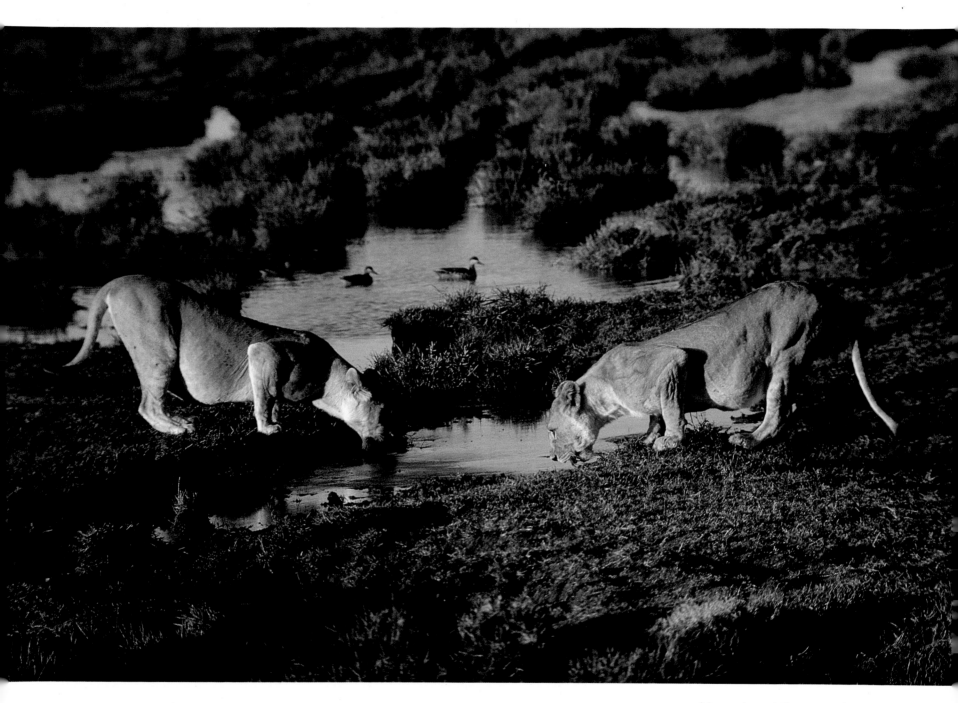

After each meal, lions pause for water.

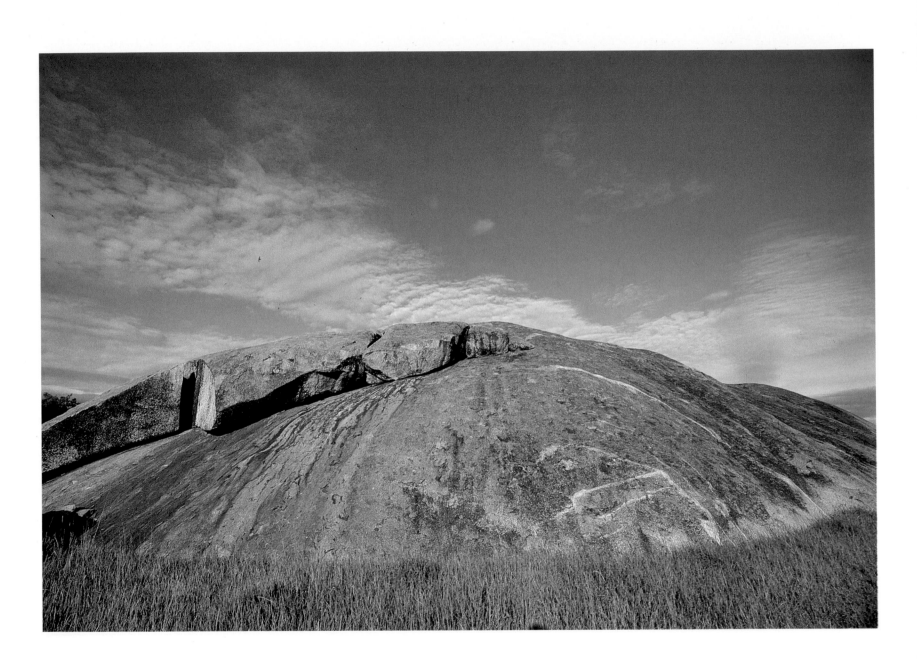

Under white clouds, a grey kopje is bordered in green.

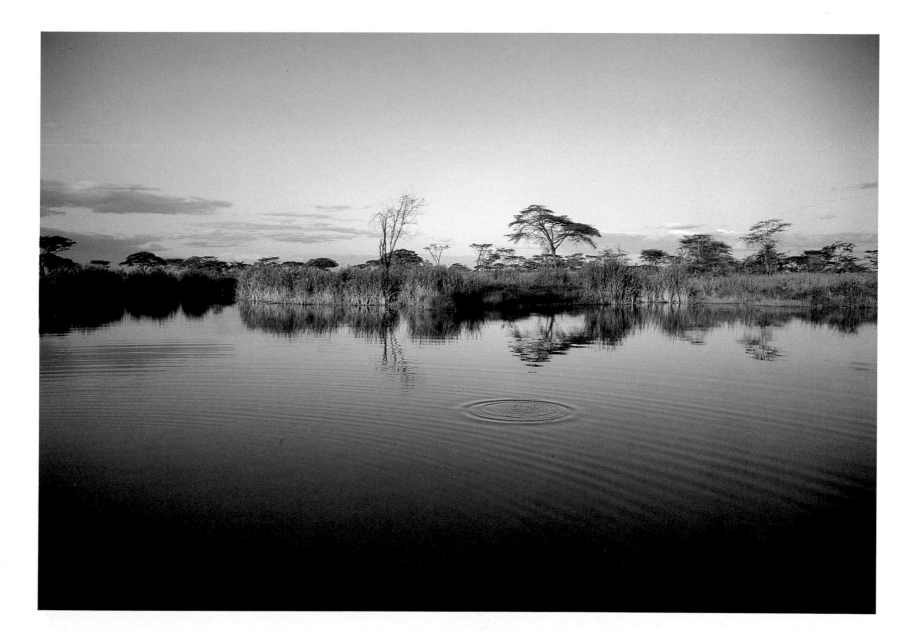

In the evening twilight, a fish feeds on swamp insects.

At sunset, two zebras mate.

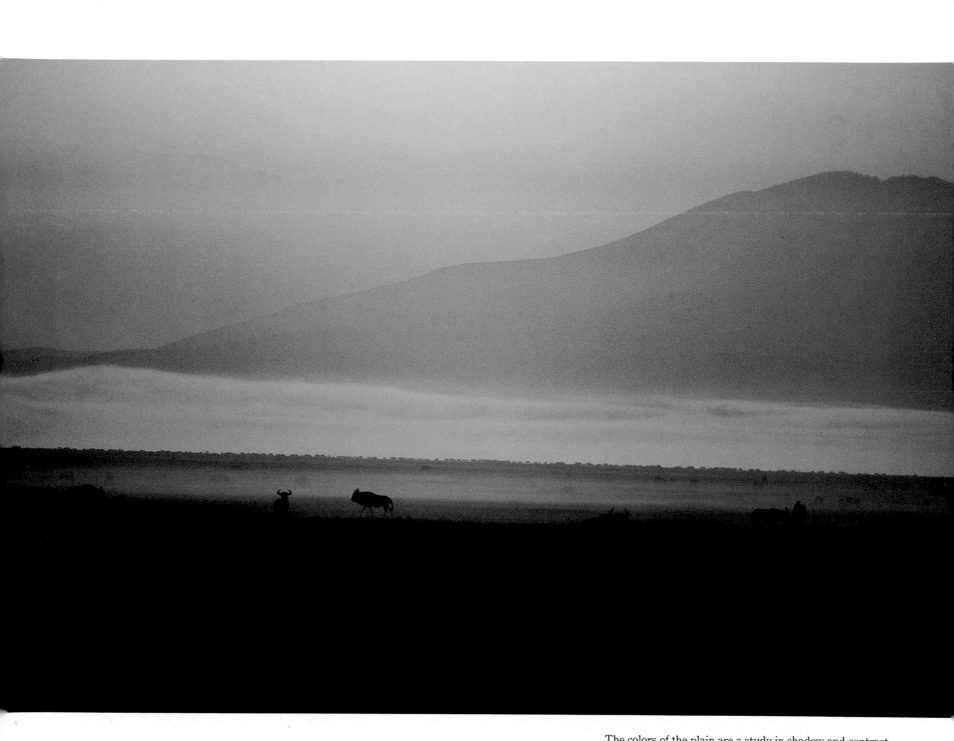

The colors of the plain are a study in shadow and contrast.

153

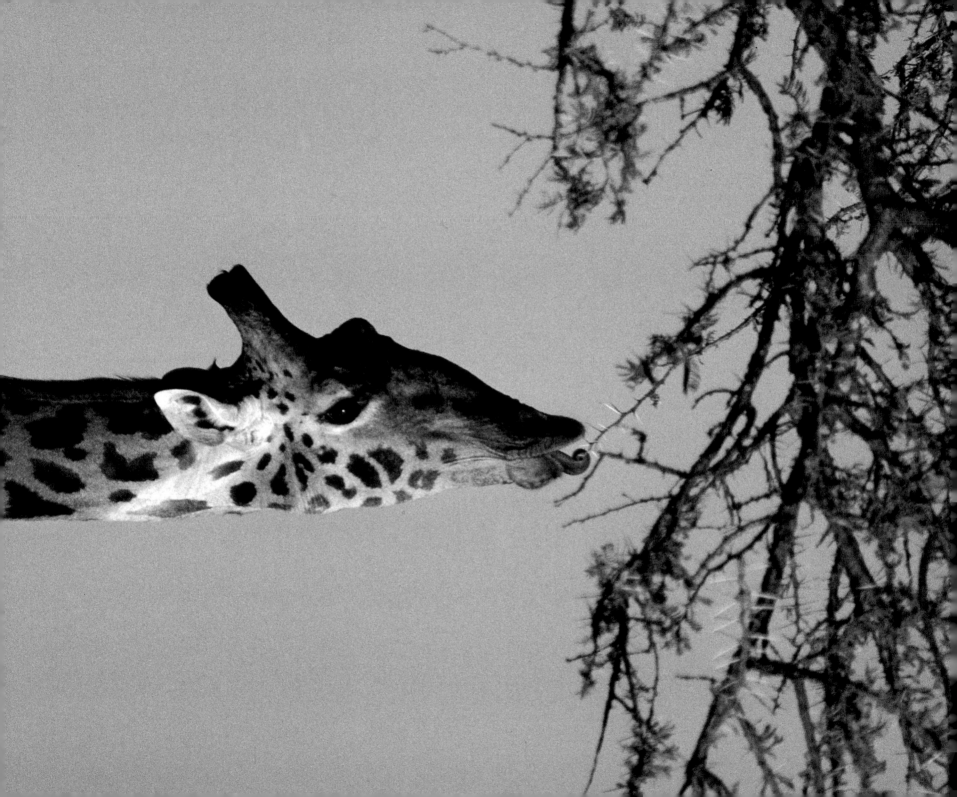

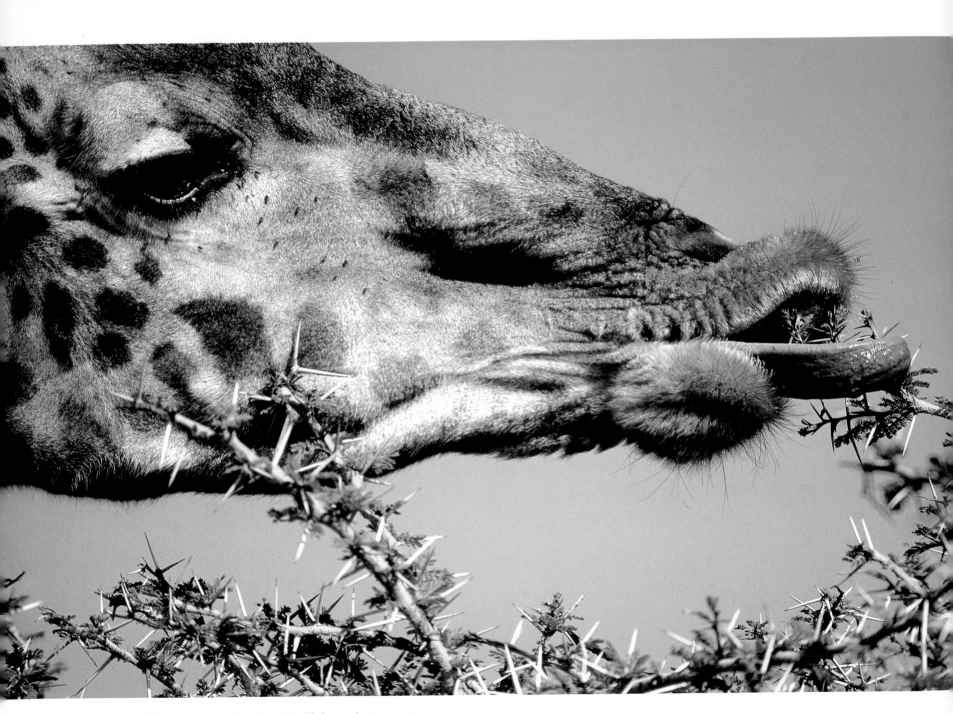

Previous pages: Giraffes are superbly adapted to life in acacia-tree country, feeding easily on the plants other animals cannot reach.

Above: The giraffe's tongue is an ideal tool for browsing on acacia buds.

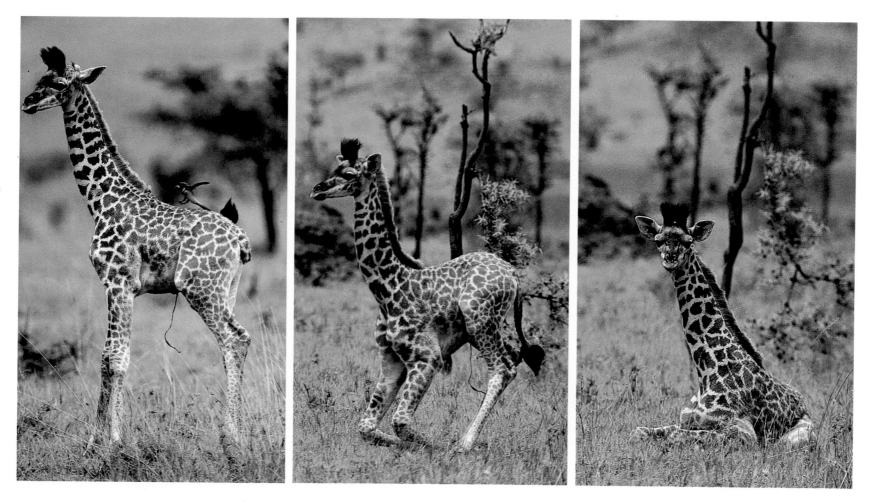

Above: Life can be tiring for a young giraffe.

Following pages: Giraffe calves do not long remain dependent upon their mothers.

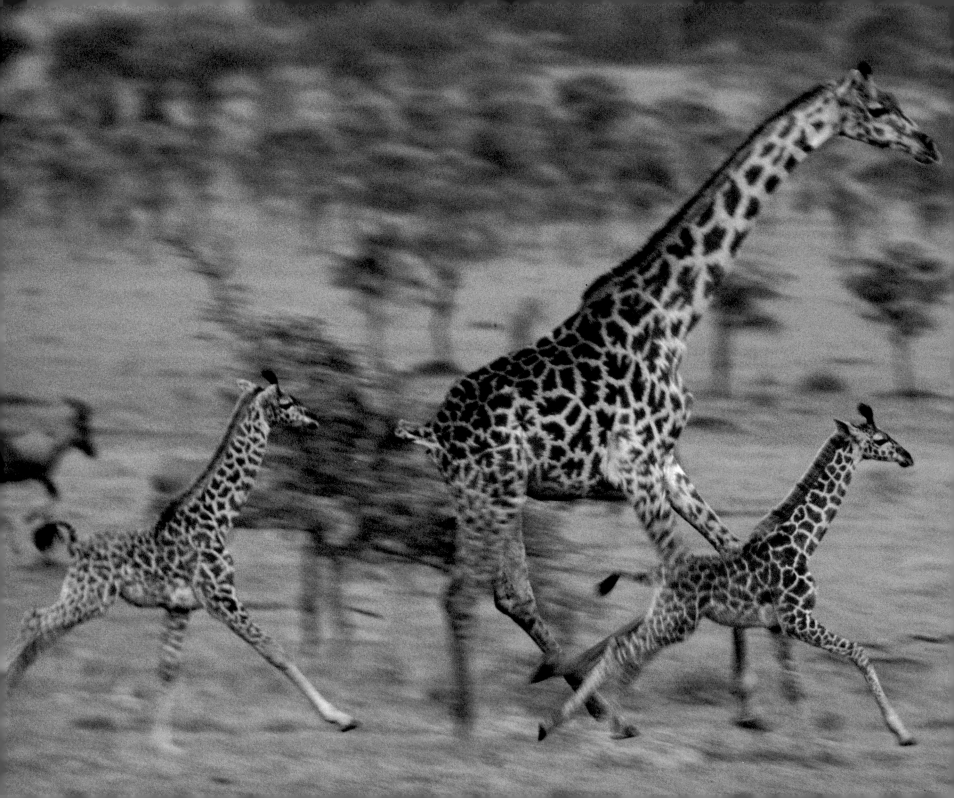

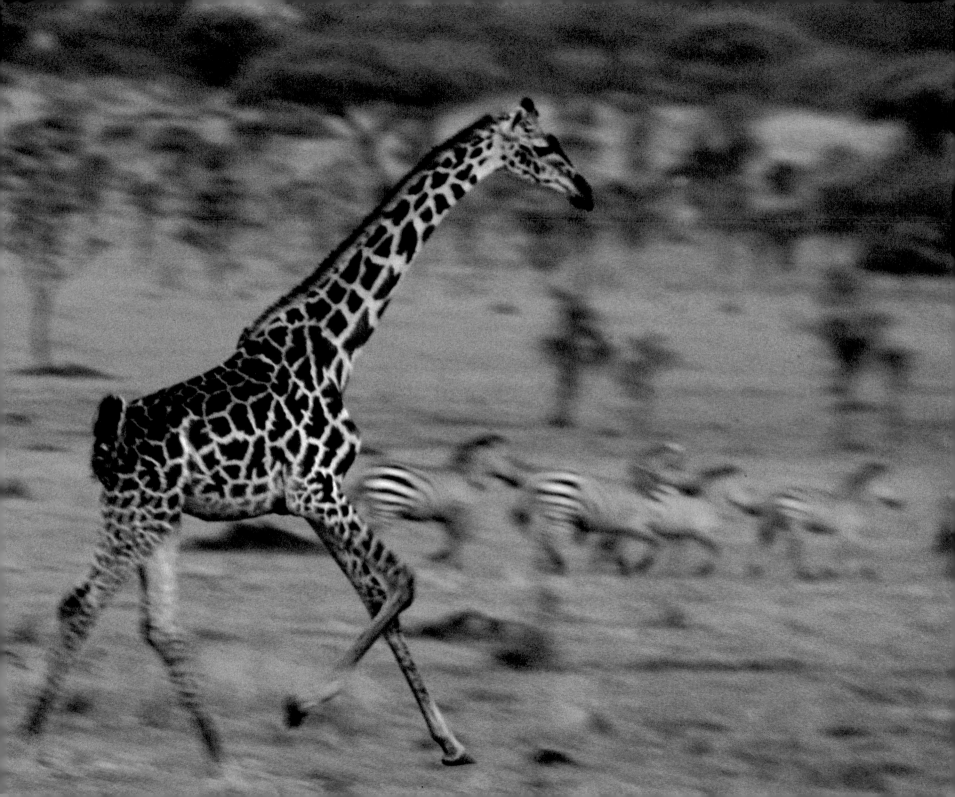

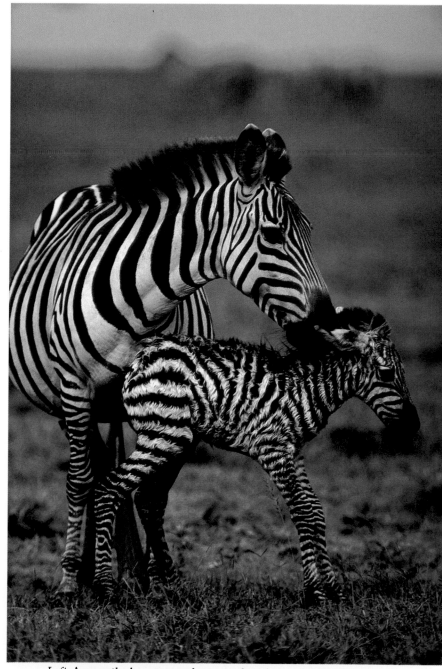

Left: Among the browsers and grazers there is an easy familiarity.

Above: The stripes of a young zebra are not so boldly colored as an adult's.

161

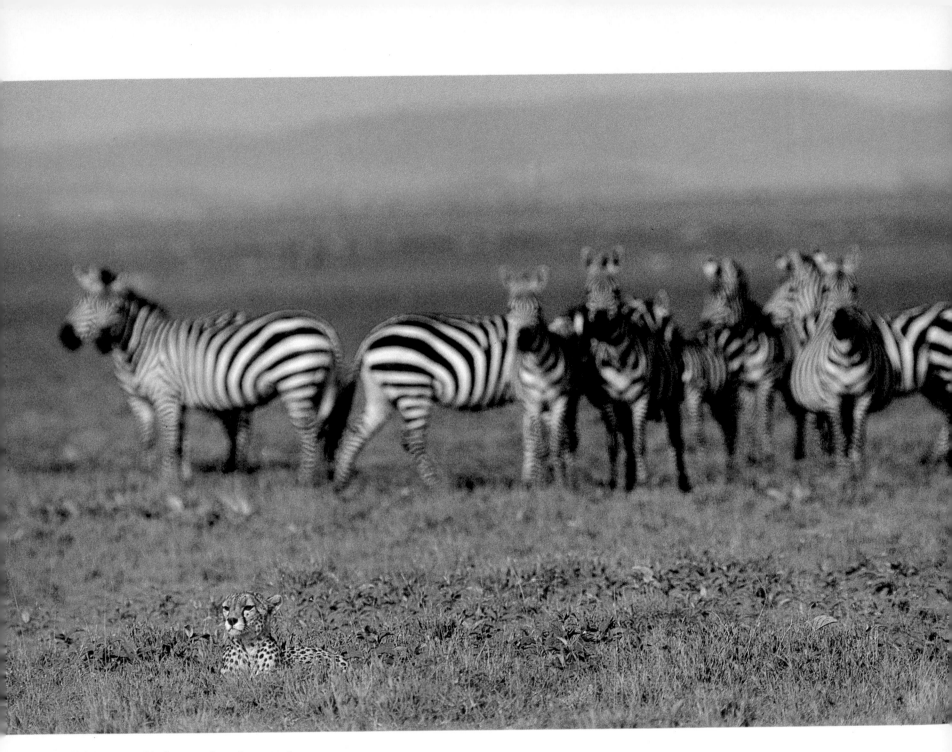

Zebras are too big for most cheetahs to attack.

A Kori bustard marks its territory by proudly holding its tail high.

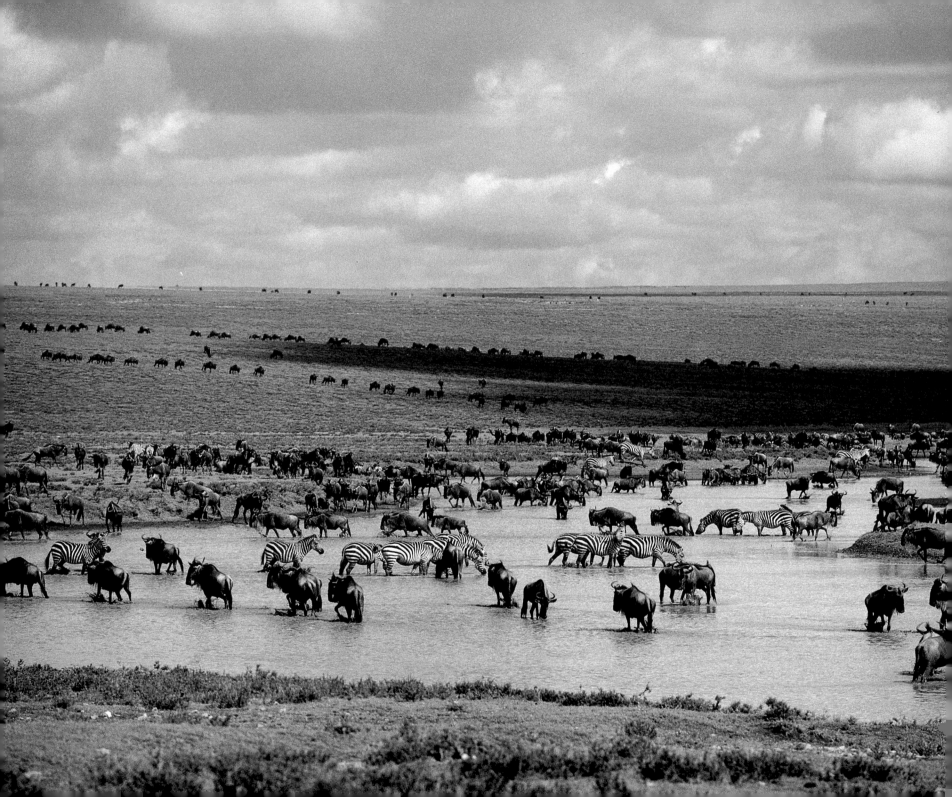

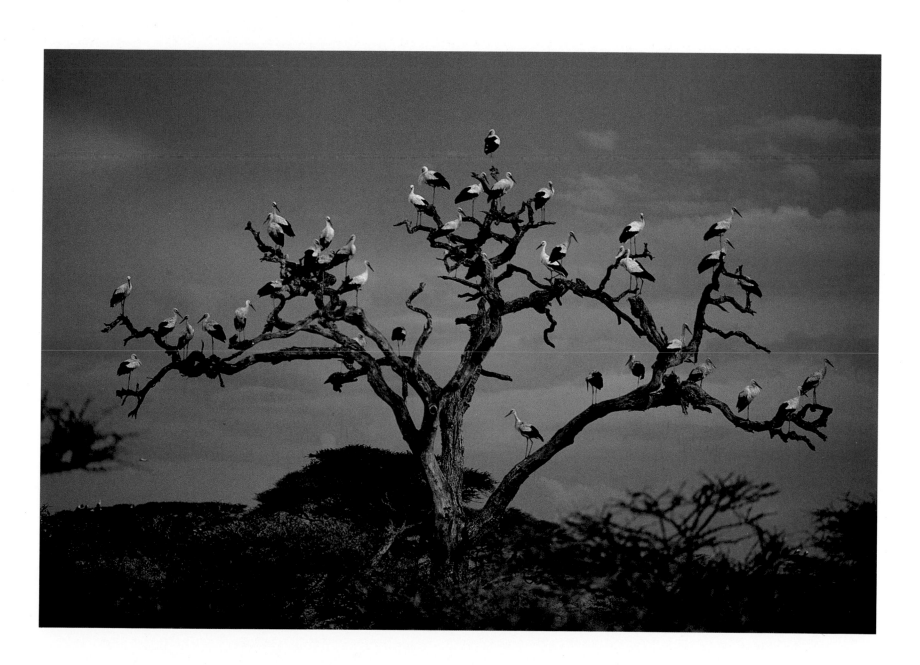

Left: The zebras' coloring makes them highly visible during the day.

Above: Storks gather in a tree.

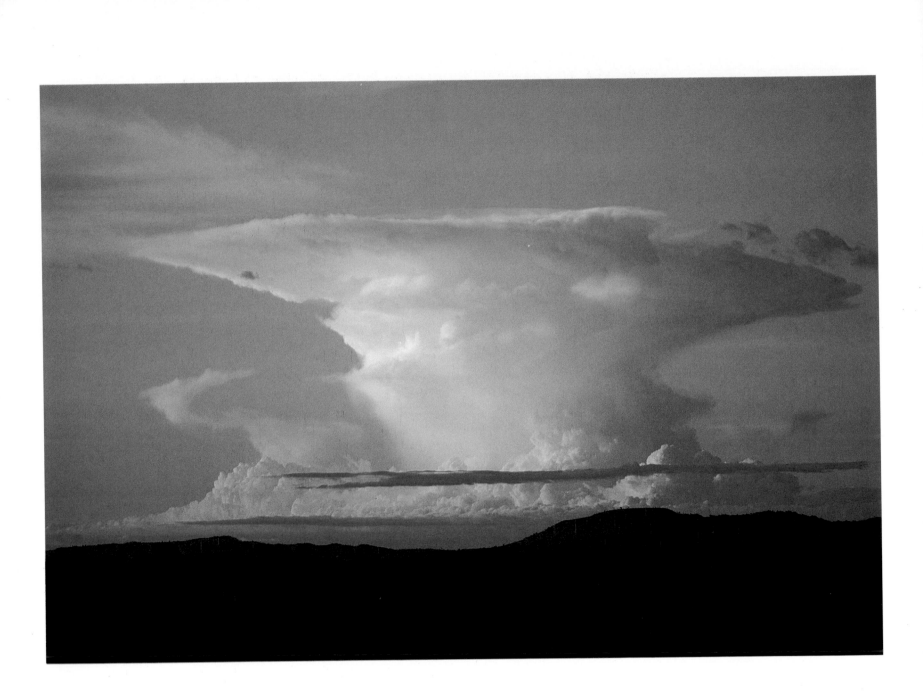

Above: As the day ends, creatures of the night begin to stir.

Right: Lions set out for an evening hunt.

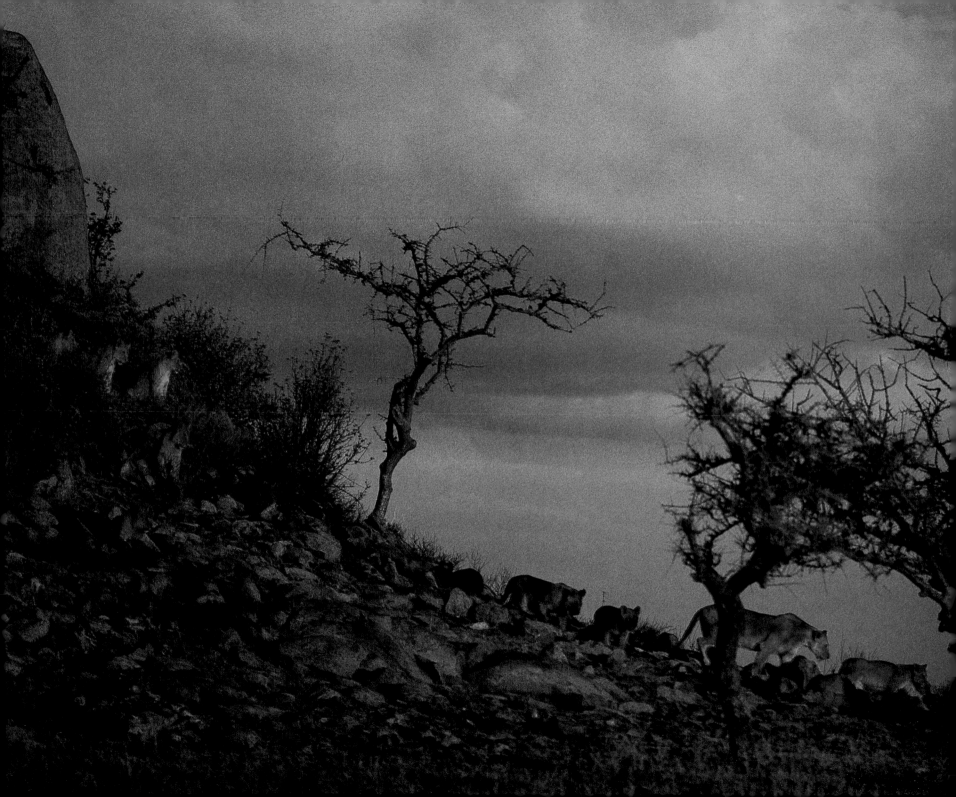

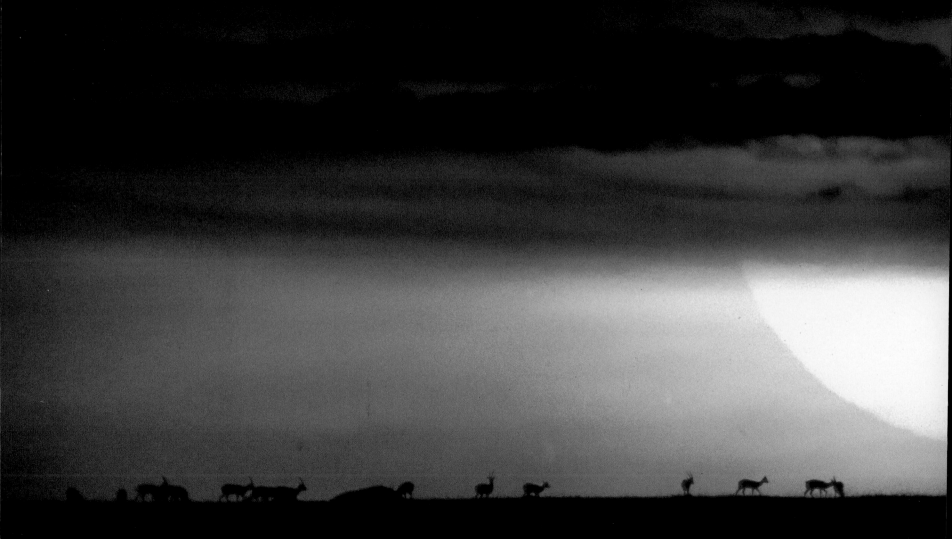

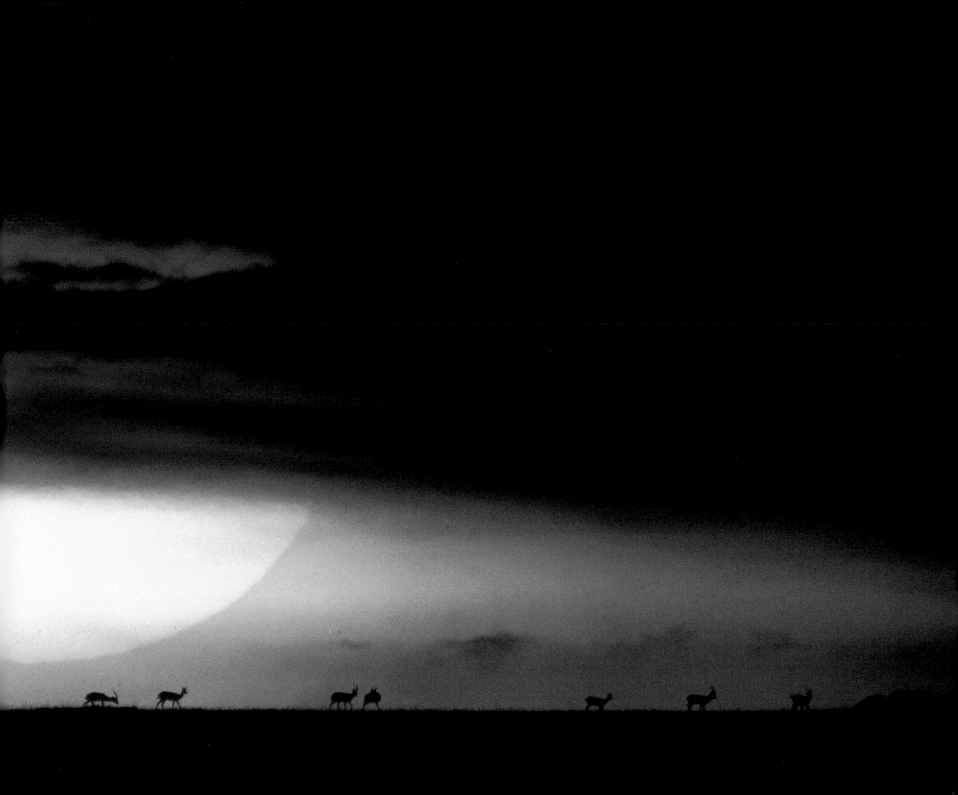

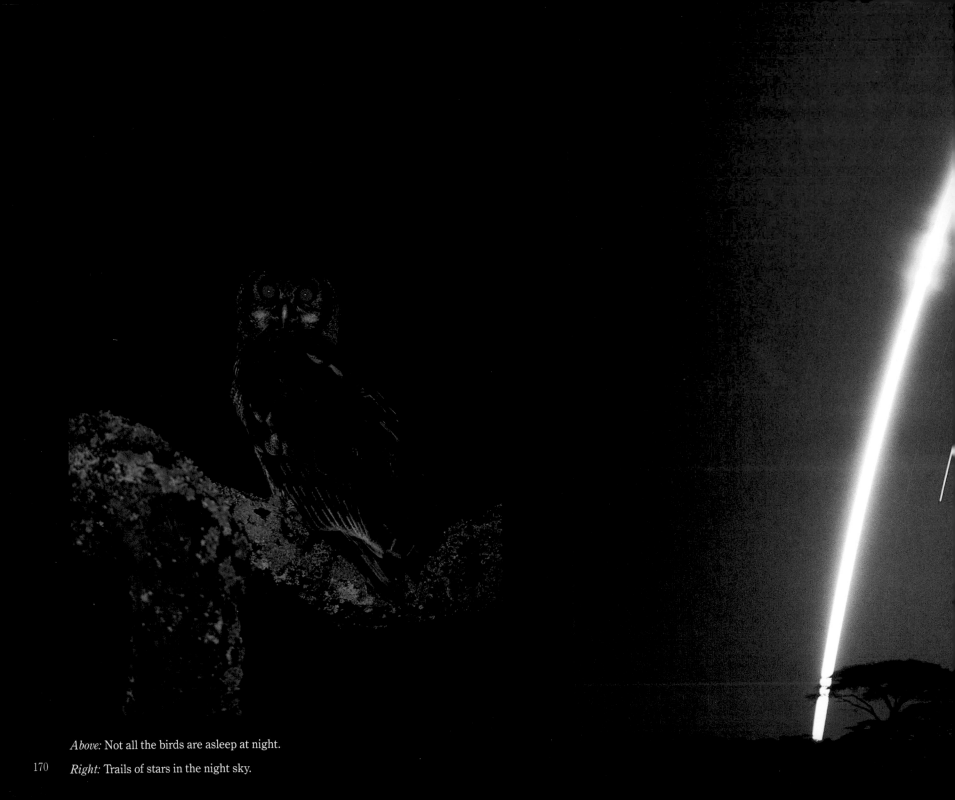

Above: Not all the birds are asleep at night.

Right: Trails of stars in the night sky.

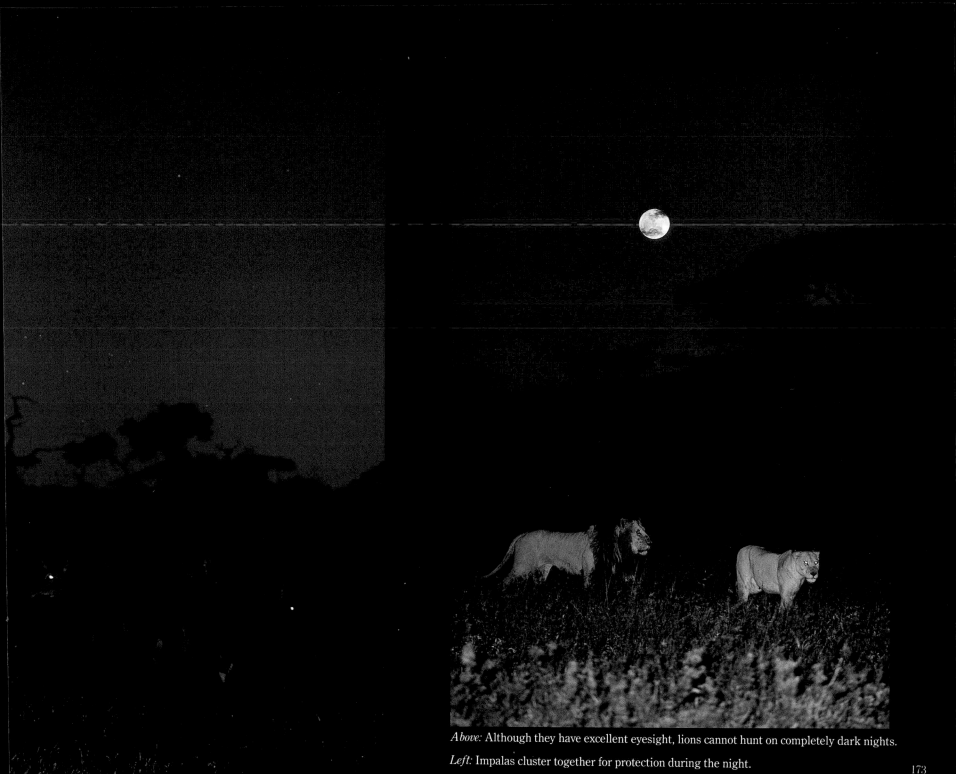

Above: Although they have excellent eyesight, lions cannot hunt on completely dark nights.

Left: Impalas cluster together for protection during the night.

173

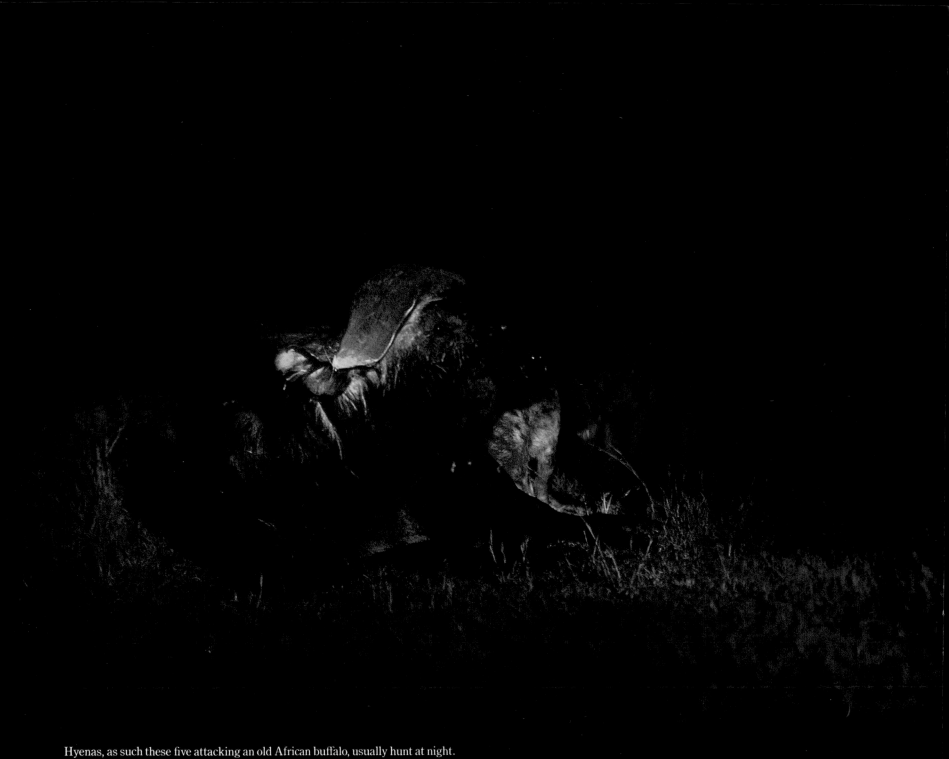

Hyenas, as such these five attacking an old African buffalo, usually hunt at night.

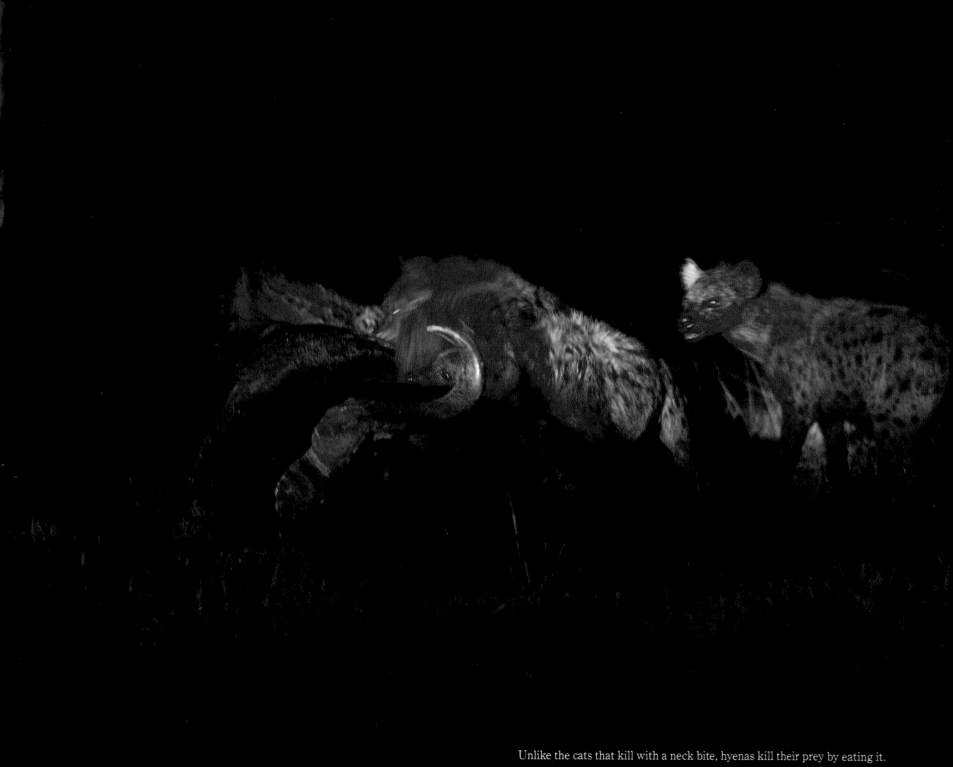

Unlike the cats that kill with a neck bite, hyenas kill their prey by eating it.

Above: A spring hare.

Left: Many animals are restless in the darkness.

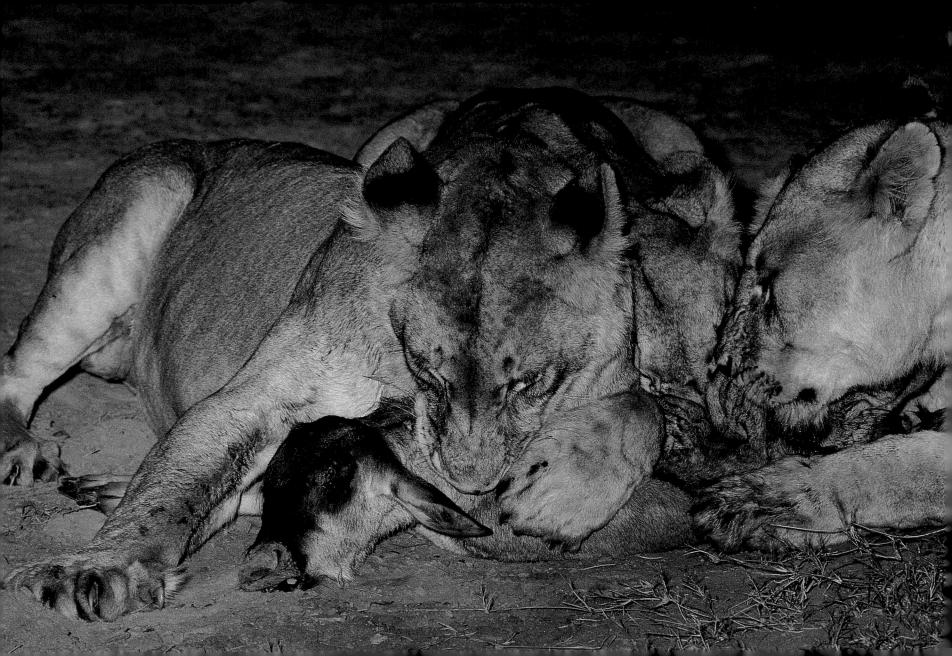

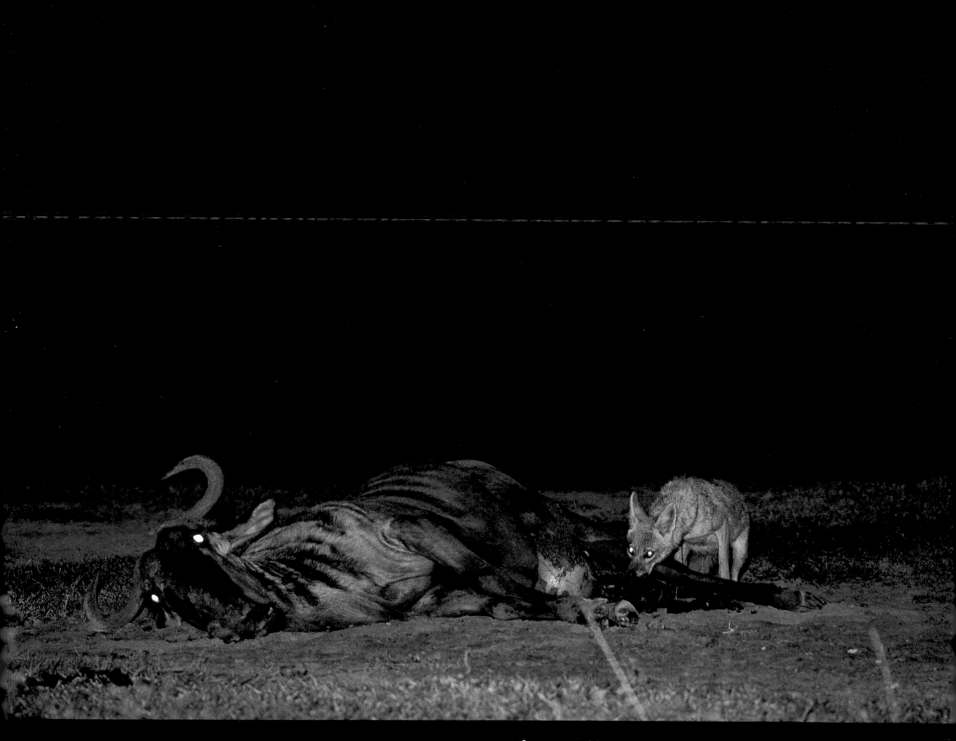

In common with other predators, jackals will steal prey if given the chance.

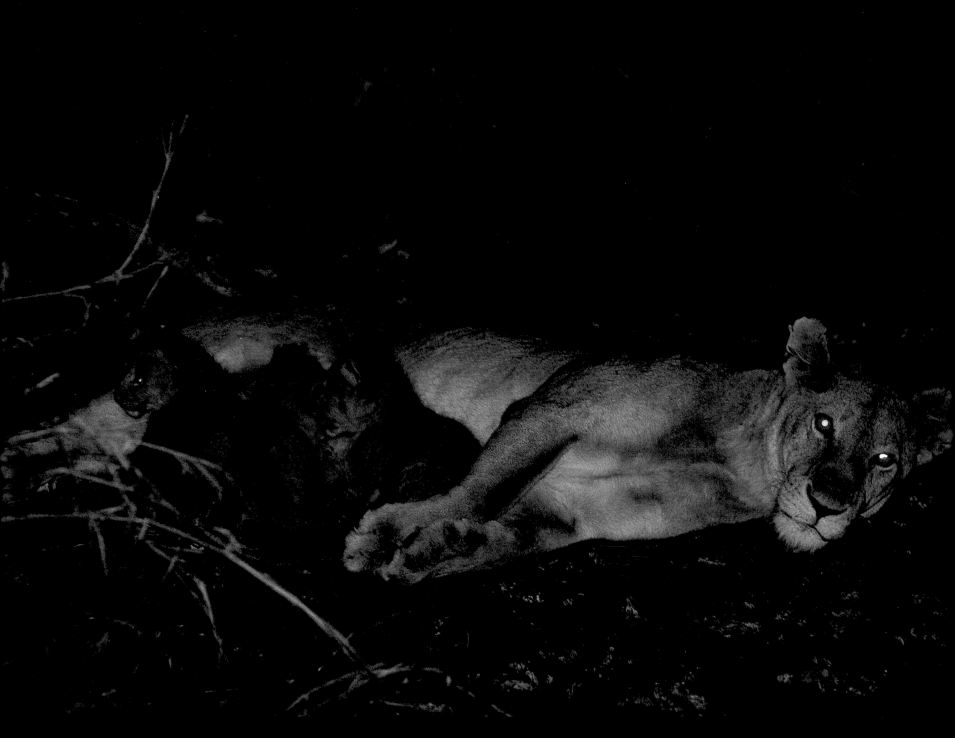

A lioness shelters her young during a pause in the hunt.

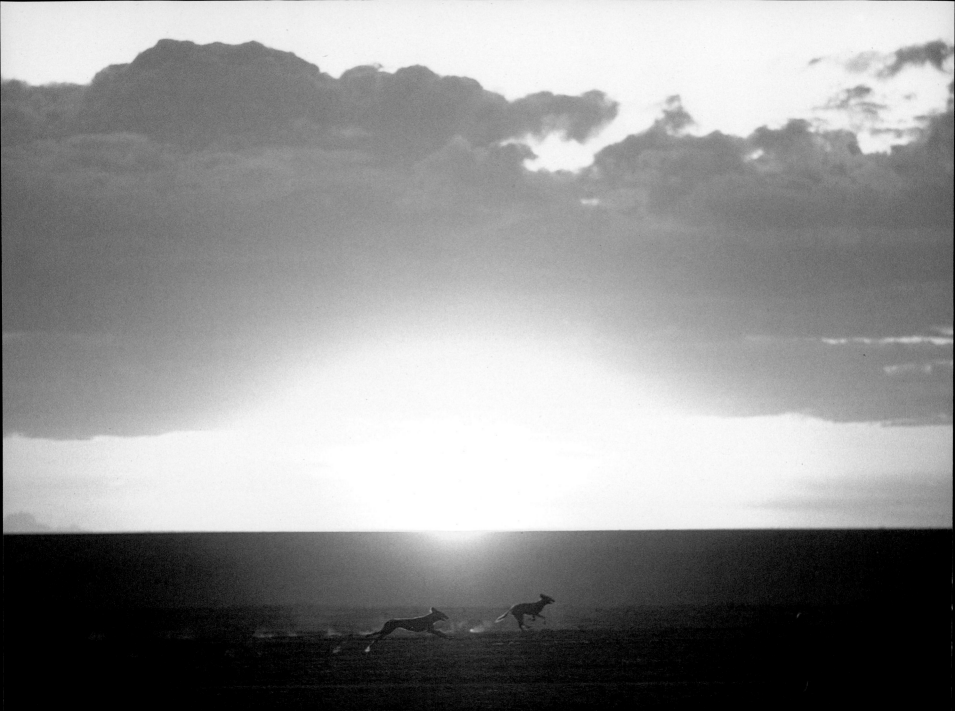

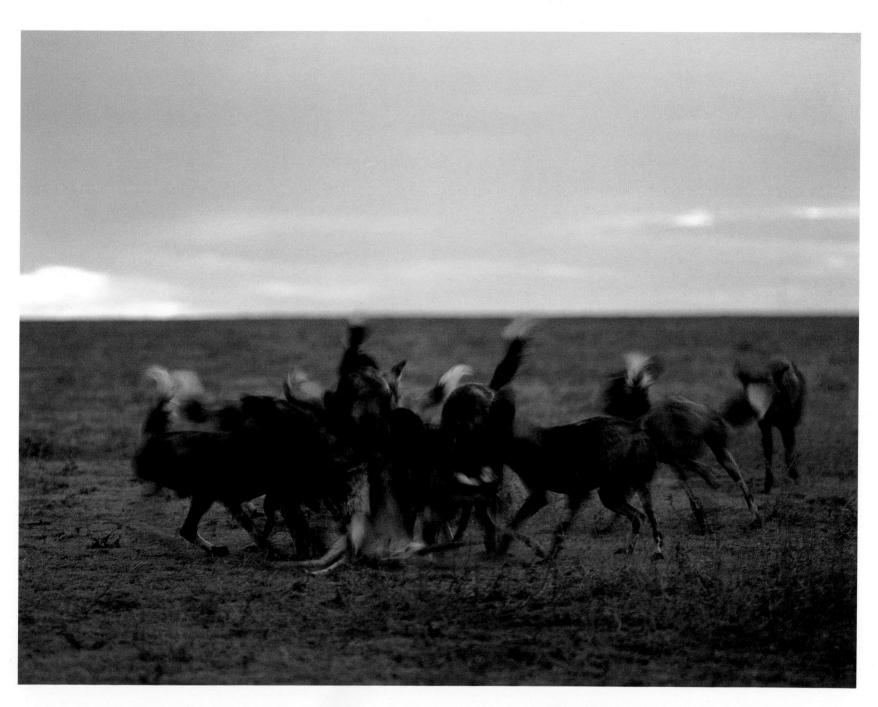

Left: In the cold dawn, wild dogs lope across the plain.

Above: These dogs took six Thomson's gazelles within an hour.

183

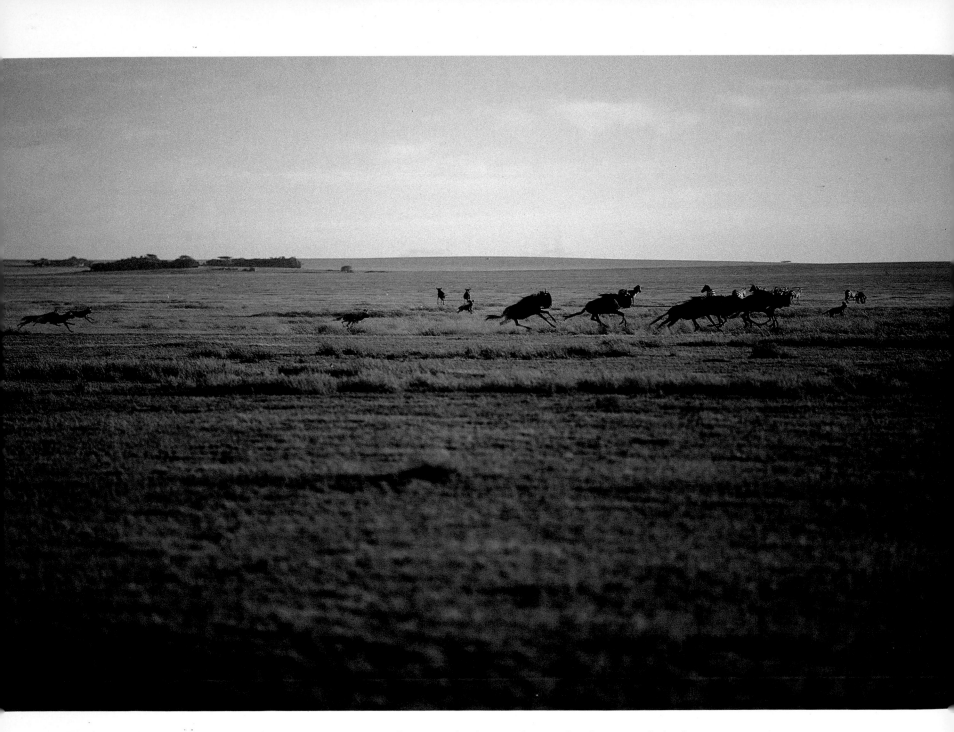

Capable of sprints to 30 miles per hour, the dogs can also run long distances and so have good success hunting among the herds.

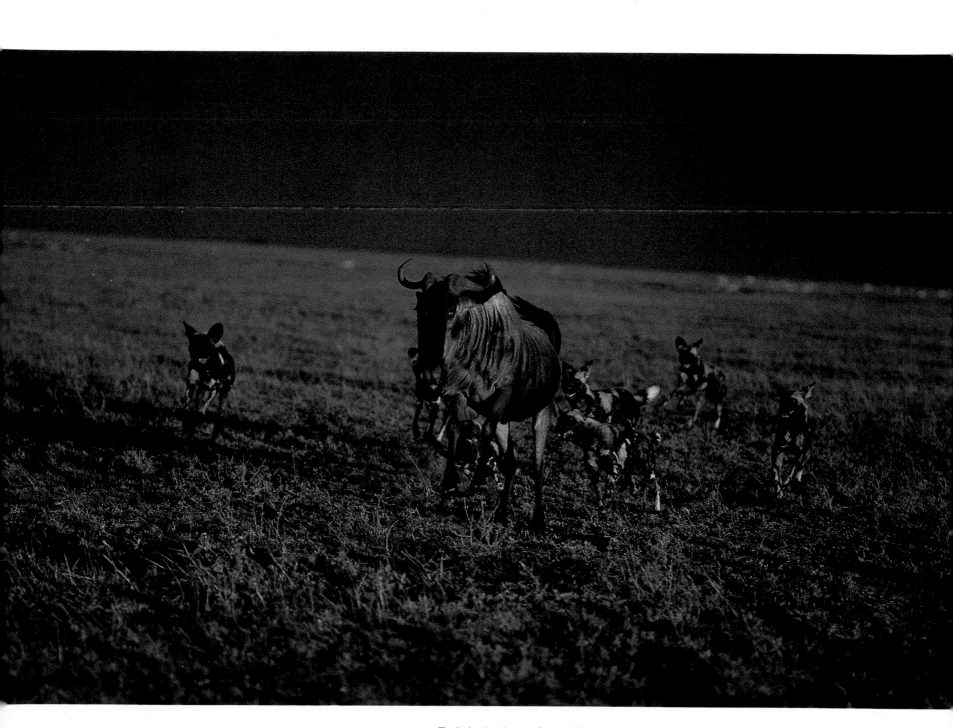

Early in the chase, the pack has selected a target, and one dog bites at the groin of the prey.

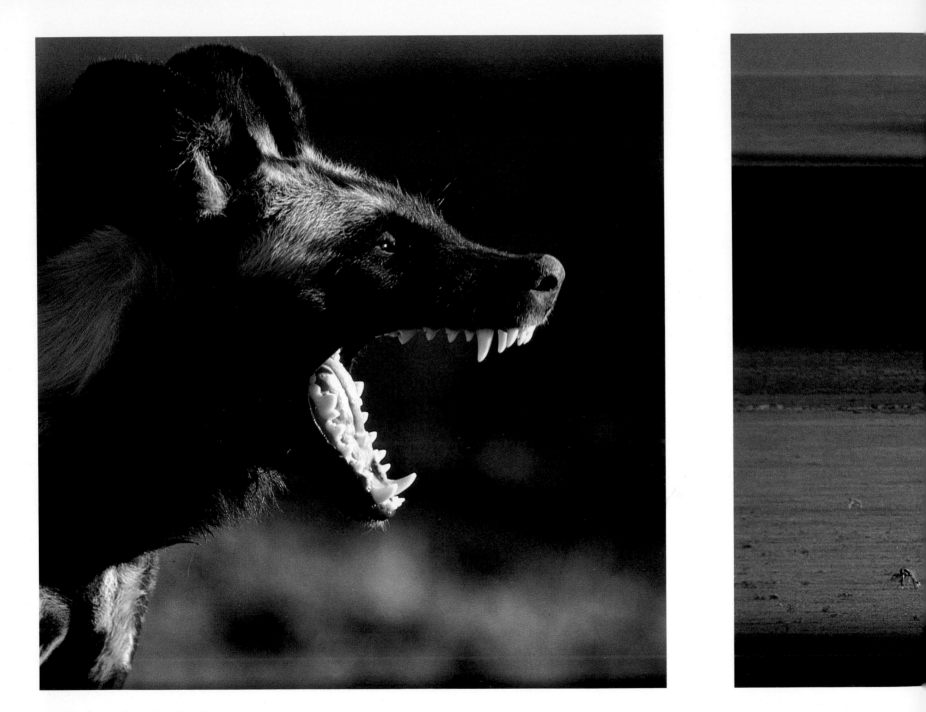

Wild dogs are well-equipped predators.

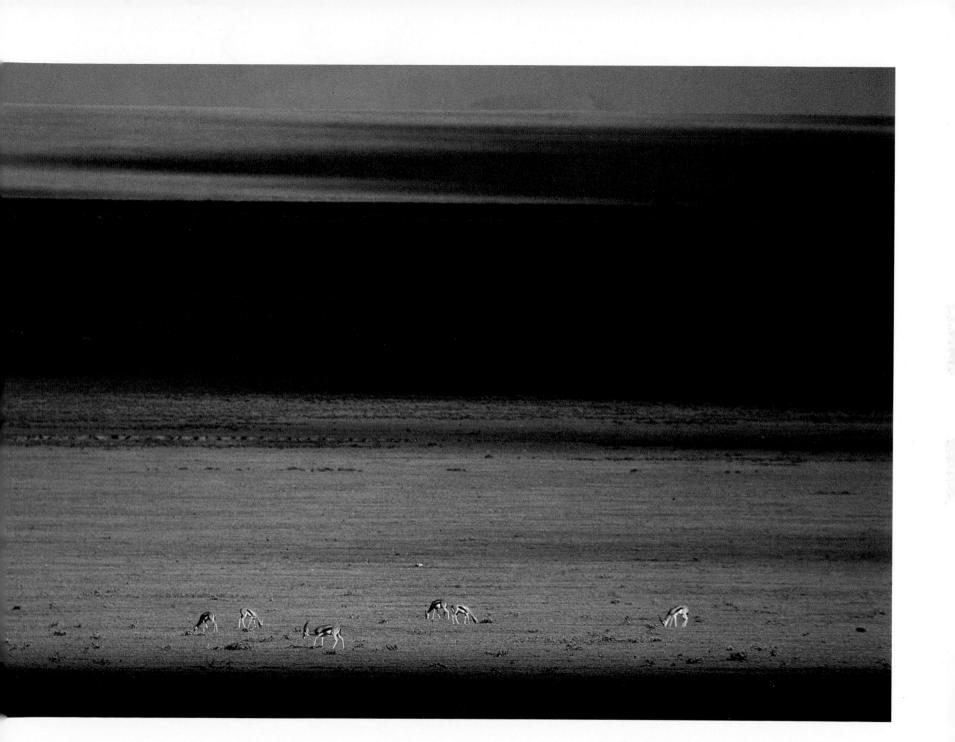

A drifting cloud casts deep, somber shadows over the plain.

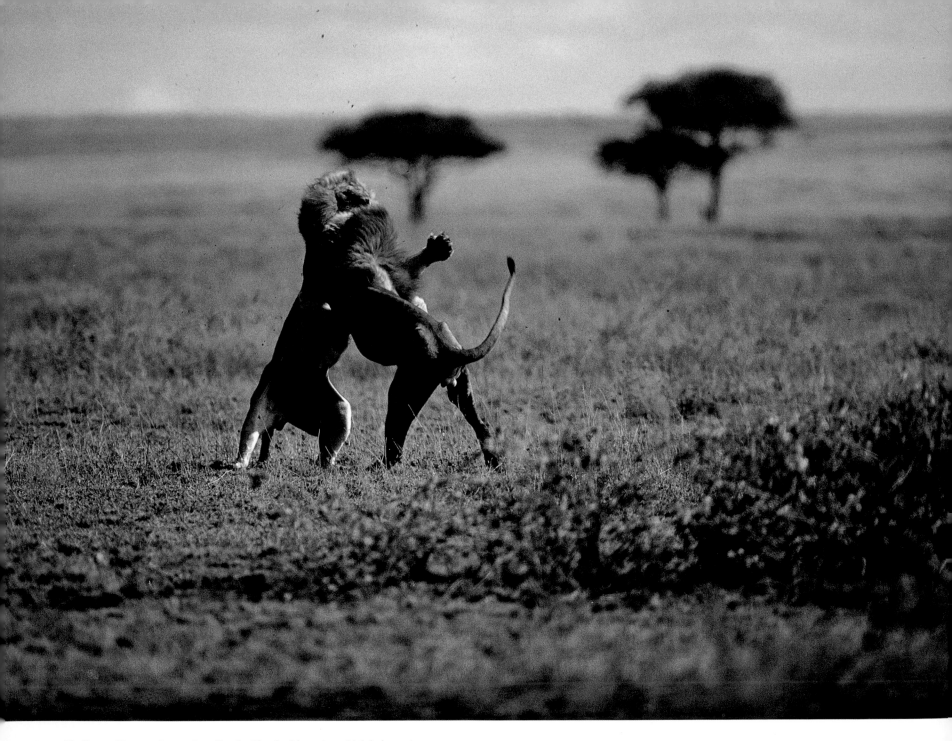

Challenged by another male, a lion battles for his mate, which is in oestrus.

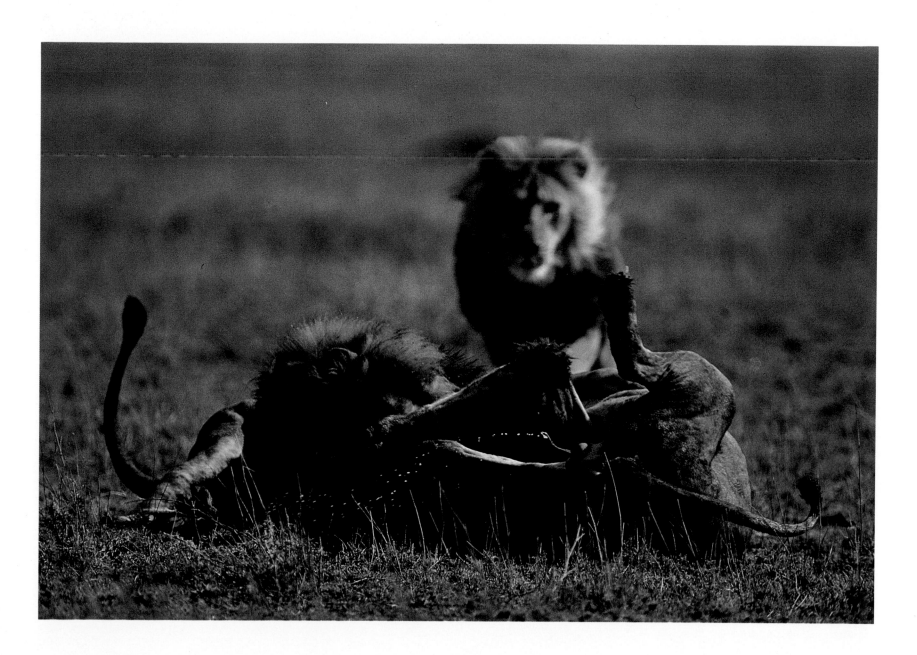

As the two fight, a third male, attracted by the female, appears and attacks the first challenger.

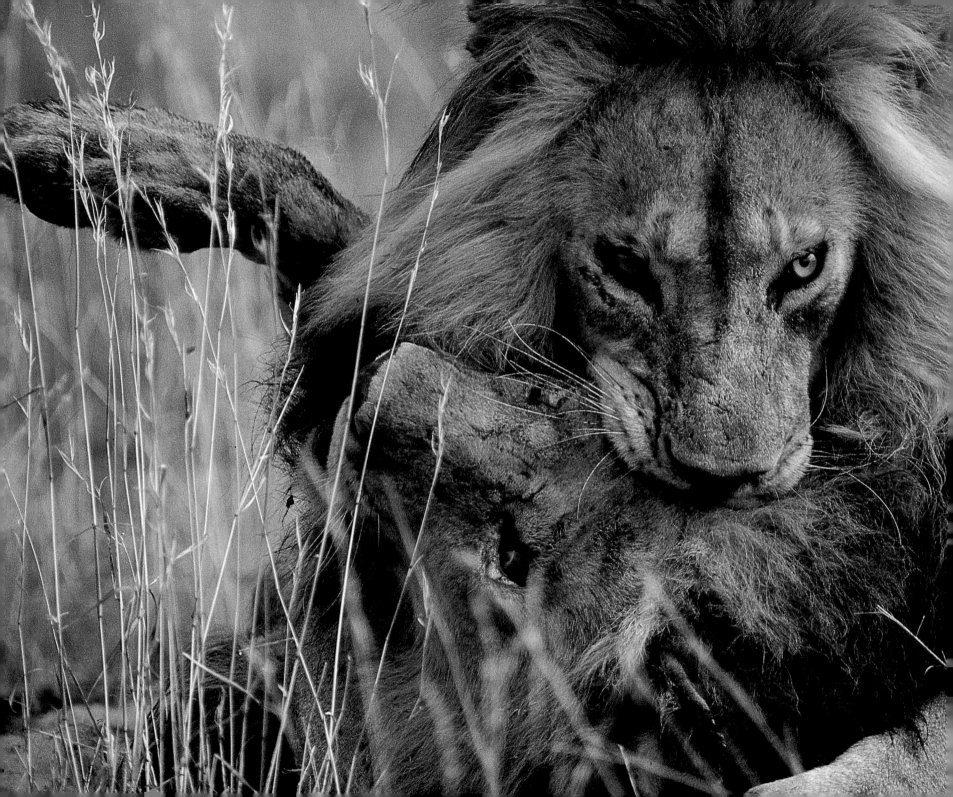

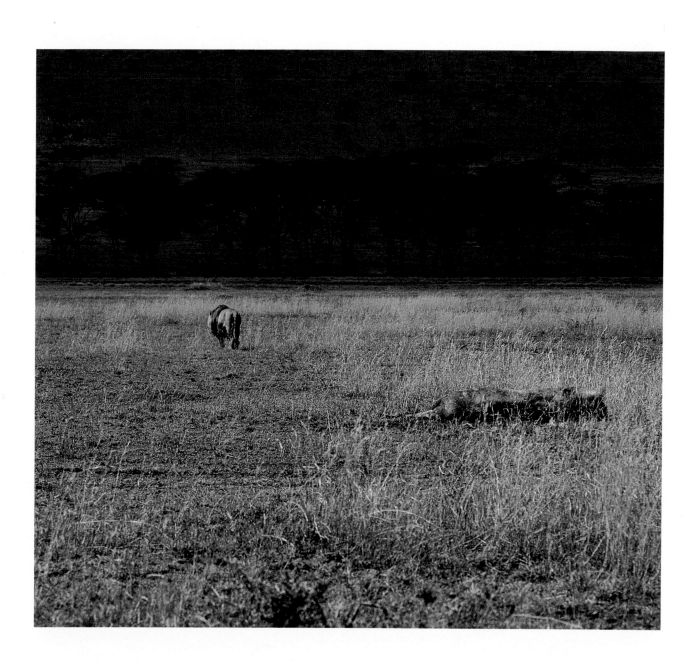

Left: The third male bites the skull of the challenger.

Above: The vanquished lion lies on the field of battle; the victorious males were undoubtedly of the same pride.

191

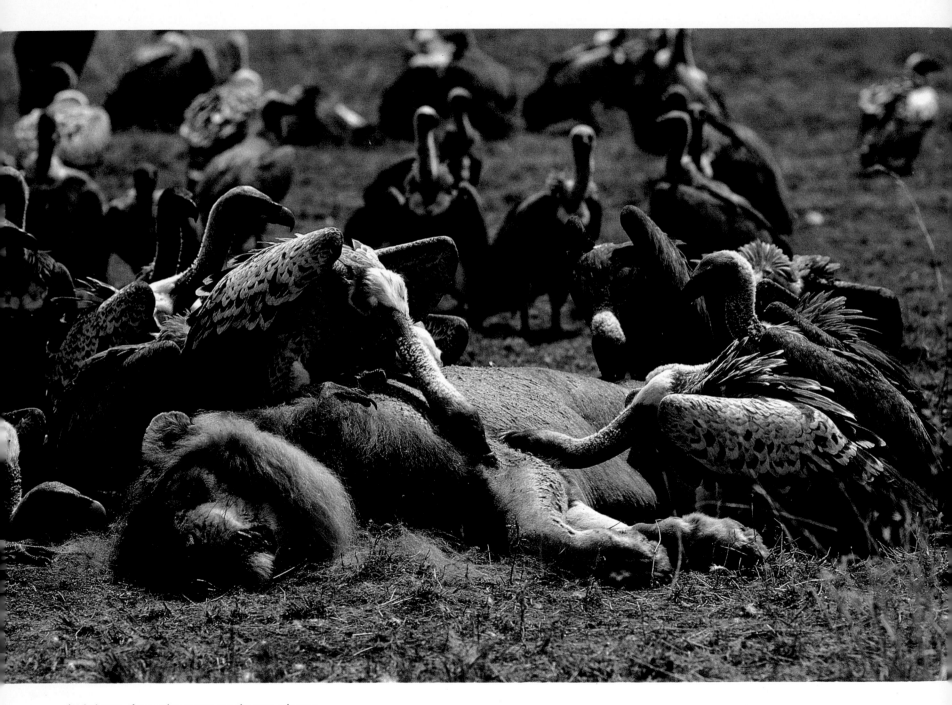

And always, the carrion eaters are the true winners.

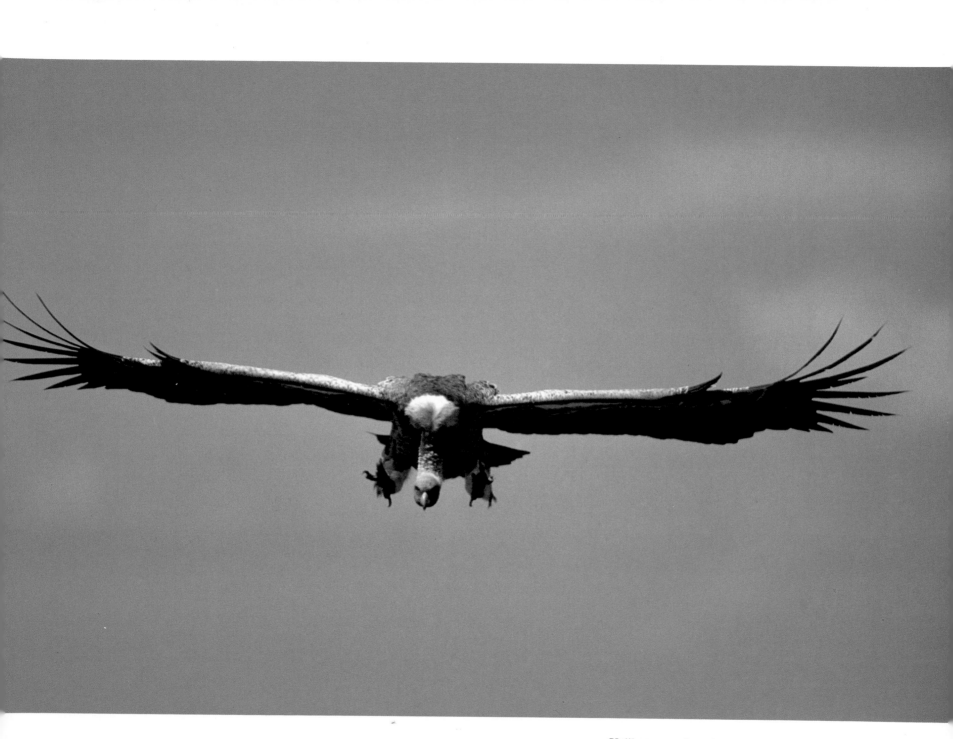

Unlike mammals, vultures survive on scavenging alone.

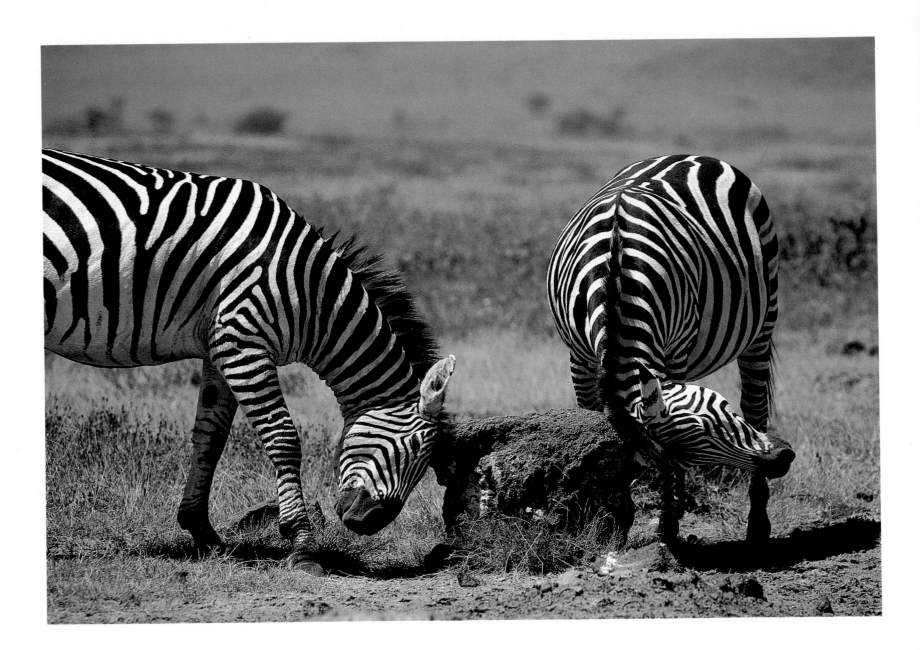

Zebras seek relief from the incessant torment of insects.

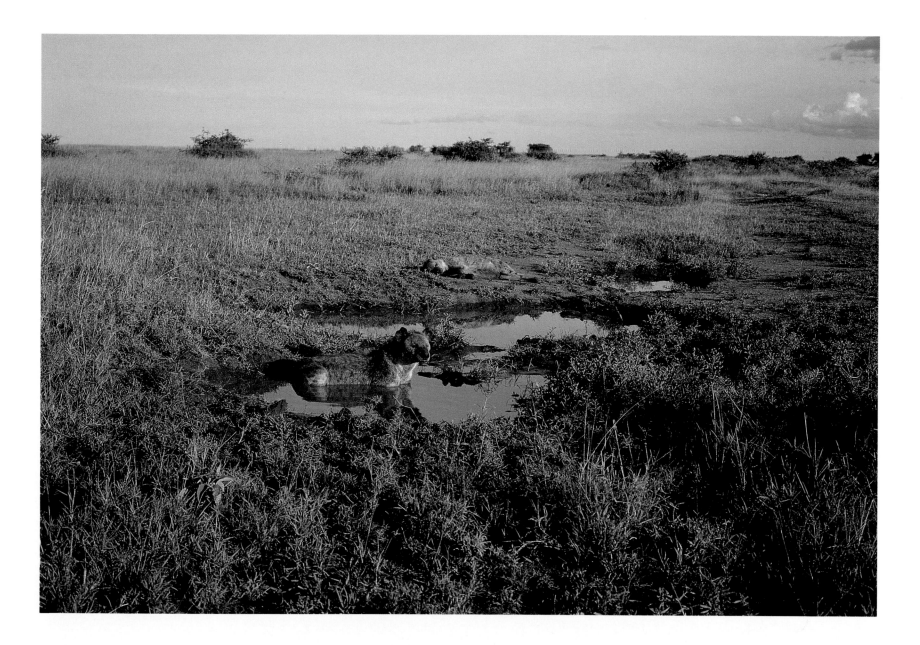

The heat on the Serengeti can be fatiguing, especially at midday.

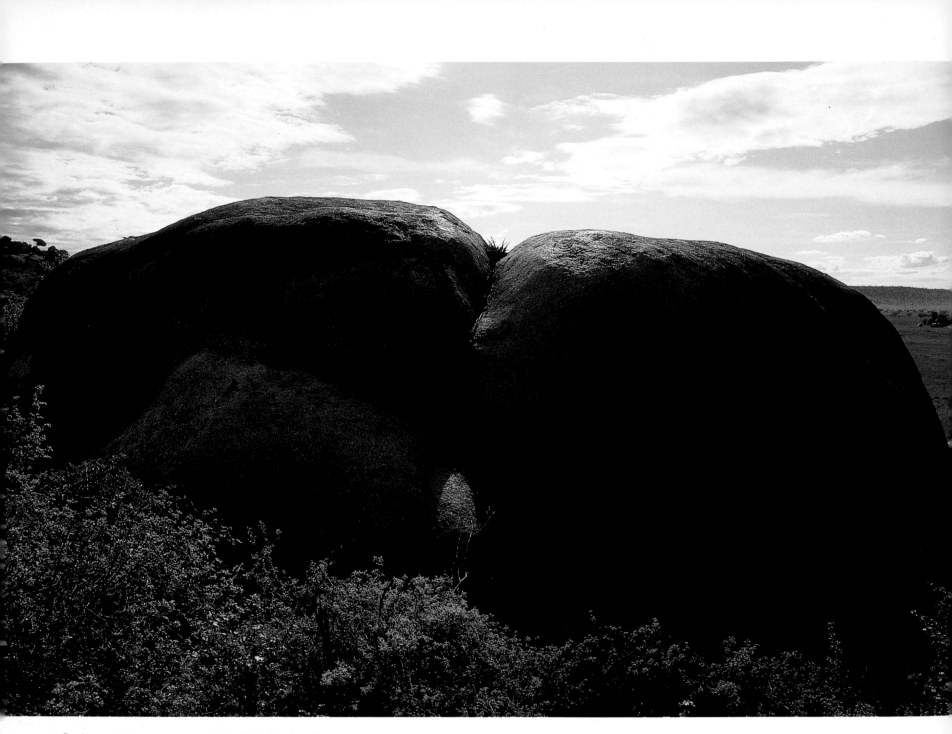

Lush vegetation grows around a kopje during the rainy season.

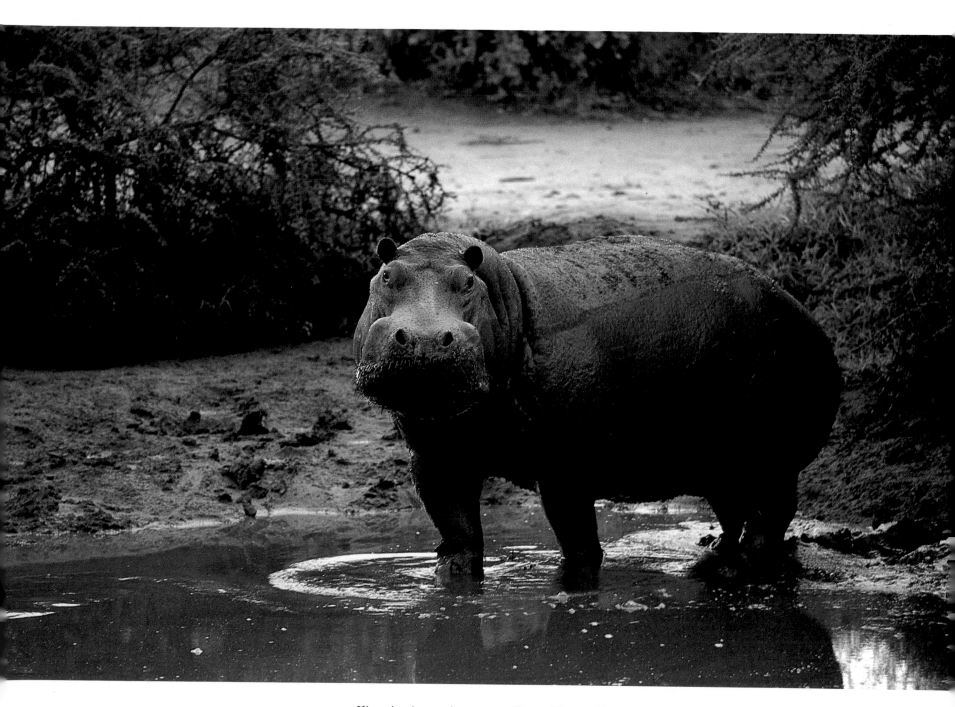

Hippos' main enemies are crocodiles and lions, although usually these predators will attack only the young.

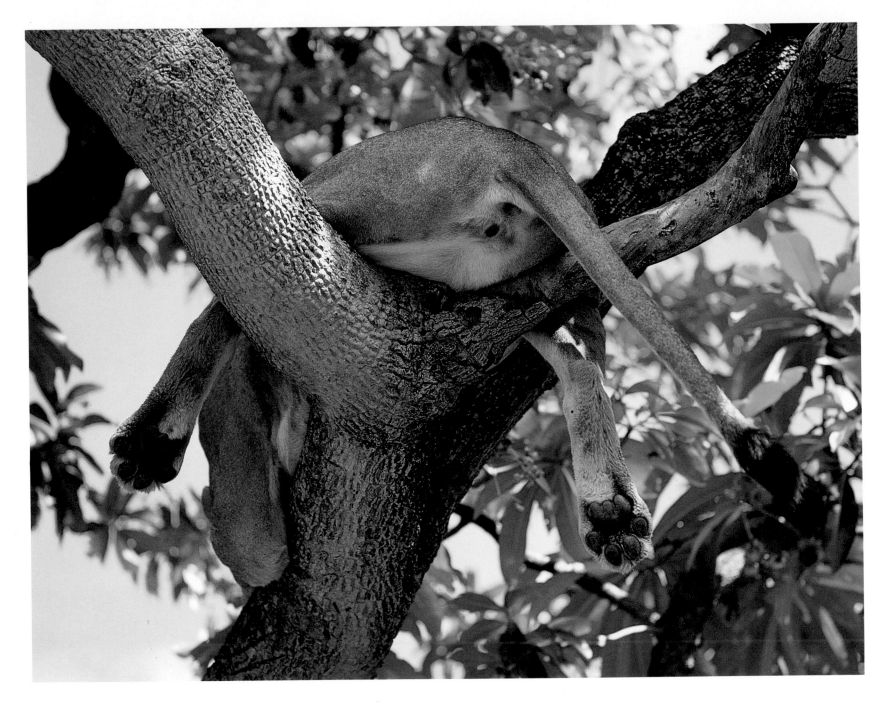

Above: Like their housecat cousins, lions spend much of their time resting.

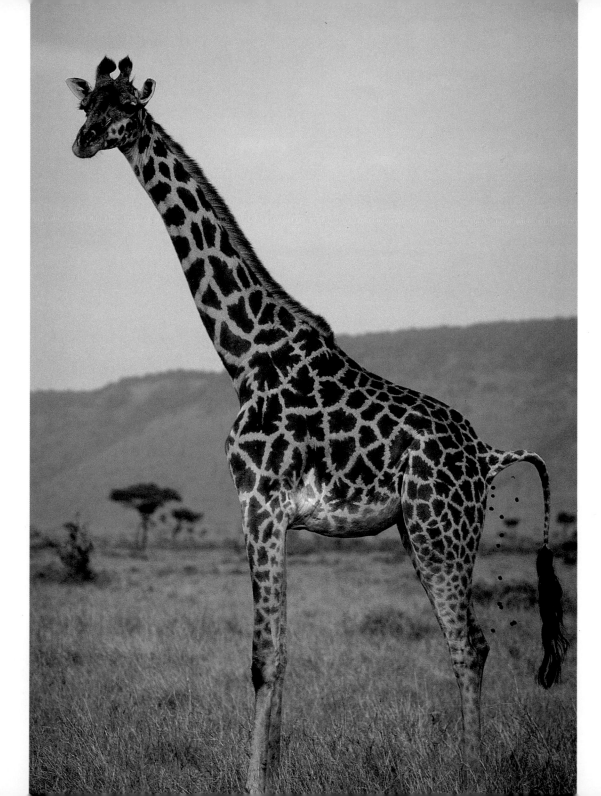

Because bending down is
extremely difficult for them,
giraffes pass most of their
lives standing.

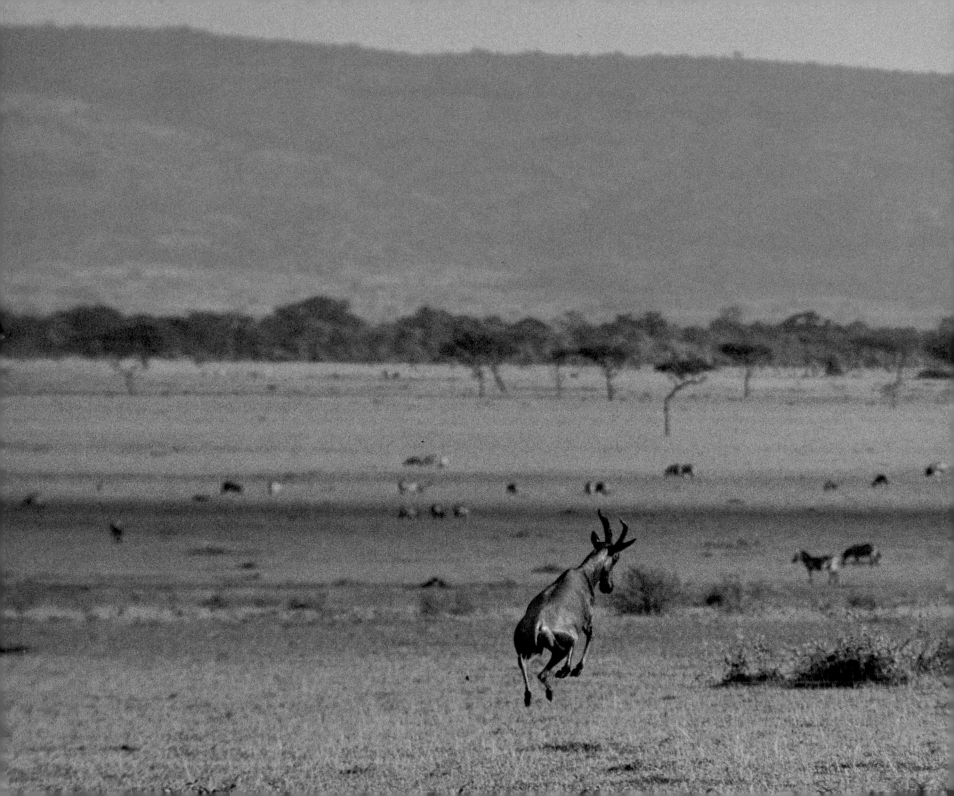

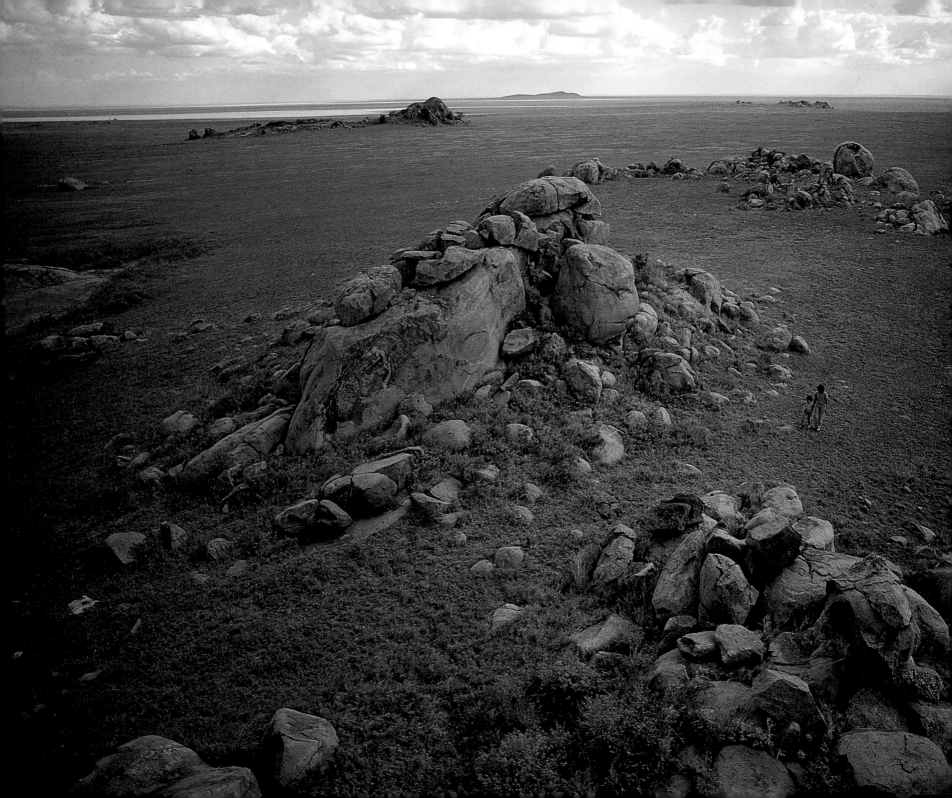

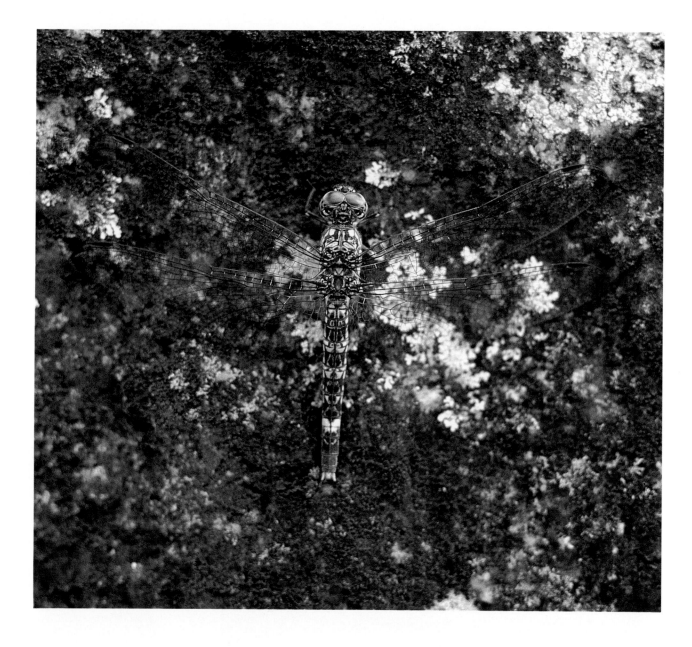

Left: These clusters of kopjes teem with concealed life.

Above: Insects provide fleeting beauty.

203

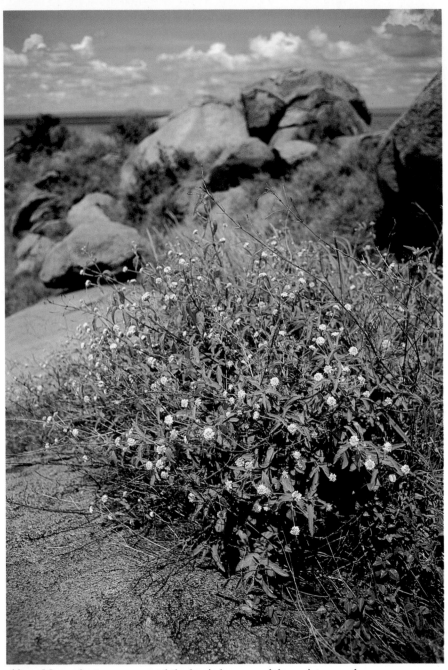

Above: Many plants grow around the kopje because of the moist ground.

Right: Lions find dens and points of vantage among the rocks.

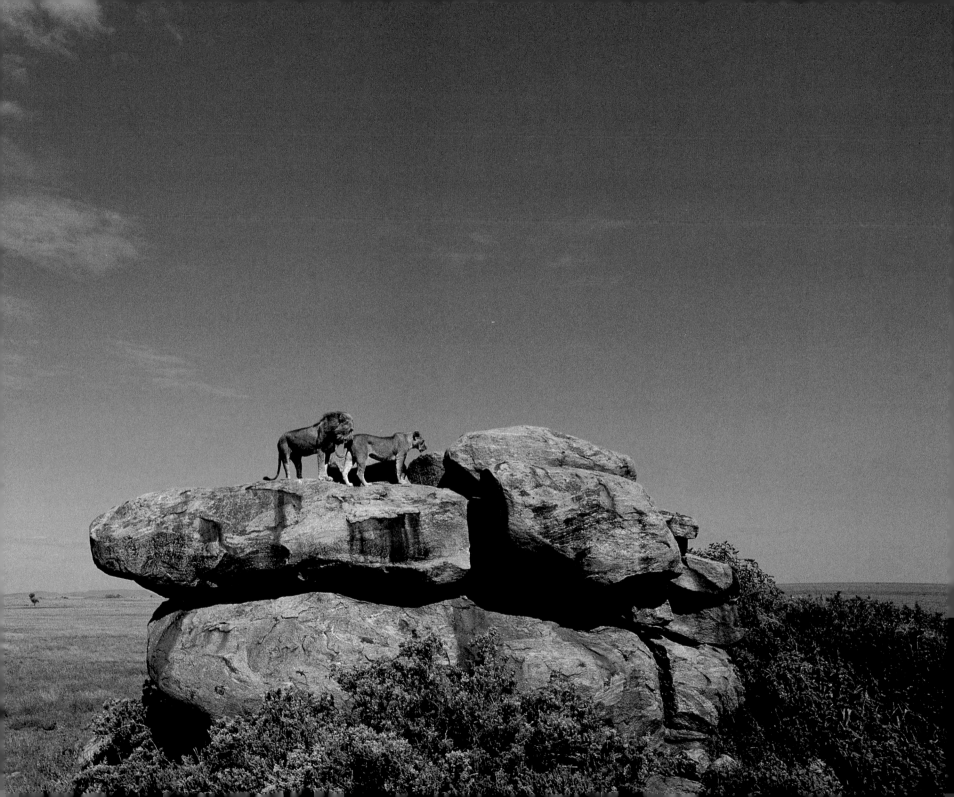

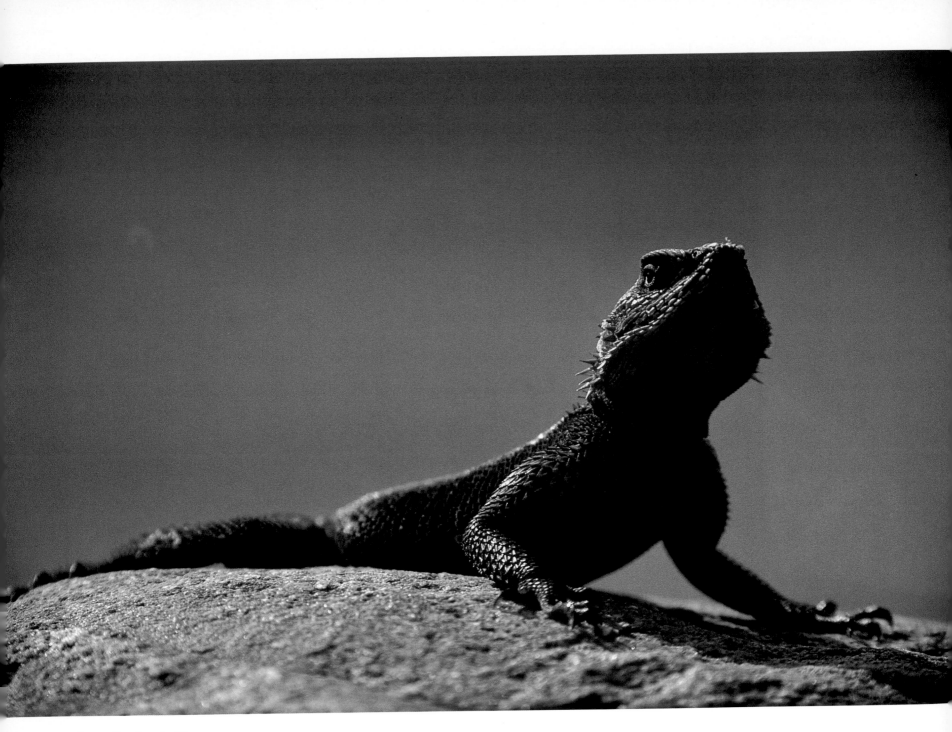

Agama lizard sunbathing.

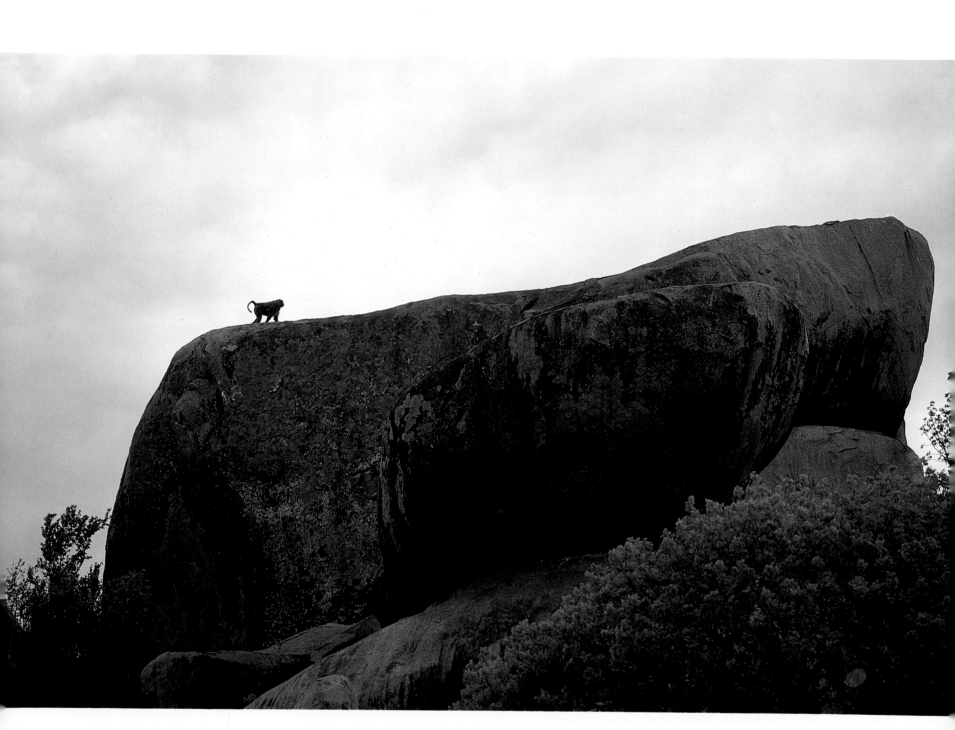

Many forms of life find shelter in a kopje.

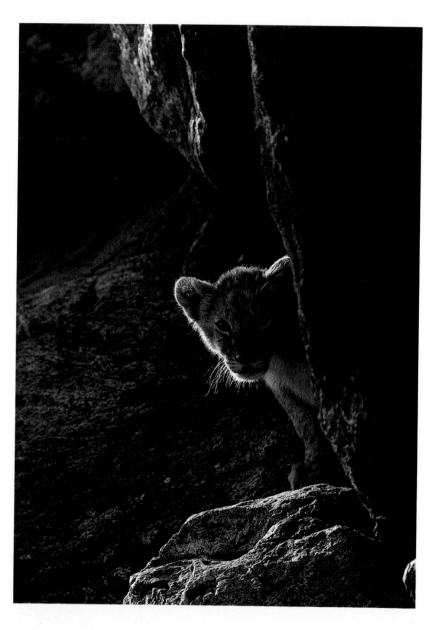

Left: A Glory lily bathes in the warm sunshine.

Above: A family of lions finds the rocks an interesting home.

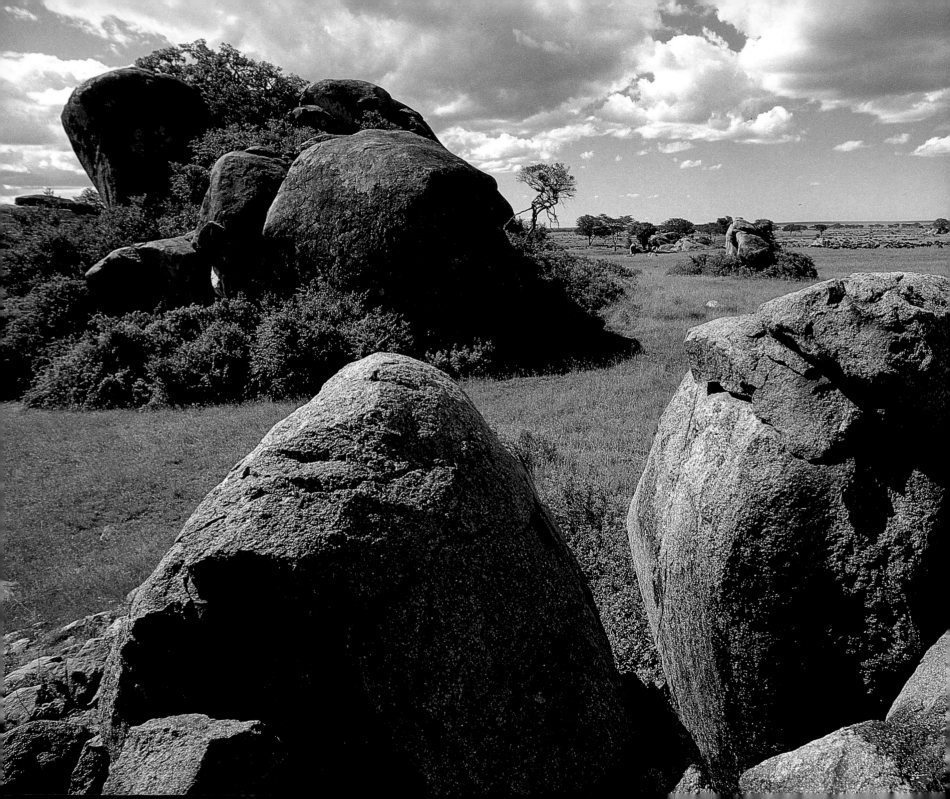

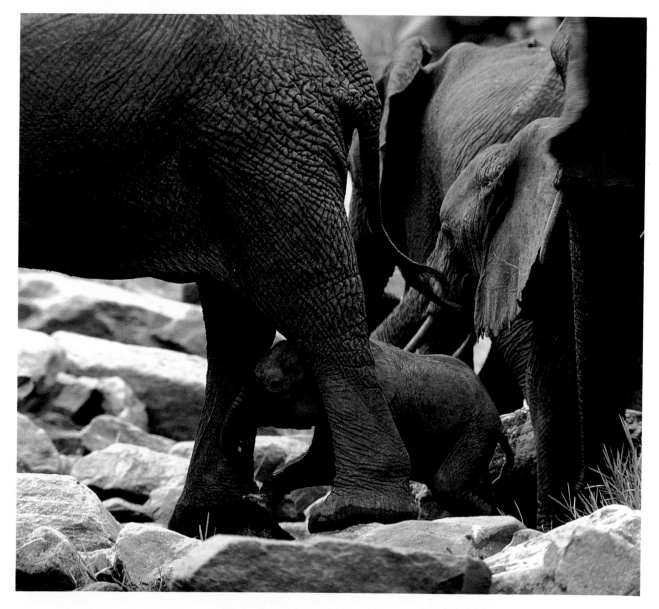

Above: Learning to use a trunk takes practice,
as witnessed by this young elephant, tripped up by its own unpredictable nose.

Left: African weather has fashioned the rocks into intriguing shapes.

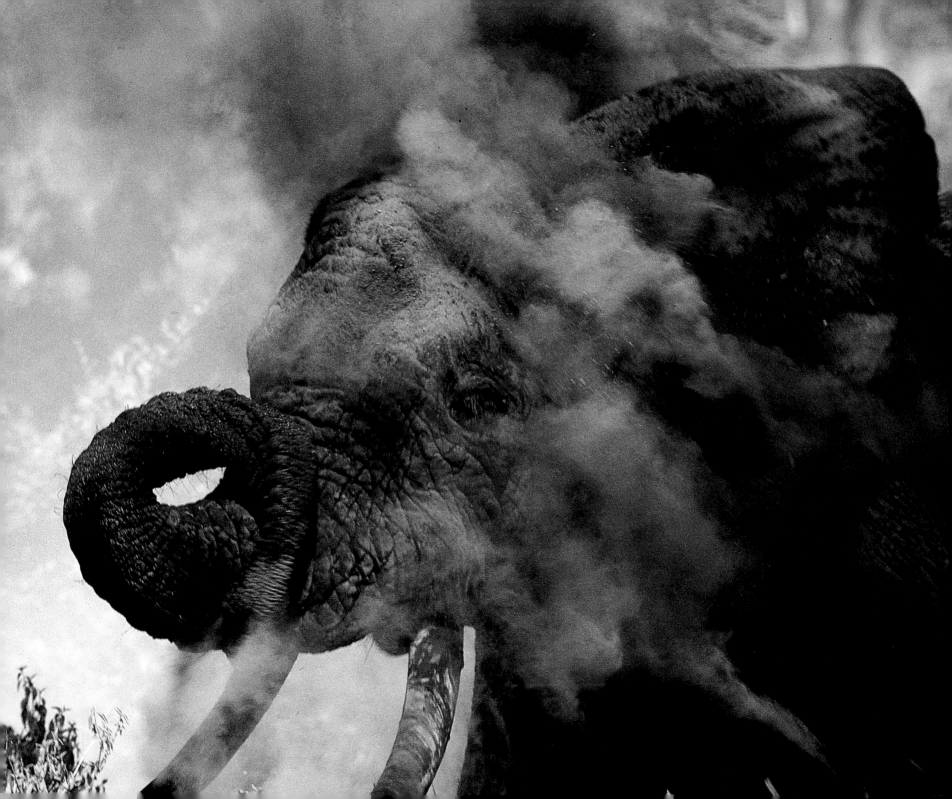

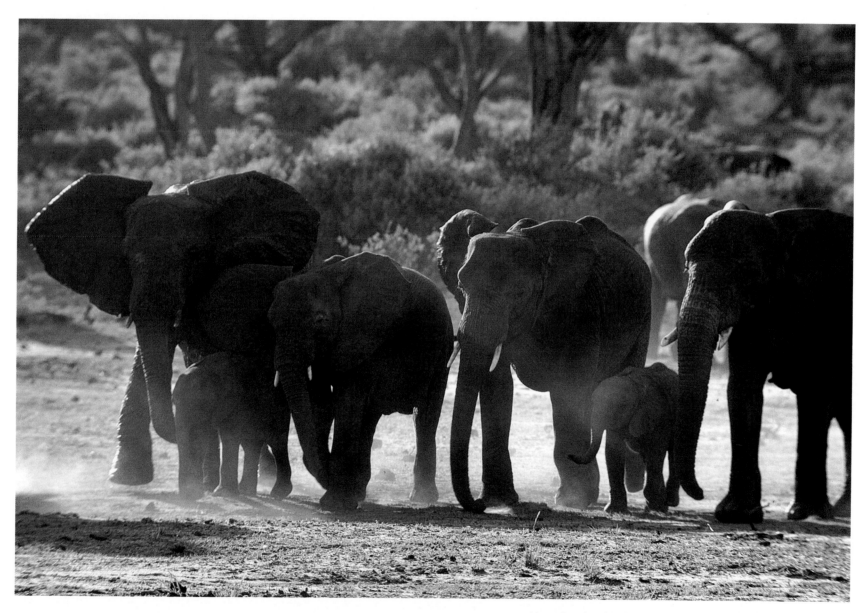

Above: Overheating is very dangerous for elephants, so this family sought relief on a hot day in the shade of a large tree, then headed for a nearby mud bath.

Left: As protection against insects, elephants often cover themselves with sand.

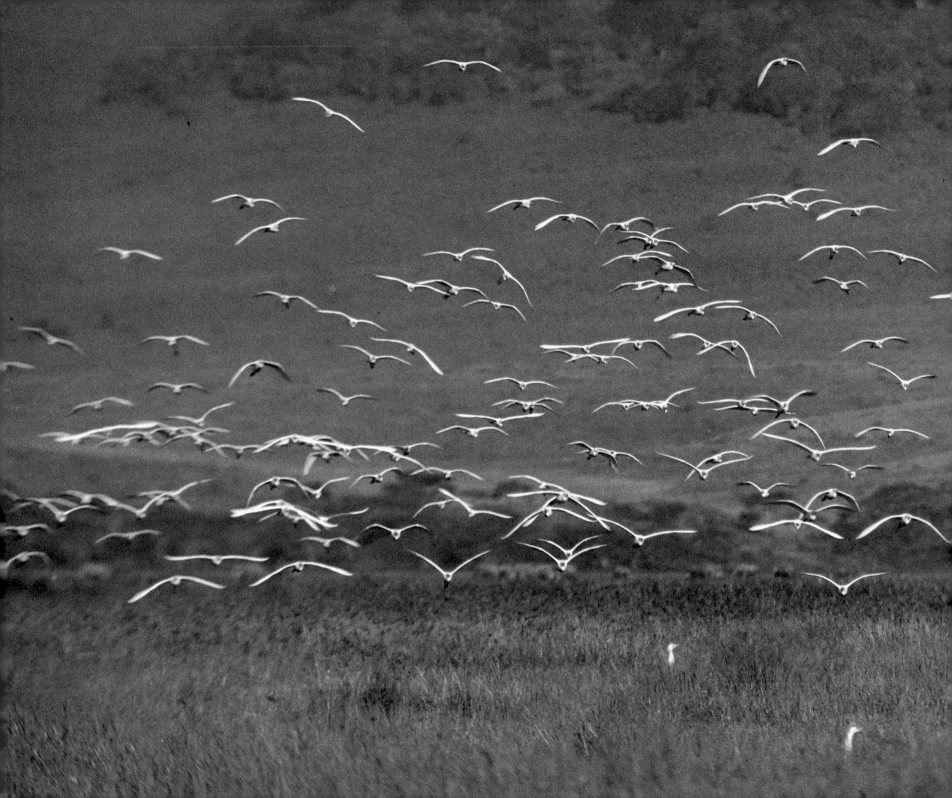

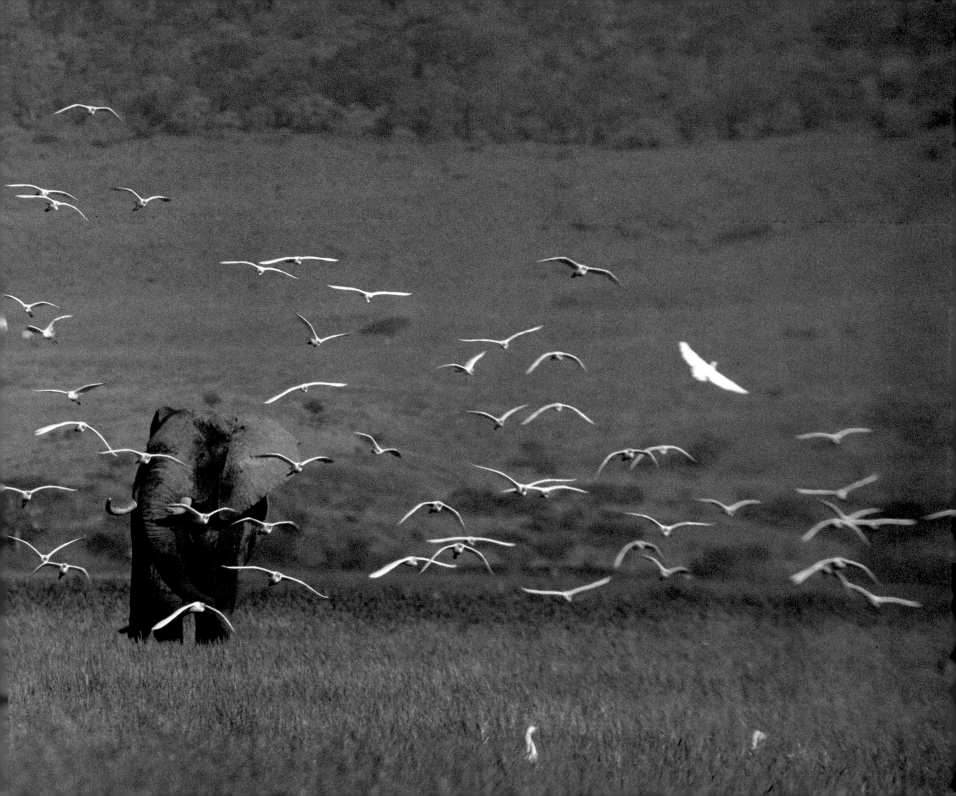

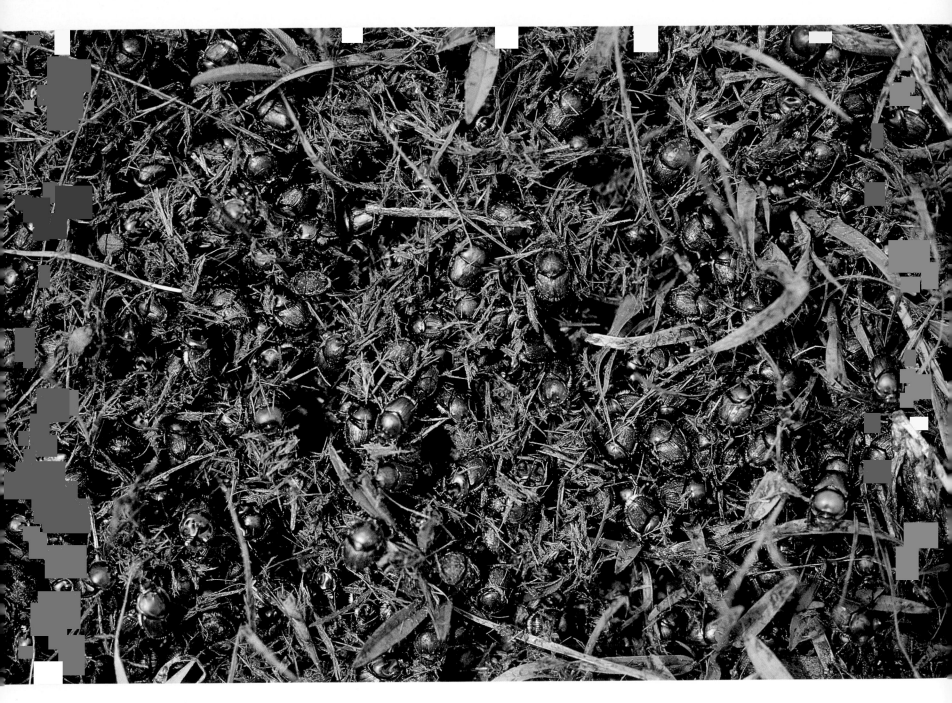

Dung beetles lay eggs in the elephant droppings.

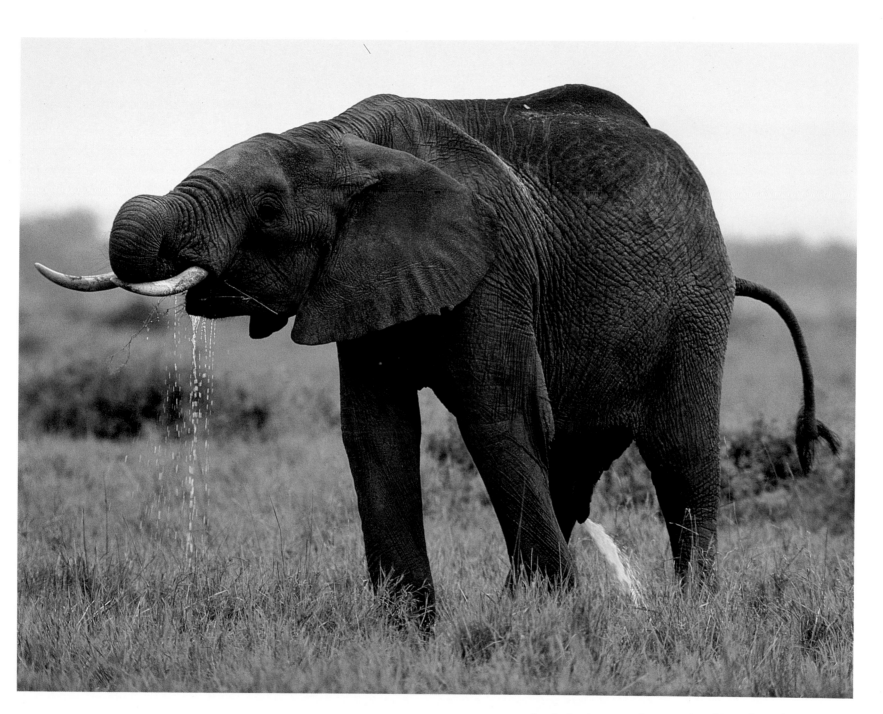

An elephant may require as much as fifty gallons of water a day.

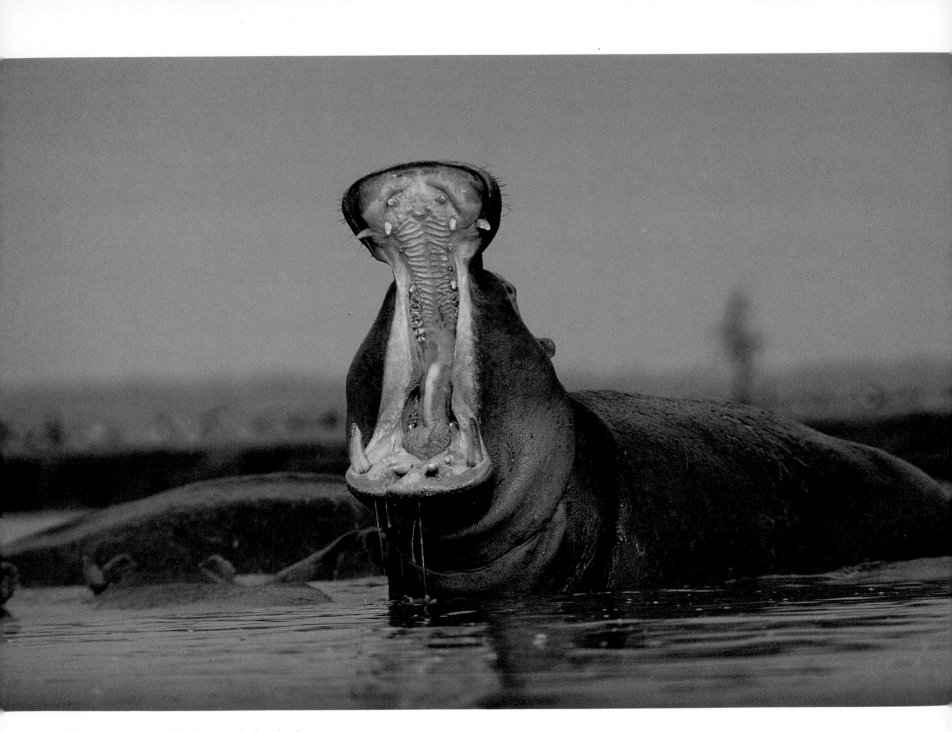

Hippopotamuses stay in the water during the day.

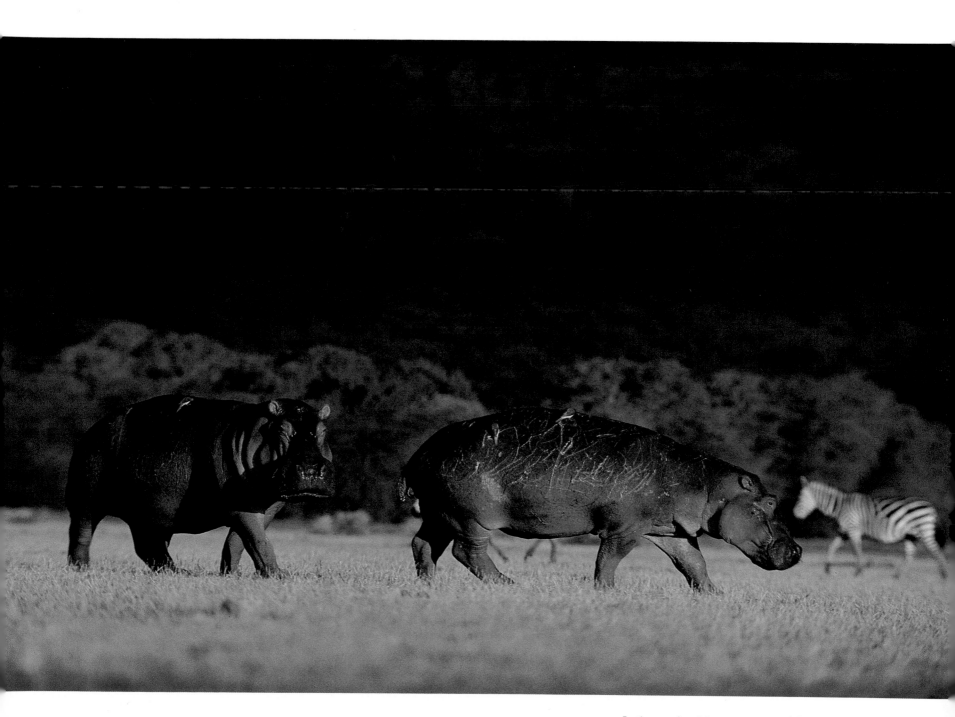

In the evening, hippos come out of the water to graze.

The most frequent cause of death among adult hippos is fighting for dominance.

Their strong teeth leave terrible scars.

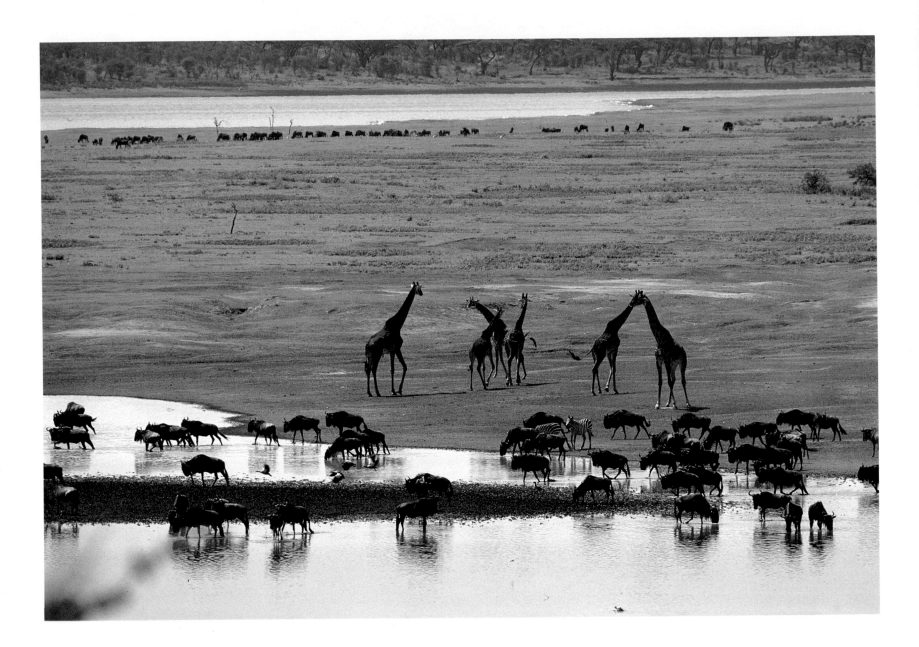

Above: As the dry season approaches, the watering places begin to disappear.

Right: Soon, dust and heat settle over the land like shrouds.

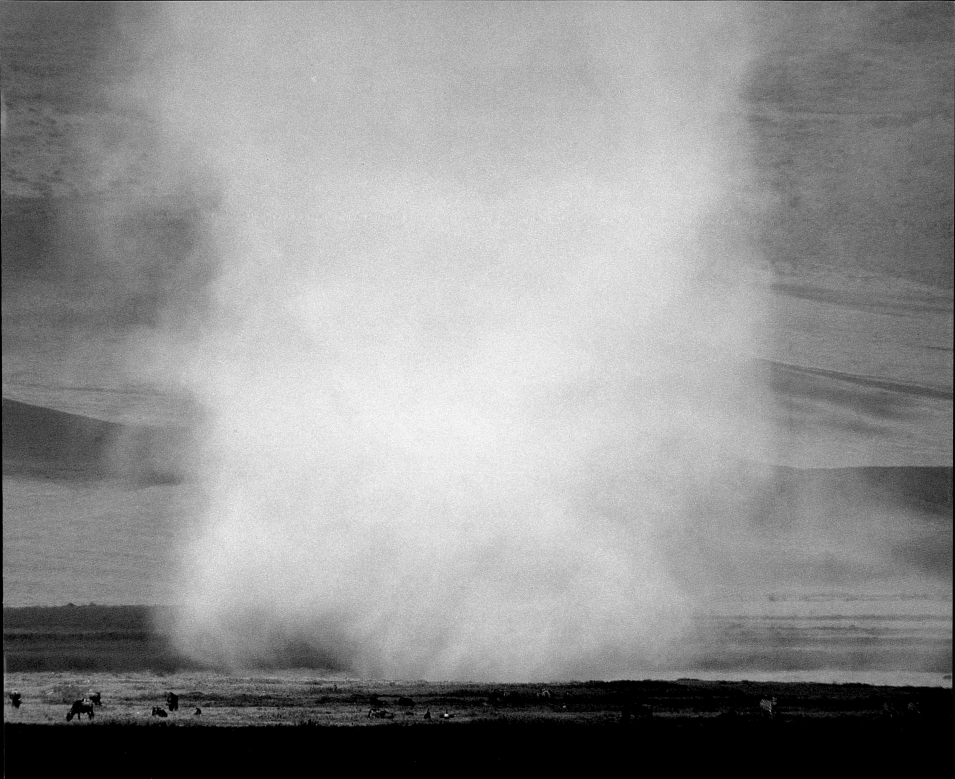

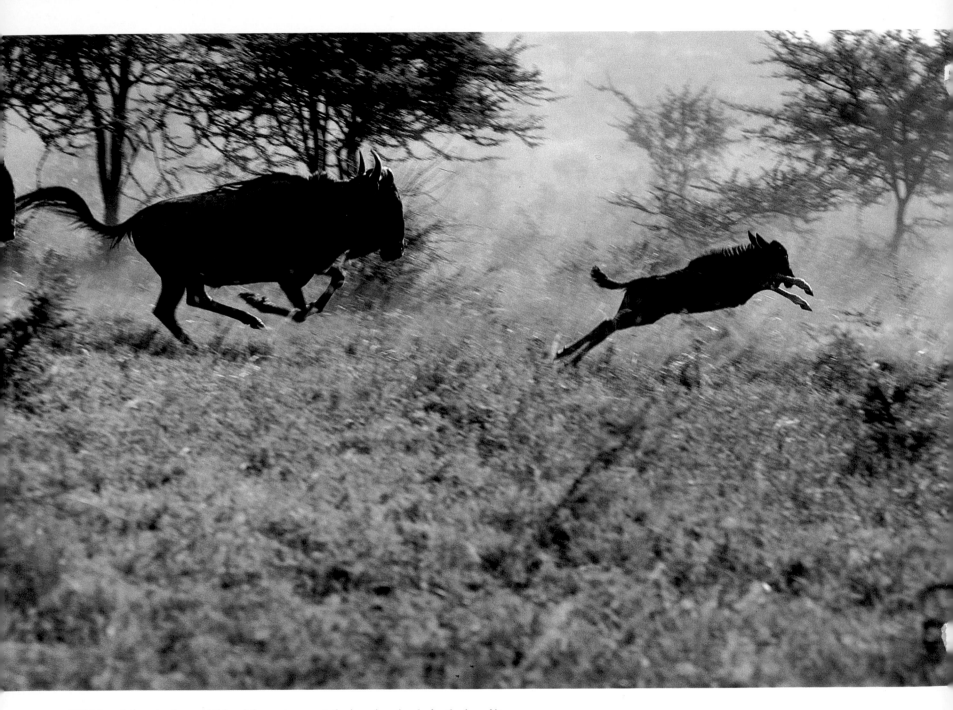

Wildebeests love to play, and this adolescent seems to be jumping simply for the joy of it.

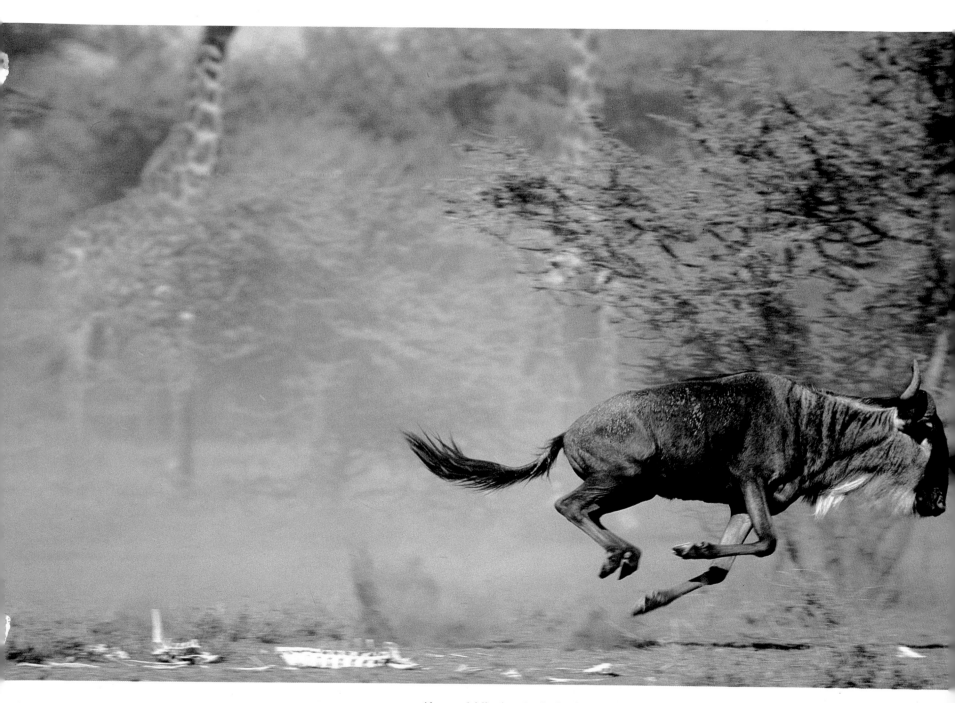

Above and following: As the land shrivels without moisture, the animals begin their migration.

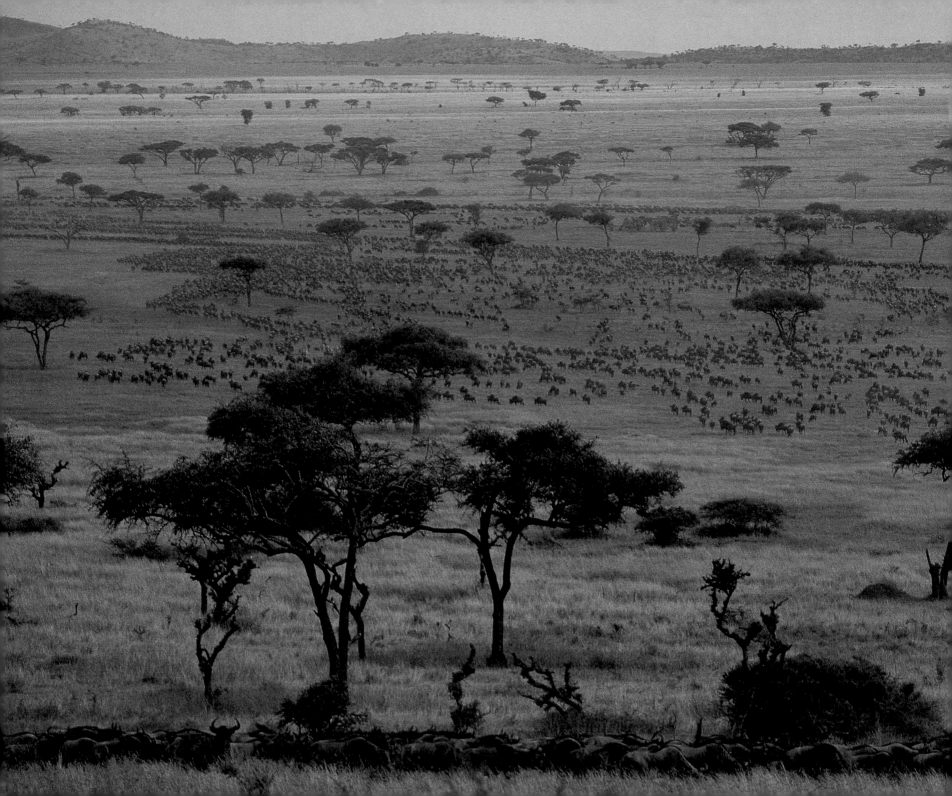

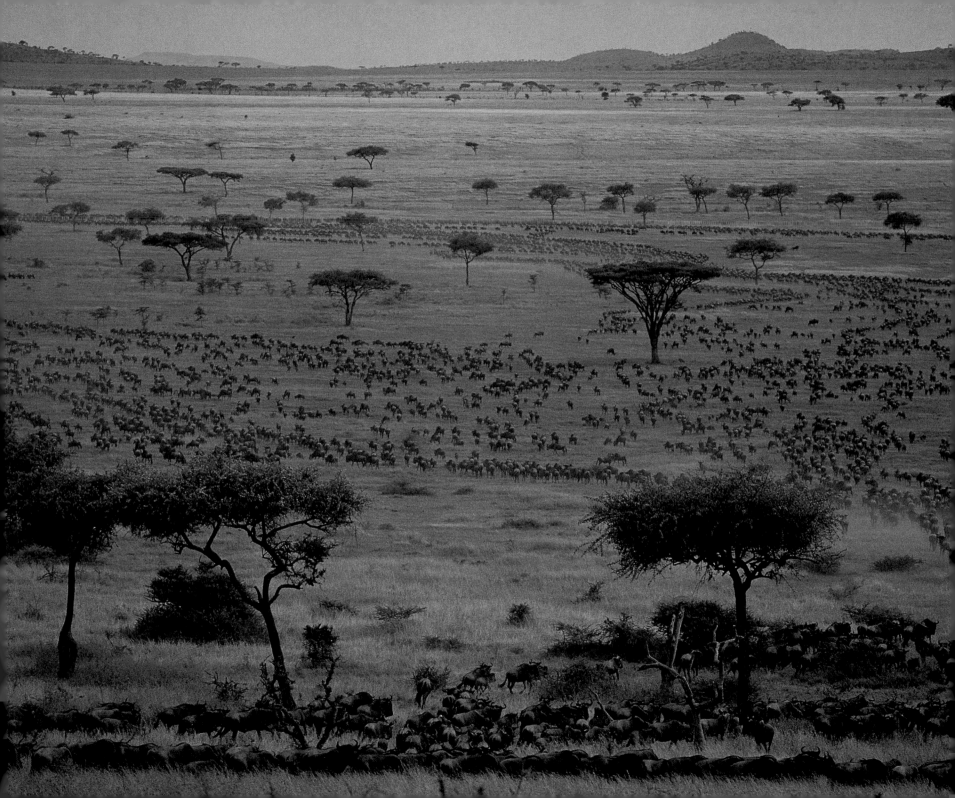

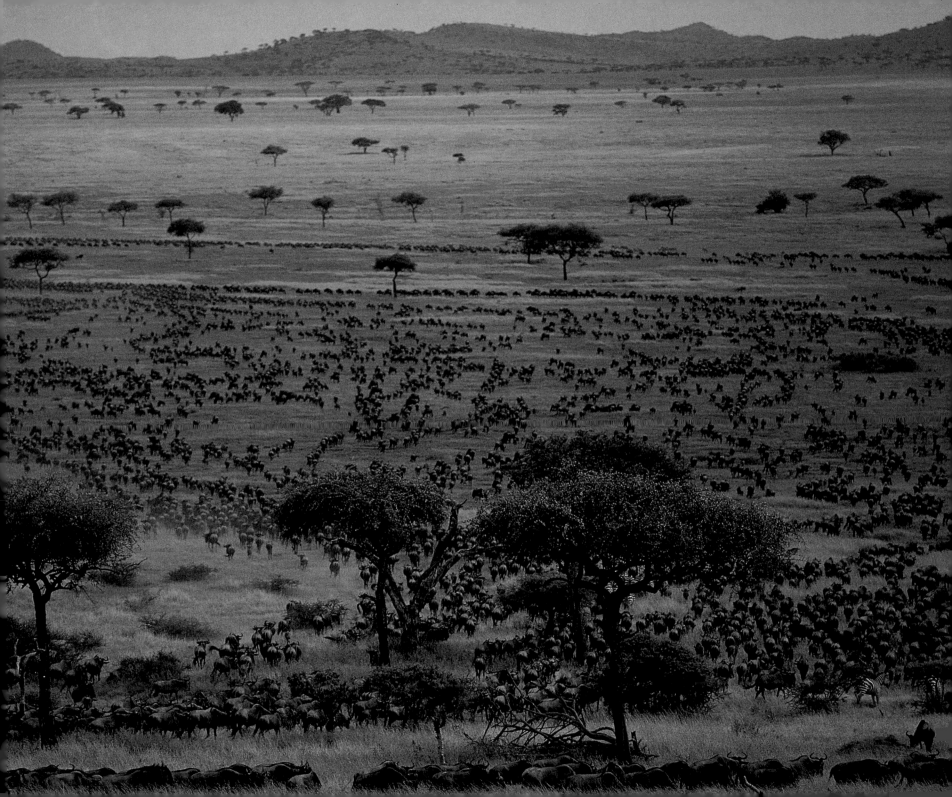

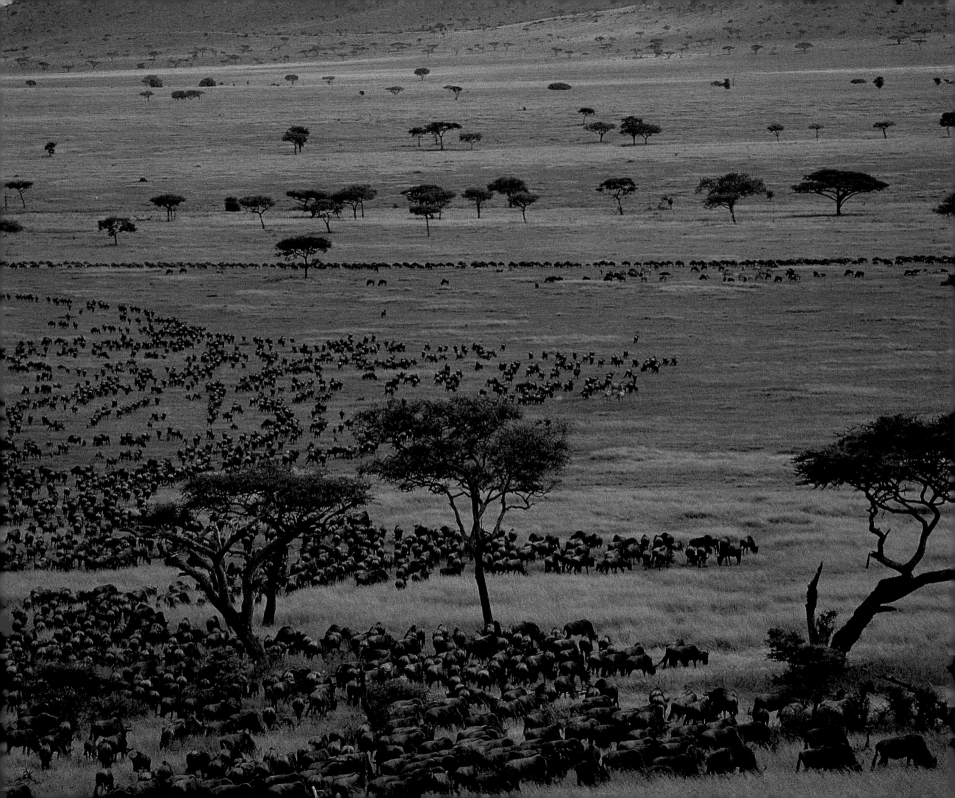

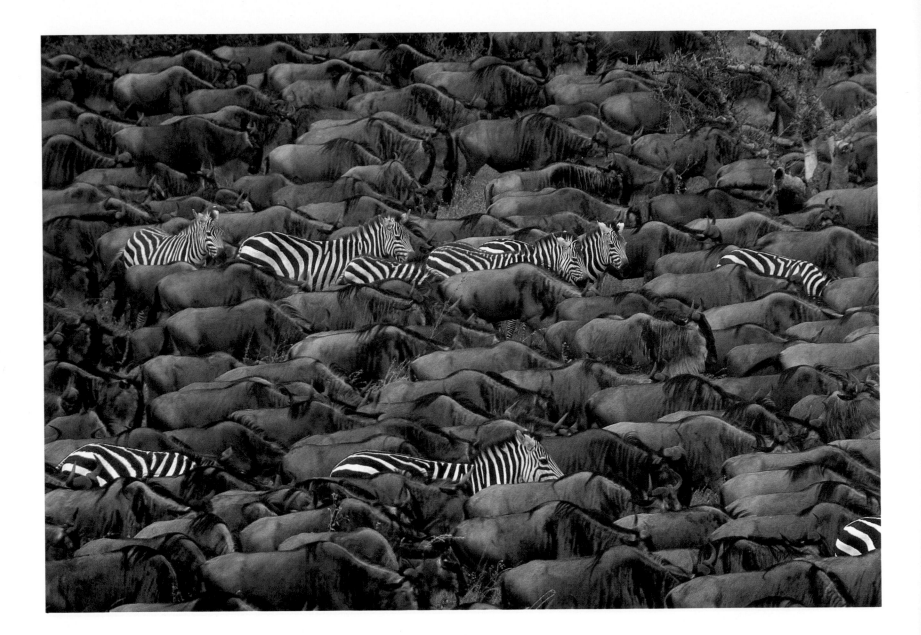

Above: Scientists still do not understand the reason for the zebra's stripes.

Right: Although highly visible during the day, zebras begin to be camouflaged as night falls.

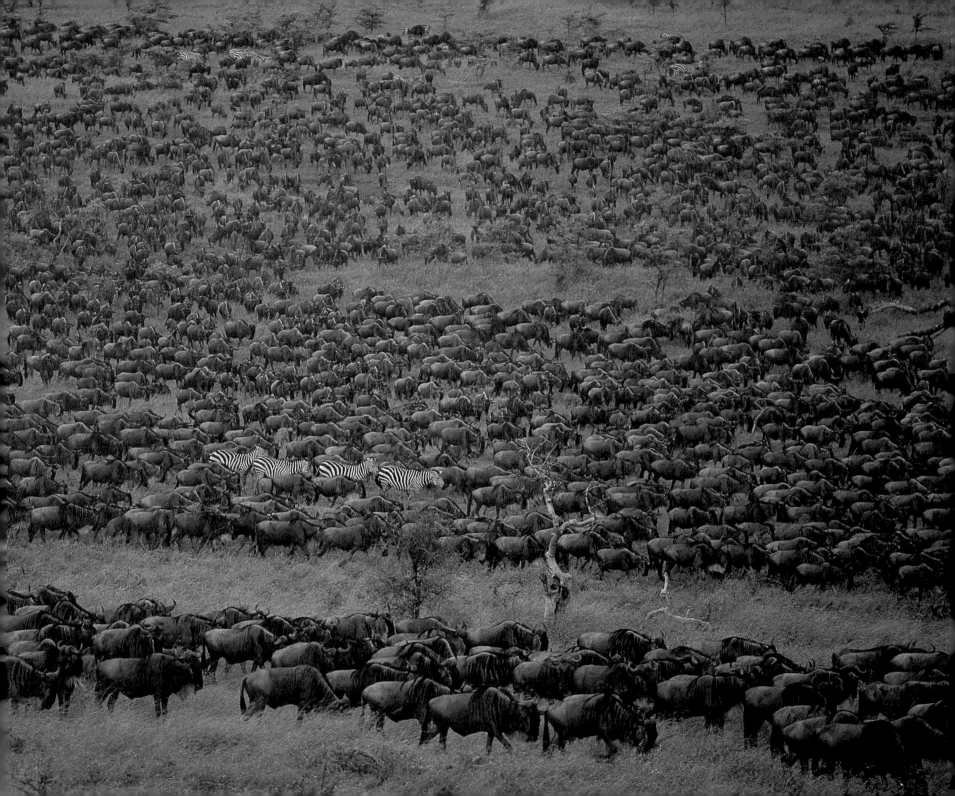

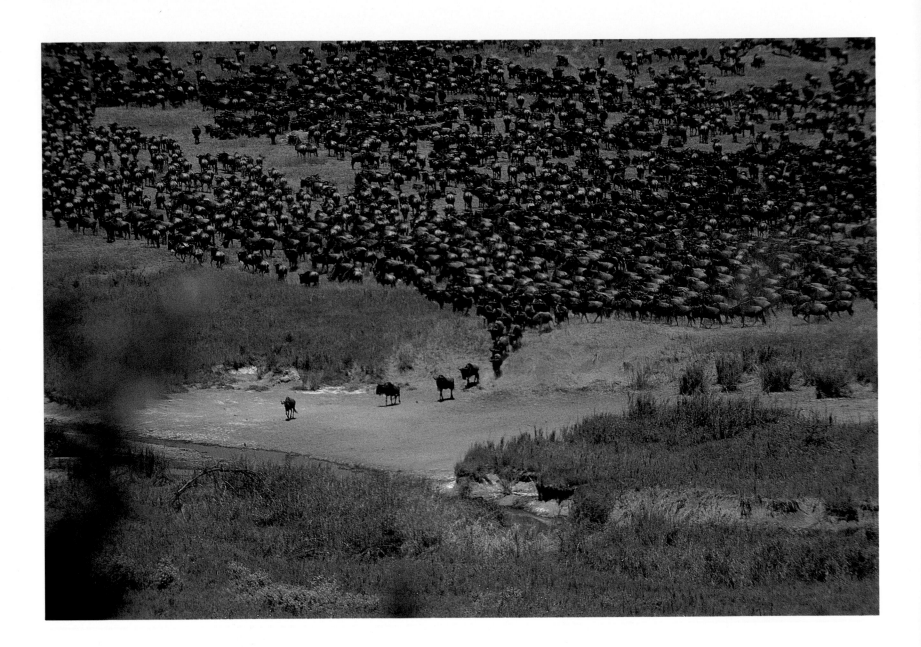

Above: As the dry season progresses, the rivers vanish.

Right: As water disappears, a sense of urgency drives the animals.

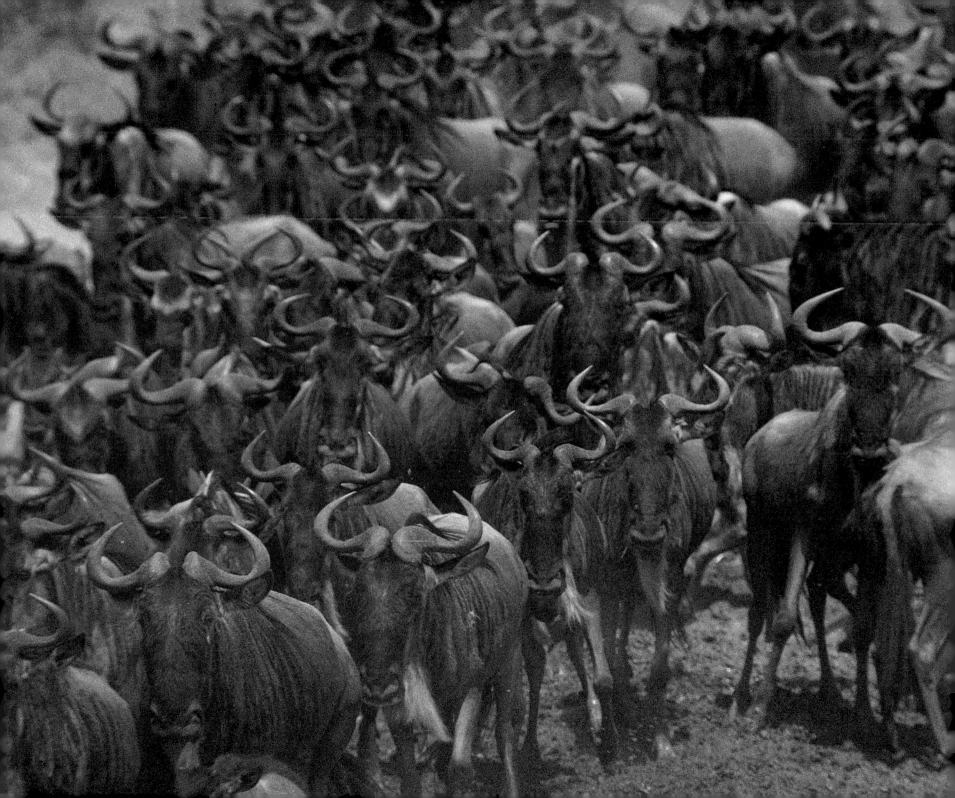

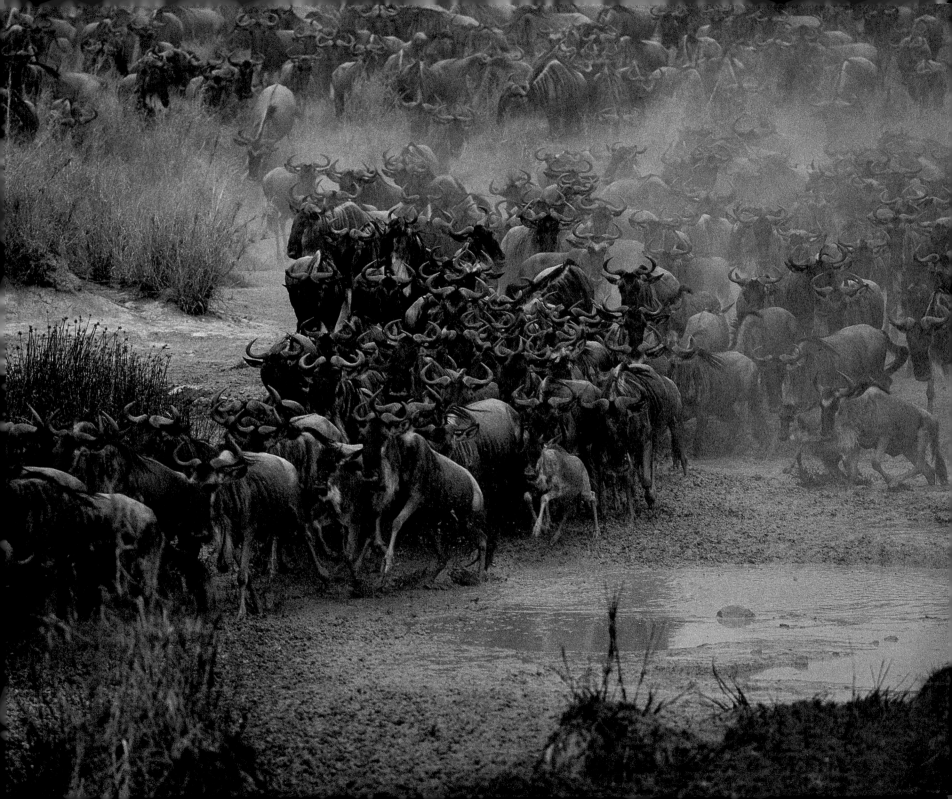

Above: Caught in a mudhole, this wildebeest will never complete the journey.

Left: In the north, they will find food and water.

Following pages: Soon, all the great herds leave the dying land.

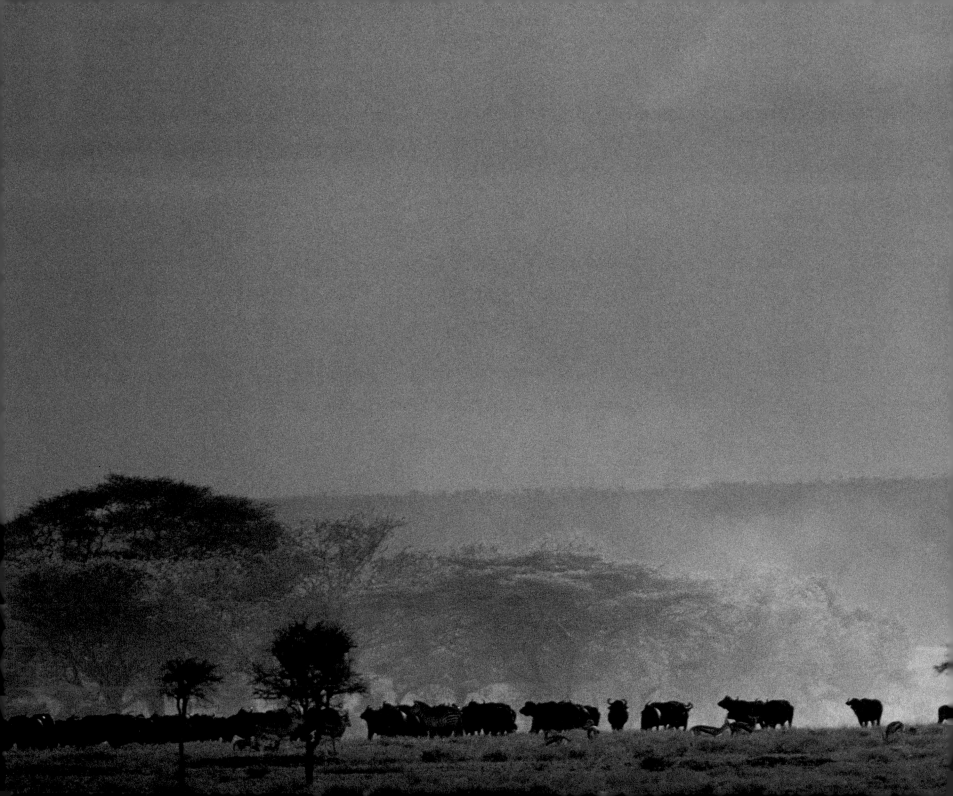

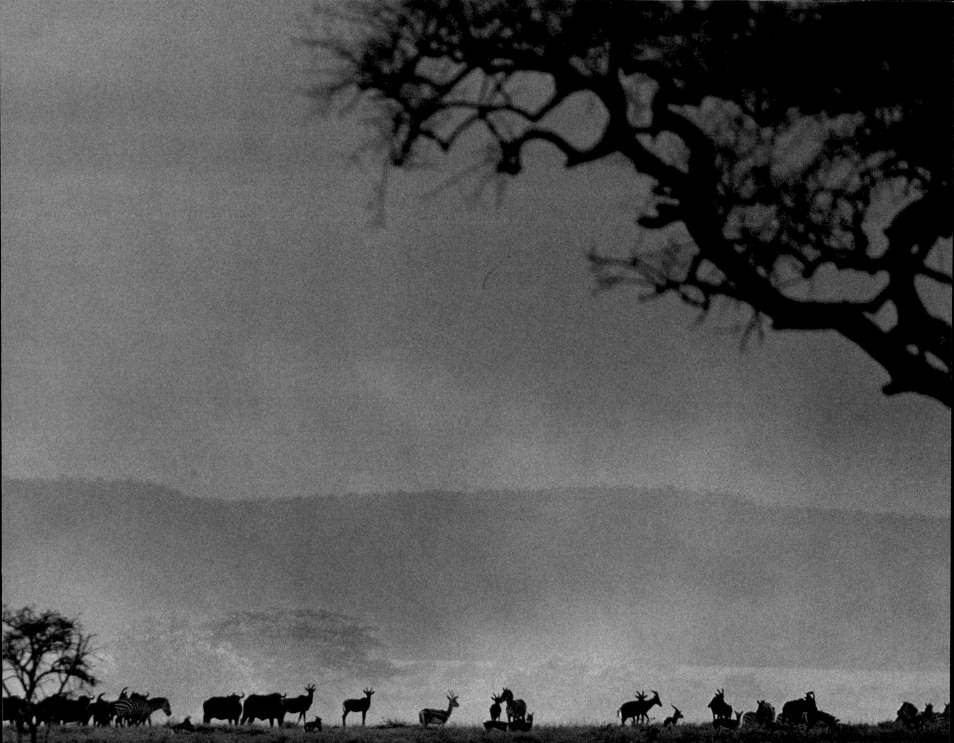

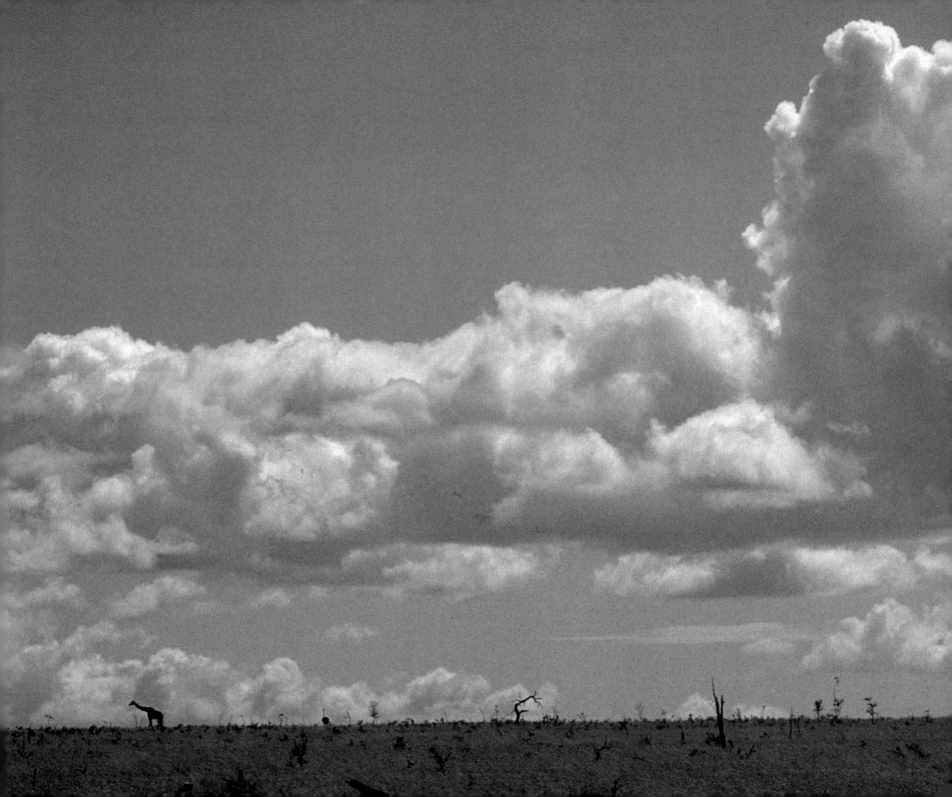

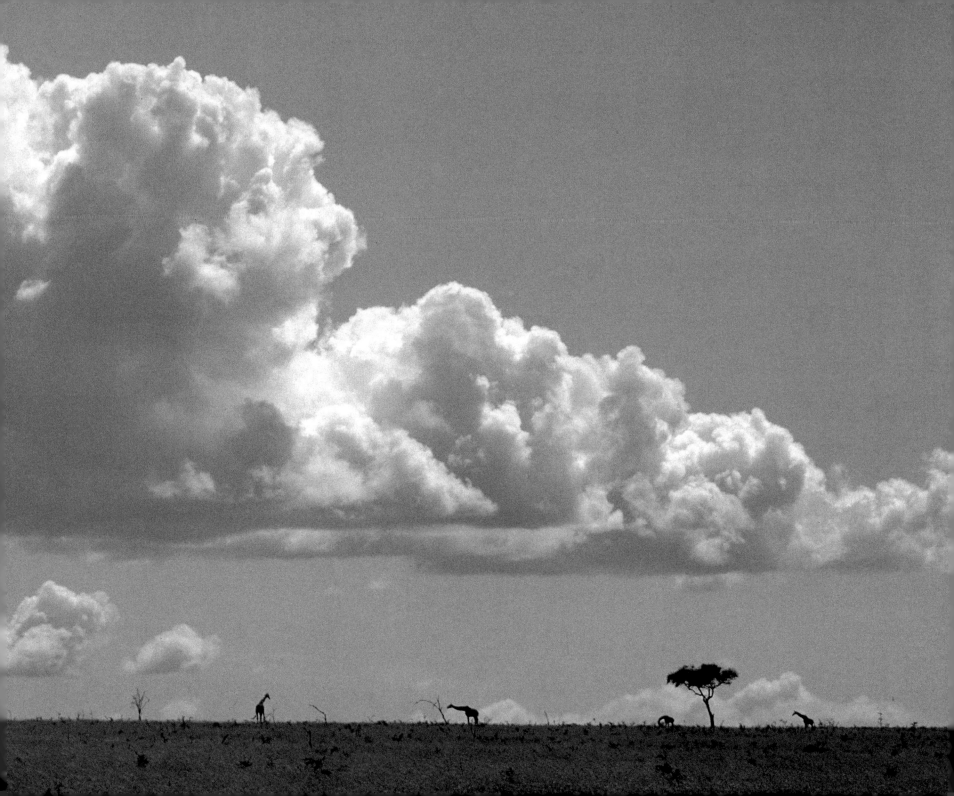

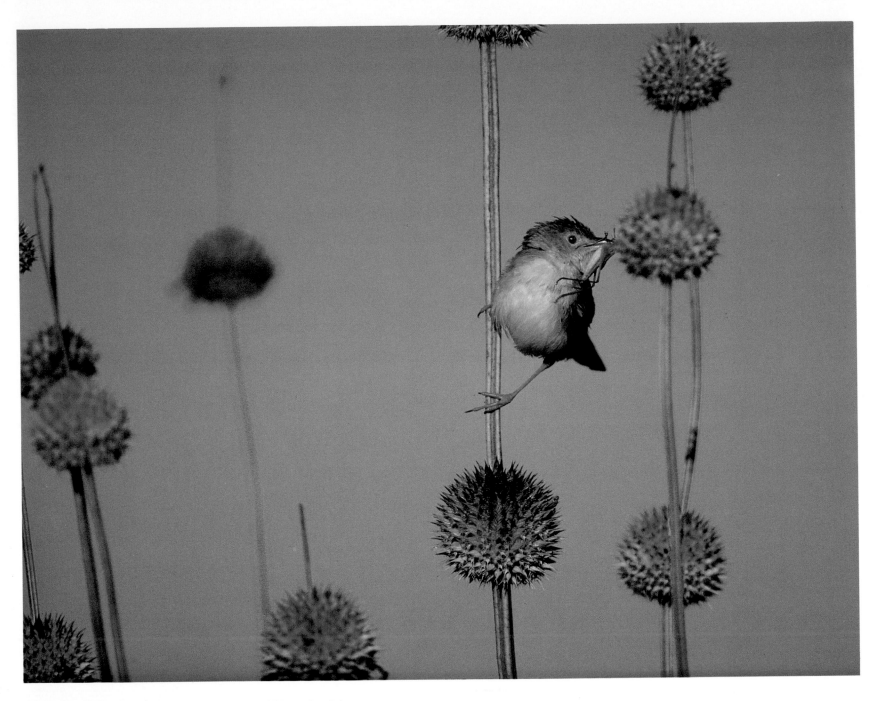

The dry season creates problems for every type of life on the plain.

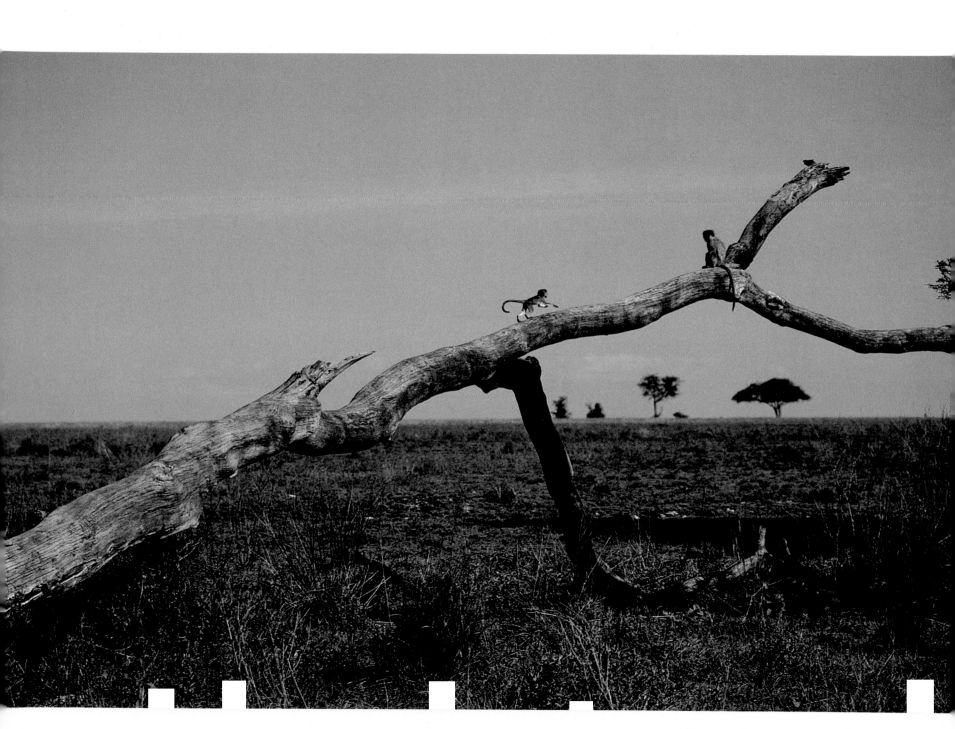

Vervet monkeys scamper on a fallen tree.

241

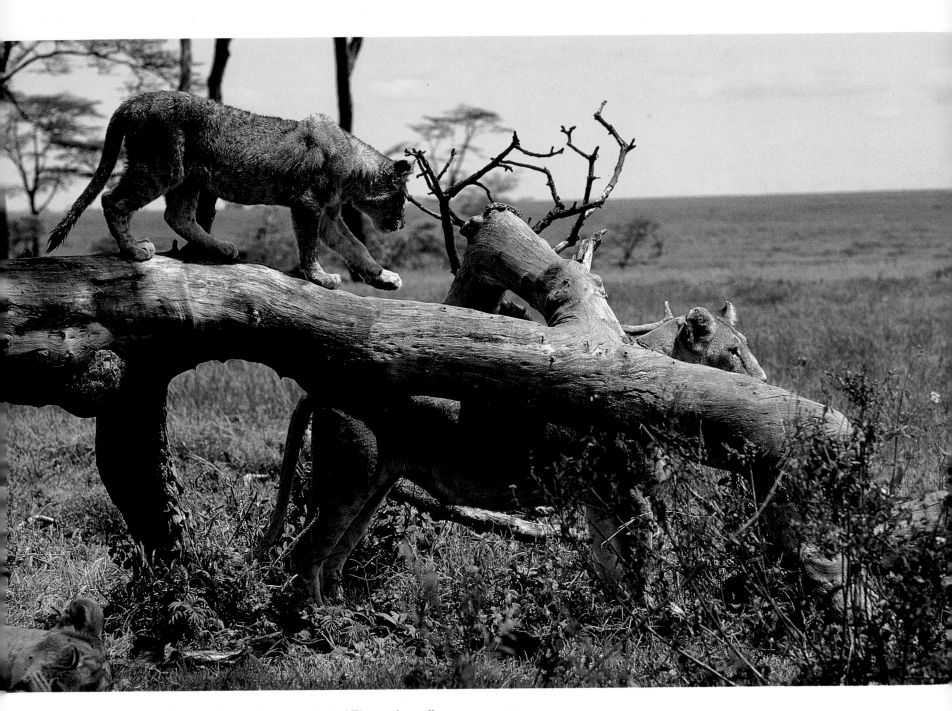

Alert for any food, a lioness with her cub surveys a herd of Thomson's gazelles.

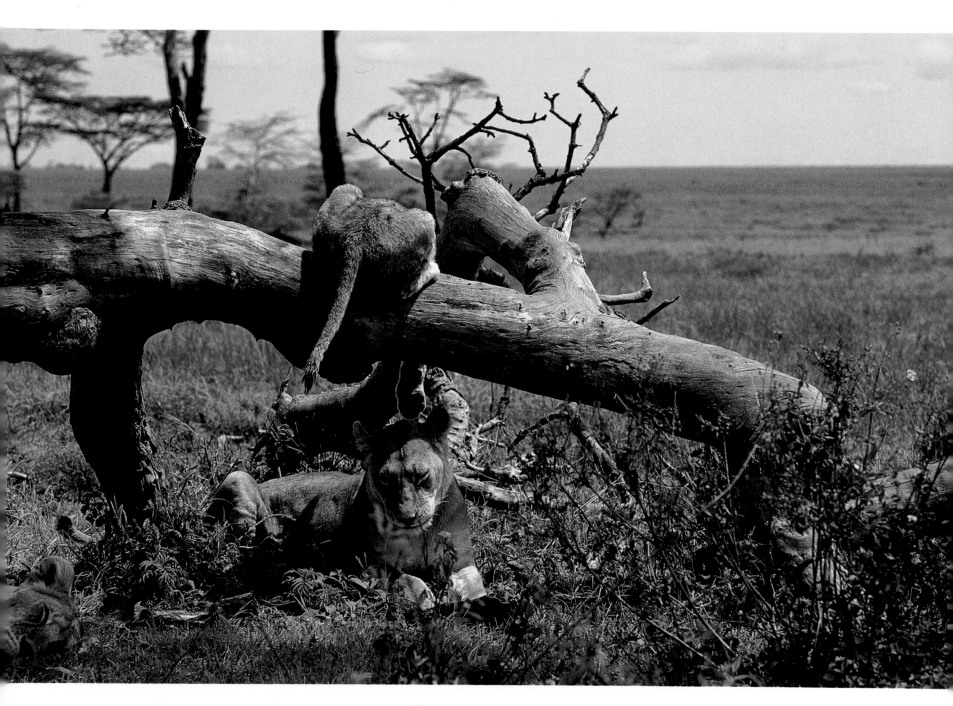

When the gazelles vanish behind a hill, she rests again, even though her youngster seems playful.

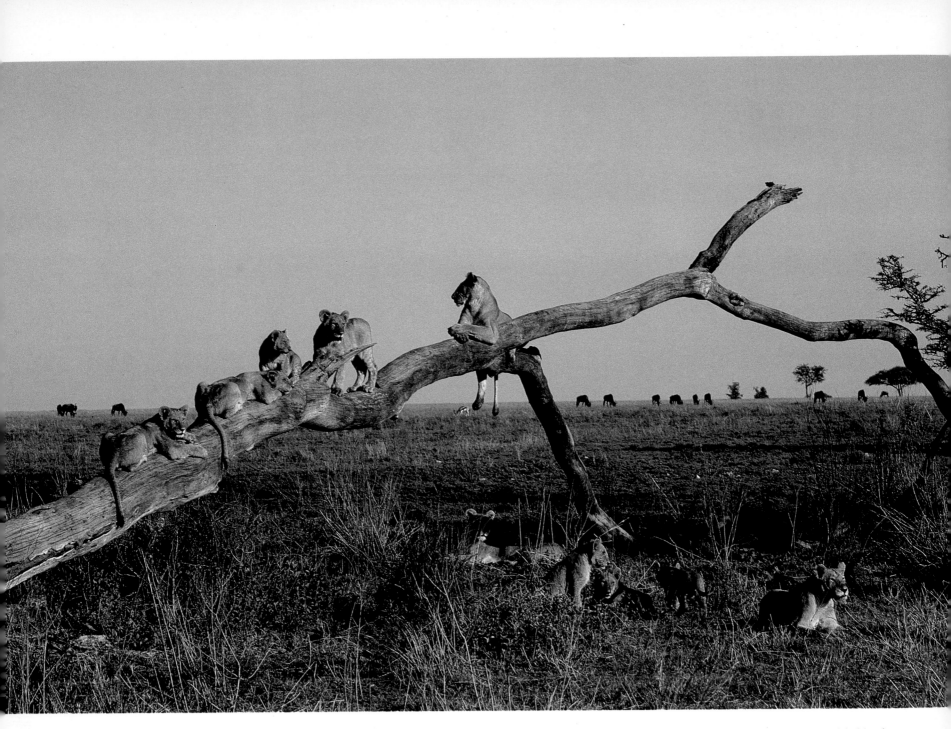

Above: Lions use trees for security and points of vantage.

Right: A tribesman strolls to a neighboring village to visit friends.

244

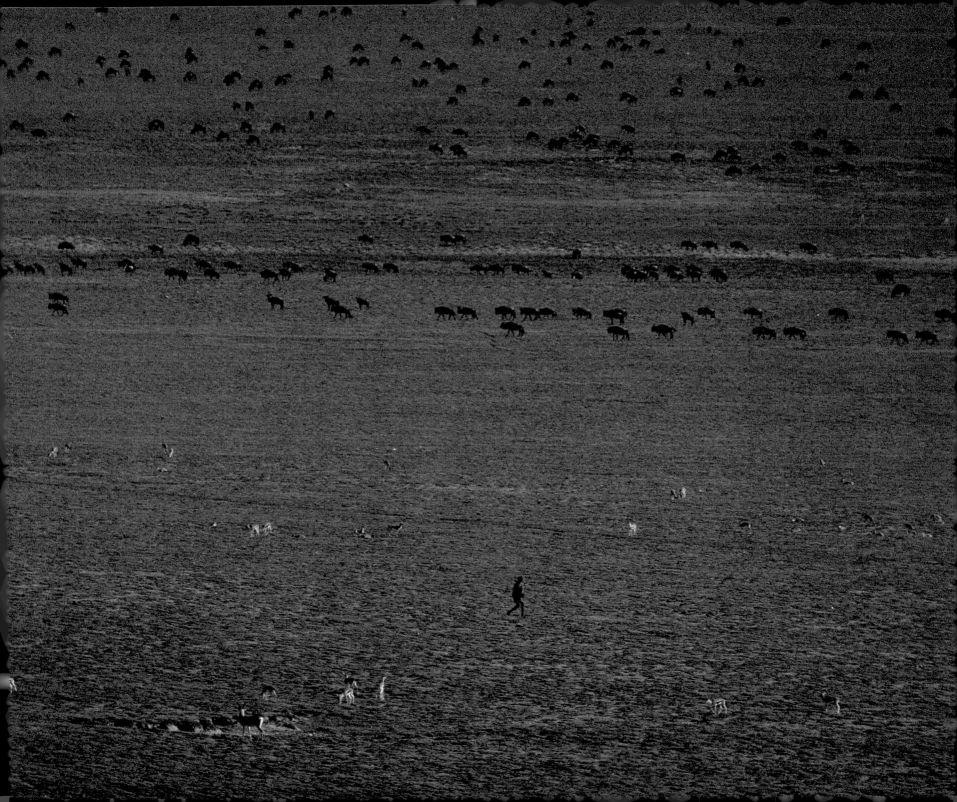

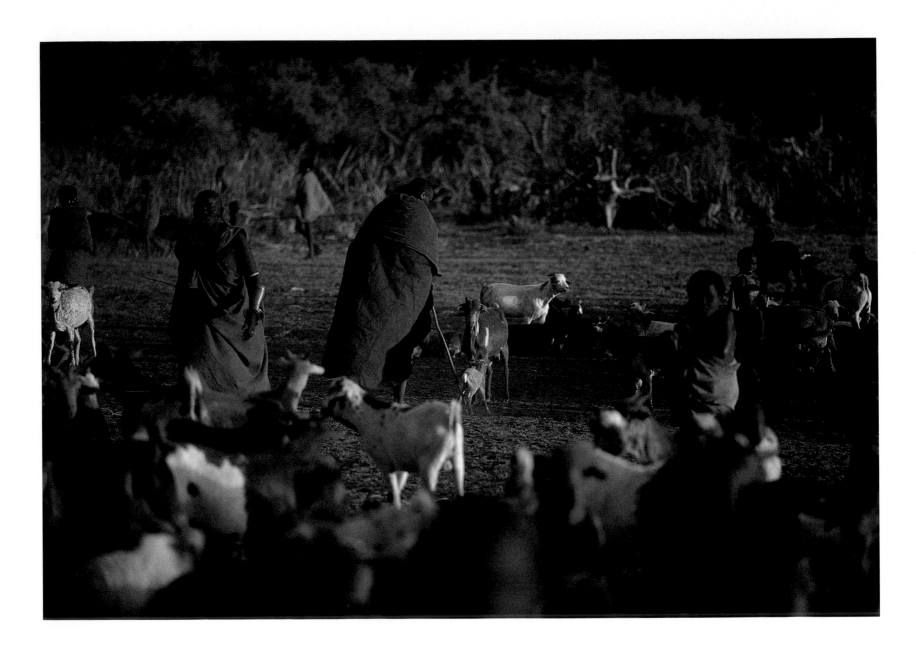

At dusk, goats return to the Masai village from the plains to begin nursing their kids.

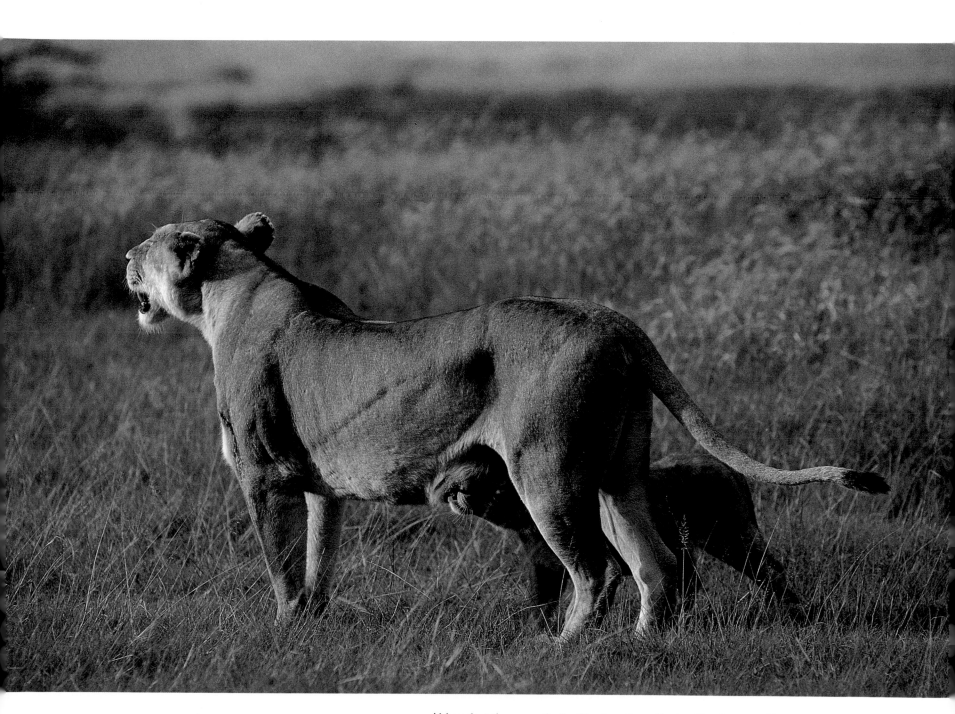

Although at three months it still enjoys its mother's milk, this cub will soon crave more meat.

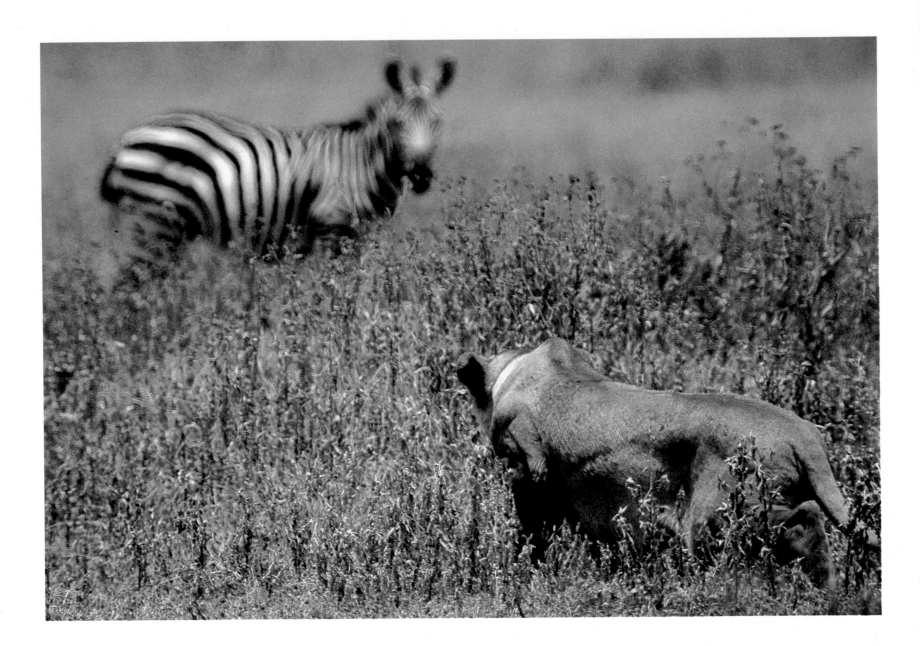

Above: Each time the feeding zebra lifts its head, the lion freezes.

Right: Attacking a zebra
is dangerous for the lion, for a well-placed hoof can easily break her jaw.

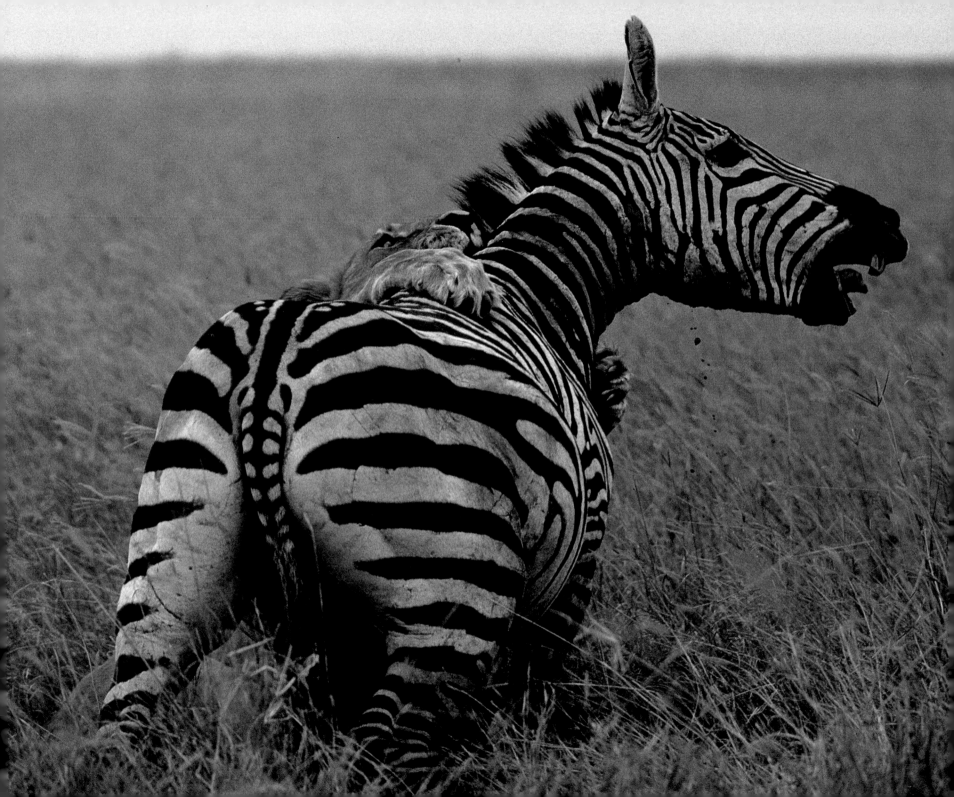

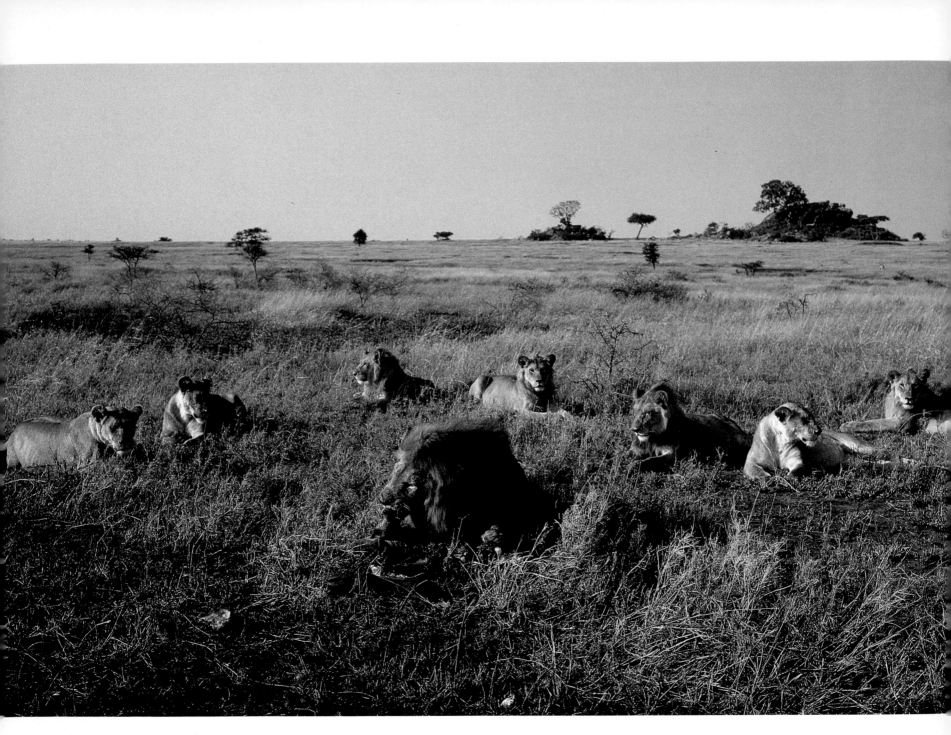

The dominant male eats first.

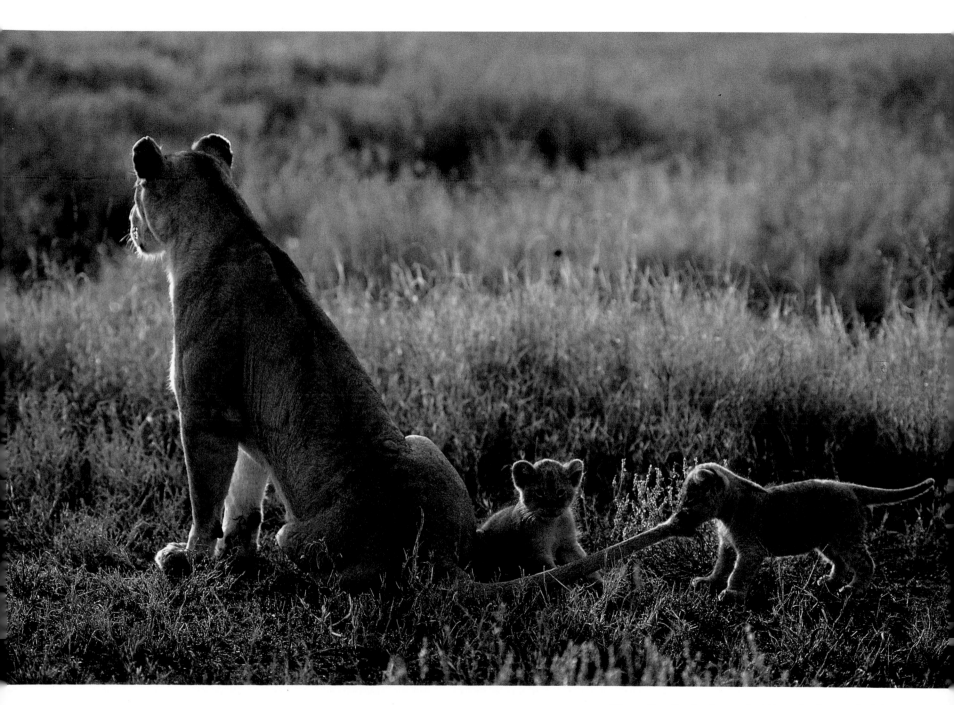

The mother lion is always alert, the cubs always playful.

Lions of the same pride maintain close contact by touching and nuzzling each other.

Right: Even in play, these cubs practice skills they will need in order to hunt and survive.

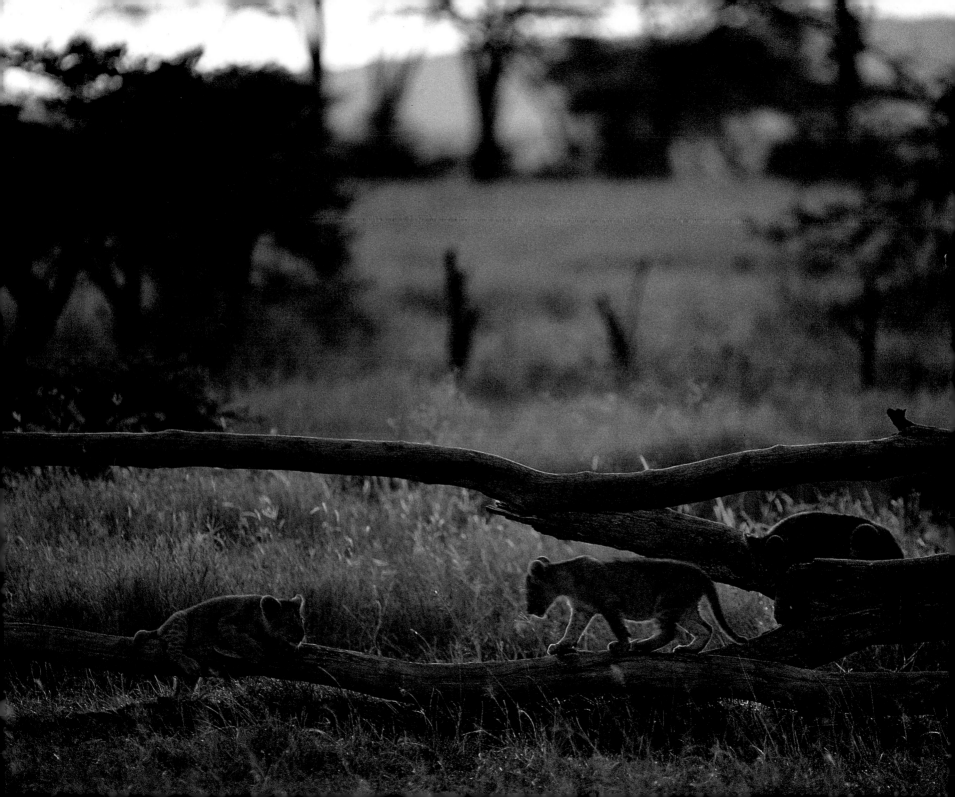

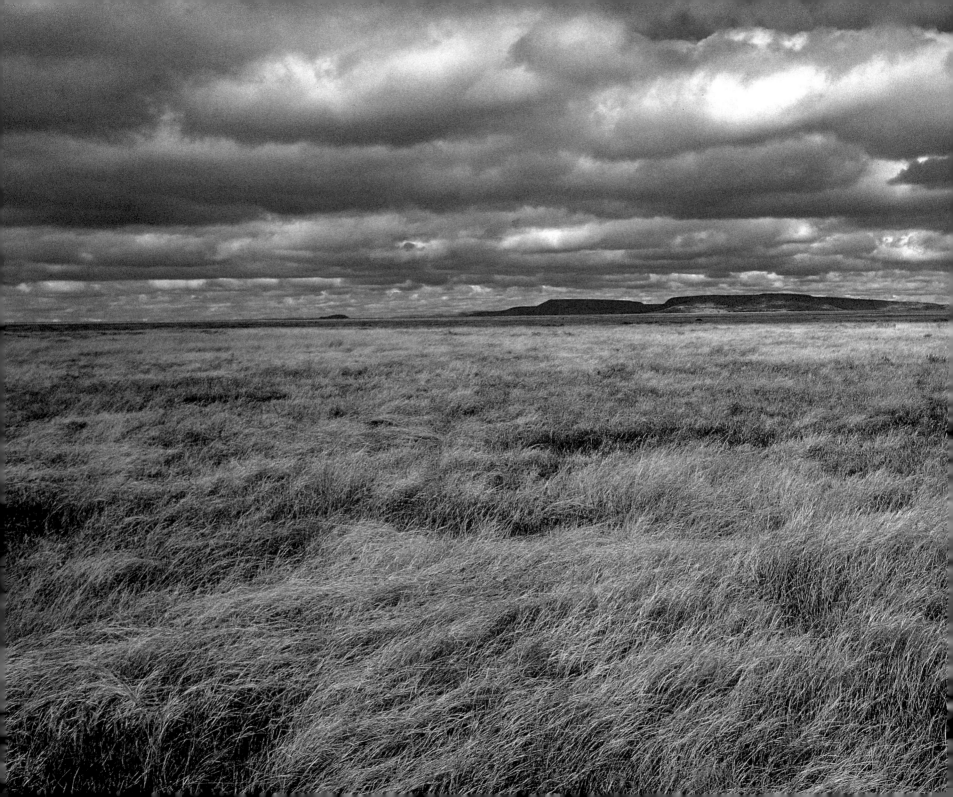

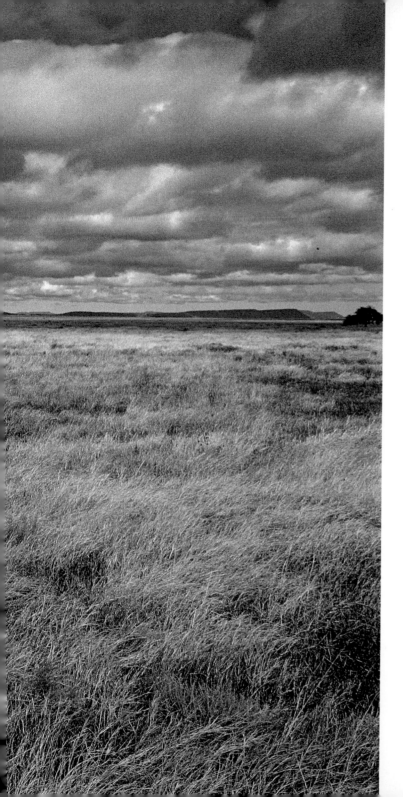

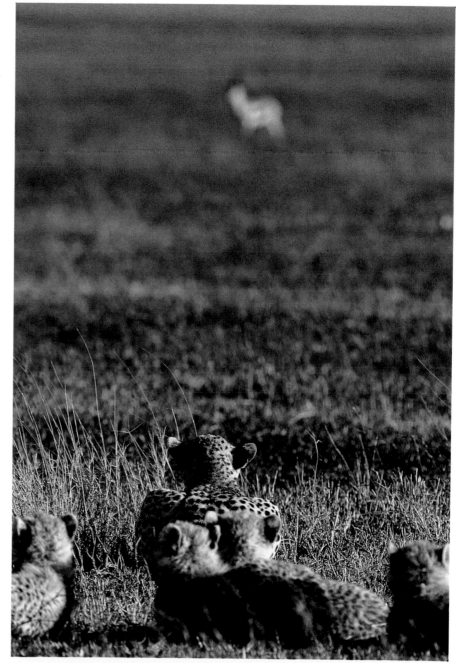

Above: Crouching close to the ground, cheetahs study the Thomson's gazelles.

Left: As the grass fades, concealment will become more difficult for the big cats.

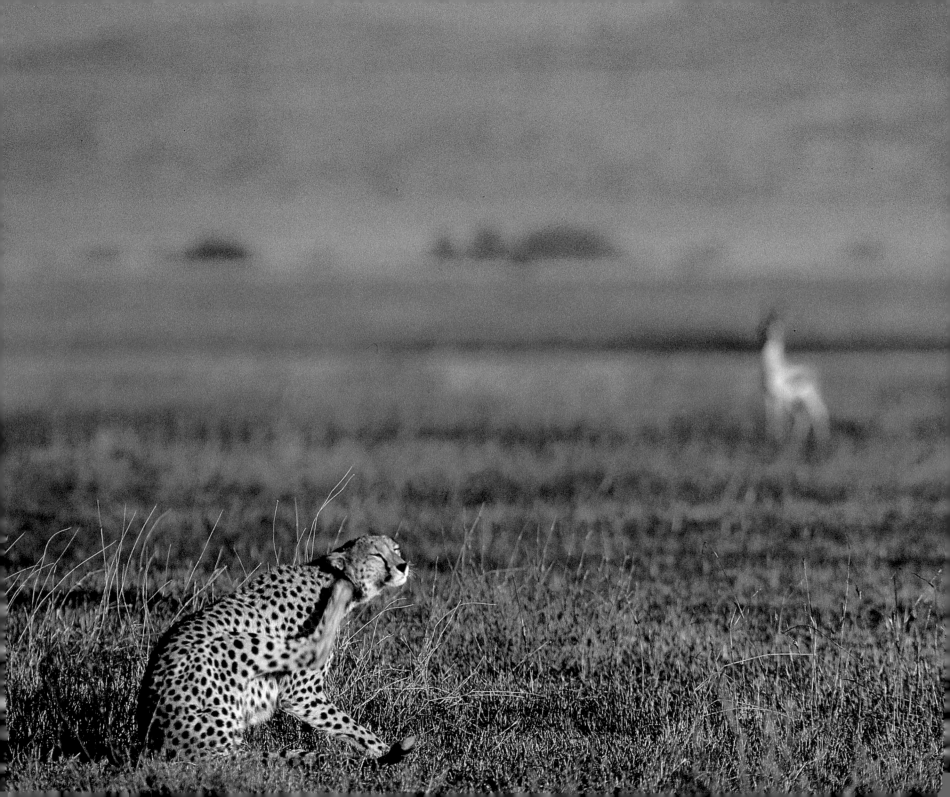

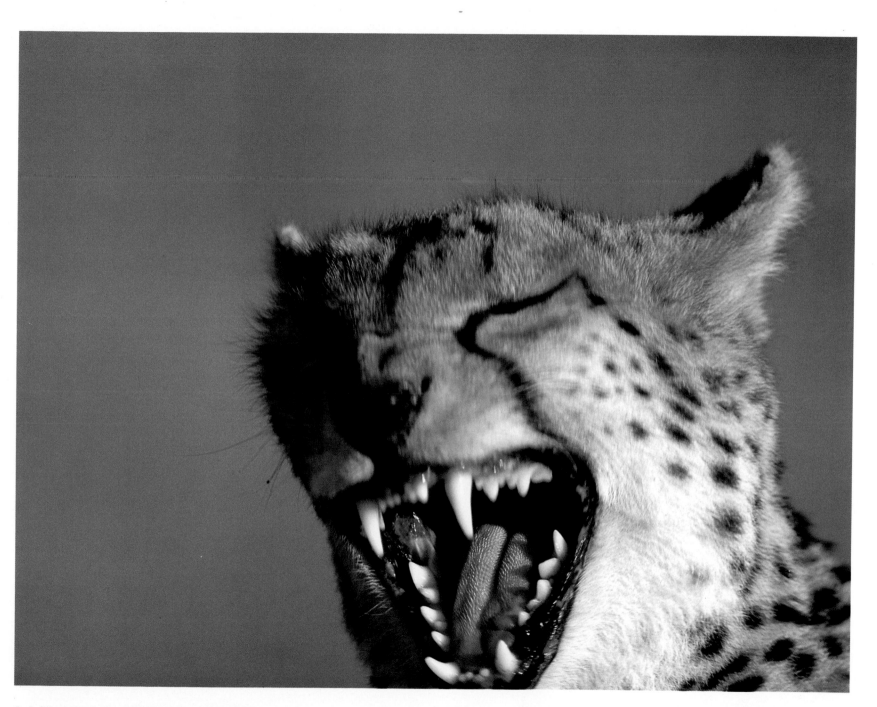

Left: Discovered, the cheetah feigns nonchalance.

Above: Large cats are often sleepy, and this cheetah is no exception.

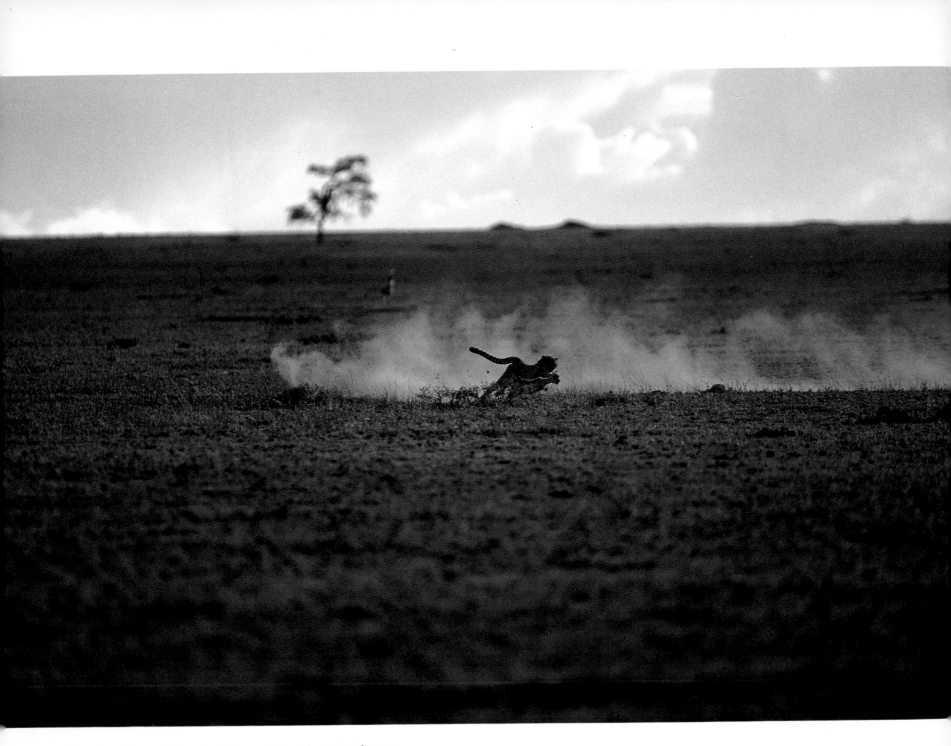

The cheetah's astonishing burst of speed closes the gap on the prey.

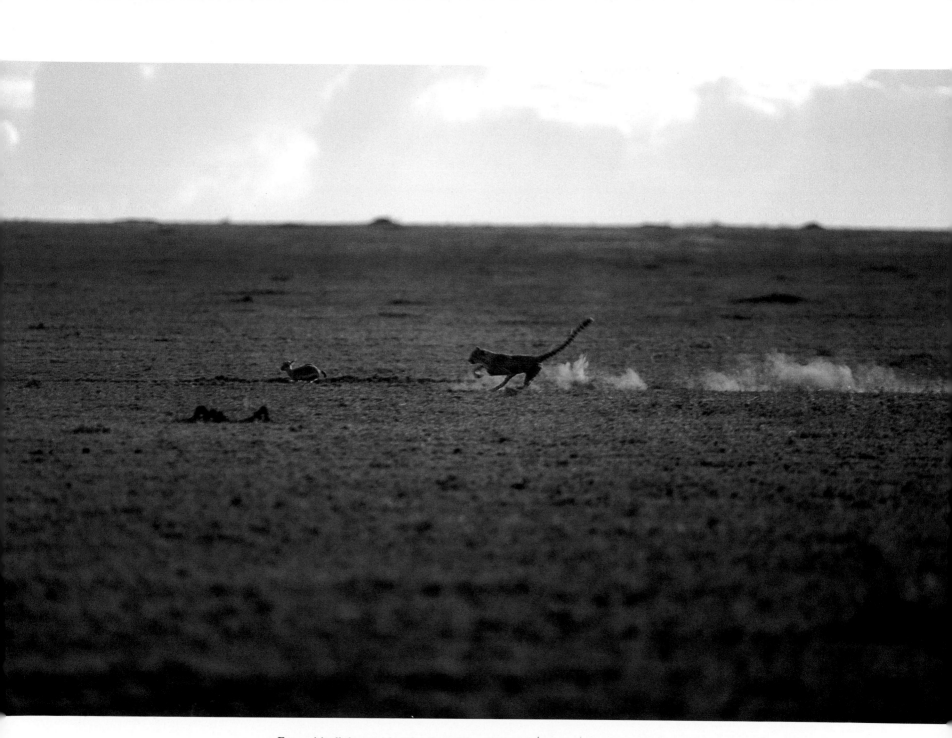

Even with all the speed at the cheetah's command, hunting results depend on how closely to the prey the cheetah can stalk.

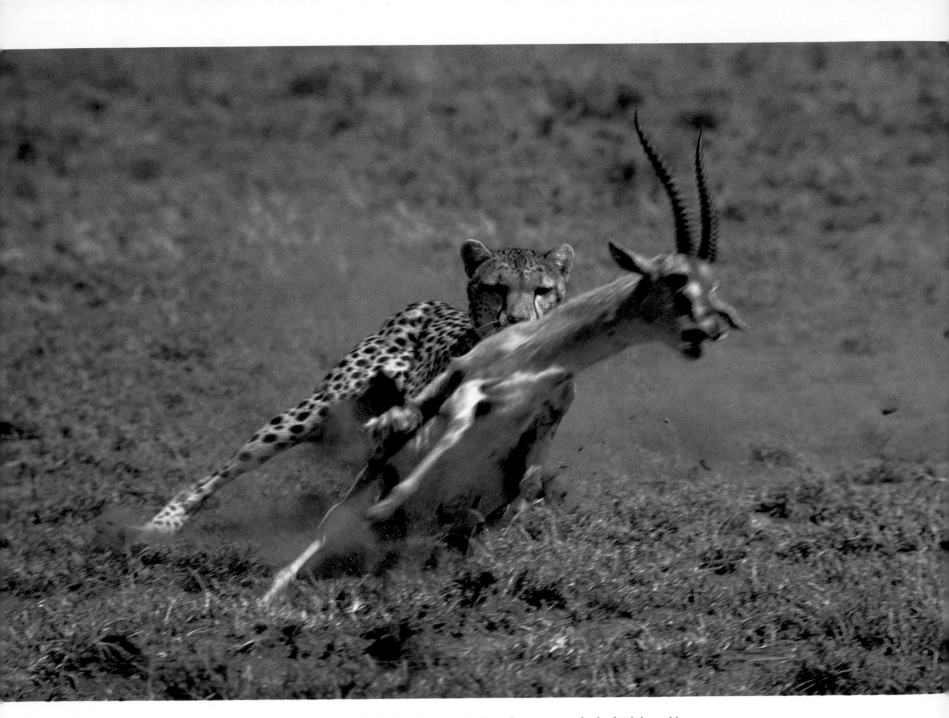

In the final instant, the cheetah will slap the gazelle's leg, tripping it to the ground where the cat can apply the fatal throat bite.

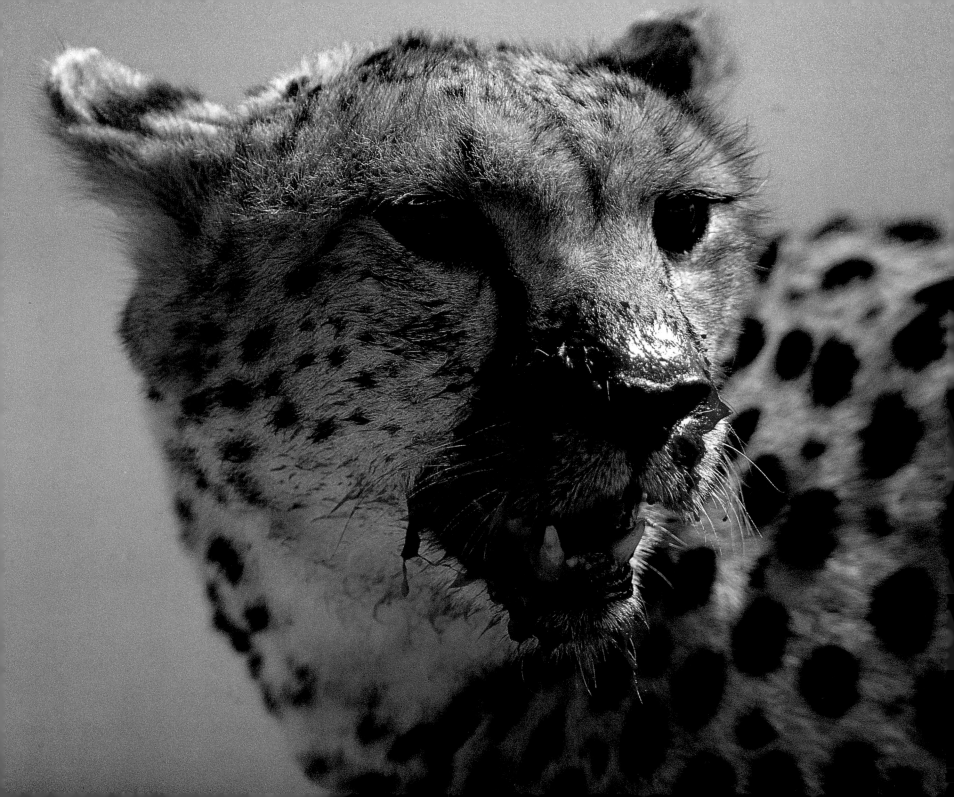

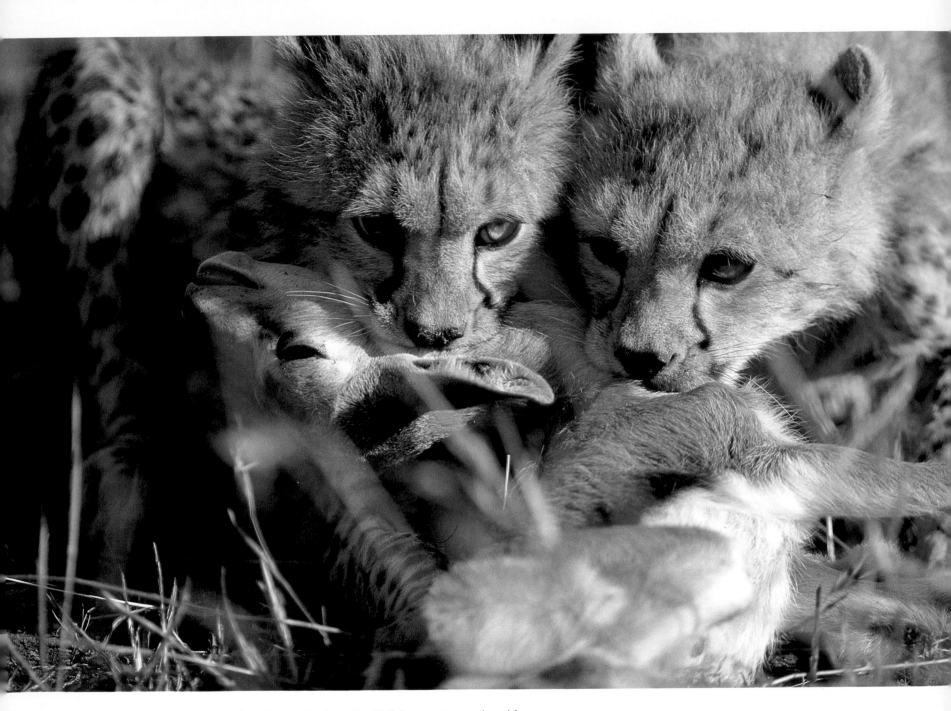

Above: To teach its cubs to hunt, a cheetah may give them its still-living prey to practice with.

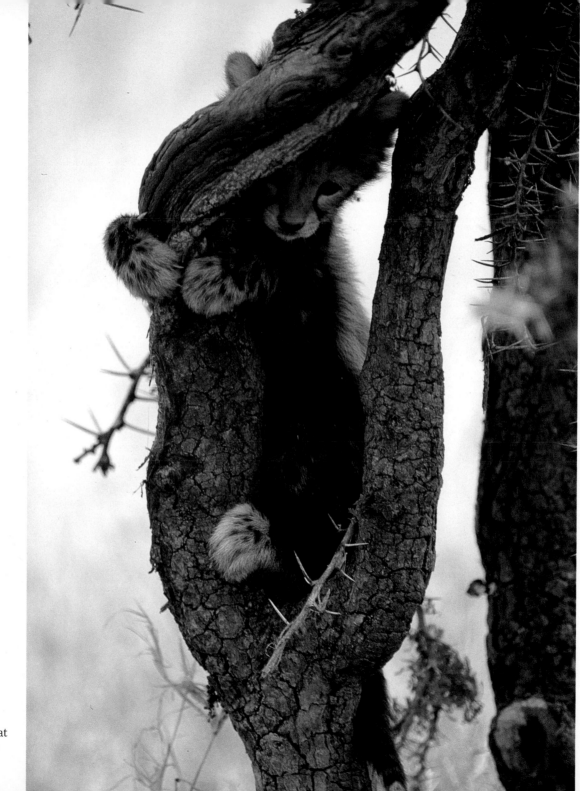

Cheetah cubs spend a great
deal of their time in trees.

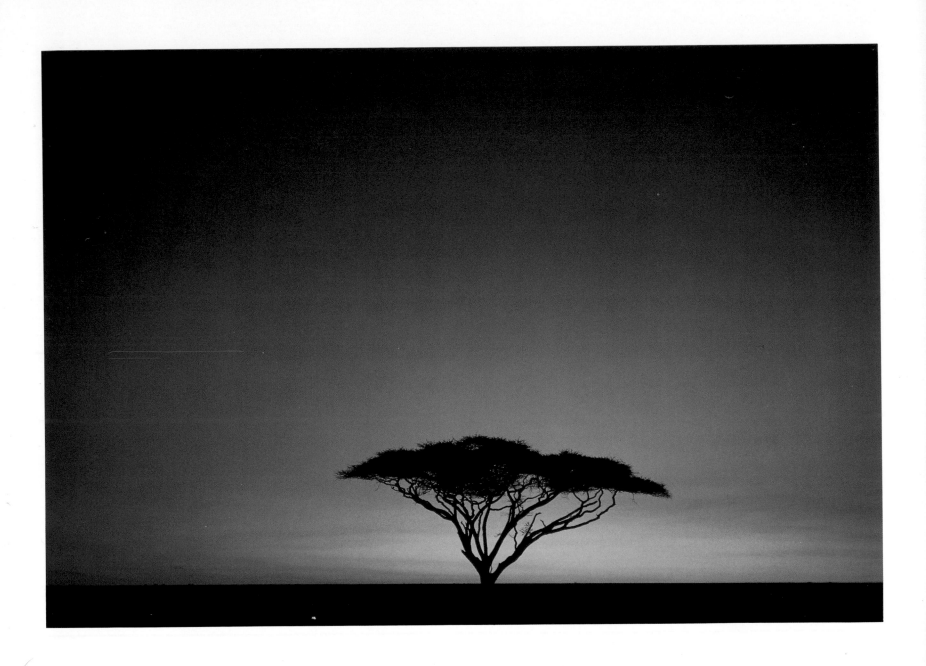

An umbrella tree at dawn.

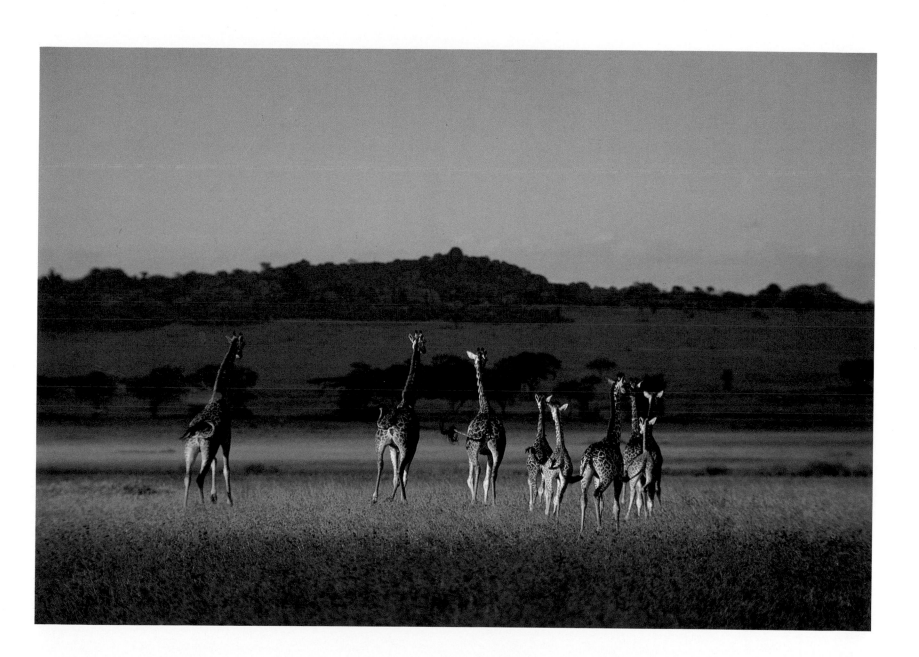

At sunset, as danger increases, the animals move to places of relative safety.

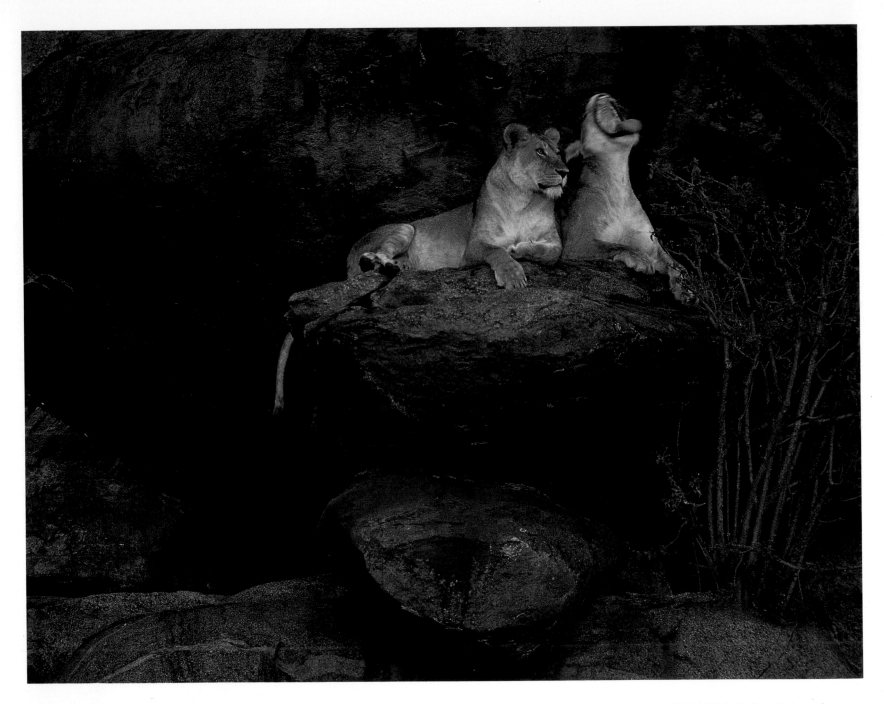

Above: The lions congregate at night to organize themselves for the hunt.

Right: Birds flock to their nesting spot.

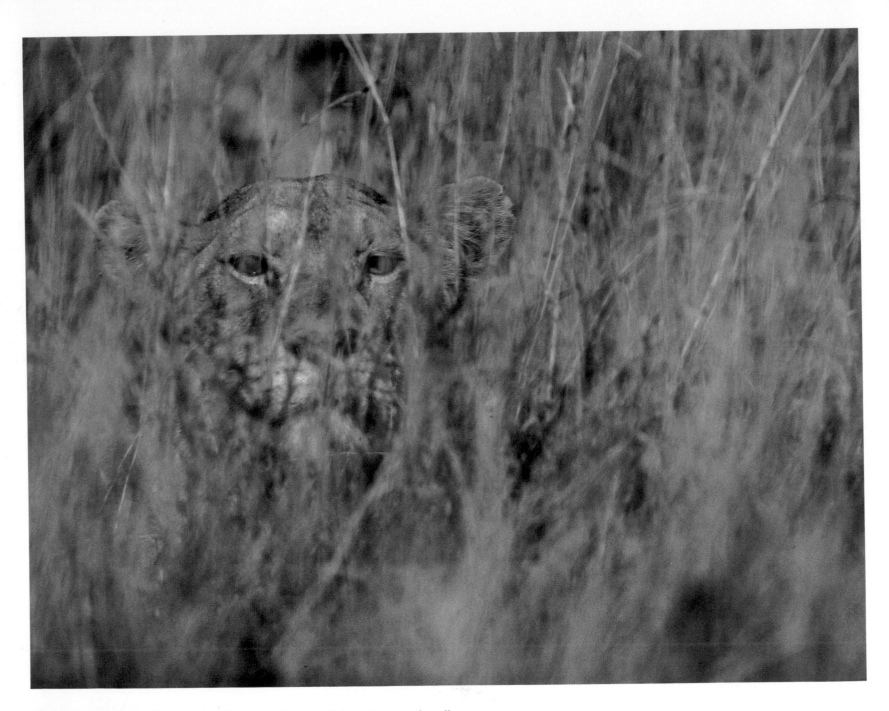

Even when the grass blocks their view, lions can stalk using their acute sense of smell.

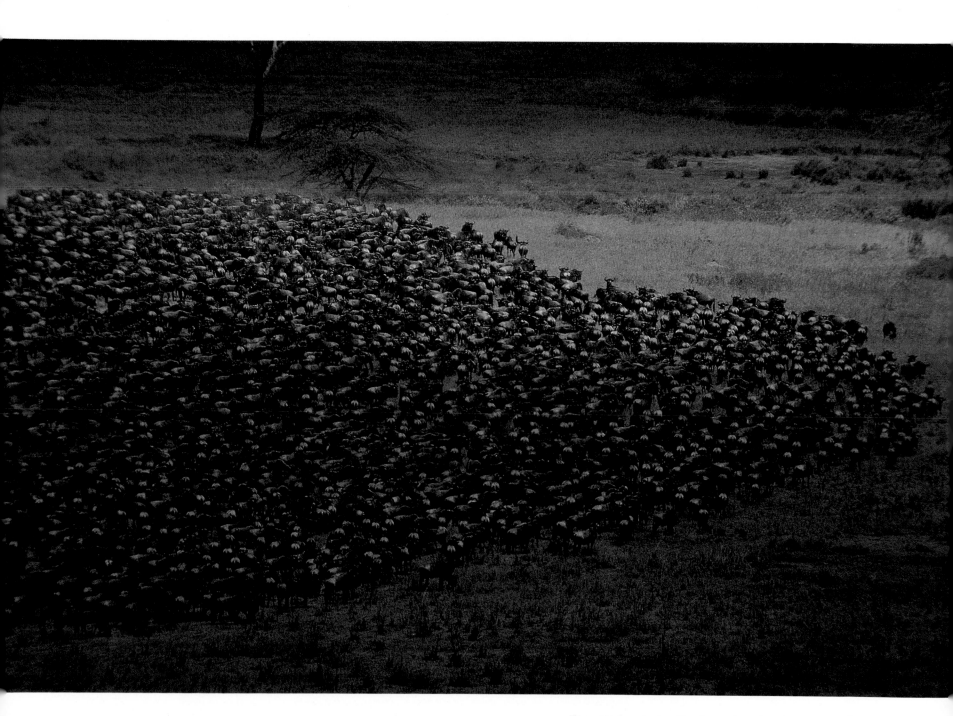

The wildebeest migration is a series of random starts and stops.

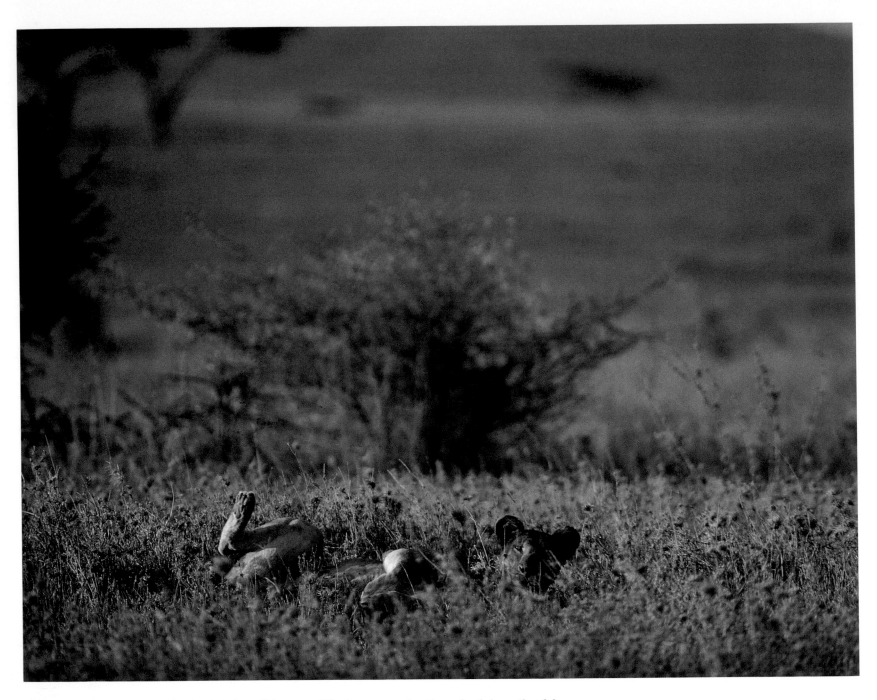

This lion seems unconcerned that her hunting will be more difficult as more migrating animals leave the plain.

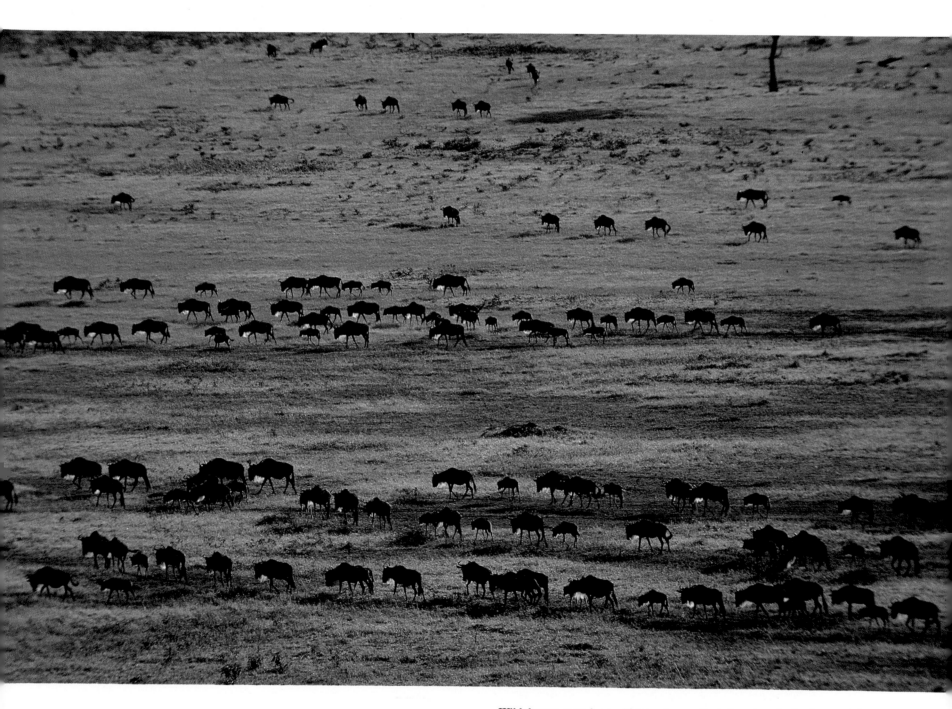

Wildebeests grow long whiskers, here reflected against the background light.

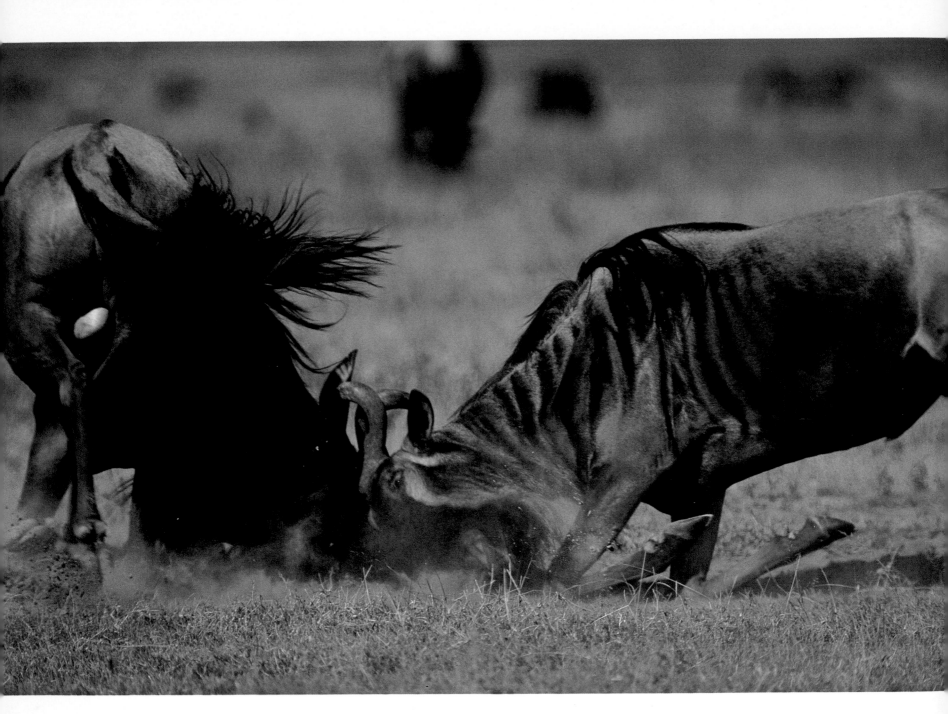

Even the migration does not end the fights between male wildebeests.

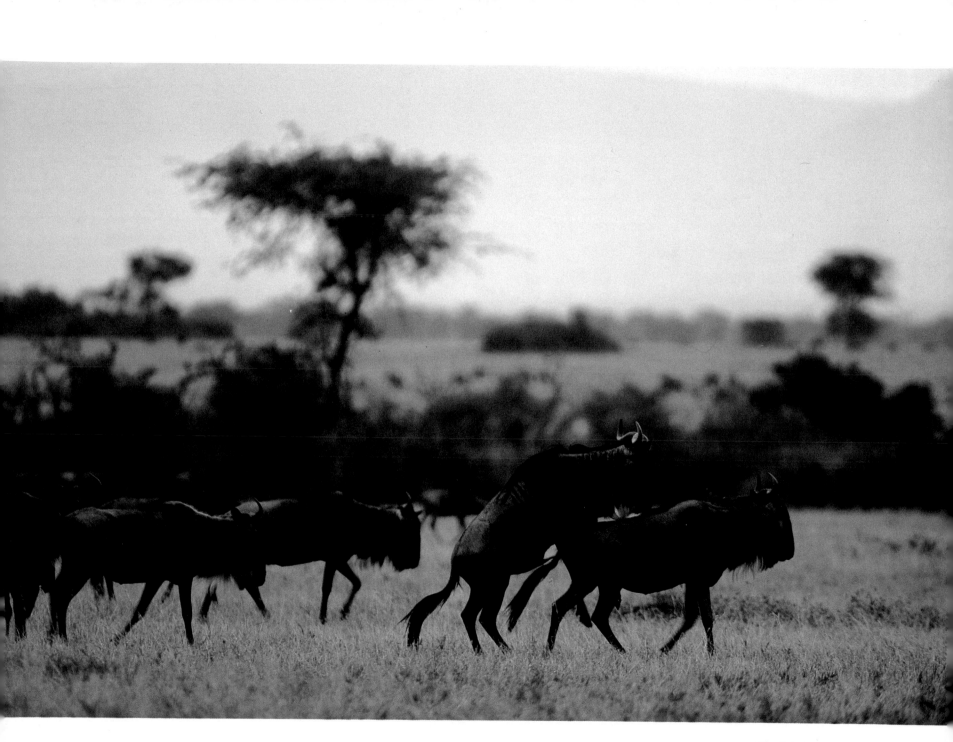

The fight is over a female.

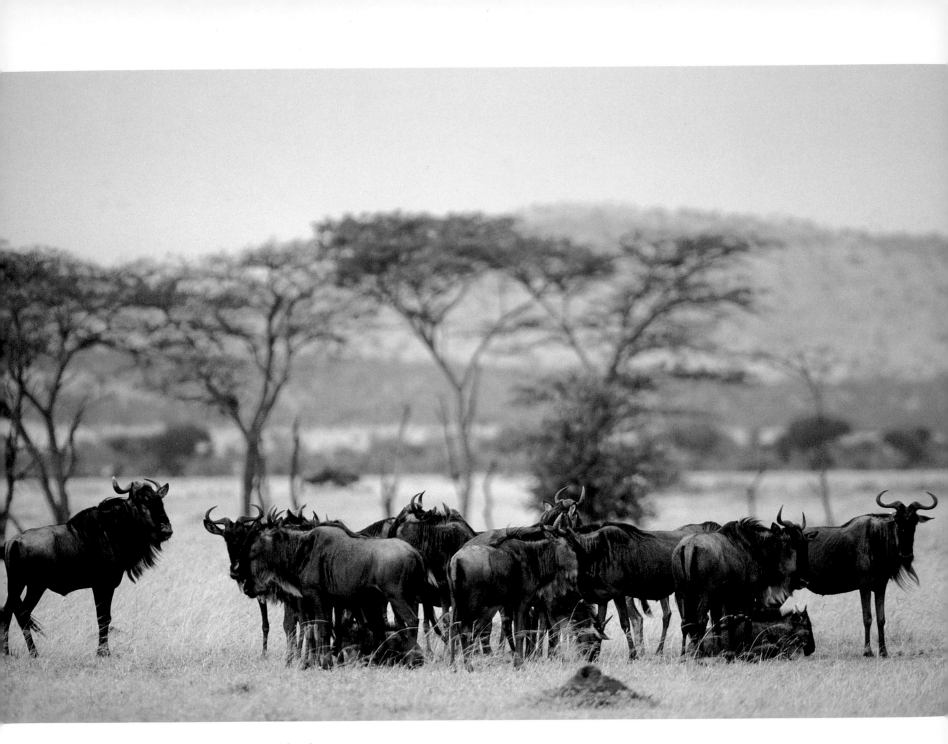

Later, the male will form a harem of several females.

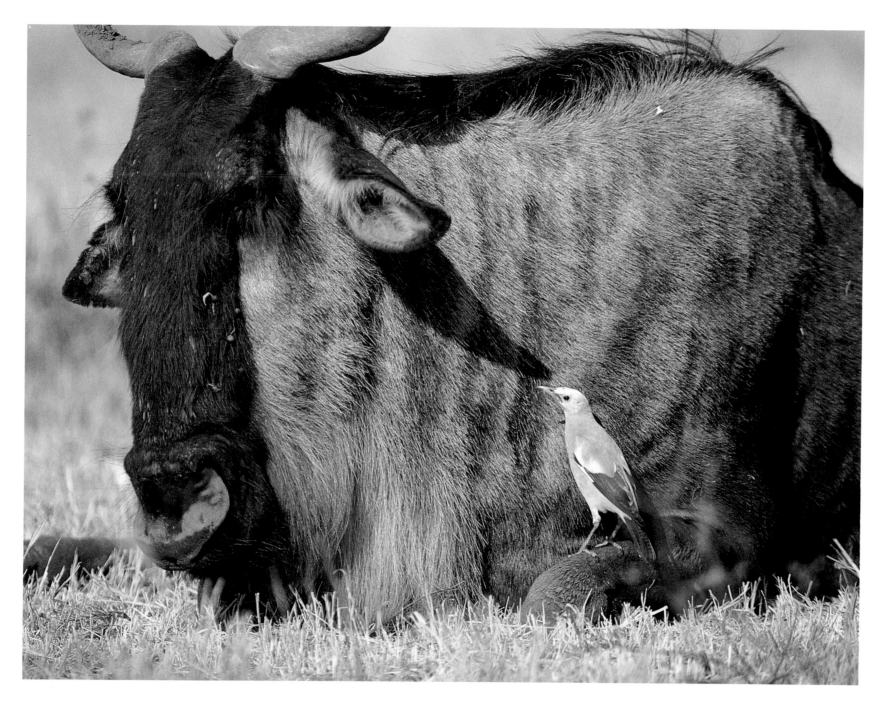

The large animals tolerate birds that rid them of insect pests.

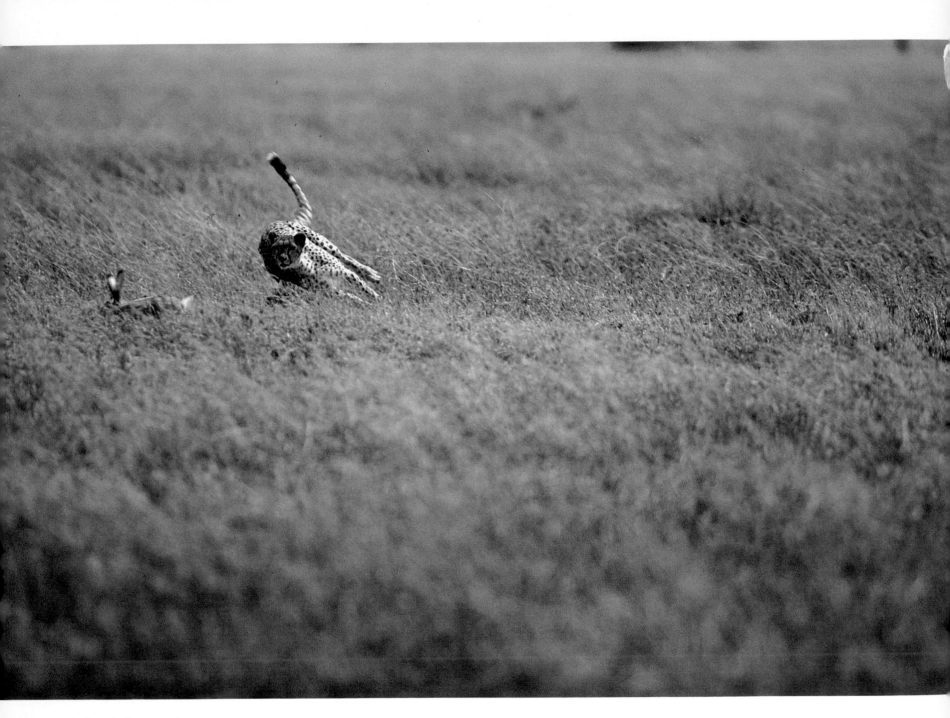

A cheetah closes on a hare.

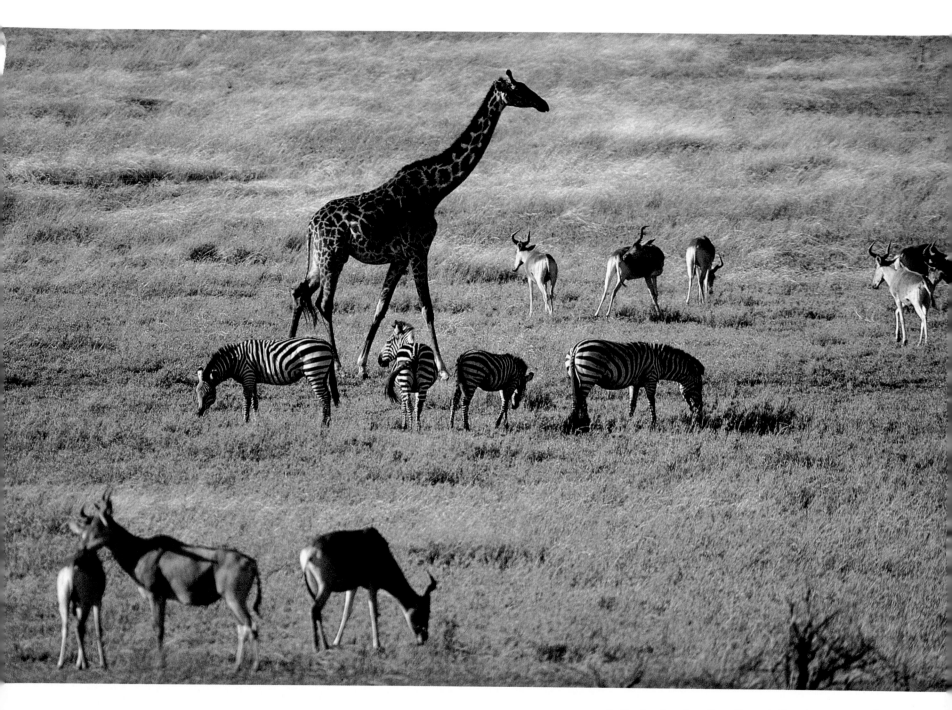

As the dry days lengthen, the grass becomes very tough.

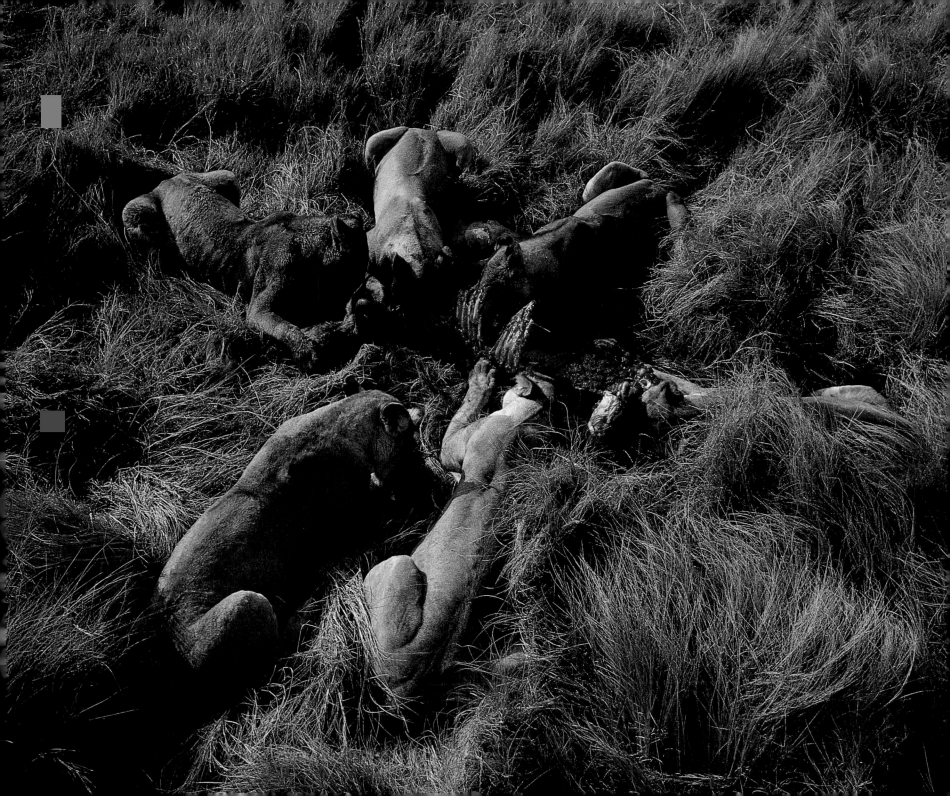

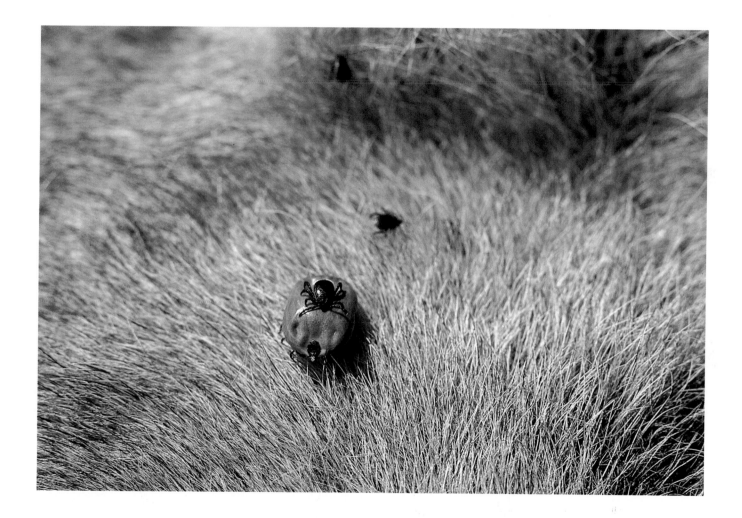

Left: The social organization of a pride insures that all will have enough to eat. *Above:* Even the regal lion is not free of tick infestation.

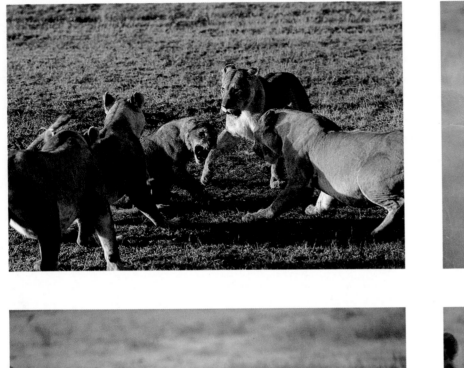

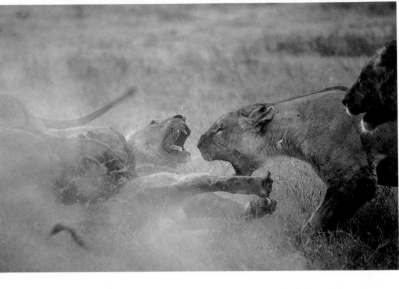

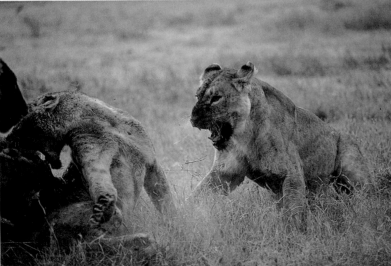

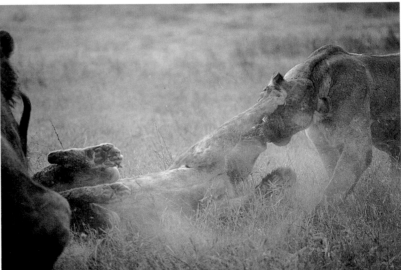

Above: A young lioness is punished in a fight over prey.

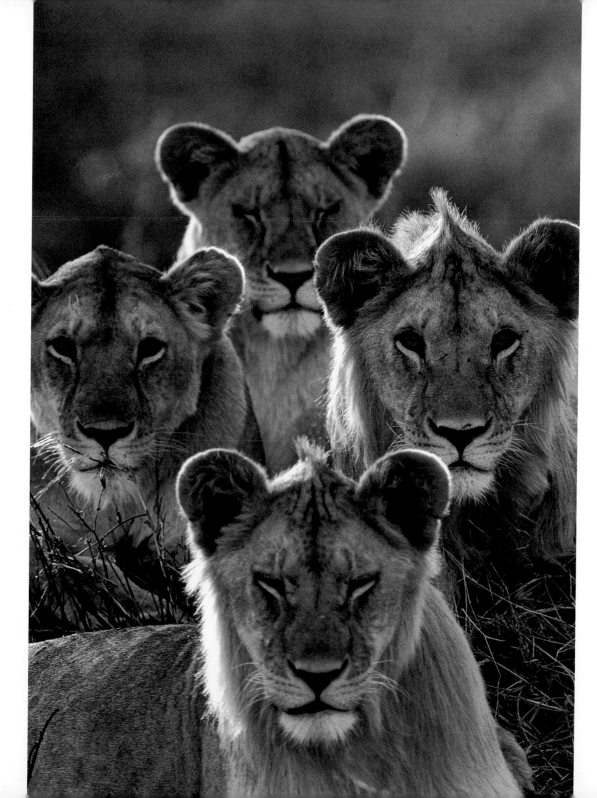

Right: Generally, all females within a pride are related. The males, expelled at the age of two from their original pride, are outsiders who have taken over the pride from weaker males.

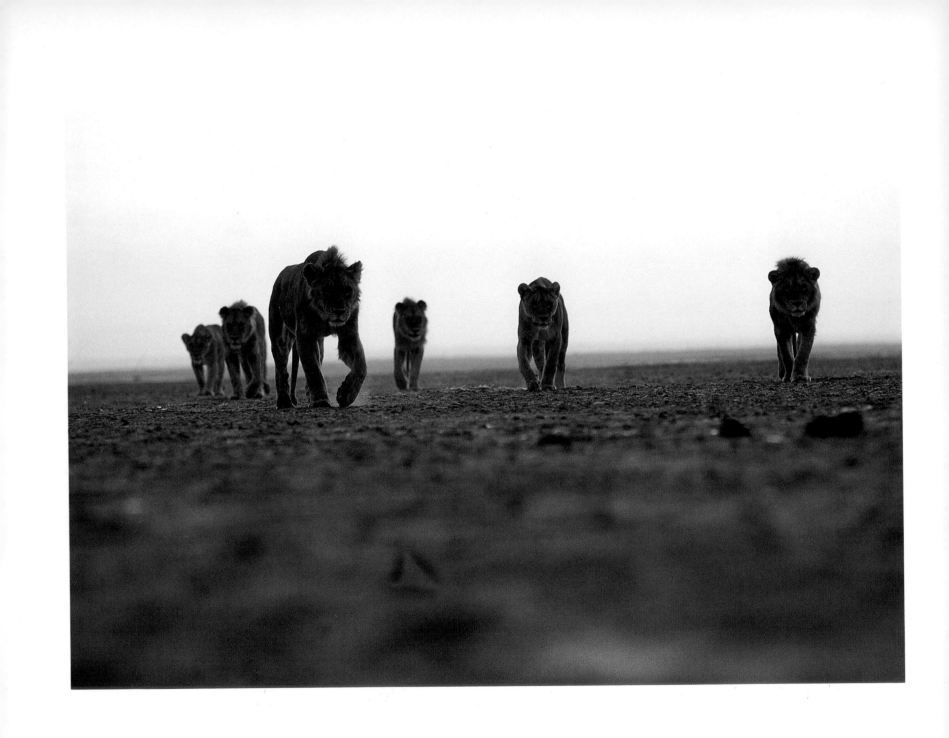

Even at two years of age, these lions are not yet accomplished hunters.

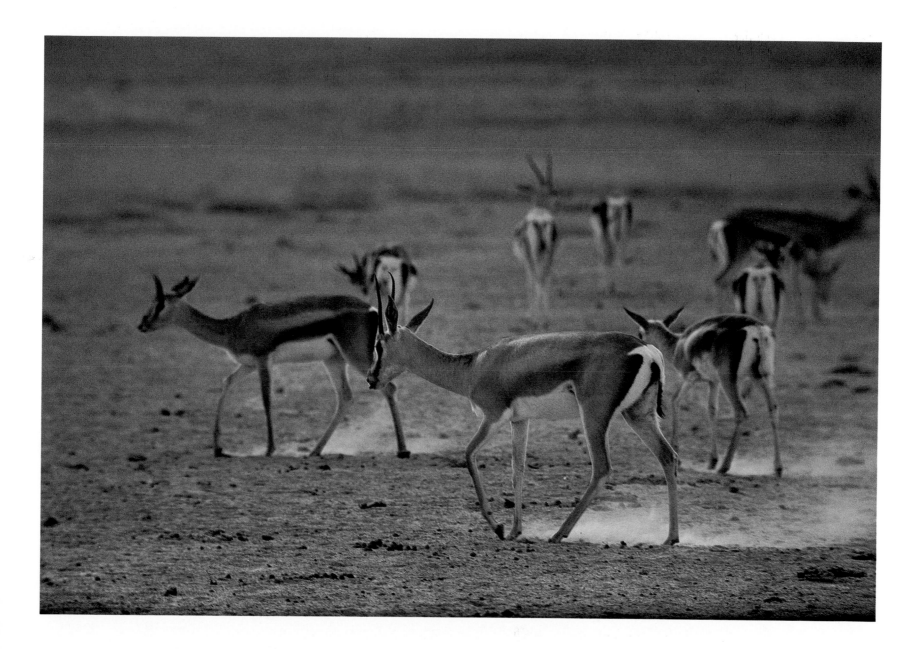

Grant's gazelles forage during the dry season.

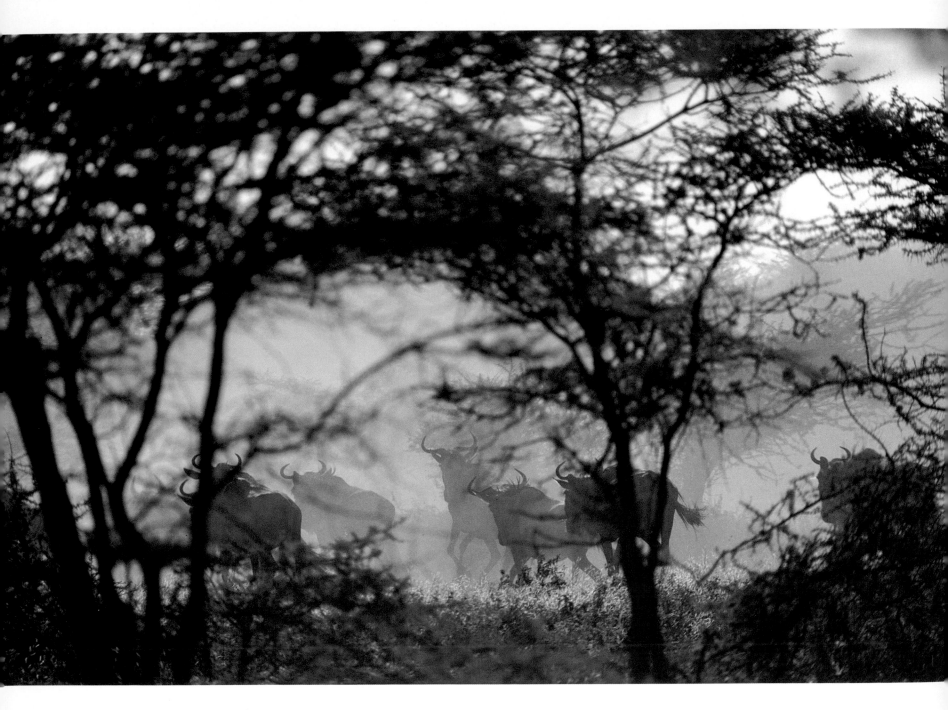

Wildebeests run through acacia woods.

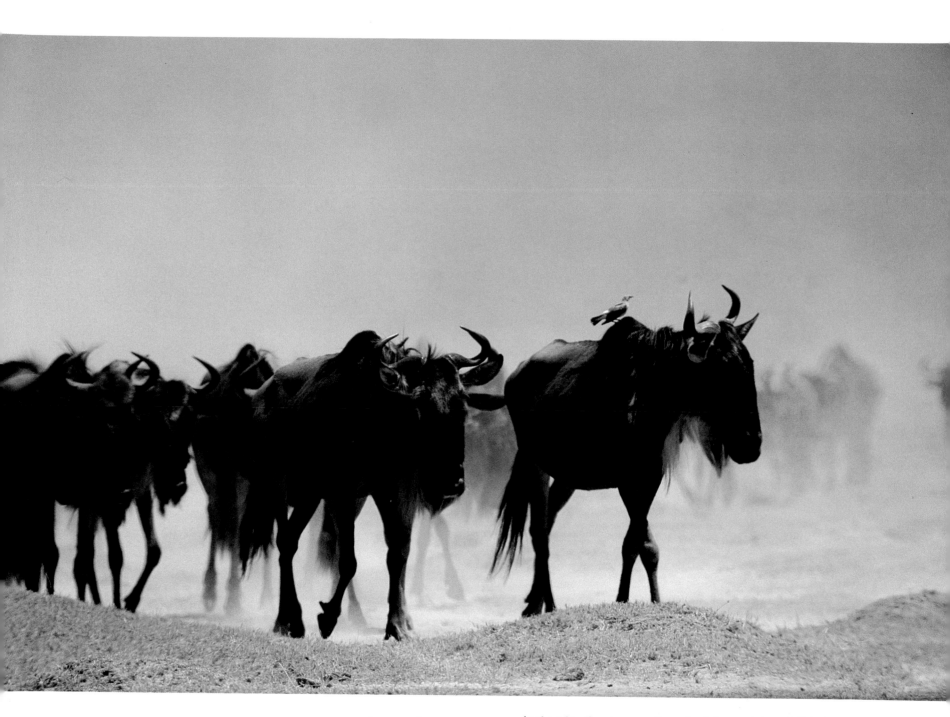

As the migration drags on, the animals lose weight and their fur its luster.

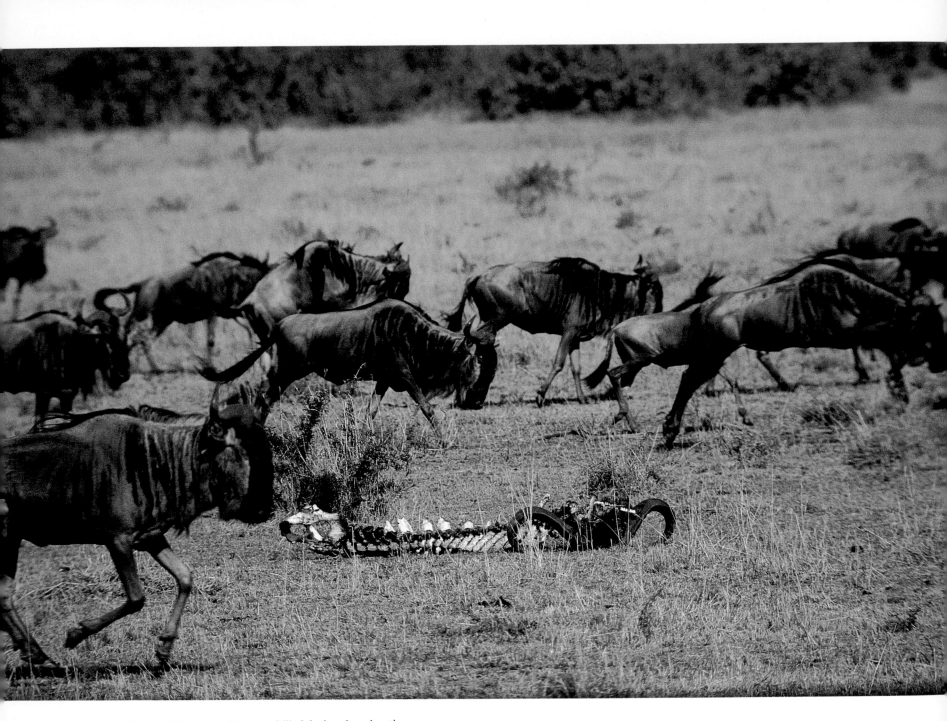

Approximately 200,000 animals die or are killed during the migration.

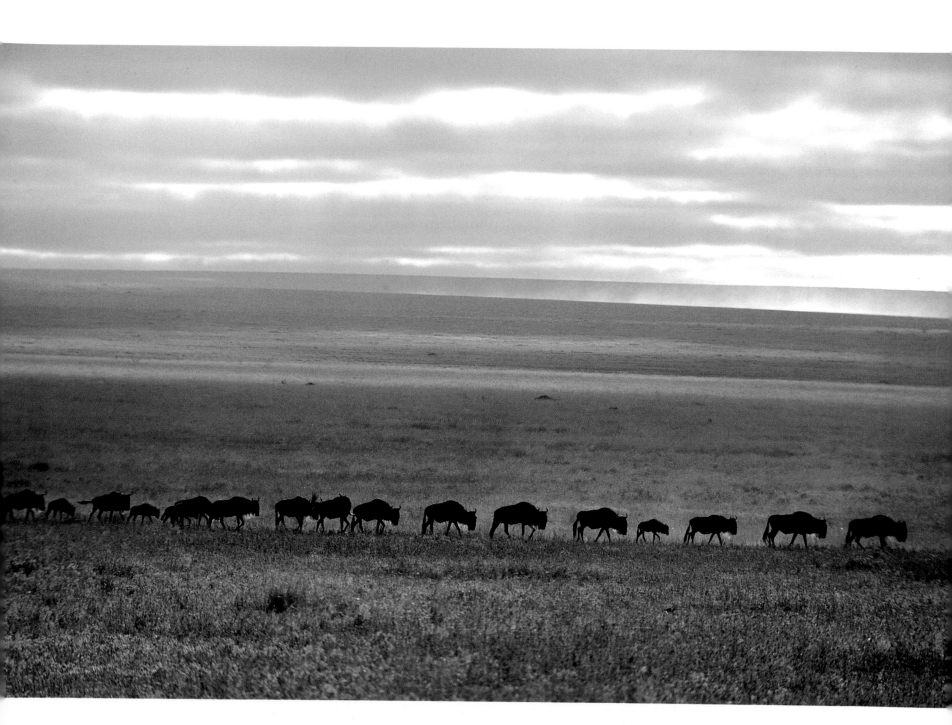

A high percentage of the losses are among the calves.

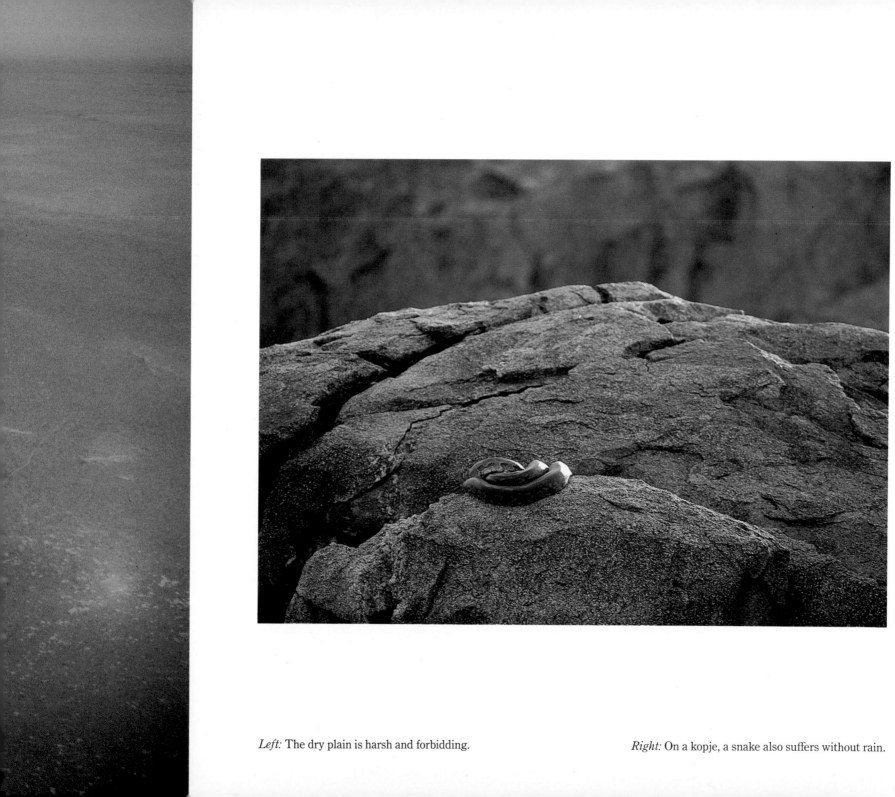

Left: The dry plain is harsh and forbidding.

Right: On a kopje, a snake also suffers without rain.

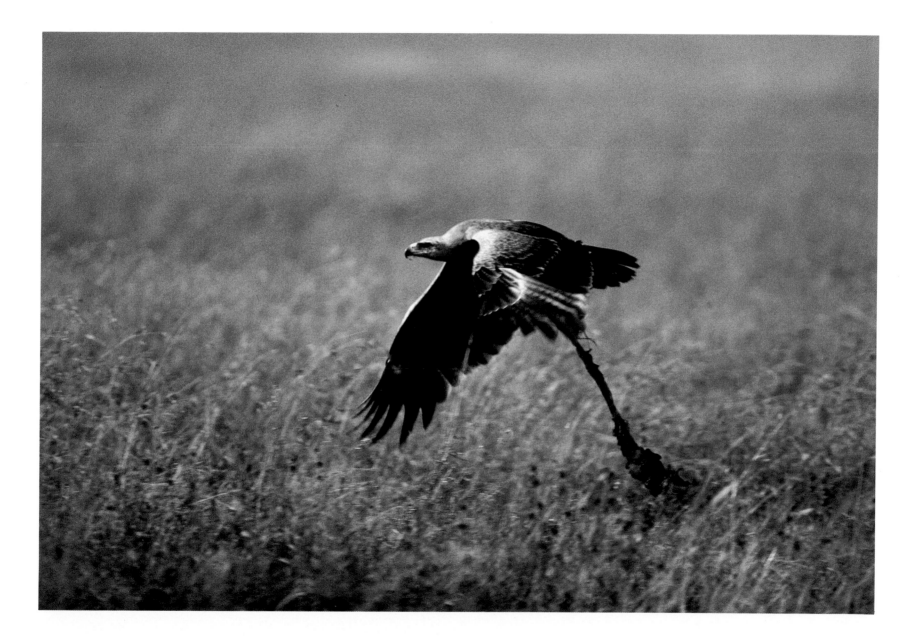

Left: Thirsty plants and trees wilt under the blazing sun.

Above: An eagle struggles to lift its leftover meat.

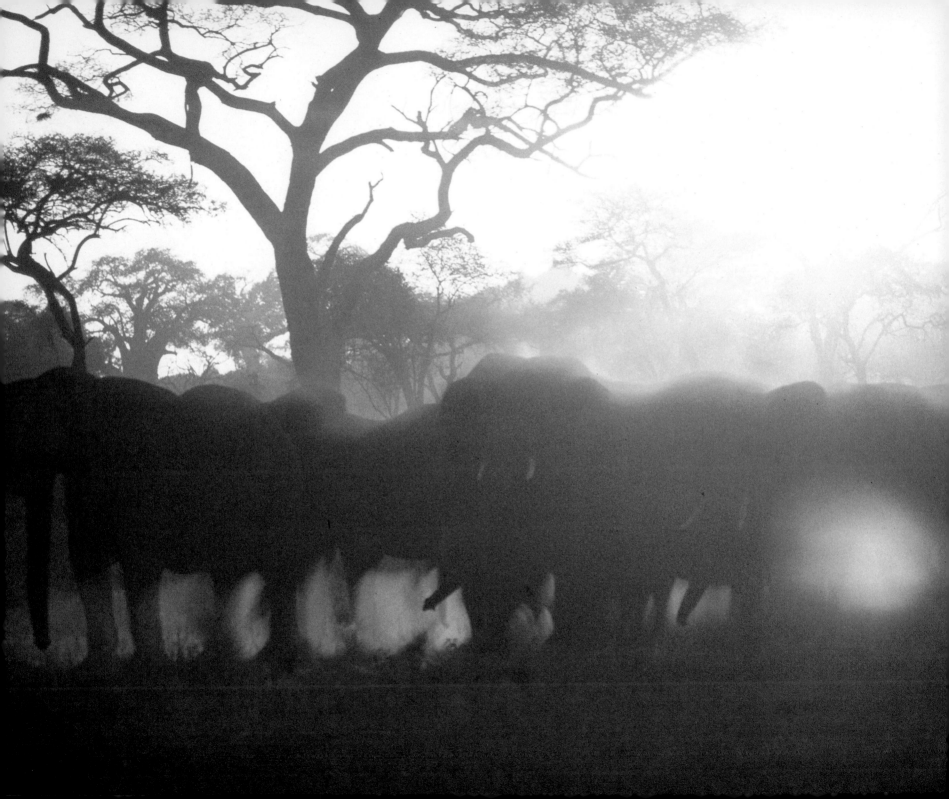

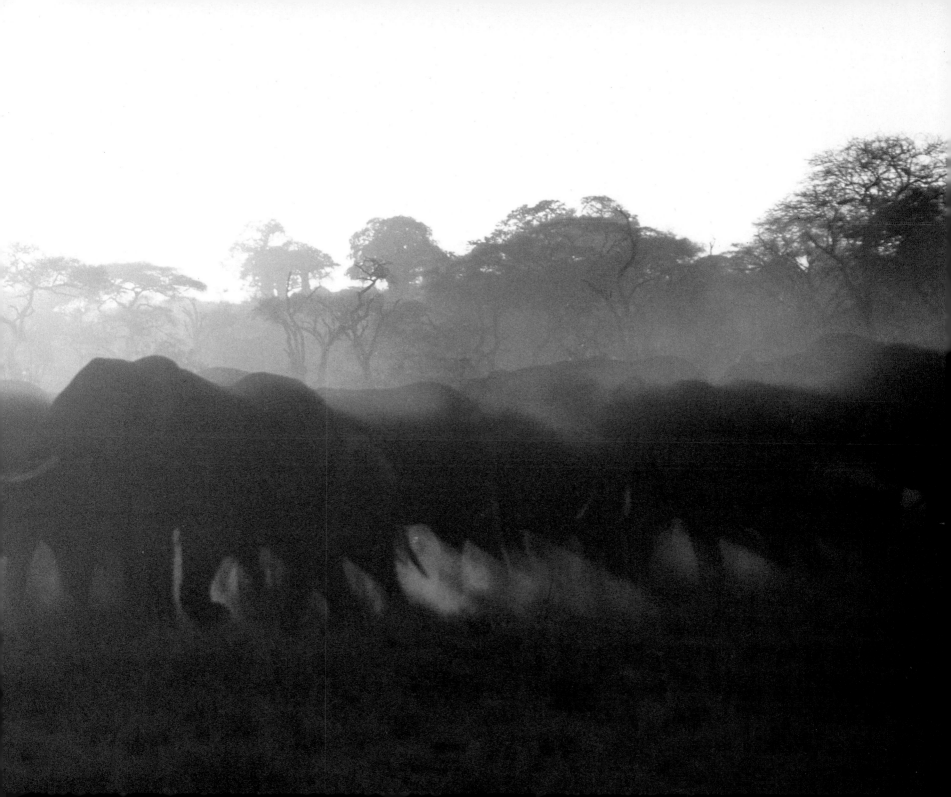

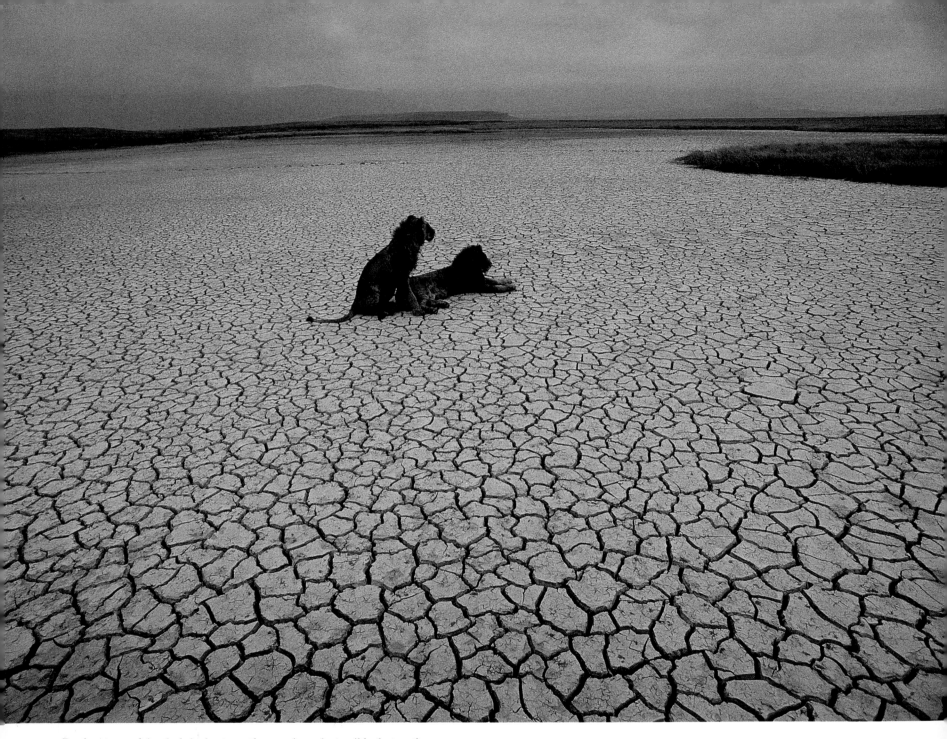

Previous pages: A herd of elephants on the march can be terribly destructive to the land, because each adult requires several hundred pounds of vegetation every day.

Above: The earth and its animals are parched.

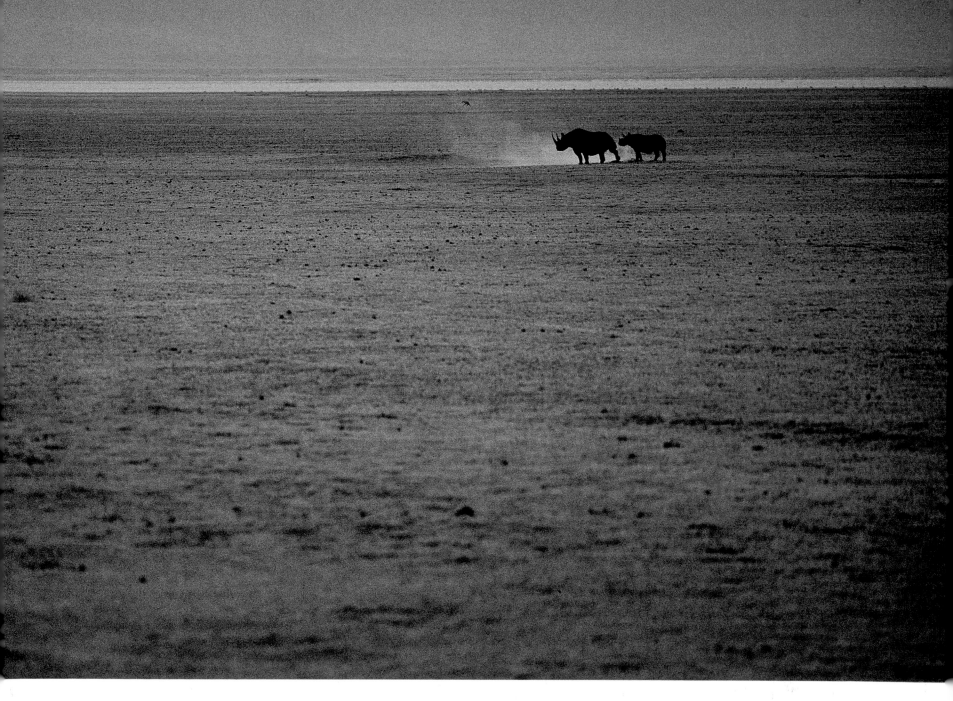

In every direction there is the dust, the featureless sky, and thirst.

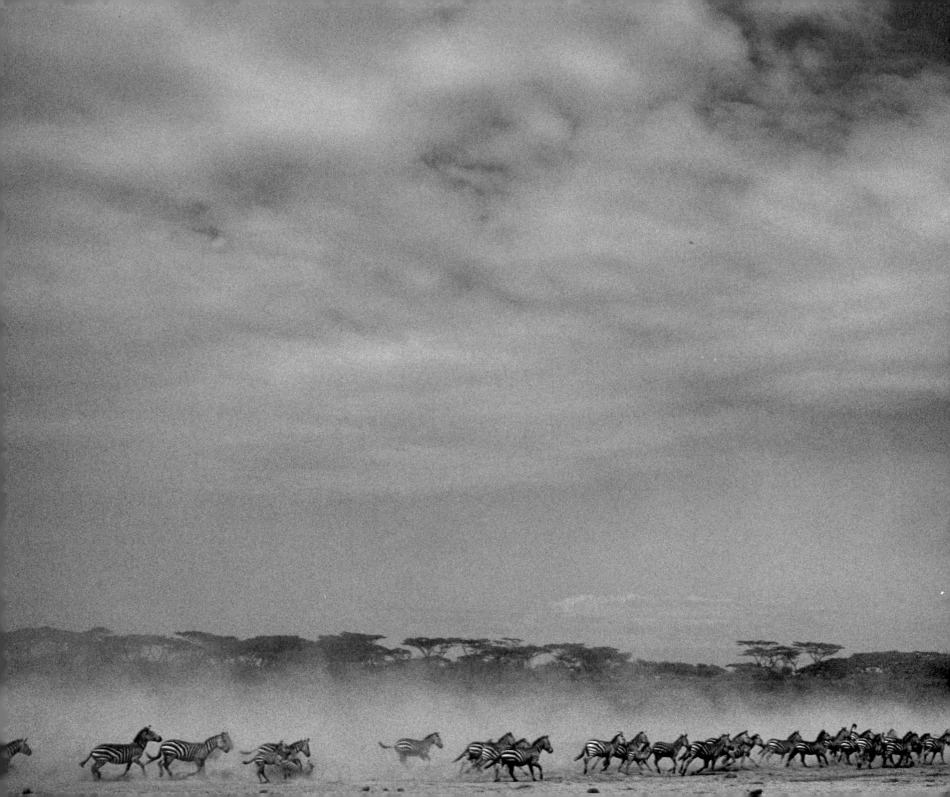

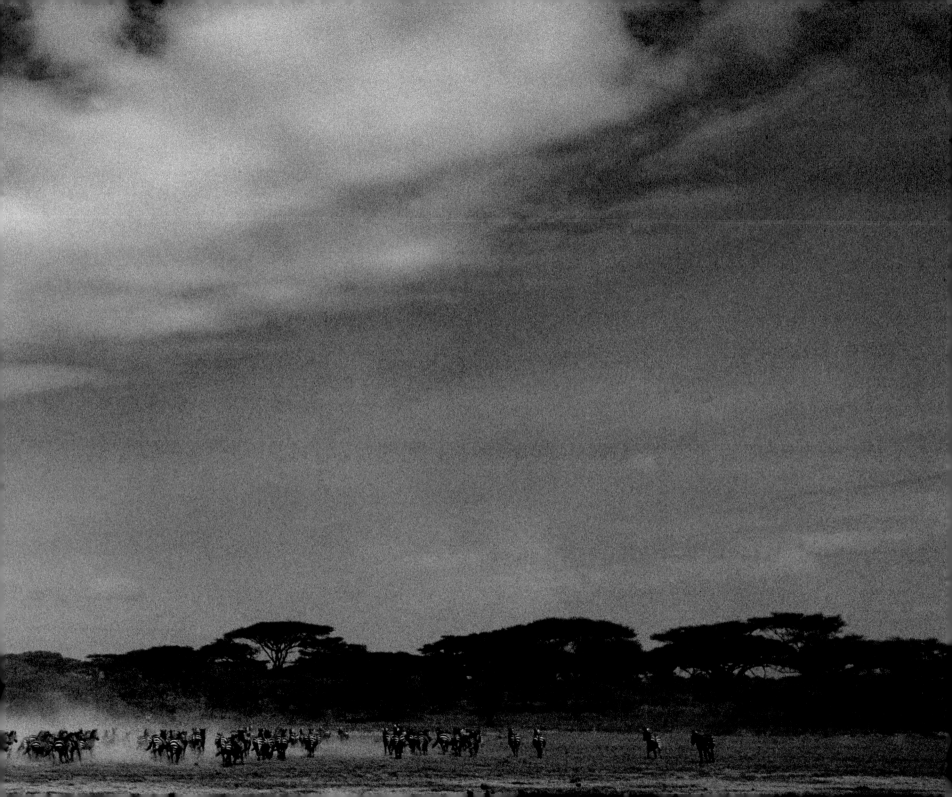

Above: A natural abstraction, this wildebeest tail will soon be one with the soil.

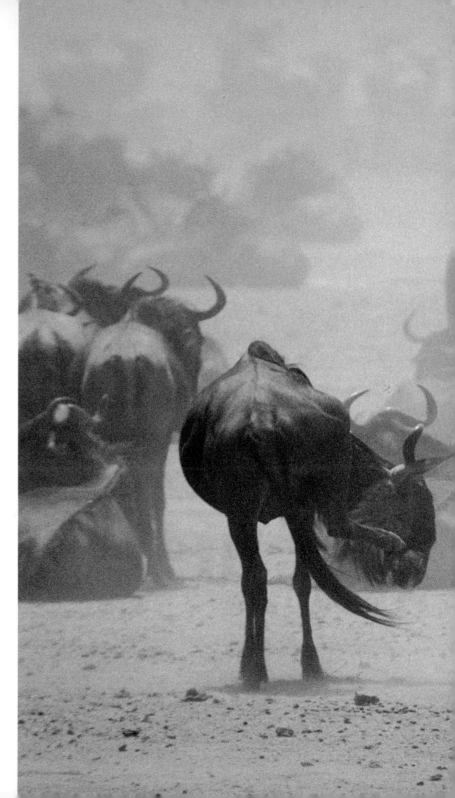

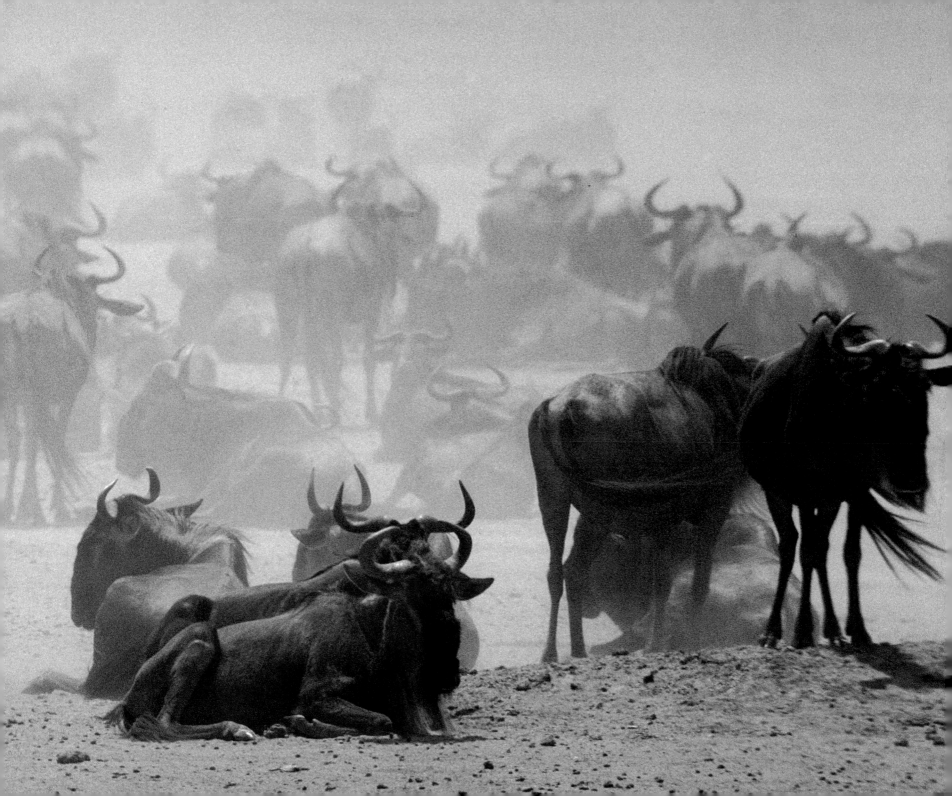

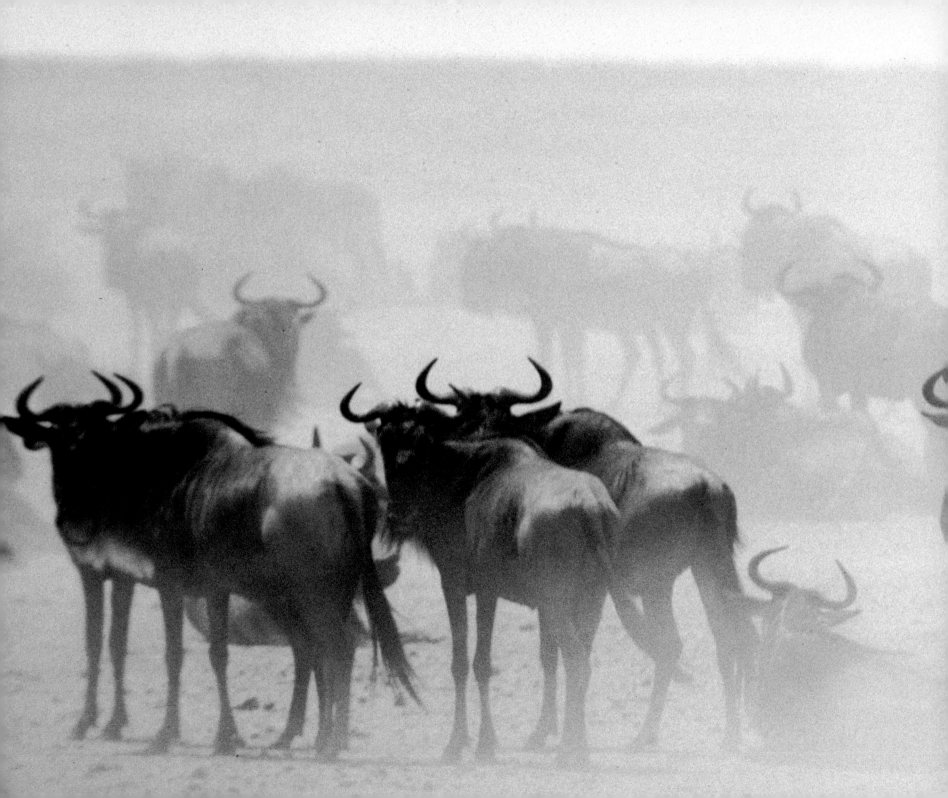

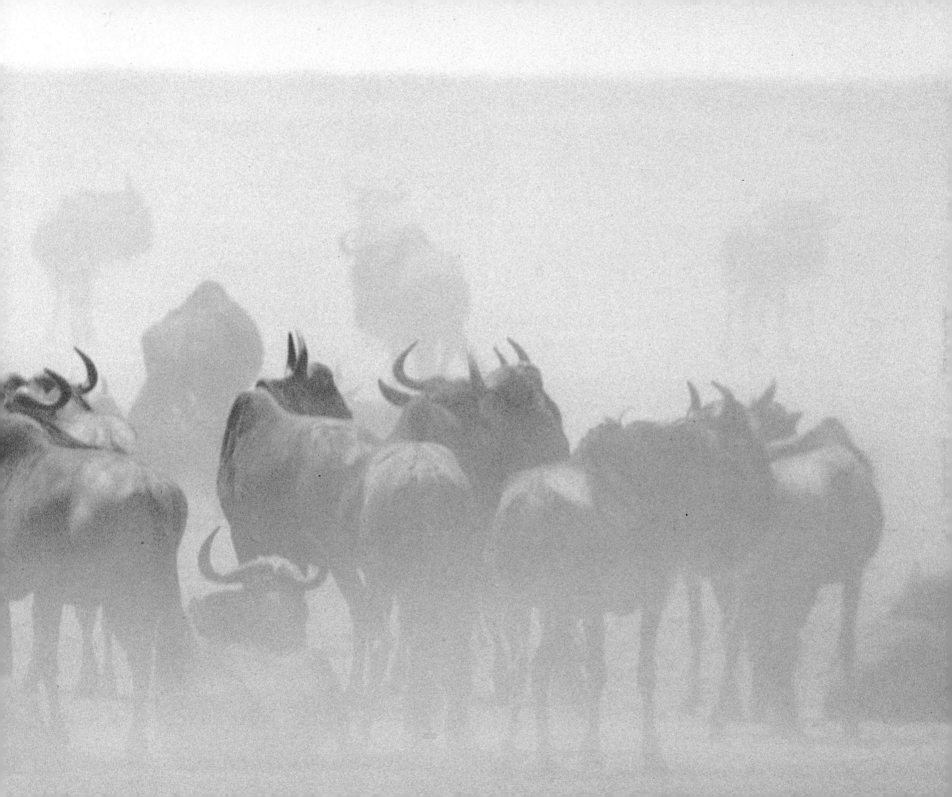

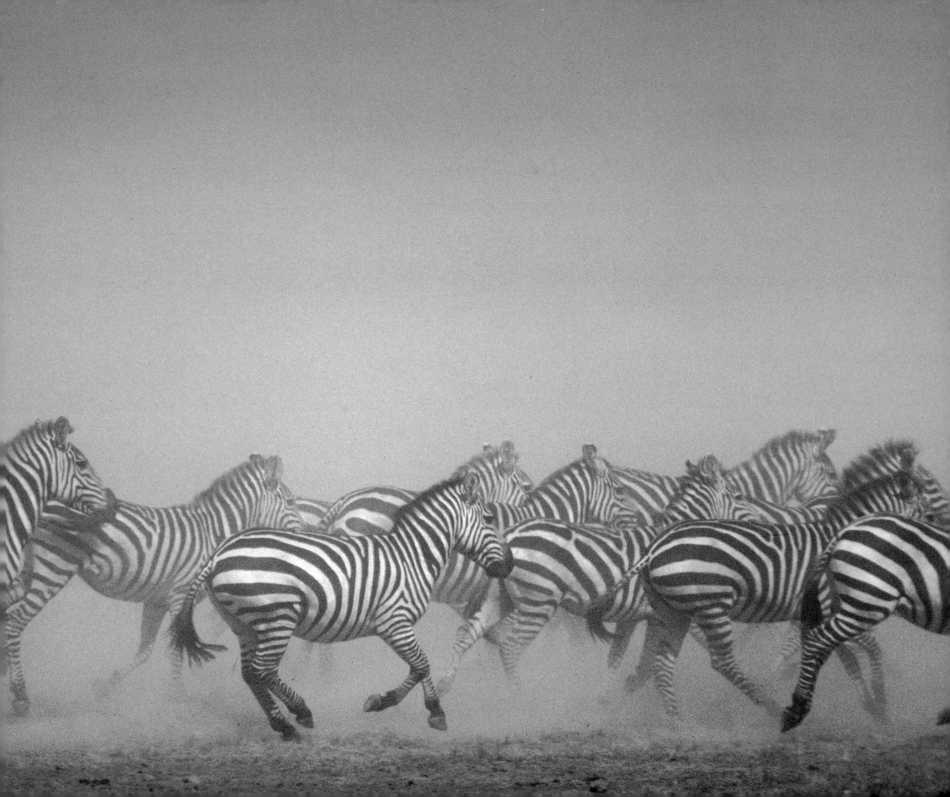

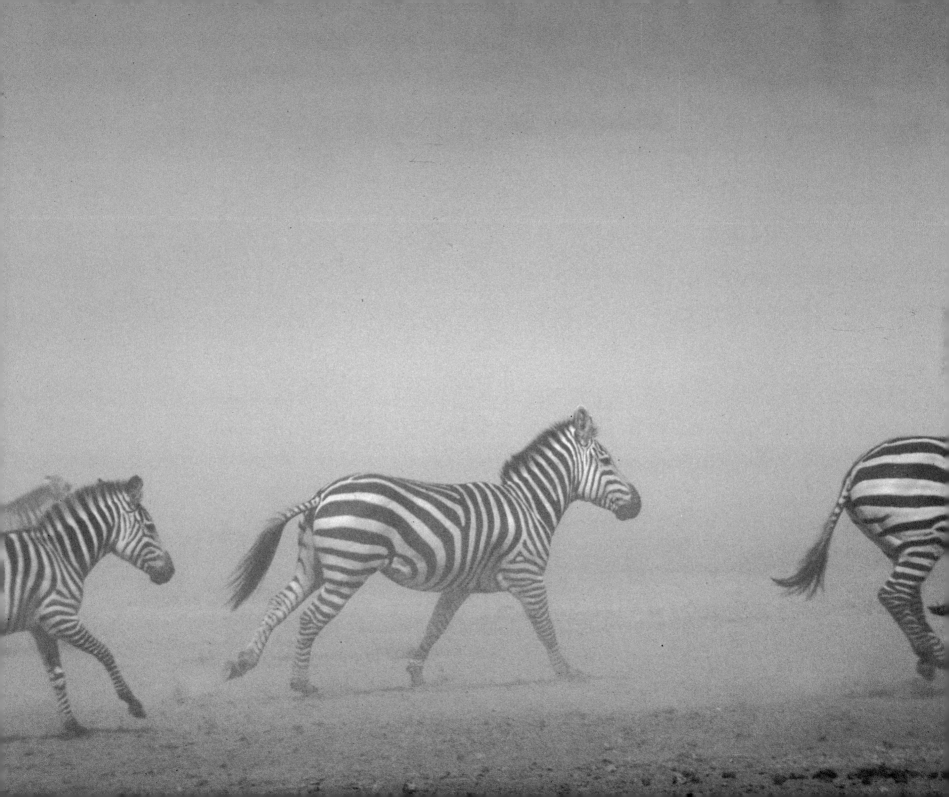

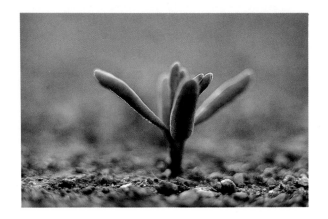

Yet even in the arid land, the birth of a tiny bud holds the promise of renewal.